photography
in the 20th century

photography
in the 20th century

petr tausk

Focal Press · London

Focal/Hastings House · London

ENGLISH EDITION ©1980 FOCAL PRESS LIMITED

📖 British Library Cataloguing in
 Publication Data

Tausk, Petr
 Photography in the 20th century.
 1. Photography–History–20th century
 1. Title
 770'.9'04 TR15
ISBN (excl. USA) 0 240 51031 3
ISBN (USA only) 0 8038 7199 6

Adapted by the author and
Translated by VERONICA TALBOT
and J. DAVID BEAL
from the original German edition,
Petr Tausk, "Geschichte der Fotografie
im 20. Jahrhundert"
published by
DuMont Buchverlag GmbH & Co.
Kommanditgesellschaft, Köln,
Federal Republic of Germany,
who hold the world copyright.

First edition 1980

770. 904

Printed in Great Britain by Thomson
Litho Ltd., East Kilbride and bound by
Hunter & Foulis Ltd., Edinburgh

Contents

Preface to English Edition

The idea of writing this book came to me when I began lecturing on 'Contemporary Photography' to students of photography in the Film and Television Faculty of the Academy of Musical Arts in Prague in 1967. When I had completed writing the book in Czechoslovakian, I reworked the material into a book in German, and I finished this manuscript in May 1975. That was five years ago, and the time that has elapsed necessitates some additions to the final part of my book, dealing with the evolution of photography after 1945. The effect of the closure of some big illustrated weekly journals can be analyzed more effectively now than in 1975. Hence I have altered the original chapter concerning the development of journalistic photography since the 'Family of Man' exhibition, making two parts of it. For similar reasons I divided the chapter about the recent evolution of the portrait, describing the psychological aspects and the influence of live photography separately. Finally, I felt it necessary to add a new chapter about the influences of photographic realism in painting on photography.

Both the German edition and this English translation concentrate on defining the main trends of the evolution of photography rather than dwelling on personalities. In keeping with this approach, I did not attempt to include all those photographers whose eminence would merit it, nor to give a complete profile of the activities of those selected. Photographers from 23 countries are represented in the book, and this indicates the great worldwide interest in photography. I admit that my treatment of some British contributions to the evolution of photography may differ from the way a British author would deal with the subject. In 1976 the Arts Council prepared a photographic exhibition called 'Other Eyes', consisting of impressions produced by foreign visitors to Britain. Perhaps the impressions made by British photography on someone living abroad could be judged similarly.

In my book I have dealt only with the evolution of creative photography. Comparison may be made with the field of drawing, in which no one will disagree that only artistic productions are considered, although large numbers of drawings are made which are in no way artistic—for instance, drawings of microscopic objects prepared by scientists, plans drawn by engineers, and so on. Thus it is very important to define the word 'creative' in this context, so that readers will not expect to find here a description of the evolution of types of photography other than those used to produce emotional effect.

With regard to the revision of the text and certain alterations in choice of illustrations, it is important for me to explain that in 1976, during the period between the completion of the German manuscript and its publication, I was granted a month's scholarship to study the history and the present state of British photography. I am extremely grateful for this scholarship,

7

which was arranged as part of the exchange programme between Czechoslovakia and Great Britain.

I am especially grateful to my programme organizer, Miss Violet Wickenden of the British Council, and to my two advisers, Mrs Sue Davies and Mr Colin A. Osman. I would sincerely thank all those who assisted in the success of my stay in Britain: especially to Mrs Lenka Musilková, Miss Penny Steer, Messrs Michael Blake, Brian Coe, Geoffrey Crawley, Charles Fraser, James Fraser, Arthur Gill, John Hedgecoe, Paul Hill, Mike Hoban, Terry Jones, Barry Lane, Jorge Lewinski, Tom Picton, Milan Pokorný, Malcolm Rogers, Chris Steele-Perkins, Peter Turner and Stephen Weiss. I should also like to take this opportunity of thanking British photographers and administrators of museums, galleries and other institutions for their friendly cooperation in supplying some of the photographs which I have used to illustrate this book.

Petr Tausk Prague, February 1979

Foreword

Nowadays photography has become a part of our cultural life which is taken for granted, just like the skills of reading and writing. Society's use of this medium is becoming much more extensive and versatile. This book, however, concentrates on creative photography, and only a very small number of photographs taken every day fall into this category. Nevertheless we think that these photographs—however small in number—are very important, for, like all other works of art, they help to enrich the cultural spectrum. It can even be claimed that photography today has found an important place in modern art. Until the turn of the century, photography was not able to emancipate itself from painting and to find recognition as an independent genre. Consequently the history of photography as a medium of creative activity does not really begin until the first decade of the twentieth century, which also marked the first important stage in the development of photographic technique.

In the nineteenth century, photographic technical procedures were improved, with the result that the taking of pictures was simplified and photographic possibilities were extended. Technical procedure played such an important role in the photographer's work that it can be taken as a guide to the stages of photographic history during the first few decades after its invention. We thus refer to certain periods of development as the 'Daguerrotype', 'Calotype' or 'collodion wet-plate' eras. With the discovery of light-sensitive gelatinous silver bromide layers in 1871 by the Englishman Dr Richard Leach Maddox, a process was created which is still in use today, although it has undergone numerous improvements and alterations through the years.

Technical requirements constitute only one of the criteria clearly differentiating the photography of the nineteenth century from that of the twentieth. Equally significant are the differing interpretations of the individuality of the photographic medium. Although there was a demand for photography in the nineteenth century (illustrated by the fact that at least twenty people besides Daguerre and Nièpce were working independently on its development), in general photography did not receive the public attention that it merited. Photography was regarded as a rational form of painting; and although the nineteenth century produced a few outstanding personalities in the field of creative photography, it is true to say that the special characteristics of the photographic image were not fully appreciated until the twentieth century.

The textual arrangement of this book is based on the one hand on certain trends in art, the fundamental styles of which are emulated in photography—for example Surrealism, Abstraction, Pop Art and Realism. On the other hand, however, photographic techniques—such as the photogram, photomontage and other darkroom experiments—also play their part, since they display the special character-

istics of photography, and develop as an artistic procedure created by physical-chemical processes with almost no manual assistance at all. Creative photography reacted to current trends even more than most of the other arts, and hence its development in the twentieth century was also influenced by social structures. The majority of social changes were not only reflected clearly in choice of theme, but also in general conception. For this reason, it seems sensible to divide the book into three periods: 1900–1918, 1918–1945, and 1945 to the present day.

The fact that photography is mainly a visual art of intuitive appreciation and not simply an artistic craft means that it has further special characteristics. It probably will not surprise connoisseurs of modern art that many photographers produce images reflecting different contemporary artistic trends almost simultaneously and yet quite independently of one another.

This book sets out to underline this important factor in its selection of illustrations. That, however, should not make us suspect the photographers of inconsistency; it only serves to indicate that photography is a completely different medium from painting. The peculiar ability of photography to react to contemporary issues manifests itself not only in today's 'social realism' school, which directly records daily events, but also in those static pictures in which the spirit of recent artistic trends is reflected in a direct or indirect form. Very often photographers react simultaneously to the problems which they notice or feel in their subconscious, and this fits in with the task of photography to record contemporary issues.

In a lecture on colour photography, *Walter Boje*[1] pointed out that many photographs exhibit strong similarities in style to paintings from the schools of Magical Realism, Impressionism or Expressionism;

but at the same time he stressed that labels of this kind, when applied to photographs, do not necessarily correspond to their parallel movements in painting. A painter in a particular period of his working life belongs only to one movement—for example, Impressionism—and can at the most devote himself to only one other movement in his time. Today's photographers, however, are neither Impressionists nor Expressionists; but by means of their photographs alone, they exercise a definite influence similar to that of the corresponding works of art.

Although Walter Boje's statement concerns colour photography, in which visual experiences from a few older schools of art are often reused, it nevertheless clearly shows how much artistic scope photographers have. In this context it should also perhaps be mentioned that only very few photographers devote themselves exclusively to one theme (for example portraits, landscapes and so on). We can usually find several subject fields in the works of famous photographers. This wide range of themes is due both to the relative simplicity of mastering photographic technique and to the differing requirements of book publishers, magazine editors and the press, for whom the majority of photographers work.

In the nineteenth century, the major centres for the development of photography were France and Great Britain, also to some extent the USA, and after 1890 Germany and Austria. Over the last few years, however, creative photography has become an almost world-wide phenomenon, even if you examine only the really important innovations. This factor was taken into account when choosing the photographs, whose authors come from more than twenty different countries. As the number of illustrations was limited by the size of the book, not nearly as many photographers could be mentioned as

merited it. Hence this book concentrates mainly on certain trends and tendencies in photography of this century, and does not claim to be exhaustive.

This book is one of the first attempts to present the theme of contemporary photography as an historical entity, and this caused a few problems. Many friends and colleagues from all over the world helped overcome these difficulties, especially when obtaining illustrations and photographers' addresses, and the author would like to thank them most sincerely for this, especially the following: Rosellina Burri-Bischof, Lucilla Clerici, Christine Hawrylak, Daniela Mrázková and Walter Boje, Oldrich Bureš, Philip L. Condax, Geoffrey Crawley, Heinrich Freytag, Manfred Heiting, Juraj Herz, Václav Jirů, Jean-Claude Lemagny, Lubomir Linhart, Bern Lohse, Colin Osman, Klaus Pielsticker, Otto Steinert and Jürgen Wilde. Sincere thanks are also due to all the photographers who kindly loaned their photographs.

I The Precursors of Modern Photography

1 Technical Foundations for the Development of Photography: 1900–1918

In photography, the 1900–1918 period marks the change from the traditions of the nineteenth century to the innovations of the twentieth. As the well-known Russian author Ilya Ehrenburg stated so aptly in his memoirs, the nineteenth century really lasted longer than it should have done: it began in 1789 and did not end until 1914. This view fits the history of modern photography surprisingly well, since its historical origins are connected with the democratization of society, starting with the French Revolution. It was far more important to the inventors of photography to develop a mechanical process of duplication than to create a new means of artistic statement.

It is therefore not surprising that the long-awaited photographic technique was regarded as a simplification of the process of image-forming as compared with painting; and it should be emphasized that for a long time painting acted as a model for photography. The photographers' efforts to try to achieve similar results as those of a painter were still very apparent at the turn of the century and up to the First World War. Nevertheless, at the same time basic efforts were being made towards the recognition of the independent status of photography. However, a development adequate for the medium did not really take place to any great extent until after 1918. The photographers' technical equipment in the 1900–1918 period consisted of plate and roll-film cameras. For professional photography, large-negative cameras were generally used, since they facili-

tated exact focusing and viewing of the subject on the focusing screen. The need to work mainly with a tripod did not constitute a disadvantage, as the chosen subjects were primarily of a static character.

The best cameras of the time were already technically very advanced; in fact subsequent improved versions of many models of the time are still well-known today. As early as 1899, Valentin Linhof constructed the first all-metal camera with a tilting lens panel—in fact the original model of those Linhof cameras which are

still used today by many professional photographers. For similar reasons it is also worth mentioning the shutter reflex camera, constructed by Goltz and Breutmann of Dresden in 1913[3]. Its main advantage lay in the fact that it was no longer necessary, after viewing the subject, to exchange the focusing screen for a cassette

containing light-sensitive material: it was now enough to swing up the mirror by hand.

Also popular at the time were various types of lighter camera which have no direct descendants today, as they were later completely superseded by simpler models which were easier to use. The latter facilitated straightforward hand-held photography by means of a simple viewfinder. The Voigtländer-Bergheil camera of 1905 and the Goerz-Anschütz camera of 1907 (both for 9×12 cm [$3\frac{1}{2} \times 4\frac{3}{4}$ in] plates) are typical examples of the most famous models.

The Eastman Kodak model from Rochester was also among the leading roll-film cameras of the 1900–1918 period. After the introduction of the Kodak roll-film camera in 1888, the first model in the series of Folding Pocket Kodak cameras came on to the market just before the turn of the century, in 1898, and many variations

followed later. A reduction in camera weight, a viewfinder, generally easy handling, and a possibility of six, eight, ten or twelve exposures on one roll of film opened up completely new potential for photography in its reproduction of reality. The production of the Autographic Kodak Special in 1916 marked another important advance in this series of folding cameras, as this version introduced the principle of a viewfinder with coupled rangefinder.[4]

For less demanding customers, Eastman Kodak brought on to the market in 1900 the simple Box Brownie, to take six exposures in the format 5.5×5.5 cm ($2\frac{1}{4} \times 2\frac{1}{4}$ in). This prototype was the forerunner of a whole series of models which were still selling successfully several decades after manufacture of the first.

Optical developments also exerted a considerable influence on the improvement of photographic technique. Soon after the

turn of the century, new lenses were devised with improved definition and somewhat better apertures allowing faster work. In this respect the Voigtländer Heliar and the Zeiss Tessar—the 'Eagle Eye of the Camera', as the advertisements called it— were forerunners, and led the way in quality for a long time.

In order to include all the possibilities that were offered to the photographer at the time, we should also mention the photosensitive materials then available, which in contrast to those of today possessed only a very low speed. The photographic plates used in 1903 had a sensitivity of 1° to 16° Scheiner[5], according to fineness of grain. They may be divided into four categories, namely 1–4° Scheiner signifying 'slow', 8–9° Scheiner 'normal', 10–12° Scheiner 'rapid' and 13–16° Scheiner 'extremely rapid'.

16° Scheiner corresponds approximately to today's 6 DIN or 3 ASA, a speed which is suitable only for special ultra-fine grain microfilm, and is no longer applicable to image photography. In 1914 Agfa introduced the 'Special Plate', which possessed the extremely high sensitivity for that time of 18° Scheiner (today 7 DIN or 4 ASA). In addition, this plate also had a wide exposure range, so that fairly large contrasts in brightness could be accommodated. At the beginning of the twentieth century, the colour sensitivity of negative materials was substantially improved. In 1904, E. König and B. Homolka discovered chemical compounds which permitted orthochromatic panchromatic sensitization of light-sensitive layers. Two years later, the firm of Wratten and Wainwright brought the first factory-made-panchromatic plates on to the market.

If you compare the photographic techniques of early times with those of today, you will observe that the main differences affecting work with photography are much more in the negative materials than in the cameras themselves. Perhaps the best evidence of this lies in the fact that many master photographers, such as *Josef Sudek* and *Bill Brandt*, have been in the habit of using cameras which were manufactured during the 1900–1918 period.

2 'Art Photography' and Impressionistic Influences at about the Turn of the Century

In the first decade of the twentieth century, which also marks the beginning of our historical survey, the majority of photographers were endeavouring to achieve the qualities of a painting in their work, as far as was possible. This attitude can be traced back quite a long way; for as long ago as 1854, *O. G. Rejlander*, often referred to as the *'father of art photography'*,[6] was making conscious efforts in this direction. This imitation of painting represented the absolute ideal also for his contemporary, *Henry Peach Robinson*, who admitted this with enthusiastic sincerity in his book *'Pictorial Effect in Photography'*[7]. In order to identify this aim in photography, people used the expression 'Pictorialism', in reference to the title of Robinson's famous

1 *George Davison*. Circus Horses. Print on silk. 1900 (Collection of Kodak Museum, Harrow)

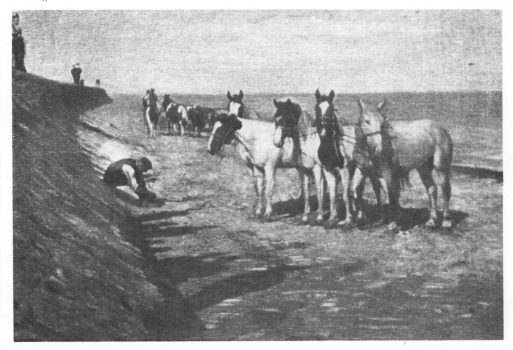

publication, in countries as widespread as Britain, America, Italy, Czechoslovakia and others. In Germany and Austria the narrower expression 'Kunstphotographie' (Art Photography) was used more often.

As painting changed, so did the ideals of pictorial photography. Especially important was the success of Impressionism, the development of which as a style was to some extent influenced by photography.

Hans Hildebrandt described this association in the following way: 'Photography, which, after Daguerre's invention in the 1830s, rapidly developed into something of greater efficiency, is of considerable significance to art. Aided by new and more refined reproduction technques to exploit its rich sources, it provides the cheapest possible demonstration material. Of course, this swift and easy process leads only to superficial acquisition, whereas the identification of oneself with the subject, which was characteristic of earlier, more specialized graphic procedures, provided a possession for all time. But the recording of things seen certainly has its advantages too, especially as the pace of living nowadays replaces the intensity and duration of experience with manifold and sudden change. Moreover, since instantaneous photography retains the most significant, the most unexpected, it trains the slow-moving eye in lightning observation. We can see the beneficent nature of this aspect of photography particularly in its influence on the Impressionists.'[8]

Since the Impressionists wanted to depict instantaneous impressions, as in photography, they had to simplify their technique in order to be able to complete a painting in a very short time. Hence they painted with broad strokes of the brush, so that outlines were diffused. By means of cameras, the Impressionists studied the changing light conditions in nature, and in this way achieved a subtle treatment of atmospheric situations in their paintings.

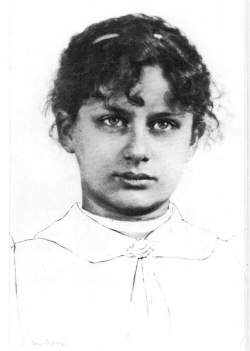

2 *Hans Watzek*. Face of Girl (platinotype). 1892 (Collection of the Federal Institute for Research & Learning in the Graphic Arts, Vienna)

Although such paintings were inspired by photography, they differed fundamentally in treatment from the sharpness and wealth of detail to be found in photographs.

Those pictorial photographers who clung to an artistic ideal were inclined to detach themselves from the typical characteristics of photography. These tendencies emerged in their exposure techniques. Perhaps the simplest method consisted of the photographer deliberately putting his lens out of focus. Another method was to use a tripod which the photographer would set in motion slightly before the photograph was taken. Finally a glass plate was sometimes put in front of a lens and smeared with grease or jelly to make it slightly

cloudy. Occasionally photographers even made use of the failings of negative materials in order to achieve artistic effects. Photographic plates and films at about the turn of the century were not as well protected as they are today against halation, which occurred in the sensitive layer by the reflection of light from the rear surface of the glass or film base. With strongly contrasting subjects or contre-jour photographs, this halation provided the contours of the picture with a shimmering halo effect.

Positive printing techniques were another means of producing photographs of an impressionistic nature. Instead of using mass-produced photographic papers, photographers preferred so-called 'fine prints' of home-made materials. These fine prints were produced as a result of complicated printing processes. Some of these were based on the fact that the layer of organic colloid adhering to the paper, to which bichromate salts were added, was insoluble in the exposed places, whereas it could be washed off in the unexposed areas with warm water. This process was known as washed-off relief. Insoluble pigments or very fine carbon could also be added to the colloid: the latter was referred to as the 'carbon process'. In aquatints, gum arabic served as a colloid, (this led to the use of the expression 'gumprint') while in pigment or carbon pigment printing, a gelatine coating performed the same function.

Later, after 1907, bromoil printing was also very popular. In this process, you started off with the normal silver bromide print, which was bleached out in a special bath. Water was allowed to infiltrate into the gelatine layer, so that the originally clear places where there were no more silver compounds received more water. After the water drops were removed from the surface, the moist paper was brushed with an oil dye, which adhered to particular places on the surface in proportion to the water content. Thus the picture was made visible again.

In these fine printing processes, the contour sharpness could be decreased so that even the smallest details became blurred. At the same time the depth of the tonal value decreased. All these characteristics contributed towards making the photograph look like a painting. The types of paper used by painters were favoured as a base. Some photographers, for instance *George Davison*, even used silk—and later other textiles—as the base for their positive prints. (Fig. 1.)

The expense involved in fine prints was not really considered to be a disadvantage at the time. Photographic enthusiasts, especially amateurs, were so infuriated by the emergence of the 'snapshooter' after the introduction of the Kodak camera in 1888 that they welcomed these complicated fine printing processes. Thus, because of its form, it was immediately possible to distinguish an artistic photograph from a simple snapshot.[9]

Thus it is not surprising that *Robert Demachy* who was one of the first to introduce fine printing into pictorial photography, was above all an enthusiastic amateur. Fine prints were so much admired that many photographers regarded the negative as merely an equivalent to the undercoat of an oil painting, and saw the real creative work only when working with the positive.[10] At this principal stage, manual additions were often made, such as the masking of various unwanted areas with red dye in the negative or the reinforcement of the image with hand-drawn details. (Fig. 2.) The materials used for the fine prints, which the photographers themselves prepared, made exact duplication very difficult, so that each print made from the same negative was in fact, to a certain extent, an original. This was welcomed by pictorial photographers, for it meant that

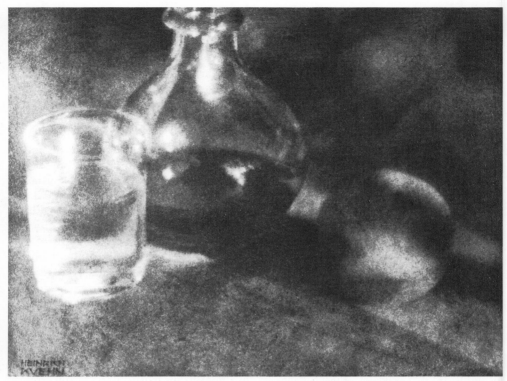

3 *Heinrich Kühn.* Untitled (gumprint). Circa 1910 (Agfa Gevaert Collection, Foto Historama, Leverkusen)

one of the characteristics of painting could also be achieved in photography.

The close relationship of art photography with painting was also demonstrated by the choice of theme. Subjects in which light was mistily diffused were especially favoured. In their original still-life studies, photographers often chose various glass objects as components of a picture, since these made the lighting softer by refraction and reflection. (Fig. 3.) Landscapes and street scenes in a light mist were also favoured. The same applied to photographs of woodland scenes, where the light came through the leaves and thus created an artistic atmosphere. For the same reason, there are a surprising number of photographs of yachts on a lake and harbour scenes, together with other subjects in which mist hovers over a stretch of water; thus, from the viewpoint of artistic photography, the diffusion of light creates an impressionistic effect.

In landscape photography, basically all the romanticizing elements were stressed. Occasionally photographers even had a romantic-looking person posing in the foreground of a photograph, as happened

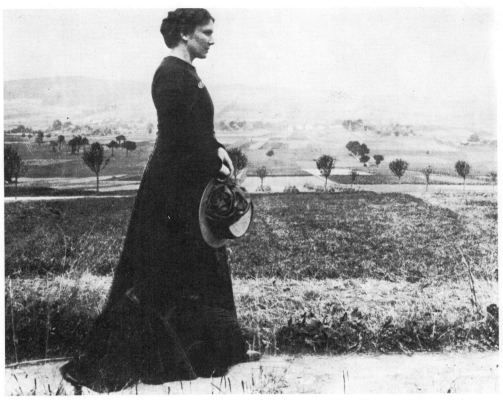

4 *Hugo Erfurth*. Woman and landscape. 1901 (Agfa Gevaert Collection, Foto Historama, Leverkusen)

in one study by *Hugo Erfurth* (Fig. 4), who, incidentally, was best known for his portrait photography.

The portrait, which had been of prime importance practically since the invention of photography, was naturally an important theme for art photographers. Here photographers tried to create artistic effects by means of extensive stylization. This concept is clearly illustrated in a portrait by *H. Berssenbrugge* (Fig. 5). The half-tones were mixed by means of the aquatint technique: this made the hair look like a dark mass on the photograph, so that the viewer's attention was directed to the clear facial tones. This principle is also underlined by the model's white clothing, and by the composition technique, which leaves the borderlines between dark and light areas somewhere in the 'medial section' ('Goldener Schnitt'). Artistic stylization is apparent also in the portrait of 'Rodin— the Thinker' (Fig. 6), photographed by *Edward J. Steichen*. The atmosphere of the picture created by the dark tonal values, together with the practical use of silhouette and profile, are unusually effective in this truly classical photograph. Artistic know-

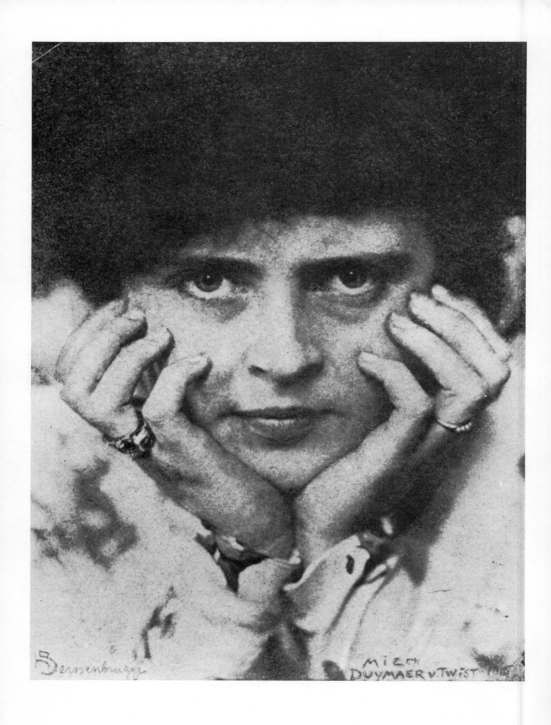

5 *H. Berssenbrugge.* Mien Duymaer van Twist (gumprint). 1910
(Photographic Collection, Design Department, Imperial Museum, Leiden)

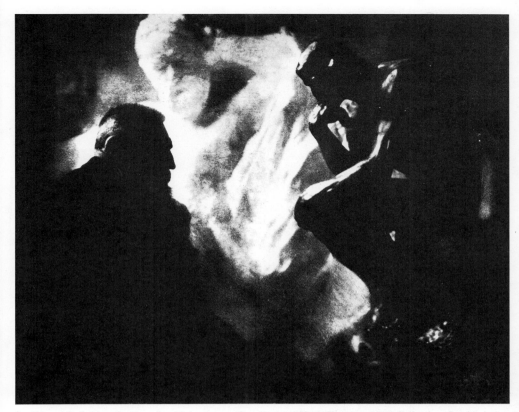

6 *Edward J. Steichen*. Rodin—the thinker. 1902 (Caroline and Hans Hammarskiöld Collection, Stockholm)

ledge and romantic interpretation were often combined in nude studies. Photography's purely documentary portrayal created a sober, almost aggressive representation of the model, which caused some problems owing to the morals and conventions of the time. The naked body was made to look as unnatural as possible by means of artificial, decorative poses, heightened by the fact that cloths were draped round the models. (Fig. 7.)

A purely artificial arrangement was also used for other subjects, for instance in *O. G. Rejlander's* allegorical scenes and in *H. P. Robinson's* poetical pictures from the middle of the nineteenth century; and this method of posing still had many supporters in the years after the First World War. *Richard Polak* arranged his subjects in such a way that they closely resembled the style of old Flemish paintings (Fig. 8). Nevertheless, photographers were often influenced by contemporary art forms; Modernism and Symbolism were especially important in this respect, and you can see their influence, for example, in *František Drtikol's* allegorical compositions (Fig. 9).

However, some photographers probably

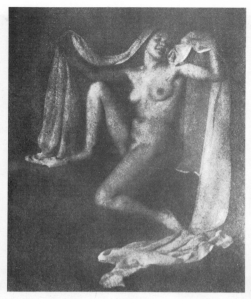

7 *Frantisek Drtikol*. Nude with drapery. 1913 (Collection of Museum for Decorative Arts, Prague)

8 *Richard Polak*. Linen chest (platinotype). Circa 1914 (Photographic Collection, Design Department, Imperial Museum, Leiden)

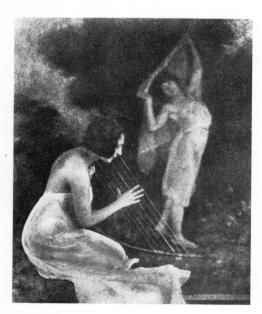

9 *Frantisek Drtikol*. Music and Dance. 1912 (Collection of Museum for Decorative Arts, Prague)

already felt deep down that unstaged scenes from everyday life were much more suited to the particular qualities of photography. Although they aimed at a picturesque arrangement, often in a misty atmosphere, in other respects the natural appearance of the real world was more or less respected. Such pictures were taken mainly in America, where gum bichromate and bromoil processes were not as popular as in Europe. The platinotype preferred there did not impair so much the reproduction of detail and tonal values. This is evident from the typical pictures of *Alvin Langdon Coburn*, for example, for whom the 'pictorial' style represented an important phase in his artistic development. (Fig. 10.) The conception of pictorial photography based on Impressionism lasted for a long time: it first emerged around 1890, reached its peak about 1910, and was still practised to

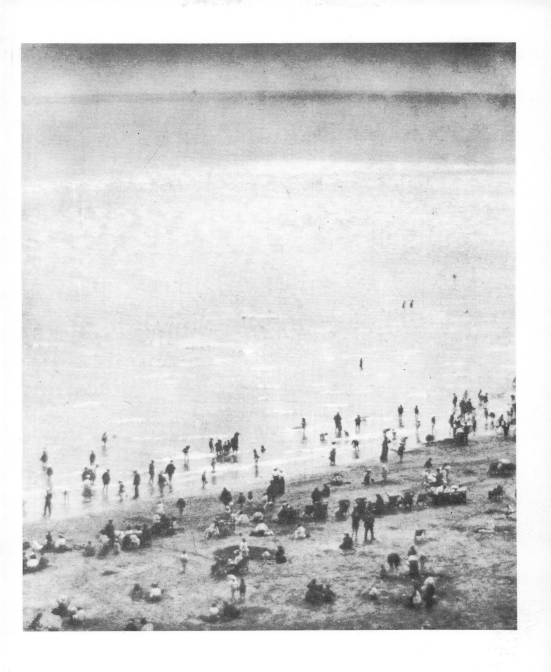

10 *Alvin Langdon Coburn*. Seashore. Circa 1910 (Agfa-Gevaert Collection, Foto Historama, Leverkusen)

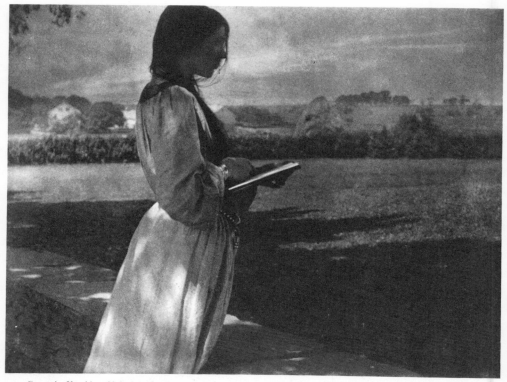

11　*Gertrude Kasebier*. Sketch. (Collection of Staatliche Museen Preussicher Kulturbesitz, Kunstbibliothek, Berlin)

some extent well into the 1930s. However, although these trends applied in most parts of the world, the results generally turned out very differently, owing to variations in interpretation in individual countries. In France, the home of Impressionism, not only did this style reach its peak, but photography was also more true to the artistic original; Robert Demachy and *Constant Puyo* should be mentioned as the most important initiators of this tendency. In neighbouring countries which had close connections with French art, the best-known photographers were the Belgian, *Leonard Misonne*, and the Dutch, H. Berssenbrugge and *J. Huysen*. German photography in its most significant works showed a slight denunciation of Modernism, as is clearly demonstrated in many of *Nicola Perscheid's* photographs, and also those of the young Hugo Erfurth and *Theodor* and *Oskar Hofmeister*[11].

The same applied to the Austrian triumvirate: *Hugo Henneberg*, Heinrich Kühn and *Hans Watzek*, all of whom exercised international influence on photographers.[12] The Bohemian photographer František Ortikol[13], who was one of the most gifted graduates of the Academy of Photography in Munich, was for a long time the model for the younger generation of portraitists in Prague.

As already mentioned, American art photography differed from European in that it did not deny to the same extent the special characteristics of photography.

L. *Fritz Gruber* has said that the reason for this phenomenon lay in the fact that Americans are more inclined towards the real and the realistic.[14] The most important representatives of American pictorial photography were members of the 'Photo-Secession' group; and from amongst the individual members may be selected the following with their stylistic peculiarities: Edward J. Steichen with the European preference for fine prints, the mistily picturesque work of *Alvin Langdon Coburn, Clarence H. White* and *Gertrude Kasebier* (Fig. 11), and even the 'straight photographs' of *Alfred Stieglitz* (see page 21).

George Davison, was one of the first British photographers to be influenced by Impressionism as can be seen in 'The Onion Field'

taken in 1890. Further works by British photographers, who had good contacts with America as well as with the European continent, were influenced from both sides. Thus some photographers followed European trends, for example, *James Craig Annan* (Fig. 12), and others like *Frederick H. Evans* tended towards the American style.

If we are to appraise this fairly long first period of pictorial photography influenced by Impressionism in its many manifestations, we should point out that different techniques of handling light provided a very broad area of variation. Many photographers were later able to use this valuable experience in a different way after turning away from pictorial photography. It certainly constituted an important benefit,

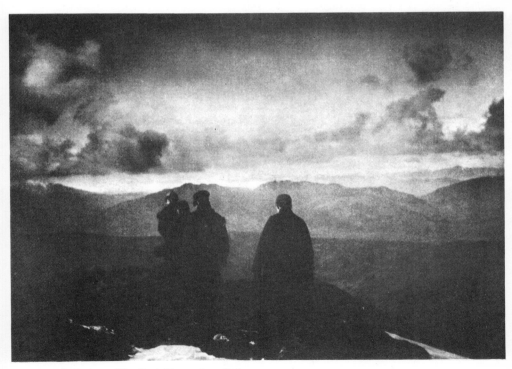

12 *James Craig Annan*. The Dark Mountains. 1898
 (Collection of Staatlich Museen Preussischer Kulturbesitz, Kunstbibliothek, Berlin)

together with the knowledge of picture composition, although these effects were often regarded as more important than the possibilities of expression through the picture content itself, and therefore contributed towards an uncritical romanticism.

One of the negative characteristics of pictorial photography was the emphasis on those elements which were typical of painting, and were in direct conflict with the individuality of photographic portrayal. This was the reason why photography in this period did not achieve recognition as an independent genre of art.

It is typical of the history of the development of modern art that while many trends experience a simultaneous boom all over the world, others are only just beginning, and others still are nearing the end of their existence. At the same time as the pictorial photography movement, other photographers were working individually on approaches which were more directly concerned with the individual nature of photography. The return to image sharpness was especially important in this respect, as also was the appreciation of the negative as the definite and obligatory basis of the positive, which should no longer be tampered with manually; only cutting down as a preliminary to the final printing was sometimes permitted.

In the development of photography, it can be observed that many phenomena were emerging independently of one another at approximately the same time. This was also true of the turn towards the true photographic characteristics of the picture, a trend which had already been taken up by many photographic personalities in the nineteenth century. Looking back, it is possible to judge these individual attempts from the viewpoint of their creative value and the influence of these contributions on the further development of photography. Some of these results were only rediscovered during the last few years and appreciated for their creative value.

The heritage of Emerson's 'naturalistic photography' was significant in preparing conditions for a return to the more purely photographic properties of the image; and the influence of this work remains clear in the efforts of some photographers during the first years of the twentieth century. This was the case with *Frank Meadow Sutcliffe*, who for some years after 1900 took a number of marvellous photographs at Whitby harbour (Fig. 13). Afterwards he dedicated himself with such intensity to activity in his own studio that he spared no more time for that creative work which assured him a place in the history of photography.

The effort to develop the documentary character of photography was an important factor in building up respect for the nature of the medium proper. If this aim was combined with a talent for sensitive perception, quite important results could be achieved. *Sir Benjamin Stone*, whose liking for visual information led him first to collect photographs and later to take them himself, gradually found his way to the creation of those pictures which are so highly rated today. Especially noteworthy was his series of portraits of Members of Parliament, which provided very detailed information of high creative quality (Fig. 14). Stone is thus one of the important predecessors of the modern realistic portrait.

Alfred Stieglitz was among those fortunate people whose works were regarded as epoch-making even at the date of their creation. His reputation and his authority were so great that his pictures were used as

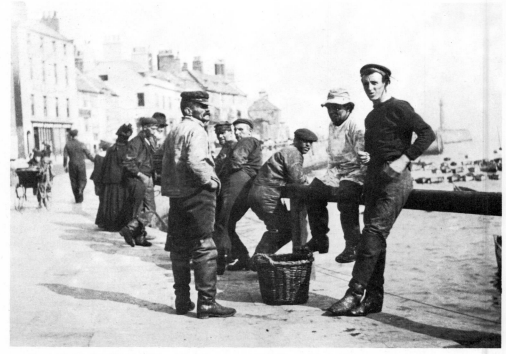

13 *Frank M. Sutcliffe*. Whitby Fisherfolk. Circa 1900 (Collection of Kodak Museum, Harrow)
14 *Sir Benjamin Stone*. David Lloyd George. 1909
 (Collection of National Portrait Gallery, London)

models for many successors. His artistic work is generally regarded as part of the foundations of the structure of modern photography. Stieglitz was an extraordinary personality who could convert his theories on creative photography perfectly into practice. Thus it was of immense importance that he had a remarkably clear idea of the special characteristics of the medium.

The well-known American art critic, James Thrall Soby, especially admires the fact that Stieglitz was determined to accept photography for itself in order to use to the full the possibilities resulting from it.[15] Stieglitz was a child of his time in that he selected mainly subjects which had a picturesque effect in their composition or

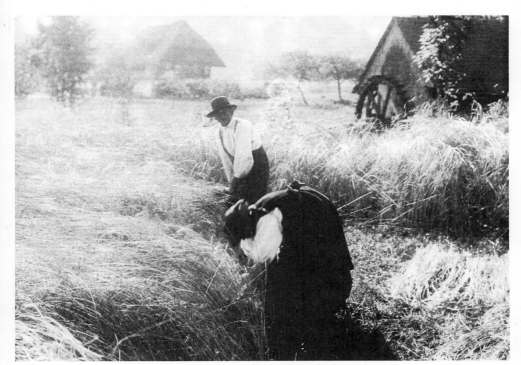

15 *Alfred Stieglitz*. Harvest. 1894 (Agfa-Gevaert Collection, Foto-Historama, Leverkusen)

lighting (Fig. 15); but in his portrayal of these subjects he demonstrated the independence of the photographic medium. Hence Charles H. Caffin was justified in calling Stieglitz's work 'straight photographs'[16] in order to differentiate it from contemporary pictorial photography.

Another photographer who was eager to exploit the advantageous properties of the medium was *Frances Benjamin Johnston*. In her time she was virtually an all-round photographer, taking vivid portraits of well-known people as well as studies of women at work, city views and landscapes. She had a special understanding of the eloquence of depicted detail in photographs.

Although *Lewis Wicke Hine* also had some

regard for the individuality of photography, his ideas were different. For him, a picture was, above all, a source of information; and what it stated could be intensified by its composition. Without introducing pathos, Hine created honest studies of social conditions in the industrial suburbs of American towns and in the factories themselves (Fig. 16). The photographs said much more than verbal descriptions of the conditions could have done, since these would probably have seemed exaggerated to many people. Sharpness of outline and wealth of detail underlined the reality of each original scene. Thus Hine's photographs were not mere documents, for he knew that he could say more about a theme with his choice of visually effective sub-

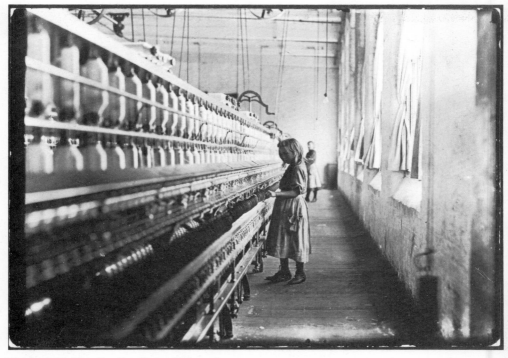

16 *Lewis W. Hine*. Carolina Cotton Mill. 1908
 (Collection of International Museum of Photography, George Eastman House, Rochester)

jects and skilful lighting than by arbitrary arrangement. His photographic style was extremely pure, direct and free from contrivance.

As well as Hine, a handful of gifted photographers from America's black minority were, at about the same time, striving to portray social conditions photographically. *James van der Zee* gained an important place among the pioneers of a photographic style which made logical use of the characteristics of photography; in an early composition he realistically portrayed the life of fellow-members of his race (Fig. 17). There is no doubt that the social criticism he expressed in his work, combined with great creative insight, led to results which may even be interpreted as important forerunners of live photography.

The portraitist *August Sander* also brought environmental sympathies into his realistic, sharp pictures. Before he made photography his profession in 1899 he worked as a miner. Perhaps his former employment made it easier for him to realize what was really important to people, for he did not think that portrait photographs should try to conform to the stereotype of contemporary ideals: they should rather be realistic reproductions of facial features which revealed personality. From the point of the view of the realistic conception of photography, the true aim of Sander's work with the medium was to exploit creatively documentary accuracy. The subjects of the portraits he photographed before the First World War were chiefly villagers from the Westerwald.

Because of his instinct for unadulterated realism, the artistic value of these photographs was enriched by a pertinent social portrayal of the standard of living in the countryside at that time (Fig. 18). However, in contrast to Hine, social documentation was not Sander's only aim, but occurred, so to speak, as a by-product.

In a completely different way, *Eugène Atget* reintroduced the sharpness of the photographic image. Atget's career was unusual in that he worked first as a sailor, then as an actor, before—albeit unsuccessfully—he turned to painting. When he discovered photography as an artistic medium, he was living a solitary life, and the disputes over pictorial photography were therefore unknown to him and remote from him. He was motivated exclusively by the very naïve belief that everything which attracted his attention was worth photographing. He photographed only those subjects which directly concerned him, for he was convinced that the effect of reality on the senses did not require any artificial stylization. In this way Atget discovered the principle later referred to in the creative arts as the 'objet trouvé'. He had an instinct for photography of which he himself was not conscious, and in fact he did not receive recognition until after his death. Atget is a prime example of the way in which a lack of knowledge about leading contemporary trends can sometimes lead to creatively original styles. *Otto Stelzer* is thus fully justified in praising this photographer and in comparing his achievement in photography with Henri Rousseau's in painting.[17]

Atget's favourite photographs were of

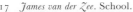

17 *James van der Zee*. School.

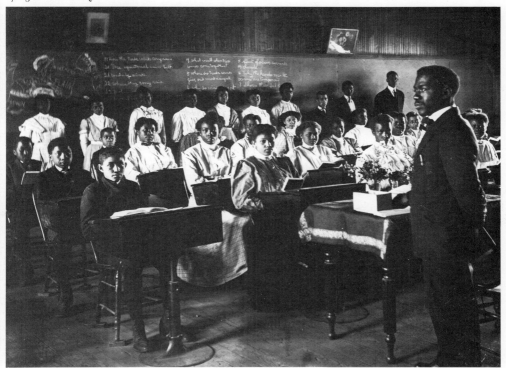

18 *August Sander*. Country Band. 1913

streets and of interesting buildings in Paris (Fig. 19). His pictures had the underlying charm of simple poetry. It is not surprising that painters bought many town scenes from him, which were put to good use as models for their paintings. Atget's photographs of shop windows—in which the shop-owners had sometimes juxtaposed incongruous items for sale—are also worthy of mention. Such arrangements were full of magical poetry, especially in secondhand shops, toyshops (Fig. 20), and, surprisingly, also in hairdressers' shops; and Atget noticed this sooner than most other photographers.

The knowledge that a good photograph depended on the discovery of an attractive subject also motivated *Jacques-Henri Lartigue*, who, even as a boy, had taken incredibly beautiful photographs. At such an early age, it could hardly be said that photographic activity could be based on clearly defined artistic ideas. The sure instinct that Lartigue later demonstrated so convincingly as a photographer was, without doubt, an inborn talent, resulting from his ability to be enthralled by the phenomena of the environment. His subject choices of racing cars and the pioneering days of flying (Fig. 21) showed that this young but very talented photographer gave his attention to topics which were of great interest to a boy. Lartigue's feeling for work that was photographically pure was combined with his desire to portray as accurately as possible those events which were of interest to him.

In this outline of the image-building

progress of photography the significant contribution of some reporters should be mentioned. Among these was the excellent *Paul Martin*, who tried not only to take his pictures in bright daylight on the streets, but also to work during the night. His series of images of London by gaslight was highly thought of at the time. Paul Martin's inventiveness was to be seen in some of his theatre photographs (Fig. 22), which he took during rehearsals with the aid of magnesium flash-powder.

A short time ago the qualities of the photographic contributions of *Burton Holmes* were rediscovered. The family fortune enabled him to live in accordance with his personal interests, which were concentrated mainly on travelling. The emotional sensations he experienced in perceiving surprising events and objects in foreign countries stimulated his photographic activity towards the creation of images which were much more than mere documents. His photographs were made into slides, to be projected during his numerous lectures.

Mention should also be made in this chapter of *Oskar Barnack*, who not only designed the Leica camera, later to become world-famous, but was also a good photographer. His pictures, which are appropriate to the individuality of photography, clearly distinguish themselves from the works of Stieglitz, Hine, Atget and Lartigue. In fact Barnack was originally an

19 *Eugène Atget*. Place St Andre des Arts, Paris. 1907

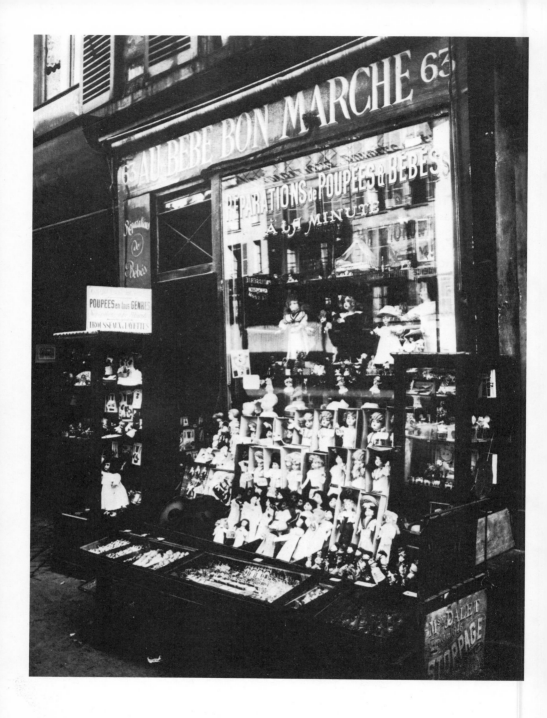

20 *Eugène Atget.* Au Bébé Bon Marche, Rue de Sevres, Paris. 1912 (Collection of Bibliothèque Nationale, Paris)

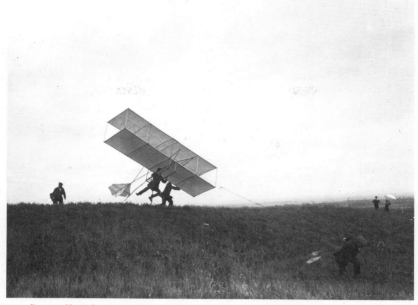

21　*Jacques-Henri Lartigue*. Before the Ascent. 1910

22　*Paul Martin*. Scene at the Alhambra. 1900 (Collection of Victoria and Albert Museum, London)

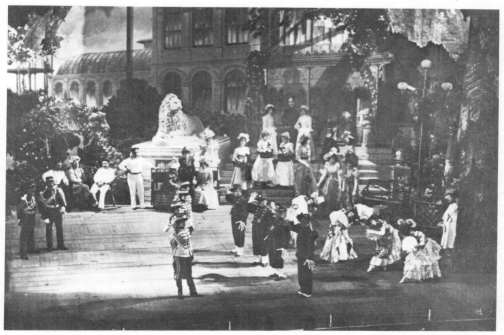

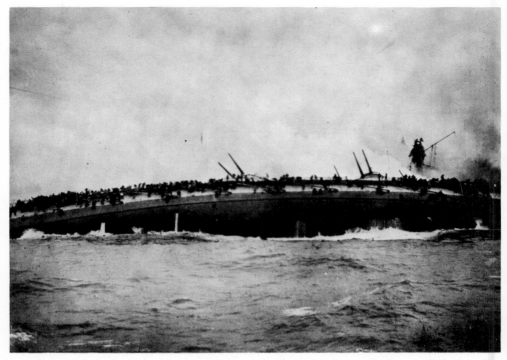

23 The Sinking of the Armoured Cruiser 'Blücher' at the Battle of the Dogger Bank, 1915 (Collection of the Imperial War Museum, London)

amateur film enthusiast. At that time the only cine film available was the customary 35 mm material, perforated at both sides. In order to use this expensive negative material economically for still photography, he decided to build a camera for film tests himself[18], since being a designer of microscopes, he possessed the necessary knowledge. In addition, he had previously used a 13 × 18 cm (5 × 7 in) plate camera[19], so that he had also mastered photographic technique. That was perhaps the reason why he ingeniously chose the 24 × 36 mm image size for his still camera, a format corresponding to two motion-picture frames. Thus the first workable prototype was produced in 1914: this was later known as the 'Ur-Leica' ('Original Leica'). The combined experience of amateur cinematographer, photographer and designer of

small instruments led Oskar Barnack to produce sharp pictures of typical scenes. In all his practical experiments, he also strove for results of the highest technical quality, for in this way he could test the camera to the limits of its capability. Thus, he even succeeded in taking an aerial photograph from a Zeppelin.

Progress continued during the First World War. The documentary strength of photography was employed at that time in a number of conscious and subconscious efforts to depict extraordinary events. Dramatic occurrences during battles on shore and at sea supplied many themes, the unusual clarity was surprising. Many of these examples had the character of snapshots. The authors of photographs of this kind were very often amateurs. For instance, a naval lieutenant took a really

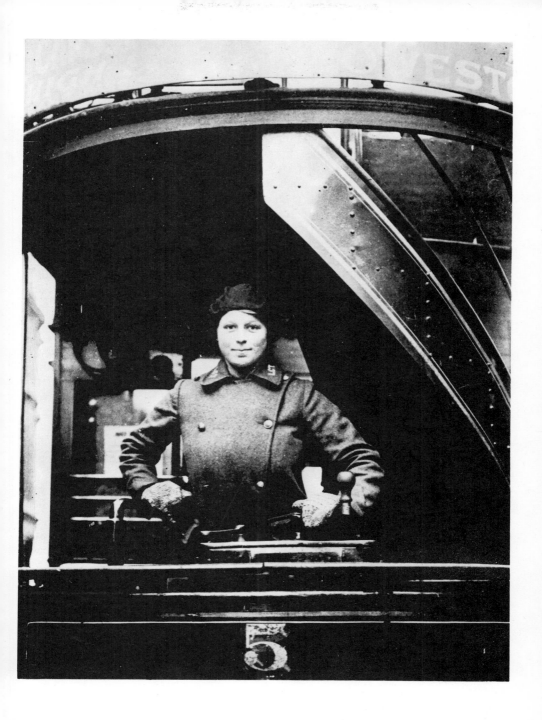

24 *Horace W. Nicholls*. Woman at War. (Collection of the Imperial War Museum, London)

good photograph of the sinking of the armoured cruiser 'Blücher' in the battle of Dogger Bank (Fig. 23). The German sailors, balancing on the side of the capsized ship, formed by chance a highly eloquent composition.

War photographs were quite often published by newspapers and magazines. For example, one of the photographs of the sinking of the cruiser 'Blücher' was reproduced as a full-page print in *The Daily Mail* of February 18, 1915. The extensive audience thus became more accustomed than ever before to vivid images, and this helped to provide a climate for the acceptance of the photographs of the post-war era.

The First World War also influenced some well-known photographers to approach realism. *Edward J. Steichen* served at that time in a special photographic unit which had the task of preparing reconnaissance pictures of areas occupied by the enemy. To fulfil this aim, the photographs had to be extremely sharp, in order to resolve a large number of details. Steichen came to understand quickly through this practice how to achieve sharpness, and he never returned to the slightly diffuse kind of photograph he had produced before the war.

Life on the home front too was changed by the unusual situation in the First World War. Often women took the places of those men who were away serving in the Forces. Sometimes it was necessary for them to be trained to carry out duties hitherto exclusively the province of males. In order to help expand the area of female work activity, *Horace W. Nicholls* took a marvellous series of photographs entitled 'Women at War' (Fig. 24). From a photographic standpoint, some of these studies foreshadowed journalistic portraits, and they were thus a significant and innovative contribution.

In a sense it could be said that conditions associated with the First World War accelerated the evolution of photography towards a purer use of the medium. However, the most important results were to be seen just after 1918; wartime acted as a transition period between older and modern concepts.

In conclusion, it should be added that the return to sharp photographic portrayal in the period before the First World War was not really a widespread stylistic trend, such as art photography. It consisted rather of independent and mostly isolated contributions of individual photographers. The photographers mentioned here were by no means the only ones of that period; however, the selection from their work should demonstrate very clearly what motivated them to make use of the special characteristics of the photographic medium.

In the section on art photography, it was pointed out how the photograph was influenced by the dominant trends in painting. Those trends which affected painting and photography at more or less the same time were intentionally not mentioned. The most important of these were the avant-garde trends which influenced the younger generation before and during the First World War. The fundamental historical and social changes and the scientific progress of this time left their mark on these new artistic endeavours.

At about the turn of the century, people still believed in the prospect of more or less universal knowledge. However, science was at that time making fresh discoveries which were revolutionary and revealed completely new possibilities. The Relativity Theory of the genius Albert Einstein, which laid the foundation for modern physics and superseded traditional knowledge, was regarded as the zenith of scientific progress. In art too, the craving for innovation and change led to decisive alterations in form and content.

Time, which until then in physics had been regarded as a classic example of a constant, suddenly became the object of new experiments which demonstrated its relative dependence. In art this reappraisal was shown above all in Futurism, although in a modified form. After creative experiments in literature and the theatre, the influences of this trend spread to the graphic arts. It is therefore worth mentioning that the earlier photographic experiments of the American, *Eadweard J. Muybridge*, and the French zoologist, *Etienne Jules Marey*, designed to show the different stages of movement, served as prototypes for paintings (Fig. 25). After these phases had been creatively transferred by painting, a few photographers also tried to build on those studies in movement which had originally been documented only for research purposes, by means of artistic interpretations. The most important contributions were made by *Antonio Giulio Bragaglia*, who played his part in the Futuristic movement by issuing a photographic manifesto (Fig. 26). In some of his photographs he used the blur of motion, in others a repeated exposure of the same plate, so that the shots of single phases of movement overlapped. Bragaglia declared in his theoretical treatise that by those methods a mechanical process of representation became transformed into an artistic statement.[20]

There is no doubt that the conscious artistic application of the blur of motion was innovative. Nevertheless, these important results lay forgotten for a long time, and their discoveries later had to be made again, not in connection with Futurism.

Cubism was another artistic trend which revolutionized painting. The artistic experiments in this direction, initiated above all by Pablo Picasso, led to a type of picture which brought together on one image plane several views of an object. This simultaneous viewing of an object from different angles was reminiscent of the

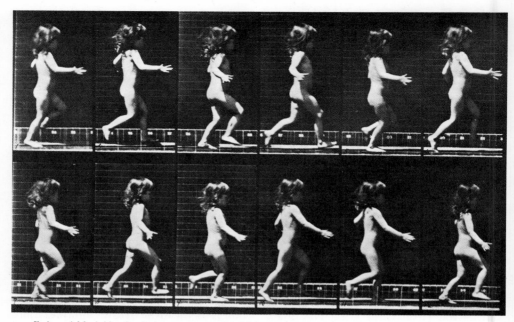

25 *Eadweard Muybridge*. Study in movement of a child. Circa 1873

principle of the Theory of Relativity. Many photographers liked Picasso's work so much that they decided this was the direction their artistic work should follow. This was specially true of *Alvin Langdon Coburn*, whose experiments were based on the principle of analytical surface dissection arising from the Cubist type of painting which he so much admired. He tried to dissect his photographs in a similar way, and achieved this by means of three mirrors placed in a triangle, between which he placed small pieces of glass, crystal, wood etc. Manifold reflection caused small surfaces to be so divided that the result in the photograph did resemble a Cubist painting, although it was actually an abstract composition (Fig. 27). Because of the circular symmetry, which gave the impression of vortex, Coburn named his result 'Vortograph'. He varied this conception in a series of pictures which he exhibited in 1917. Thus Coburn was the creator of the

first collection of deliberate photographic abstracts.

The influences exerted by Dadaism should also be mentioned here. The social conditions of the time are reflected in this trend; not the possibility of new scientific discoveries, of which man could justifiably have been proud, but rather the indescribable horror of war. The ever-improving military technology represented in some artists' eyes the senseless mass murder of millions of soldiers. Dadaist artists who met in Switzerland as emigrants from countries fighting against each other expressed the futility of war by means of nonsensical-sounding texts, consisting of newspaper cuttings put together at random. Similar experiments led to the formation of new words, referring neither to objects nor to abstract concepts, but connected as onomatopoeic sounds in meaningless poems. The public was introduced to such works in 1916 at the Voltaire Cabaret in

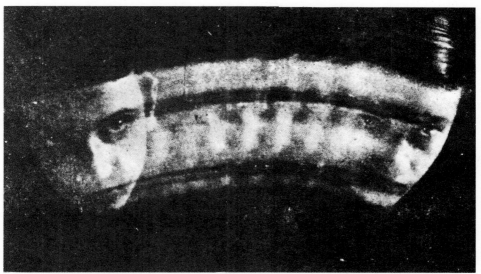

26 *A. G. Bragaglia.* Young man, moving from side to side. 1911

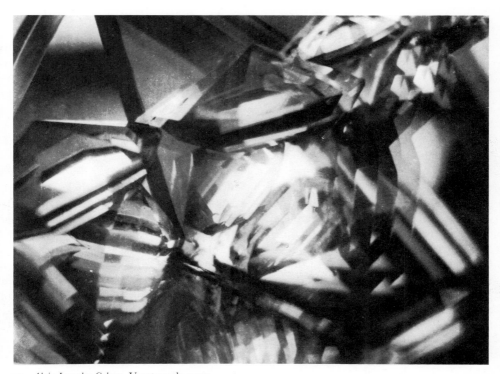

27 *Alvin Langdon Coburn.* Vortograph. 1917
 (Collection International Museum of Photography, George Eastman House, Rochester)

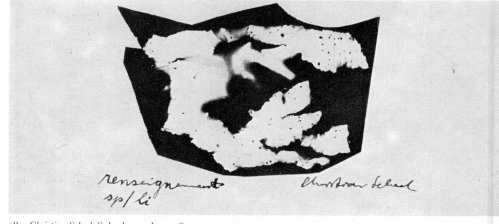

28 *Christian Schad*. Schadograph. 1918

Zürich. Many visitors found the Dadaist productions provocative, and finally managed to ban these establishments.

Meanwhile, as artistic genres extended their borders, the Dadaists' activity grew, and at the beginning of 1917 the Dada Gallery was opened.[21] At the same time as their experiments in the field of literature, the Dadaists were also producing collages from visual elements which had no logical connection with each other but were arranged in a quite haphazard manner. In the Zürich Dada group, *Christian Schad* tried to carry out similar ideas by means of photography. First he and his friends collected pieces of waste, the raw material for the elements making up the picture. By about 1918 he was trying to arrange some fragments in the dark in front of the light-sensitive layer of photographic papers or plates, in order to achieve—after exposure and development—compositions resembling collages (Fig. 28).[28]

An avant-garde group in New York had basically the same aims as the Zürich Dadaists. This developed round the personality of the photographer Alfred Stieglitz.

His influence, and the fact that he exhibited not only photographs but also modern art in his 'Gallery 291', was of great help to the whole group. Besides his personal friend, *Francis Picabia*, who had been contributing to the Stieglitz journal *Camera Work* for a long time, Marcel Duchamp and *Man Ray* played important parts in the New York movement. It is interesting to note that during the first phase, up to 1918, hardly any creative experiments were made in the field of photography. This seems surprising in view of Alfred Stieglitz's obvious patronage. Nevertheless, this artistic early phase of the Picabia-Duchamp-Ray triumvirate was of great importance in the future development of modern photography after the First World War. With his 'Ready-Mades', in which he interpreted industrially ready-made objects like a bottle-drying brush or a urinal as works of art, Marcel Duchamp aroused a new consciousness of observation and experience, which also creatively exploited modern mechanized consumer living, and at the same time put the traditional appreciation of art in its place. Thus

44

'Ready-Mades' became works of art, nominated by Duchamp for that purpose.[23] This possibility of transforming the applications of different objects by artistic interpretations was later used a great deal in photographs, partly in direct connection with Duchamp's intentions, partly in the context of a Neo-Dadaist consciousness of reality.

As was observed by the Dadaist chronicler, Hans Richter, Man Ray extended his experimental activity from painting to photography, following the example of Alfred Stieglitz.[24] This encounter with photography was tremendously fruitful, both for Man Ray and for photography as a medium. However, the results of the encounter were not appreciable until the 1920s.

Photography received further stimulus after the First World War from other Dadaist centres such as Berlin, Hanover, Cologne and Paris, each of which possessed its own special characteristics. These will be presented in chronological order in the next section.

The history of colour photography is older than is often assumed. The first colour photograph was taken in 1861 under the guidance of *James Clerk-Maxwell*, as proof of the theory of the additive mixing of light, by means of three black-and-white colour separations photographed through three different filters. Maxwell projected the three split images on to a screen through three corresponding filters, with the result that a colour picture of his subject, a piece of tartan, became visible. However, to adopt this method for photographic practice was completely impossible, owing to its complexity. The same applied to different methods used afterwards. Many other experiments gave creatively interesting results, such as, for example, those achieved by the Frenchman, Louis Ducos du Hauron, around 1870, again with three colour separations, which he ultimately mounted on top of one another on a white base, using three colour pigment tissues.

Many devotees of art photography, such as Hans Watzek, used coloured aquatint for a similar purpose (Colour Plate 1). 'Three exposures are taken of the objects to be reproduced in the colour picture. The first exposure, on a non-orthochromatic plate, serves as the yellow print. The second exposure is on an orthochromatic plate with a dark yellow screen. The exposure time is twenty times longer than with the first. This negative serves as the red print. The third exposure, on a red sensitive plate with a red-orange screen, needs 80 to 100 times longer than the first

exposure. This serves as the blue print. The paper used for the print is first coated with a 2–5% aqueous shellac solution. The first print is the yellow one, produced like a normal aquatint. I use gamboge as printing colour. When the yellow print is completely dry, the red print follows with dark madder varnish, and then the blue print with agate. The colour is liberally mixed with rubber and spread on very thinly.'[25]

Not until this century, however, did the first commercially produced materials for colour photography come on to the market, in the form of autochrome plates, manufactured by the brothers *August* and *Louis Lumière* in Lyon from 1907 onwards. The basic principle was the use of a fine screen of transparent particles (grains of potato starch) in violet, red and green, through which the light reflected by the object had to pass before it reached the sensitive layer. The particles thus acted as countless small colour filters. After reversal development, a transparency was then produced behind this screen, made up of small black-and-white points. When the plate was projected or viewed, you could see a picture built up of very fine colour points, similar to the Impressionists' pointillistic paintings, in which the additive colour mixture formed into a colour picture when viewed at a certain distance. These colour photographs could even be reproduced by colour printing. Many well-known photographers, such as Edward J. Steichen and Heinrich Kühn, immediately tried out this new possibility. Their results, which were without a doubt

evidence of the great potential of colour vision, even appeared in a few specialist photographic journals of the time. Louis Lumière himself also created a few artistically interesting colour photographs.

In spite of the delightful results, still admired today, the autochrome plates could not achieve success. Both their high price and their low light sensitivity meant that their use was limited. Partly independently, partly following the example of autochrome, there appeared similar colour screen materials in other countries besides France: for example, the Agfa colour plate in Germany. Later, however, these screen plates were also replaced by film.

II The Dawn of Modern Photography

The conditions for creative photography between the two World Wars were extremely favourable and encouraging. The big illustrated periodicals began to include photographs, with the result that they not only enabled many photographers to find work, but also acquainted the general public with the new medium. This increased familiarity with photography educated wider sections of the population to become conscious viewers. At the same time, many publications also appeared in the field of book publishing; in these the photographs both illustrated the text and also sometimes became the central theme. At this time, too, people were learning about the characteristics of the photographic medium. Photographers not only became aware of how the unsurpassable documentary quality of photography could be extended to portray reality, but also consciously made use of the speed with which a photograph could be processed.

As photographic technology progressed, the introduction of the snapshot greatly assisted reportage photography. Technical progress was heralded by camera models which came on the market in the period between the two World Wars. The Ermanox was a predecessor of models with fast lenses; it used plates measuring $4.5 \times 6\,\mathrm{cm}$ ($1\frac{3}{4} \times 2\frac{1}{4}\,\mathrm{in}$), and was manufactured in 1924. It was equipped with the Ernostar $f20$ 100 mm lens. Perhaps even more important was the introduction from Leitz of Wetzlar of the Leica miniature camera, which opened up completely new horizons for

creative photography because of its light weight and its large supply of 36 exposures per film.

The first 31 Leica cameras, produced in 1923, were manufactured by hand; but two years later, the Leica Model A with fixed lens went into mass production. Further improvements, which considerably widened the scope of these cameras, soon followed; in 1930 the Leica C appeared, fitted with a new, faster standard lens, and supplied with two interchangeable lenses

for wide-angle and telephoto shots. Thus the existing compactness of this camera was complemented with extra flexibility. The incorporation of a coupled rangefinder in the Leica II (1932) increased the accuracy of operation. Almost every year there were additional important innovations which increased either the shutter-

speed range or the number of interchangeable lenses.

Another significant contribution towards the change in the modern photographer's work-pattern was the introduction of the Rolleiflex twin-lens reflex camera in 1929, using the medium-size $6 \times 6\,\mathrm{cm}$ ($2\frac{1}{4} \times 2\frac{1}{4}\,\mathrm{in}$) format; this combined accuracy of focus on the ground-glass screen with speed of operation. In 1931 a Rolleiflex for the miniature $4 \times 4\,\mathrm{cm}$ ($1\frac{1}{2} \times 1\frac{1}{2}\,\mathrm{in}$) size was produced, and in 1933 the Rolleicord, a simpler and cheaper twin-lens reflex, appeared on the market.

The interest aroused by the twin-lens reflex camera accelerated the development of single-lens reflex cameras, the principle of which had been known for a long time. In this field, the Dresden firm of Ihagee succeeded in 1933 in developing the Standard Exacta, using roll-film of $4 \times 6.5\,\mathrm{cm}$ ($1\frac{1}{2} \times 2\frac{1}{2}\,\mathrm{in}$) format, and eventually the

was also employed successfully in a few medium-format models ($6 \times 6\,\mathrm{cm}$ [$2\frac{1}{4} \times 2\frac{1}{4}\,\mathrm{in}$]), such as Curt Bentzin's Primarflex and the Reflex Korelle.

Large-format cameras, of course, continued to improve. Nikolaus Karpf, who after the death of Valentin Linhof in 1928 had taken over his firm, improved the trunnion of this type of camera, thus enabling it to be used with versatility in the

famous Cine Exacta, which caused a real sensation at the 1936 Leipzig Fair. The single-lens reflex camera offered decisive advantages for the miniature format, with its exact framing of each exposure by the taking lens, avoiding the danger of parallax of viewfinder image and film image. The idea behind the single-lens reflex camera

fields of object, commercial and architectural photography.

Technical developments in negative materials were perhaps of even more importance to modern photography, since the increase in film sensitivity brought photographers closer to their ideal, namely to be able to photograph everything they

could see. By 1929, the sensitivity of the best photographic material of German origin was 21–23° Scheiner[28], which corresponds to today's 11–13 DIN or 12 ASA. Medium-speed film material was normally 16–17° Scheiner. At the same time, film was continually replacing the clumsy plates as photographic material.

1936 marked a great advance in the development of negative materials when Dr Robert Koslowsky of Agfa managed to raise the light sensitivity of the coating by means of a gold compound. This meant that the speed of today's standard films, that is approximately 21 DIN or 100 ASA, could be achieved.

After the First World War, pictorialism lost more and more of its attraction. It was still being disputed whether the end-product should be presented as a fine print or as an enlargement on bromide paper manufactured by industry; the young generation, however, searched for their own solutions. Just as a few great creative photographers had discovered at an early stage the precision of the photograph as a stylistic medium, some now set out to emphasize image sharpness. This process eventually became known as the 'New Objectivity'.

This concept was first used in connection with a style in painting. *G. F. Hartlaub*, the well-known art critic, coined the expression at the opening of an exhibition of realistic painting at the Mannheim Art Gallery in 1925. The pictures to which Hartlaub referred in this way set out to portray the external existence of still life or landscape subjects as objectively as possible. Independently of this trend in painting, and a few years earlier, photography made a similar approach to reality. *Paul Strand* had been working in the spirit of this trend since 1916, and *Albert Renger-Patzsch* and *Edward Weston* also took the same path from about 1922; thus their existing works were to some extent 'adopted' by this movement.

The photographers who devoted themselves to the 'New Objectivity' concentrated in their pictures on the sharpness of a section of reality; thus they could also emphasize the interesting variety of everyday things, which went unnoticed in the hustle and bustle of modern living. This creative interpretation of photography is especially evident in the work of Albert Renger-Patzsch. At the start, his photography was in the style of impressionistic art photography, and he only gradually became an advocate of realism as opposed to the older romanticizing style. This conversion was due to his awareness that one of the oldest laws of art, namely the preservation of the unity of technique and medium, should also be respected in photography. According to his own theory[30], the possibilities and boundaries of photography lay in the broad spectrum of all grades of highlights and shadows, lines, planes and spaces. To achieve the living and formal creation of these phenomena, the photographer had natural and artificial light, optics, negative and printing material, processing chemicals, his eyes and his own photographic taste. These means opened up for him numerous stylistic possibilities— within the limits of technology. Because of this viewpoint, Renger-Patzsch declined to use most of the ways of expression associated with art photography, and particularly criticized the fine-print process. He even went so far as to say that good photographs could be turned into bad pictures because of this apparent improvement of the negative. His book 'The World Is Beautiful'[31] was to serve as a battlecry against those photographers for whom photography was not 'artistic' enough. It was published in 1928, as a sort of manifesto of the revived Realism movement, and in it he summed up his concept in a few words:

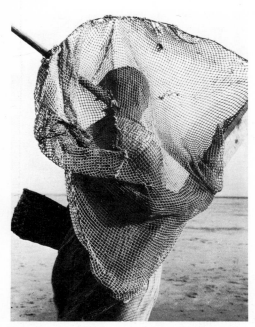

29 *Albert Renger-Patzsch*. Crab fisher, Halle. 1926
(Photographic Collection, Folkwang Museum,
Essen)

'Let us leave painting to the painters; let
us try to create pictures by photographic
means, which can be complete in them-
selves . . . without borrowing from paint-
ing.' In Renger-Patzsch's volume of pic-
tures, the attractiveness of textures is
especially noticeable in the individual
photographs. The title of his book was
decided upon by his publisher, and was a
little misleading, for Renger-Patzsch's main
wish was not to emphasize beauty but to
show the nature of everyday things. As
Fritz Kempe later aptly declared, Renger-
Patzsch's book should simply have been
entitled 'Things'.[32]

Renger-Patzsch photographed a wide
range of subjects: he directed his attention
to nature as much as to objects of everyday
life, taking unusual close-up shots of plants
and animals (Fig. 29). He also took photo-
graphs of modern buildings, historic archi-
tecture and even of factories (Fig. 30).
During the second half of the 1920s and at
the beginning of the 1930s, his interest in
the theme of industry was particularly
intense, as this corresponded to the econ-
omic importance of heavy industry in
Germany, at that time increasing by leaps
and bounds.

This interest in the photographic repre-
sentation of modern technology was demon-
strated very expressively in the illustrated
volume *Technical Beauty*, in which most
of the photographs were by Albert Renger-
Patzsch, E. O. Hoppé and W. Roertz. In
the introduction to this book, Hans Gün-
ther mentions that the artist's imagination
is constantly being fed from different
sources. It was surely logical that at that
time inspiration grew from the contemp-
orary working world and its products.
Günther even believed that the creative
work of an engineer had much in common
with art, and he lost no time in inventing
the phrase 'Engineer Art' to describe it.
Although he himself saw photography
more as a means of documenting 'technical
beauty' than as a way to artistic self-
expression, he selected the photographic
examples in such a way that they confirmed
his belief in the ability of photography to
reflect satisfactorily the spirit of con-
temporary problems. At the same time,
the outlook of many avant-garde architects
and civil engineers was paralleled here—
the concept that 'what is functional is also
beautiful'.

In Germany, where an important centre,
the 'New Objectivity', was created, other
photographers besides Renger-Patzsch
were developing a personal style completely
independently of one another, before the
time of the official proclamation of this
artistic trend; and this style corresponded
to the concept of the 'New Objectivity'.
August Sander, who has been previously

54

30 *Albert Renger-Patzsch*. Essen, bridge at main station. 1913
 (Photographic Collection, Folkwang Museum, Essen)

31 *August Sander*. Master baker. 1928

32 *August Sander*. Peasant children. 1923

mentioned, was particularly noted for his portrait photography. In the twenties, his work gave precise information about the people who, in their life and labour, represented that changeable period between the bourgeois era of Kaiser Wilhelm and the time of Hitler's fascism. In order to cover this subject, Sander's photographs concentrated on portraying representative occupational categories and social classes. The types of people chosen were distinguished by representative features, which Sander then underlined with his special photographic perspective. Just as Renger-Patzsch brought about an understanding of the true value of humdrum everyday life, Sander made studies of the lives of average citizens, upon whom he bestowed general acceptability as a group, photographing them in their Sunday best, staring straight ahead (Figs. 31 and 32). In this way, he probably aimed to bridge the gap between the different social classes. The most striking proof of Sander's humanistic attitude towards these people of his time lies perhaps in the fact that the remaining copies of his book *Face of the Time*, which contained the best of his portrait photographs, were seized by the Gestapo in 1934. After that year, Sander was prohibited from any further publishing of his portrait photography, and so he devoted himself completely to landscape work, as can be seen from his poetic and romantic series of Rhine landscapes. After the Second World War, Sander's type of work was creatively continued in the photographic portrait conceptions of *Diane Arbus*, *Richard Avedon* and *Irving Penn*.

The influences of the 'New Objectivity' are also apparent in *Helmar Lerski's* portrait photographs, especially in *Everyday Heads*, produced between 1928 and 1931. Berthold Viertel very aptly described these photographs in the pictorial monograph published shortly after Lerski's death: 'What Lerski had visualized as larger than life,

appeared as larger than life: it was the living thing. The living skin with its pores, roughness and crevices; hairs in the ear and nose; warts: the whole battlefield which man's face becomes in the conflicts of life, as though it were pervaded with trenches. But when the obvious details have been collected together—the expression, the physiognomy; the mouth, which can say and betray so much when it is silent; the forehead, with its diagonal and longitudinal furrows; the eye, often large and deep-set and powerful—the result is sometimes only an empty mirror. Thus *Everyday Heads* came into being, causing a sensation and arousing admiration in cultural circles in Germany when it appeared.'[34]

The 'New Objectivity' also had a great effect on photographic illustrations used in advertising or in the catalogues of enterprising firms. Many photographers were fascinated by this field of work and its realism, and this was particularly true of the representatives of the young generation. The early work of *Heinrich Freytag*—who later became one of the most important photographers in the German-speaking parts of Europe—serves as a good example of this. He depicted the attractive-looking components of a contemporary radio set with the same unemotional precision as he would have portrayed a simple glass dish.

In the exploration of artistic possibilities within the 'New Objectivity' movement, the photographic work of *Karl Blossfeld* is also very important, and all the more so because he was not really a professional photographer, but came to photography from sculpting. In his capacity as lecturer in plant modelling at the Educational Institute of the Berlin Royal Museum of Art, he produced numerous photographs involving supernaturally large blossoms, leaves and seeds (Fig. 33). These details of nature's remarkable architecture not only formed ornamental patterns, but also served towards the better understanding

33 *Karl Blossfeldt*. Impacticus glanduligera Balsamine (plant). Circa 1928 (Wilde Gallery, Cologne)

of the plants themselves. Although Bloss-feldt regarded his photographs as teaching materials, he also complied with the basic principle of the 'New Objectivity'. The great enlargements of detail were very powerful in their conception, and demonstrated how far this principle could be used for artistic expression. The industrial and interior photography of *Werner Mantz*, who went to Maastricht in the thirties, was outstanding in its clear simplicity, and was also associated with the 'New Objectivity' (Fig. 34).

These trends soon spread from Germany to neighbouring countries, where the ground had already been prepared for their acceptance. However, in the process of adaptation these influences lost something of their unemotional realism, and incorporated a more poetic interpretation, though without anywhere destroying the accuracy of the illustration and the detailed reproduction of the surface structure. In France, where fine prints originated, *Emmanuel Sougez*, who later became one of the most important photographers of his time, was one of those influenced by this more poetic modification of the 'New Objectivity'. He would often arrange the objects he had selected in an unusual way, which nevertheless provided an attractive picture (Fig. 35). Sougez used the principle of the New Objectivity in depicting interesting architecture. Thus he took a series of fifty photographs of Notre Dame Cathedral in Paris, in which he showed not only a view of the entire church, but also many well-chosen details. The whole series appeared as a set of loose pages, excellently photo-engraved, in a large-format portfolio published by Éditions Tel in Paris, with texts in French and English. The Cathedral of Chartres was the subject of a similar picture series by *André Vigneau*. Paris, thanks to its exciting atmosphere, became in the twenties and thirties a very attractive city for all those who wished to advance their artistic skill. Among these foreign visitors was *Jaroslav Rössler*, a follower of the well-known Czechoslovak portraitist František Drtikol. Rössler widened his photographic experience at G. L. Manuel Fréres, and later at the Lucienne Lorelle. At that time he began to be influenced by the 'New Objectivity'. This change in his approach was to be seen especially in a series including detail views of the Eiffel Tower, which fascinated him very much. His photographs of the simple constructional elements next to the spiral staircase (Fig. 36) indicated his understanding of the spirit of modern technology, as well as of trends in photography.

The Dutch were perhaps more inspired by the 'New Objectivity' than the French, and H. Berssenbrugge and *Jan Kamman* achieved particularly remarkable results (Fig. 37).

In Britain the most notable contributions in association with the principles of the 'New Objectivity' were made by photographers who had contacts with Germany. *Emil Otto Hoppé*, for example, who was born in Munich created work in the twenties and thirties which showed obvious signs of this trend, both in choice of themes and in the use of sharp detail. Photographs by Hoppé were included in the book previously mentioned, *Technical Beauty*.[33]. *Helmut Gernsheim* came to Britain in 1937, and worked first as a freelance photographer, becoming a distinguished historian of photography after the Second World War. He received his photographic education in Germany between 1934 and 1936, and there is no doubt that he then came directly in touch with the influences of the 'New Objectivity'. This background was still noticeable in the work he did during his first years in Britain.

The 'New Objectivity' also underwent considerable development in Czechoslovakia, where the return to image sharpness had already begun, as a result of the

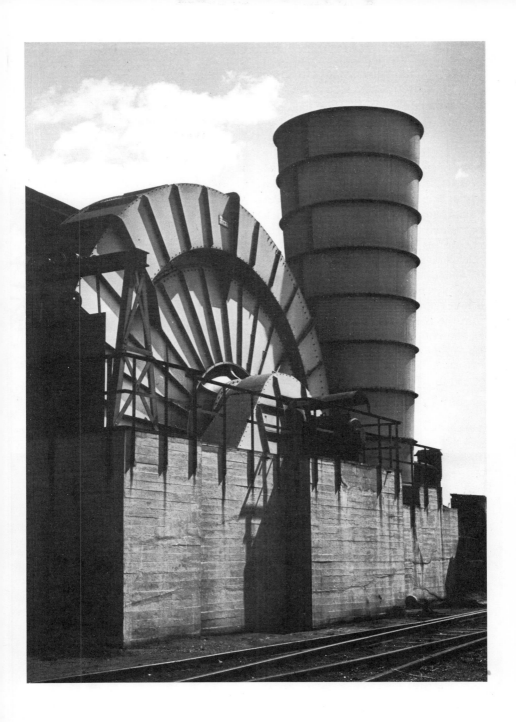

34 *Werner Mantz*. Mijnen in Limburg. 1938

American 'Direct Photography' movement, the basic principles of which had been introduced to his fellow-countrymen by J. Ruzicka. At the State School of Graphic Arts, great emphasis was placed on the autonomy of photography by the professors at the time, *Jaromir Funke* and *Josef Ehm*. The technical skill required by photographers using this style provided good examples for teaching purposes. This school in fact published a small booklet entitled *Photography Sees the Surface*[35], which demonstrated the principle of image sharpness by means of practical examples.

The work of *Jan Lauschmann* (Fig. 38) owed something to his intellectual qualifications: as a chemist he recognized sooner than many other photographers how important the true image is for the practical application of photography.[36]

Some Soviet photographers, working

36 *Jaroslav Rössler*. Eiffel Tower. 1926 (Collection of Schürmann and Kicken Gallery, Aachen)

37 *H. Berssenbrugge*. Razor blades. 1935 (Photographic Collection, Design Department, Imperial Museum, Leiden)

35 *Emmanuel Sougez*. Fifteen glasses. 1933 (Collection of Bibliothèque Nationale, Paris)

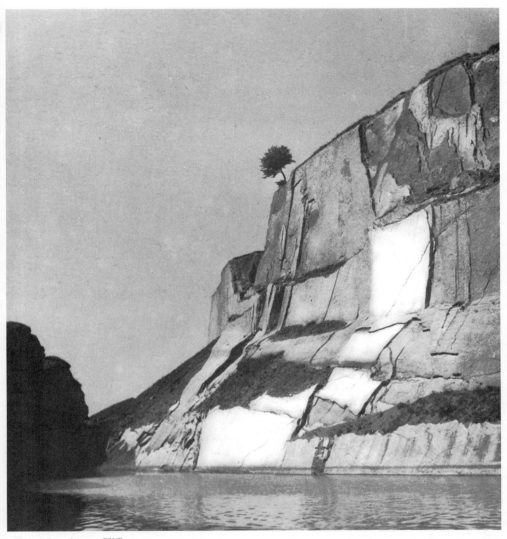

38 *Jan Lauschmann.* Cliffs. 1932

independently of one another, also discovered some of the basic principles of the 'New Objectivity', as a logical result of their efforts to depict newly erected factories or dams. Cinematographic experience in the Soviet Union also certainly helped in this respect, for realistic representation had been highly esteemed from the beginning, as is revealed by M. Tschiaureli's remarks: 'In films, you could extend the action from the narrow stage to the vast realm of living nature; you could,

even using the primitive equipment available at the time, show a great deal that is beyond the scope of the theatre, which is forced by the circumstances of the stage play into a limited framework. And although the possibility of taking pictures anywhere, and of being able to portray a number of things which the theatre cannot, certainly does not in itself constitute art, the sum total of these characteristics nevertheless determined the originality of the cinematographic art form, and constituted a powerful medium in the film producers' hands, giving the best and most progressive of them the opportunity to develop and extend the creative medium of cinematography, and thus to make use of the experience obtained in all art forms over the years.'[37]

The recognition of the importance of realism in film and photography was so strong that many Soviet painters, such as *Alexander Rodschenko*, who became known as pioneers of abstract art, switched over to realism in photography (Fig. 39). In his photographs, Rodschenko particularly emphasized the geometrical forms of industrial products by means of unusual perspectives, in order to glorify technology.

A further focal point for the 'New Objectivity' outside Europe was America, which, as a highly industrialized country, had developed a certain taste for accuracy. The transition here from art photography to objectivity gradually took place as a consequence of experiences gained from 'direct' photography, which had already stressed image sharpness and the representation of detail. The decisive step was taken when the subject was freed from being represented picturesquely. Perhaps Alfred Stieglitz made the best analysis of this trend when he said, upon first seeing *Paul Strand*'s photographs: 'They are brutally direct, pure and devoid of trickery.'[38] This sentence expresses it all—Stieglitz's initial shock when he found no romanticiz-

ing elements in the pictures, his growing respect for the purity of the work, and finally his appreciative assessment of the complete honesty of the pictures.

Strand did not arrive at this specific artistic conception by chance, but by a very clear estimation of the nature of photography (Fig. 40). In his theoretical essay, which he published at a very early age,[39] he laid special stress on the objectivity of photography, which he believed was its true nature, and emphasized that, because of this characteristic, it differed from all other art forms, which were completely 'unphotographic'. According to Strand, the full exploitation of this medium was associated with the pure way in which it was used.

Edward Weston went still further in his

39 *Alexander Rodschenko.* The mother. 1924 (Lubomir Linhart Photographic Collection, Prague)

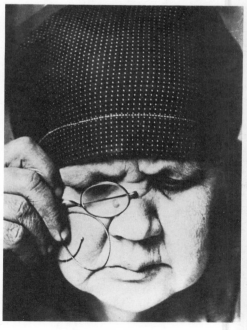

40 *Paul Strand*. Kitchen, Loch Eynort.

41 *Edward Weston*. Tree study, Lake Tenaya, Yosemite National Park. 1938

estimation of image definition and truth. His work was not characterized by the subject proximity found in young Strand's pictures, but he made full use of emotional ways of presenting an exaggerated sharpness. Like Renger-Patzsch, Weston worked first in the area of Pictorialism, before he discovered Realism around 1920, which he then used almost passionately to obtain photographic exactitude. The wealth of detail in the surface structure of things was for him a stimulating incentive to photographic composition (Fig. 41). His conscientious use of all the incomparable advantages of photography made it possible for him to develop a still-life technique by using a large format 8 × 10in (20 × 25cm) camera and contact prints.

In 1932 a group of photographers formed around Weston whose aim was evident from their name '$f64$'. This referred to 'aperture 64', signifying that in photographic practice the members of the group aimed at extreme depth of field and precise detail rendition in their pictures, by means of the smallest possible apertures.

Apart from Weston, the landscape photographer *Ansel Adams* also became famous in the '$f64$' group. His photograph of the structure of a rock in juxtaposition with a frozen mass of water (Fig. 42) shows his masterly command of detail representa-

42 *Ansel Adams*. Ice and rocks in the Sierra Nevada. 1934

tion. This American school also utlized varied lighting effects in landscape photography, as is illustrated in another of Ansel Adams' photographs (Fig. 43). The enchantment of the light effect is substantially heightened by the extraordinary sharpness of the whole picture.

In the early thirties, when state support of the impoverished farmers of the USA was about to be cancelled, a photographic team (the Farm Security Administration) which has become legendary—amongst them *Dorothea Lange*, *Walker Evans* and *Ben Shahn*—recorded the wretched standard of living of those people, and helped to enforce a programme of assistance, thanks to those magazines and newspapers which enlightened the whole nation by publishing the photographs (Figs. 44 and 45). For this purpose a photographic concept was adopted which closely resembled that of the 'New Objectivity'.

The importance of the 'New Objectivity' lay in its detailed depiction of surface structure, and this made it a genuine artistic movement. Its discoveries opened up new ways for the development of modern photography, since they greatly furthered an increased consciousness of the nature of photography. It spread so rapidly not only because the time was right for that way of looking at reality, but also because its photographs could be used by people in general.

43 *Ansel Adams*. Refugio Beach, California. 1947

44 *Dorothea Lange*. Westward Bound, Tulare Lake, California. 1939

45 *Walker Evans*. Photo from the southern States. 1935–36.

3 Portrait Photography from the After-Effects of Pictorialism to Glamour Interpretation

George Davison, Robert Demachy and C. Puyo, who began their impressionist-influenced pictorial photography during the last decade of the nineteenth century, were all amateurs. It thus seems all the more remarkable that this movement survived longest, in the form of professional portrait studies. Well into the thirties and even up to the beginning of the forties, there were absolutely no exceptions where photographs in this style were concerned. These portrait photographers can basically be divided into two groups.

The first group consisted of those who developed what they had learnt from Pictorialism in a commercial way, to suit their clients' taste, without enriching their photography with personal elements of style.

The second group consisted of those photographers who aimed at giving an elevated expression to their portrait photographs by means of stylization. Most of these photographers made use of their personal association with the models to achieve a psychological interpretation. This was emphasized in correct image tones by a fine printing process. This normally called for unusual models, who were so individualistic that each photographer knew from the beginning what he wanted to express in the portrait. *Hugo Erfurth* chose mainly well-known painters or writers for his portraits, and he tried to portray each one in a personal way, as can be seen from the portrait of Paul Klee (Fig. 46). The bright tones which assist in a very detailed portrayal, and the manner in which Klee is posing, are intended to give an idea of the precise essence of the man. In contrast to this, Erfurth suffused Marc Chagall's portrait with a dark atmosphere (Fig. 47), with the artist's enigmatic smile giving some indication of his imaginative spirit.

Certain decorative trends were also very important to the further development of portrait photography. These were associated with a general tendency to portray attractively and competitively articles of furniture and other consumer goods which were being promoted by the decor and design trade in the twenties and thirties. This style directly influenced consumer advertising, particularly poster design, and in part it also influenced painting and sculpting. It was subsequently named 'Art Deco'[40] at the exhibition 'Les Annees 25' ('The 25 Years') held at the Musée des Arts Decoratifs in Paris in 1966. These decorative photographic settings were foreshadowed during the period of Pictorialism, which had emphasized everything picturesque. The later modification of this, stimulated by youthful stylistic trends, particularly in German-speaking countries, was especially important. Thus we find that many photographers, who had grown up with the ideals of Pictorialism and yet had found the 'New Objectivity' too crude, associated themselves with these decorative trends. It should be pointed out that this applied chiefly to portrait photographers. It is also very likely that this was because

46 *Hugo Erfurth*. Paul Klee. 1920 (Agfa-Gevaert Collection, Foto-Historama, Leverskusen)

47 *Hugo Erfurth*. Marc Chagall. 1926 (Agfa-Gevaert Collection, Foto-Historama, Leverskusen)

48 *Rudolf Koppitz.* Painter (gumprint). Circa 1930
(Collection of the Federal Institute for Research
& Learning in the Graphic Arts, Vienna)

draping, which photographers had successfully been using for a long time to achieve various effects, should be mentioned here first, because of its simplicity. Ingenious photographers who were also able to paint produced special scenery to suit their purposes. František Drtikol, already mentioned in the chapter on Art Photography, was full of ideas in this respect. In his most famous portraits, even the facial expressions are appropriate to the atmosphere created by his scenery (Fig. 49).

Drtikol made many of his props from plywood. He often used these props for his nude studies as well (Fig. 50). The decorative conception naturally diminished the erotic effect of the naked body in the photograph, since it emphasized the harmony of the lines rather than the sexual symbols. This technique was indeed necessary if such

49 *Frantisek Drtikol.* Sitter. 1925 (Collection of
Museum for Decorative Arts, Prague)

portrait photography was always obliged to follow the fashion of the time, since most people wanted to be photographed in accordance with prevailing ideas of beauty. These decorative trends naturally applied more to photographs of women than of men.

Many photographers did not rest content with stylish photographic studies, but tried to increase the decorative effect by the addition of a few accessories. The props were chosen so that person and objects blended meaningfully together in the picture. *Rudolf Koppitz* adopted this style in his portrait of a painter (Fig. 48), in which the palette in the subject's hand indicates her profession. Studio photographs made use of props which particularly helped to increase the decorative effect. Traditional

50 *Frantisek Drtikol*. The Wave. 1927 (Collection of Museum for Decorative Arts, Prague)

photographs were to be published, in view of the moral code of the time.

The endeavour to emphasize the finest features of the face was also closely associated with decorative trends in photography. Members of the upper classes were the first to request this stylization of the model, which later became known as 'glamour interpretation'.

Of Drtikol's followers, the two most gifted were *Jaroslav Rössler* and his wife *Gertruda Rösslerová-Fischerová*, whose perpetuation of their master's ideas took the special form of using shadows projected on to the background of a portrait in order to complete the composition. Instead of making use of scenery, they completed the picture in a purely photographic way, by means of the appropriate application of lighting. This respect for the photographic medium helped Rösslerová-Fischerová to depict the male nude in a very simple but at the same time noble composition as early as 1922 (Fig. 51).

In Great Britain, where respect for tradition and class structure had deeper roots than anywhere else in the world, *Cecil Beaton* came to the forefront in the second half of the twenties. He developed a tremendously clear insight into ways of

portraying the upper class consciousness of tradition.

In the further development of those glamour pictures which aimed at decorative effect as well as an idealization of the

51 *Gertrude Rösslerova-Fischerova*. Male nude. 1922

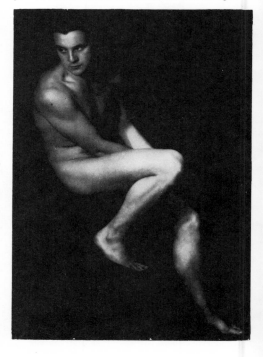

human face, three major factors were decisive: the constantly growing film industry, with its public relations activities; the society columns of leading journals; and fashion magazines, which were ever increasing in popularity. All these influences created very favourable conditions for many photographers to specialize in this subject. *Edward J. Steichen*, who worked for the American publisher, Condé Nast, successfully photographed film actors, famous society figures, and others who attracted his attention on account of their fashionable clothing or extravagant ways. Mention should be made here of other American fashion photographers *Alfred Cheney Johnston* and *George Platt Lynes*. Among the most famous glamour photographers on the European continent were *George Hoyningen-Huene* and *Dora Kallmus*, who was better known by her pseudonym *D'Ora*.

Glamour photographs were very well received in most countries, since large numbers of people were interested in the film industry and in its public relations exercises. Most of the film companies had their own photographers, who took attractive stills of film sets and glamour pictures of the film stars (Fig. 52) for publicity purposes. These photographers almost always remained anonymous, as the name of the film company was provided instead of that of the photographer (e.g. 'Photo: UFA'). The growing number of photographers of this kind had such a great

52 Portrait of the film actress Lil Dagover. Photo: 'UFA'. Circa 1925 (Juraj Herz Collection, Prague)

influence on the public's taste that many clients, when ordering studio portraits of themselves, wished to be photographed in a similar way to their screen favourites. Such trends in taste produced many imitations of famous works, often taken by less gifted photographers. Without a doubt this tendency was damaging to the progress of artistic fashion photography.

It has already been pointed out that the stylistic elements of the 'New Objectivity' were true to the nature of photography. While this productive union of art and photography was taking place, another artistic trend, namely Surrealism, turned out to be highly conducive to the exploitation of artistic modes of expression in photography. Probably the Surrealists' love of experimenting also substantially encouraged this fortunate encounter between photography and Surrealism. In any case, it can be said that in comparison with the other movements of the time, Surrealism displayed an uncommon aptitude for individual style; participation in this movement called for acceptance of these maxims of Breton, the Surrealist theorist: that the creative power of the subconscious and the unconscious had to free itself in artistic activity, without being influenced by intellectually imposed barriers of logic. It was immaterial whether a Surrealist painter created a picture composed of abstract visions, or a scene which at first seemed realistic but whose actual content was unreal and enigmatic. Subjects ranged from subtle hints of psychological experiences, through fanciful erotic ideas, to intentional provocations of bourgeois conventions.

The Surrealists not only liked works created from psychic automatism, but also everything which was apparently supernatural but which had an accidental cause in nature—for example, by storms or by fortuitous human action. These accidental compositions, which aroused the interest of

photographers influenced by Surrealism, we may regard as analogous to 'Objet Trouvé'. The term 'Objet Trouvé' (which means 'Object Found') was originally defined by Kurt Schwitters in connection with things used in artistic composition of the Merz Colleges and the Merz Building[41]. The word 'Merz', indicating his poetic nonsensical montages of tickets, corks, newspaper cuttings, screws, pieces of wood etc, was extracted quite dadaistically by Schwitter from the second syllable of the word 'Kommerz' (commerce), which he happened to cut out of an advertisement for the Kommerzbank (Commercial Bank).

The sensitive eyes of the photographers often found subjects and themes from everyday life which were in complete harmony with Surrealistic visions. Since they were sensitive to such phenomena, the photographers were able to turn these photographic subjects into works of art. The use of the 'Objet Trouvé' represented to a certain extent a Surrealist continuation of 'Ready-Mades', to which we referred in the section on the Dada movement.

As a key to a better understanding of this art form, we may use the observation of the *Count de Lautréamont* (the pseudonym of *Isidore Ducasse*): 'Beautiful as the chance meeting upon a dissecting table of a sewing-machine with an umbrella'. The surrealist painter, Max Ernst, later explained this concept in more detail: 'Let a ready-made reality with a naive purpose apparently settled once for all, i.e. an umbrella, be suddenly juxtaposed to another very distant

and no less ridiculous reality i.e. a sewing machine, in a place where both must be felt as out of place, i.e. upon a dissecting table, and precisely thereby it will be robbed of its naive purpose and its identity; through a relativity it will pass from its false to a novel absoluteness, at once true and poetic; umbrella and sewing machine will make love.

But how could an 'Objet Trouvé' be used artistically? If it were a matter of a spatially small structure, or of only one object, the technique of the 'Ready-Made', known even before the Dada movement, could be used. For an 'Objet Trouvé' which was particularly large, or which for some reason could not be isolated from its real environment, it would at any rate be better to perpetuate this poetic arrangement in photograph rather than in a painting. If the chronicler of Surrealism, Marcel Jean, could compare a poet with 'a simple apparatus for recording inner voices'[43], then a camera would be the ideal instrument for recording pictures of 'Objets Trouvés' discovered by chance. To portray such subjects, the photographer preferred to use all the typical characteristics of photography, especially realistic contour definition. The documentary accuracy of the picture then became evidence of the actual existence of such an accidental encounter. Just as important was the recognition that the 'Art of Seeing' was completely sufficient for this creative production. This principle formed the decisive bridge between the Surrealistic and the spirit of modern photography.

Of course, the choice of the correct viewing angle as an essential factor in Surrealism—which was concerned only with supernatural and paradoxical compositions—was more critically observed than in photography, in which the 'art of seeing' was the decisive factor in making the work true to nature. Thus, the photographers influenced by Surrealism did not deviate from the individuality of their medium, as had happened when other artistic movements such as Impressionism had been adopted. For many photographers, Surrealism signified their first encounter with the 'art of seeing', which they later used not only in Surrealistic pictures but also for many other purposes.

On the other hand, it should also be stated that the strangely poetic character of the 'Objet Trouvé' had been recognized by a few photographers even before Surrealism discovered it. Eugène Atget, who has already been mentioned, is an excellent example of this. His photographs of shop windows contained enchanting arrangements of objects, often not connected in any way, and thus they surprisingly fulfilled the condition laid down by Lautréamont. It is therefore perfectly logical that the Surrealists were the first to admire Atget's pictures. They even published four of them in the journal *La Révolution Surréaliste*. These were probably the only photographs published under Atget's name during his lifetime.

The Surrealists obtained many ideas from shop windows, as may be seen from some of Jindřich Štýrský's photographs (Fig. 53). They also favoured subjects of a dreamlike, ludicrous nature, such as old graveyards, town fairs and waxworks.

The followers of Surrealism also thought highly of photographs whose authors remained anonymous, as the photographer as an individual was not important to them. Since the Surrealists liked to reveal the hidden poetry in things rejected by civilization as rubbish, they began to make completely new poetic interpretations of documentary photographs from old magazines. They were specially interested in photographs which they came across in old albums, boxes and so on. As they felt these photographs to be poetic, they used them to illustrate their own magazines and other publications. This attitude was similar to

53 *Jindrich Styrsky*. Display window. Circa 1935 (Collection of Museum for Decorative Arts, Prague)

Duchamp's creative principle that certain articles from everyday life were acceptable as works of art.

When they discovered that fortuitous photographs could have a Surrealistic effect, the avant-gardists became very unconventional, for they also favoured drastically extreme shots, such as the photograph of the head of a decapitated Chinese thief together with half a dozen stolen umbrellas, left as a warning in the market place.[44] The Surrealists also showed a lack of prejudice as far as nude photography was concerned. In the spirit of the

'Objet Trouvé', they set great store by the poetic interplay of curves and shapes in the female body, which could be varied by the choice of different locations and by slight movements. Sometimes the Surrealists used the naked model for compositions which had occurred to them quite by chance while the subject was posing. The photograph by *Josef Ehm* (Fig. 55) was based on this principle; in it a Surrealist effect was created not only by an unusual arrangement of legs and arms, but also by the contrast between the naked limbs and the gloved hands.

The Surrealists did not object to the erotic effect of the naked body in photography. On the contrary, they saw something magical in the attractiveness of the female body which was worthy of inclusion in the creative process. As a typical expression of the subconscious, many of them even wanted to emphasize the erotic effect of nude photographs. It is superfluous to add that photographs were sometimes produced which could not be published owing to the moral outlook of the time.

The photographers who took pictures of various 'Objets Trouvés' during the first years of Surrealism may be divided into two categories. The first group was composed of those Surrealistic painters who turned to the camera because of their admiration of the poetry of the chance encounter; the other group comprised the photographers who were directly influenced by Surrealism. The first group used the camera purely to record, and this was easy to achieve because of the simplicity of photographic technique. The second group, on the other hand, namely the Surrealist photographers, were able further to increase the effect of the original 'Objet Trouvé' by choosing the most suitable perspectives. Mainly because of the imagination of this second group, the Surrealist interpretation of the 'Objet Trouvé'

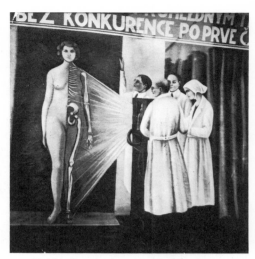

54 *Jindrich Styrsky*. At a parish fair. Circa 1935 (Collection of Museum for Decorative Arts, Prague)

in photography was further developed and modified during the course of time. Apart from choice of location, Surrealist picture compositions were also achieved by other effects from the repertoire of photographic technique, such as varied exposure effects, unusual distances between camera and subject, and reflections (Fig. 56). Many experienced photographers such as *Bill Brandt* found a Surrealist effect in lively scenes to which they had to react very quickly as photographers (Fig. 57).

Even though the interpretation of an 'Objet Trouvé', without any artificial treatment, was the most convincing form of Surrealist self-expression, it was not alone in influencing modern photography. Just as there were a great number and variety of Surrealist statements in paintings, so photography was also effective in very different ways. Very soon the 'chance encounters' and contrasting visions were being arranged artificially, or at least partly artificially, in

55 *Josef Ehm*. Imaginary space. 1936

the photographs. In the very first issue of the journal *La Révolution Surréaliste*, published in December 1924, a photograph appeared showing a cloth which had been thrown across a sewing-machine and tied with a rope.[45] But the whole composition suggested the inclusion of a woman concealed underneath. The title of this photograph, 'The Problem of Isidore Ducasse', was associated with the remark of the poet Isidore Ducasse, which has already been mentioned; he was hiding behind the pseudonym of Lautréamont. It later transpired that this Surrealist photograph was the work of Man Ray, who had become famous already in the Dada movement.

The artificial contriving of a 'chance meeting' often seemed to be very difficult. Accordingly some photographers tried to realize their Surrealist visions by means of montages, which will be discussed in a later chapter of this book.

56 *Josef Ehm*. View and reflection. 1936

57 *Bill Brandt*. Tic-Tac men.

The boom in live photography, the roots of which are to be found as far back as the First World War, and even to the nineteenth century[46], was due partly to the progress of photographic technique and partly to increased prospects of the live photographs being used by the press. Photographers were able to react much more quickly and immediately with the newly developed cameras, as is illustrated in the photographs taken by the camera engineer *Oskar Barnack* (Fig. 58). If his early photographs are compared with those he took in the twenties, it is obvious how dynamic they had gradually become. Just as important was the constantly growing demand from the illustrated magazines for live photographs, with the result that photographers interested in this style were assured of a steady living.

The twenties heralded a new era, which broke with tradition and created a new

58 *Oskar Barnack*. Flood in Wetzlar. Circa 1920 (Leica-Barnack Archives, Leitz firm, Wetzlar)

59 *Erich Salomon.* 'Ah, le voilà! Le roi des indiscrets'. 1931 (Peter Hunter, Amsterdam)

social structure, producing not only technical progress, faith in science and sociopolitical experiments, but also inflation and unemployment, civil war and racial hatred; a spectrum of events that was reflected in photographs in the new media of mass communication.

The standard of photographic technique was such that all 'live photographers' used similar raw materials. However, only a few people in the profession made use of these facilities with any great degree of inventiveness. Although it is true that every art requires first and foremost a good knowledge of the underlying craft, it should also be emphasized that a photographer is often judged by how much more skilfully than the others he can use the equipment available to him to carry out his intentions. If we trace the development of live photography between the two World Wars, this connection can be seen very clearly when we assess individual photographers. It would be quite wrong to speak of uniform trends in the general development of live photography, as each single production was really achieved by a photographer as an individual.

One of the leading photographers, *Erich Salomon*, began his pioneering work using the Ermanox camera, with its extremely fast *f*2/100mm lens. He was completely fascinated by the possibility of being able to take reportage photographs indoors. Salomon was so technically gifted that by the second half of the twenties he had almost achieved the old ideal—to be able to photograph everything that could be seen. This was done with the aid of various tripods and a thoroughly-mastered way of using the camera with longer exposure times. Thus Salomon combined his ability to make use of all the tricks of photographic technique with the discernment of a skilled psychologist, who was nearly always cap- able of photographing people just when their expressions were betraying something of their inner selves. Salomon often stood a few yards away from his camera, amongst ministers and diplomats, with his shutter-release cable concealed in his hand. No one noticed that he was watching the scene very closely, and that he pressed the shutter release at exactly the right moment. He usually took the photograph at a moment when everything was relatively quiet and still. In 1932 he began using the Leica instead of the Ermanox, as he felt that it was easier to manipulate. Improvement in film sensitivity added to the advantages of the miniature camera. As a lawyer, Salo- mon was well trusted by the upper class

60 *Erich Salomon*. Bruno Walter conducts. 1929–30 (Peter Hunter, Amsterdam)

61　*M. Ozerskij.* Majakowski. 1929

photographs served as an example for the early work of the photographer *Alfred Eisenstaedt*[47], who was twelve years his junior. Eisenstaedt soon developed his own style, however, based on his understanding of the technical possibilities of the easily handled Leica. He made special use of the fact that there were 36 exposures to one film, and that the miniature camera was always ready for action. Eisenstaedt gradually developed a photographic technique that bore a certain resemblance to the scientific method of 'trial and error'. He would take several shots of one subject, in an attempt to come nearer to what he was trying to express with each exposure. He did not economize on exposures of the climax of an event which he was recording, but he also paid attention to details, which were to complement the final work as an integral part of the whole. As a reporting photographer in Abyssinia in 1934 and 1935, Eisenstaedt demonstrated his skill.

people whom he portrayed in his live photographs. His portfolio consisted of hundreds of photographs taken at various diplomatic conferences (Fig. 59), and these are still admired today because of their vitality. Especially worth mentioning are his photographs of famous conductors taken during concert performances (Fig. 60): these were the first of their kind in the field of journalistic portrait photography.

At about the same time, though quite independently, a few Soviet photographers were also attempting indoor reportage photographs. The journalistic portrait of the well-known poet, Vladamir Majakowski (Fig. 61) is particularly worth mentioning here; this was taken in 1929 by *M. Ozerskij*. The atmosphere of a writers' convention is here captured very well, although the photographer was devoting his chief attention to Majakowski.

The magical vitality of Erich Salomon's

62　*Alfred Eisenstaedt.* Barefoot Abyssinian soldier. 1935 (*Time-Life* Archives, Picture Agency)

63 *Boris Ignatowitsch*. In front of the Hermitage in Leningrad. 1929 (Lubomir Linhart Collection, Prague)

In that country, whose freedom was being threatened by Mussolini, he produced the enormous number of 3500 photographs, which was unusual under the circumstances. One of those photographs was a close-up of the heels of a barefooted soldier (Fig. 62). The surface of the skin showed clearly that the man had never worn shoes. This detail provided a more telling impression of the condition of the Abyssinian army than would have been conveyed by photographs of their antiquated military weapons. With this picture Eisenstaedt showed how the miniature camera was able to make use of experiences gained from the influences of the 'New Objectivity'.

Soviet photographers, separated from the major focal points of contemporary events, also made an important contribution to the live photography of the twenties. Their distance from the disputes that were taking place in America and Europe

between the protagonists of traditional art photography and the supporters of the newer trends helped the photographers in the young Soviet state to make their own decisions, which were in accord with the social conditions after the Revolution. As with Atget, this independence helped them achieve very original results. The real driving force influencing these photographers was their endeavour to portray their contemporaries who had participated in the formation of the new society in as spectacular a fashion as possible. Photography was a medium which could be easily understood by anyone, and this very soon brought it social recognition. Live photography played an important part in this, although it was not yet known by that name. By the second half of the twenties, *Boris Ignatowitsch*[48] was attempting to take effective photographs from everyday life, in which nothing extraordinary ever hap-

87

64 *Max Alpert*. Work begins on the Fergan Canal. 1939 (Lubomir Linhart Collection)

pened. His pictures were always attractively lively, because he skilfully chose the right moment and also observed how groups of people arranged themselves (Fig. 63).

Only in a few other countries was live photography so widely used as in the Soviet Union. In addition to Ignatowitsch, *Max Alpert, S. Fridland, G. Petrusow* and *Arkadi Schajchet* were among the founders of modern journalistic photography in the Soviet Union.

As well as reporting vividly on their contemporaries' lives, most Soviet photographers were also continually searching for new and even more dynamic ways of portraying the environment. As a striking testimony to these endeavours, we can compare one of Ignatowitsch's photographs with the picture taken by Max Alpert ten years later when work had started on the Fergan Canal (Fig. 64).

Some years after these first Soviet photo-

graphers, the Frenchman *Henri Cartier-Bresson* discovered the significance of the 'decisive moment' in his photographic work. After studying painting for two years, he turned to photography in 1930, and used the insight given him by his artistic training, not so much for purposes of composition as for the discovery of those moments which captured the tension of the events being recorded. For such a style, the straightforward Leica was again very helpful. In his very first photographic exhibition in 1933, Cartier-Bresson's style was labelled as 'anti-graphic'; in fact his early pictures were probably greatly influenced by Surrealism.[49] However, he enriched the 'Objet Trouvé' with dynamic elements, for he preferred subject arrangements which existed only momentarily. In this connection, he discovered the principle of the 'decisive moment', as most of his pictures could come into existence only at a certain

instant. At the same time, he based his work on the 'totality of vision', which signified that the image as seen in the viewfinder was complete and final when he activated the release. He would not allow his pictures to be subsequently enlarged, and he let them be printed with the perforations of the miniature negative. Since he believed that creative photography ended with the discovery of the best viewing angle and the best moment of exposure, he handed over all the darkroom work to a reliable laboratory. Cartier-Bresson's portrayal of reality is characterized by the fact that he refused to manipulate his subject in any way. Thus the photography critic Anna Farova is fully justified in evaluating his contribution in the following way: 'His photographs have given back to photographic art its original role – namely, to provide a true testimony of our time.' (Fig. 65.)

Live photography used various ways of heightening the dynamic effect. The deliberate unsharpness provided by some moving object was soon recognized as a very significant method. During his work in Paris, *Jaroslav Rössler* took a photograph in which a car was depicted with blurred contours, while the outlines of the houses in the street remained perfectly sharp (Fig. 66). In the thirties a photograph of geese running with raised wings, taken by the Hungarian *Ernö Vadas*, became especially well-known. This picture was reprinted in many contemporary photographic journals as it was useful in discussions about the ability of photography to show dynamic movement. This photograph was not an isolated example, as Vadas made a quite

65 *Henry Cartier-Bresson.* Dessau, Germany. 1945

66 *Jaroslav Rössler*. Boulevard in Paris. 1926 (Collection of the Schürmann and Kicken Gallery)

systematic investigation of the photography of moving subjects. His photographs of horses on the Hungarian plains were also significant.

Live photography was also frequently used as a social document. In 1934, Lubomir Linhart attempted to define the differences between bourgeois and socialist realism in photography in his book *Social Photography*[51]. He felt that the middle classes were mainly interested in static representation; as opposed to this tendency, he suggested that the dynamics of socialist realism were based on the fact that only by this method could the relationships in the development of society be dialectically portrayed. His ideas were a positive theoretical complement to the practical results achieved by many photographers in the twenties and at the beginning of the thirties.

In Germany, the following photographers were making social statements by means of live photography: *Eugen Heilig, Herbert Hensky, Walter Nettelbeck, Erich Rinka, Ernst Thormann* and particularly *Wolfgang Weber*. The latter documented the social situation in black Africa for the *Vossische Zeitung* in 1923, and reported on the plight of citizens

90

at the Bohemian border, under the title *Village without Work*, for the *Berliner Illustrierte Zeitung* in 1931.

Social documentary photography also had an important place in America, and went as far back as the pictures by Jacob A. Riis and Lewis W. Hine. In 1928 the 'Film and Photo League' was formed in New York, with the aim of recording events of social significance.[52] Eight years later, the cinematographers separated from the photographers, with the result that there was an independent 'Photo League'. The aim of this association of photographers was to present the true face of America, and also to interest young talent in the medium. *Sid Grossman* in particular, who organized a group project of pictures of New York, distinguished himself as a teacher in this society.

However, the most important social commentary action group in America between the two World Wars was the Government Farm Security Administration campaign, which had the task of producing a full report on living conditions in the country, under the leadership of *Roy E. Stryker*. Within the framework of this project, a group of capable photographers—as has already been mentioned in the

67 *Arthur Rothstein*. Sandstorm, Cimarron County, Oklahoma. 1936

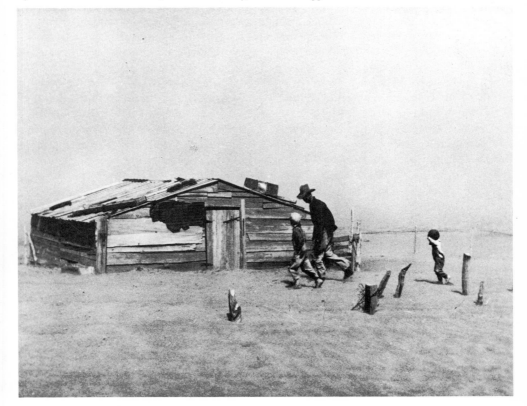

chapter on the 'New Objectivity'—produced a large number of photographs, amounting in the region of between 130 000 and 270 000.[53] Stryker was fully aware that the concept of live photography was well suited to his purposes. The project's generosity enabled individual photographers, who had grouped themselves around Stryker, to develop their skills. When we look back on it today, we see the Farm Security Administration as almost a school for live photography. Some of the photographers involved later became known in connection with the important illustrated magazines: for example, *Gordon Parks* with *Life* and *Arthur Rothstein* (Fig. 67) with *Look*.

Some camera manufacturers launched advertising campaigns to show the advantages—in particular the versatility—of their products, by publishing the works of photographers whom they favoured; and this aroused a completely new interest in live photography. The enthusiastic amateur photographer *Paul Wolff* showed by means of vivid examples the many ways in which the Leica could be used. To celebrate the tenth anniversary of the introduction of this camera, he published the book *My Experiences with the Leica*,[54] which contained a considerable number of live photographs. Wolff eventually gave up his profession as a doctor in favour of professional photography, and he established with *Alfred Tritschler* a studio in which were produced not only the usual portraits but also successful dynamic industrial reportage.

We should also mention those magazines which skilfully matched photographs with reports. During the second half of the twenties and the beginning of the thirties, the most important German papers of this kind were the old-established *Berliner Illustrierte Zeitung*, founded in 1890, and at that time under the inspiring leadership of the chief editor, Kurt Korff, and the *Münchener Illustrierte Presse*, whose chief

editor was Paul Feinhals[55]. In addition to Salomon, Weber and Eisenstaedt, the following well-known photographic reporters worked for these two papers: *Walter Bosshard*, the brothers *Georg* and *Tim N. Gidal*, *Felix H. Man*, the Bauhaus scholar *Umbo* (Otto Umbehr), *Kurt Hutton* (Hübschmann), *Martin Munkacsi*, and *André Kertész* (Fig. 68), though the last-named produced only a few reportage photographs at that time. Each of these included his own style and inclinations in his photographic reportage—for Hutton the prominent factor was a certain *joie de vivre*, Bosshard stressed the adventurous side, the Gidal brothers explored the vast realm of the world of experience, Salomon favoured the prickly atmosphere of political events, Weber constructed on social criticism, and Munkacsi aimed at the delineation of poetic beauty in a picture. Apart from these famous illustrated newspapers, the *Arbeiter Illustrierte Zeitung* is also worthy of mention, as it devoted a good deal of space to social-documentary photographs, and showed a deep understanding of modern pictorial communication.

In Britain, *Bill Brandt* became interested in live photography. He took many important photographs of this kind during the thirties in London's East End, in some coal-mining areas, and also in the country. In comparison with Henri Cartier-Bresson, whose work he sincerely admired, Bill Brandt often became quite contemplative in his live photographic images. He also frequently made use of lively situations, the photographs of which approached the Surrealist 'Objet Trouvé', as is evident in 'Tic-Tac Men' (Fig. 57).

During the second half of the thirties, the evolution of live photography in Britain was stimulated by the establishment of Mass-Observation. This was an organization founded by a small group of upper-middle-class intellectuals and artists, and its aim was to collect information about

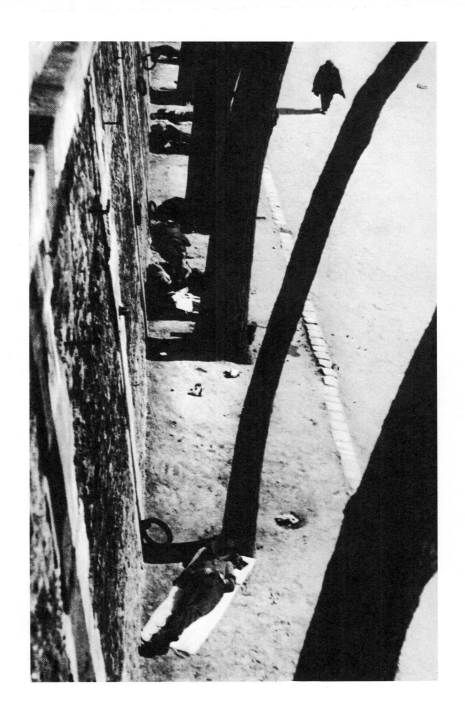

68 *André Kertész*. On the banks of the Seine. 1926

everyday life. Its official photographer was *Humphrey Spender*, who during his association with it took a large number of photographs depicting typical situations in British life. His sense of simple poetry led him again in some pictures very close to Surrealism.

At about the same time, the Soviet monthly *USSR in Construction* introduced not only a really modern style of live photography but also a very original layout. With the picture report *A Day in the Life of the Fillipow Family*, produced by Max Alpert, Arkadi Schajchet and S. Tulesa this magazine showed a modern understanding of visual communication of everyday events.

After the Nazis came to power, the German illustrated magazines stagnated, and the focal point of modern photographic journalism moved chiefly to America, where the famous weekly, *Life*, was founded in 1936, and fortnightly *Look* in 1937 and to Great Britain, with its important magazines, *Picture Post* and *Illustrated*. Immigrants from Germany such as Alfred Eisenstaedt and Kurt Hutton brought their experience to these new magazines.

It can be said that the choice of the right time, or even the 'decisive moment', which would show a dynamic reaction, played an important role in the formation of live photography. Willi Baumeister later provided a fitting definition of live photography: 'The photographer fundamentally converts the movement of life into the stillness of form. The person viewing the photograph converts the stillness of form back into the movement of life by means of his imagination.'[56]

Theoretically, the analysis of the choice of the right moment for the most effective portrayal of an event can be traced back to Gotthold Ephraim Lessing's thoughts in his *Laokoon*, although that book was written a long time before the invention of photography. According to Lessing's ideas, the moment before the climax was more suitable for portrayal than the climax itself, for the viewer was thus compelled to work out the further course of events in his imagination. The ensuing excitement then evoked the illusion of movement.

Even the earliest live photographs made one aware of the importance of capturing the right moment. Thus all the contributions in this period encouraged the further development of photography and the observance of its media-specific criteria.

Photomontage had already been in existence for a long time, having been used in the middle of the nineteenth century for complicated scenic subjects which could not be photographed in a simple manner because the technology at that time was not sufficiently developed. The exposure time for such photographs was for the most part quite normal: only in a few exceptional cases were the reasons for photomontage purely technical. Its main objects were to bridge the gap between great differences in contrast, and to achieve an unusually large depth of field. For example, a montage was necessary if a photograph was to be taken of an interior room including a window through which a landscape could be seen; for this purpose two photographs were combined, the negatives of which were partially covered with retouching colour and then one was superimposed on the other. Only a professional would be able to tell from the finished photograph that it had been produced in this way.

In other montages of this kind, clouds would be subsequently added to a landscape photograph, or silhouettes of parts of the picture would later be painted into the photograph. In contrast to these pictures, which eventually took the form of quite normal photographs, were those photomontages which did not try to hide their true nature. As Otto Croy pertinently explained, the rigidity of the subject was in that way relaxed.[57] The photomontage demonstrated that with its help the photographer was capable not only of formally structuring the image, but also of giving free vent to his imagination, in order to express certain ideas in pictures. These conceptions of photomontage could be technically achieved in three different ways.

The simplest process was a collage technique with the aid of scissors and glue, which made it possible for the montage produced to be photographed again and reproduced at will.

Also fairly simple was the montage achieved by multiple exposure on the same image field, requiring only a skilful estimation of how the exposures should be superimposed in the camera. It soon became apparent that there was an advantage in working against a black background—resulting in a transparent, smooth surface in the negative—or of covering up various parts of the image.

The most ambitious method consisted of mounting two or more negatives during the enlarging process, these being printed, one after the other, on to the same positive paper. In the final stages after the positive printing, the photographer usually had to treat the joins between the separate parts with reducer and brush.

The Berlin Dadaists, *Raoul Hausmann, Hannah Höch* and *Georg Grosz*, introduced photomontage as an art form, and used in particular the method of cutting out and sticking together photographs to express their provocative 'anti-art'. They also used a process which would today be

69 *John Heartfield*. Ghost-time. 1930 (Academy of Arts Collection, Berlin, E. Germany)

described as 'mixed-media technique', in which together with photographic elements from originals and prints, they used pieces of printed texts and various scraps of paper to form experimental pictures, sometimes completing the whole work by graphic retouching.

Many art historians regard Raoul Hausmann as the father of artistic photomontage.[58] He had been first inspired while on holiday in Usedom by a primitive tableau, on which were fixed photographs of his landlady's sons in uniform, together with various state symbols.[59] After the autumn of 1918 as a result of this montage, which he came across by chance, Hausmann treated photomontage as an art form. However, Alfred Durus[60] claimed that the first photomontages had been produced by *John Heartfield* during the war in order to outwit the military censorship which suppressed any possible criticism found in letters. It is said that Heartfield overcame this risk by compiling letters from newspaper cuttings, photographs and drawings.

After the First World War, Heartfield used photomontages chiefly for purposes of political satire. For instance, he employed incongruous picture components in support of the struggle against National Socialism (Fig. 69). Many of these works appeared in the *Arbeiter Illustrierte Zeitschrift*, to which he regularly contributed. In this connection he also created montages proclaiming his ideas for a better social future (Fig. 70). Durus did not consider the word photomontage to be particularly fitting, since montage had mechanical and therefore technical connotations, which were not in keeping with those creative possibilities which Heartfield used to the full.

Many members of the Berlin Dada group did not differentiate so strongly between the use of the artistic and the technical imagination. They even stated that they felt almost like 'creative engineers', and this they also expressed by their preference for manual workers' clothing.[61]

The possibilities offered by photomontage for the visual representation of fanciful ideas were soon welcomed by the Surrealists and those photographers influenced by Surrealism, since they could easily produce

70 *John Heartfield*. Lenin's vision became reality. 1934 (Academy of Arts Collection, Berlin, E. Germany)

picture nucleus, so that the conception could be clearly viewed as an entity, although it often consisted of different visual and intellectual superimpositions (Fig. 71). Moholy-Nagy compared this picture composition to a fugue or an orchestral arrangement, both of which are more or less composed of numerous overlapping components and yet make sense as a whole. The ideas of the Bauhaus are also embodied in this theory, for it aimed at firm constructional principles in all spheres of art. In addition to certain similarities between his own and Surrealist montages, Moholy-Nagy's method, based on a conceptual order, was very different from the Surrealists' theory of the accidental.

Many Bauhaus pupils followed the example of Moholy-Nagy in the field of photomontage, and among these should be mentioned particularly *Herbert Bayer*, who

71 *Laszlo Moholy-Nagy*. The crank. 1927 (Photographic Collection, Folwang Museum, Essen)

their visionary picture by these methods, and would not have to depend solely on the 'Objet Trouvé' principle. Thus, *Max Ernst* and *Paul Eluard* soon included photomontages in the collage form in their works. *Karel Teige* produced a large number of Surrealist montages, in which torsos of naked women adjoined town houses, natural formations and inorganic substances. Many of these ideas continued until after the Second World War.

Laszlo Moholy-Nagy saw in photomontage a new possibility for creative work. He valued the Dadaists' early attempts to try to provoke, demonstrate and experiment visually be means of their montages.[62] However, he pursued his own course with his technique of combining several picture components in the production of a new work; he termed this technique 'photoplastics'. According to him, photoplastics differed from Dadaist photomontage chiefly in that it had a central meaning and a

72 *Herbert Bayer*. The lonely town-dweller. Circa 1930 (Otto Steinert Collection, Essen)

73 *Paul Citroen.* The city, Circa 1923 (Photographic
Collection, Design Department, Imperial University, Leiden)

74 *Heinz Hajek-Halke.* The Tearjerker (two negatives
as a sandwich, enlarged one upon the other)
1920s.

entered the Bauhaus in Dessau as a student
in 1921, and was appointed lecturer in
typography and commercial art in 1925
(Fig. 72).

Paul Citroen, who had been studying in
Dessau since 1923, also based his work on
the Bauhaus style. Earlier, in 1919, Citroen
had created a few montages of street
scenes in Amsterdam,[63] which, however,
did not reach their peak until the appearance of the metropolis pictures of the Bauhaus period (Fig. 73).

Photomontages were very frequently
used for book jackets. The publishers
Malik of Berlin were among the first to use
this new possibility. John Heartfield and
other Dadaists often worked for them.

Photomontage was of considerable importance in advertising, since a com-

75 *Emanuel Sougez.* Toxicomania. 1930 (Bibliothèque
Nationale, Paris)

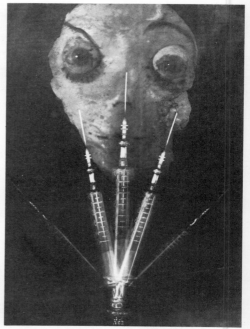

munication could be considerably ampli-
fied by such a photograph. *Heinz Hajek-
Halke*'s picture 'Tearjerker' (Fig. 74) serves
as an example of this kind of combination
of two images. Often, for similar purposes,
montages of fantasies were also successfully
created, such as Emanuel Sougez's 'Toxi-
comania' (Fig. 75).

During the Second World War, some
montages used in the field of advertising
reached a very high standard, and pro-
vided examples for the future, since they
had been created by painter/photograph-
ers. In these montages, photographic and
graphic elements complemented each
other, and there was a freer treatment of
content and form (Fig. 76). In the twenties
and thirties, photomontages in book illus-
trations and posters created new and
stimulating impulses, which greatly en-
riched the artistic repertoire.

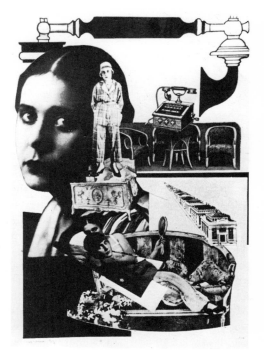

76 *Alexander Rodschenko*. Photomontage for a book
by Majakowski. 1923 (Lubomir Linhart Collec-
tion, Prague)

While researching into photographic techniques, many photographers also took the opportunity of photographing directly on to the photographic paper. This technique was actually discovered by an accident which Man Ray described in his autobiography[64]. During positive development, an unexposed piece of photographic paper got into his developer by mistake. When Man Ray noticed this, he unthinkingly put the spoilt piece of paper next to a glass filter funnel, a measure and a thermometer. When he switched on the room light, he noticed to his surprise that a silhouette of these objects could be seen on the paper which had been dampened by the developer. This chance discovery can be said to have marked the birth of the first photogram, if one is to disregard Fox Talbot's experiments with photogenic 'drawings' back in the nineteenth century. Man Ray then experimented to see what variations his discovery permitted. The output of results was so great that by 1922 he was able to publish a portfolio of twelve photograms, which he called rayographs, under the title *Les Champs Delicieux*. The introduction to this series of pictures was written by Tristan Tzara. Thanks to Man Ray's inventive power, each rayograph presented a fundamentally different product. The differences in picture composition were mainly dependent on the nature of the objects placed in front of the photographic paper. Very flat objects—such as a comb or a knife—were reproduced as silhouettes, and their real indentity could be established

fairly easily (Fig. 77). On the other hand, the portrayal of three-dimensional objects owed much to chance, since their outlines were partly combined with heavy shadows (Fig. 78).

Laszlo Moholy-Nagy also worked intensively with the photogram. In contrast to the accidental manner in which Man Ray arrived at the technique, Moholy-Nagy's experiments were established theoretically.[65] He began with the principle that photography is based on light. From this correct assumption he deduced that the

77 *Man Ray*. From the folio 'Les champs délicieux'. 1922 (Collection of Museum for Decorative Arts, Prague)

essential tool of the photographic process is not the camera but the light-sensitive layer. As a result of this deduction, Moholy-Nagy felt fully justified in using the light-sensitive for direct picture composition, without using the camera; the pictures emerged with a pure radiance. The effect of light was used much more successfully in this way than in the previous manner; the contrasts between the differentially shaded merging grey tones produced an immediate visual result, which could be experienced by anyone without reference to the object

78 *Man Ray*. From the folio 'Les champs délicieux'. 1922 (Collection of Museum for Decorative Arts, Prague)

79 *Laszlo Moholy-Nagy*. Photogram. Circa 1930 (Otto Steinert Collection, Essen)

(Fig. 79). Moholy-Nagy generally produced his photograms on printing paper, since he wanted to be in direct control of the process by which the outlines of the objects with their shadows became bright surfaces on a dark background. He experimented with many variations; amongst them there were photograms of transparent objects, such as crystal, glass, veils, nets and so on. Thus instead of sharp and clearly defined silhouettes, he achieved shapes with subtly shaded degrees of brightness. As a result of these experiments, Moholy-Nagy came to the conclusion that the effect of light on photograms was completely within the photographer's control.

Moholy-Nagy's investigations into the use of photograms led him to artistic experiments with X-ray photographs, as he appreciated the fact that they were also photograms: that is, pictures taken without a camera. Most of these experiments were carried out in cooperation with Dr Moses of Dessau. The resulting pictures were very fascinating, as they made it possible to see inside the selected object and were based on the attraction of the concealed contents rather than the known effect of the external shape. Such pictures could even be used to great advantage in modern advertising.

The photogram technique could also be combined with 'classical photographs' by means of montage. Technically, this process depended on enlarging a negative on to a paper on which an object had previously lain. Heinz Hajek-Hallke used a similar method for his experiments. Deliberate arrangements of light and shade projected on to a surface could also be taken with a camera. Although this had nothing to do with the photogram technique, namely the 'camera-less photograph', the idea behind both methods was the same. The photographer could control very precisely the effect of the light, and could manipulate the arrangement of individual objects in the rays of light until the required image

was obtained. Here too the results took the form of more or less abstract images, whose creative content lay in the composition. This method was tested very intensively by Jaromir Funke (Fig. 80), who emphasized that he obtained his results by photographic techniques—that is, with his camera and the light-sensitive layer—and could therefore call them photographs.

Like other photographic techniques, the photogram could also be used extensively in advertising. Thus Moholy-Nagy particularly valued the contribution it made towards education in photographic techniques: 'The person who has conquered the meaning of light recording by the production of cameraless photograms, will be able to make the best use of his camera.' This assessment is still valid today; many authors base their textbooks about composition on the photogram.[67] [68]

80 *Jaromir Funke.* Lights and shadows. Circa 1927 (Collection of the Schürmann and Kicken Gallery, Aachen)

The term 'unconventional techniques' generally refers to those processes which deviate from the usual negative/positive processing. These methods were very often first devised by scientists or researchers and only later used for artistic purposes. This applies especially to pseudo-solarization, discovered by Armand Sabattier between 1860 and 1862.[69] Pseudo-solarization is based on the fact that the post-exposure of a negative on a wet collodion plate during development causes a reversal of tonal values. Sabattier intended to use this method for the direct production of positive images on the glass plate, but needed to find exactly the right moment for illuminating the developing negative. For a short exposure, only a partial reversal was achieved.

In the second half of the twenties, Man Ray discovered the application of pseudo-solarization (or, as it is commonly known nowadays, the Sabattier effect) for modern art photography, and he deliberately aimed at a partial alteration in tonal values. In this way the contours were very clearly emphasized, and the subject of the picture was usually brought into stronger relief against the background. The plasticity of some objects could be toned down according to the extent of the reversion, and this produced an artistic levelling effect.

Man Ray had also experimented with pseudo-solarization when developing transparencies. In this way he obtained a positive with the tonal values of a negative, so that the pseudo-solarization evoked a stronger sense of unreality.

Very few photographers carried out so many darkroom experiments as Man Ray did. Encouraged by his eager curiosity and lively imagination, he later tried out other unconventional techniques, such as a deliberate graininess, distortion by tilting the enlarger, and a relief effect which he obtained by enlarging a negative together

81 *Josef Ehm*. Nude (Sabattier effect). Circa 1940

with a slightly displaced, thinner transparency. The processes discovered by Man Ray opened up an entire range of possibilities for other photographers. The majority, however, only touched the fringe of these special techniques, for they would soon have become tired of the striking results of such experiments if they had been repeated too often.

Pseudo-solarization was particularly successful in portrait photography. It was still more effective in nude photography, as the alienating effect modifies the nudity of the model and lessens the eroticism, as is exemplified in the picture by Josef Ehm (Fig. 81). Pseudo-solarization introduced a new style to photography which was based strongly on chemistry. Because of its emphasis on outlines, pseudo-solarization was used in advertising in the thirties; with this method retouching could be carried out on the final print.

The Bauhaus Academy of Design was well-known as an educational establishment for architects and painters. It was at first situated in Weimar, but was later transferred to Dessau, where Gropius built a new college, and finally to Berlin. As the first Principal, Walter Gropius endeavoured to form an association of artists from different fields for this institute, similar to the mediaeval stonemasons' lodges. In selecting the individual instructors, Gropius looked above all for a progressive approach towards creative activity, and gathered round him pioneering personalities, who took new paths. Teachers like Laszlo Moholy-Nagy, and students like Herbert Bayer and Paul Citroen, distinguished themselves by their progressive attitude to photography.

Most of these artists' achievements in the photographic field have already been discussed, so that a separate comment on the activities of the Bauhaus might seem superfluous, but it is justified in this case because of the stylistic conception it represented. Lazlo Moholy-Nagy in particular understood the possibilities of photography, having experimented with many different genres and techniques. His unshakable conviction as to the artistic importance of photography is all the more interesting in view of the fact that he was working at the Bauhaus at a time when there was no independent photographic department; not until he left was a separate photographic studio opened in 1929 by *Walter Peterhans* (Fig. 82).

In his theoretical studies on the meaning of photography, Moholy-Nagy dug deeper into the subject than did most of his contemporaries. It is particularly to his credit that, in his book *Painting, Photography, Film*[72], he analyzed the role modern photography could play in typography. The spirit of the Bauhaus was clearly reflected in Moholy-Nagy's basic conception; he proposed a dialectical foundation for photography, based on the needs of society. Thus in the above-mentioned book he set forth the following theory: 'Every period in time has its own visual approach. Our era has films, neon signs, the immediacy of physically perceived events. It has also produced for us a new, constantly developing creative basis in the form of typography. Gutenberg's typography, which extends almost to our times, moves exclusively in a linear dimension. But the intervention of the photographic process has introduced a new dimensionality, which we recognize today as total. The initial work on this was undertaken by the illustrated papers, by posters and by job-printing.'

Moholy-Nagy even attempted to introduce a new term for a reproduced photograph associated with a printed text, by intenting the word 'typophoto'. He explained his idea in the following way: 'What is typophoto? Typography is communication expressed in print. Photography is the visual representation of what is optically comprehensible. The typophoto is the communication which is visually most precisely represented.'

Although the expression typophoto was

82 *Walter Peterhans*. Untitled. 1936 (Agfa-Gevaert Collection, Foto-Historama, Leverjusen)

not accepted, Moholy-Nagy's ideas were further developed both in theory and in practice. They found practical application in the illustrated press, which in Germany in the second half of the 1920s and at the beginning of the 1930s was of a very high standard. Ideas on the application of photography activated by the Bauhaus were soon taken up by other German journalists. Thus, the connection between typography and photography was also emphasized by *Paul Renner*, as may be seen from the title of his book, *Mechanized Graphics*. He correctly recognized that the new photography, like the new typography, had gained its specifically modern characteristics through its mechanical production.[74]

An interesting collection of photographs was assembled in 1929 by Franz Roh in his book *Photo Eye*, which demonstrated very well the position of photography at the time.[75] Among the contributors were the Bauhaus teachers and students, Laszlo Moholy-Nagy, Walter Peterhans, Herbert Bayer and *Andreas Feininger*. It was drawn even closer to the Bauhaus spirit by the choice of pictures, which showed the various ways in which society could use the medium of photography. Examples showed how photography could be incorporated into the page of a book or into a poster (shown by the photographs by Jan Tschichold, who also worked on the graphics and typography of the book). In the same year as *Photo Eye* appeared another classic: *The Arrival of the New Photographer*, by *Werner*

Graff (in cooperation with Hans Richter). Although this book was popular in style, and was therefore an unconventional textbook for students of modern photography, it also contained a cross-section of the many different applications of photography. The Bauhaus was represented by Herbert Bayer, Andreas Feiniger and Siegfried Giedion, and the attitudes expressed in the book were very close to those of Moholy-Nagy.[76]

The Bauhaus also earned high praise as an educational institution on account of its international contacts. In the area of photography, *El Lissitzky* is specially worthy of mention, since he introduced a new kind of typographic work using photography. Through his personal friendship with Moholy-Nagy, his ideas spread to the Bauhaus.

The Czechoslovak art historian and critic *Karel Teige*, who had strong connections with photography, gave some lectures as a visitor to the Bauhaus. He had created a number of Surrealist collages, in which the image of a nude torso was associated with objects from nature. For these pictures he used both the original photographs and printed reproductions.

In the final period of the Bauhaus in Berlin, among Walter Peterhans's photography students was the gifted *Irena Blühová*. After the closing of the institute, she returned home to Bratislava; thus it happened that her work done as a student under the supervision of Peterhans survived as a rare exception. In Bratislava, Blühová found a place among progressively oriented artists. Perhaps this was why she even contributed some of her photographs to John Heartfield—who was at that time living in exile in Czechoslovakia—for his collages. Blühová also became known for her socio-critical photographs.

The outbreak of the Second World War came at a time when people were very familiar with the concept of live photography, and the representation of action no longer presented any technical problems. The further development of photography was also helped by the prominence of the big illustrated magazines at the time, commanding as they did a very extensive readership. The popular desire for reliable information about the actual situation of relatives who were at the Front brought about a growing demand for war photographers. Consideration for the wishes of people at home led to war photographers for the Axis Powers and the Allies developing different styles.

The Axis Powers wanted their initial victories glorified in photographs, and this naturally resulted in pictures which did not show the true face of the horrific war. Those almost idyllic pictures had nothing to do with the true situation on the battlefields where hundreds of thousands of soldiers were being killed. On the other hand, the photographic reporters who worked for the Allied press had no reason to glamourize the war; and hence portrayed the events which they had witnessed with complete realism. Some of them had already witnessed tragic experiences in Spain, where a bloody Civil War was waged on the eve of the Second World War. A most important photographer in this respect was *Robert Capa* (whose real name was Andrei Friedmann), an emigrant from Hungary. His photographs portrayed the war both realistically and dynamically. Capa's photograph of the soldier being killed in action in Spain, taken at the moment when the bullet struck him, has for some time been regarded as one of the most important photographic works in existence. Capa's 'realistic' reportage of the war, which he understood and at the same time hated, included a large number of authentic photographs taken at the front line.

Many photographers thought it their duty to take part in the war as photographic reporters, although their peacetime work had been of a quite different nature. Thus the British fashion photographer Cecil Beaton took not only many photographs in hospitals of the victims of air raids, but also very effective photographs of the American campaign. Similarly, *Bill Brandt* took pictures of people sheltering in the London tubes during air-raids. His photographs of St Paul's Cathedral were also very impressive, taken during the night in the blackout, with the ruins of bombed houses in the foreground.

However, the most important contributions to war photography in Britain were the work of reporters. *George Rodger* was a witness with his camera while people were removing furniture from their ruined houses in Coventry after the heavy attack in November 1940 (Fig. 84), as well as recording events in the deserts of Africa and on board coastguard vessels. *Bert Hardy* also photographed people helping during air-raids, quite often during the night, while enemy activity was at its height. Out

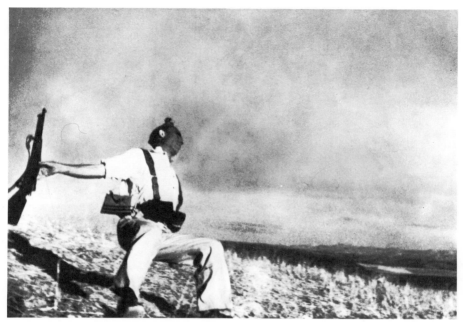

83　*Robert Capa*. Soldier hit by bullet in the Spanish Civil War. 1938 (Magnum Photos, Düsseldorf)

of the relatively large number of other British photographers who made creative reports during the war, *Humphrey Spender* should be mentioned particularly. His images were especially vivid as a result of his association with 'Mass Observation'. It is important to note that during the war the British Government took over the 'Mass Observation' organization, in order to use its activities for propaganda purposes.

Soviet photographers adopted a dynamic style of picture reportage in the 1920s and 1930s, which they then used consistently during the war. In addition to experienced photojournalists like Max Alpert, Boris Ignatowitsch, *Boris Kudojarow, Georgi Lipskevow, Iwan Schagin,* Arkadi Schajchet and *Alexander Uzljan* (Fig. 85), younger photographers—scarcely thirty years old at the outbreak of the war—such as *Dimitri Baltermans, Anatol Garanin, Jakow Rumkin, Michail Sawin* and *Michail Trachman,* also

84　*George Rodger*. Man removing furniture from bombed house, Coventry. 1940

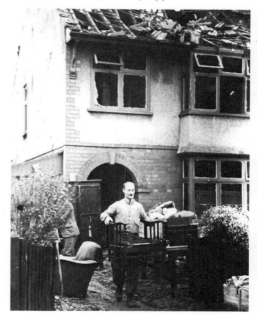

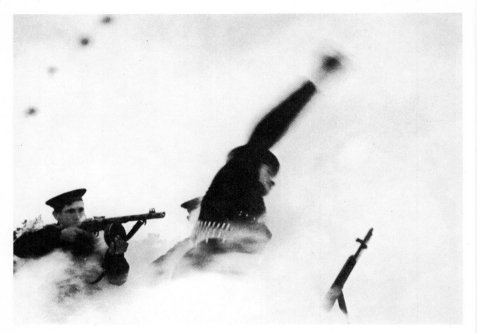

85 *Alexander Uzljan.* Black Sea fleet. Autumn 1942 (Collection of the quarterly review *Photography*, Prague)

became important at this time as representatives of photojournalism in the USSR.

When the USA entered the Second World War, very many American photographers were to be found among war reporters. Particularly powerful photographs were taken in the Pacific by *W. Eugene Smith*, who was not content to show dramatic events of battles, but portrayed also human relationships in wartime. *Joe Rosenthal* was awarded the Pullitzer Prize for his photographs of the raising of the flag on Iwo Jima. Robert Capa also worked for American journals. Some young photographers, too, began their work during the Second World War, and soon became well-known as war reporters; an example is *David Douglas Duncan*.

The end of the war in Europe also marked the liberation of the concentration camps. The torments to which the prisoners had been exposed deeply moved the photographic reporters when they arrived with the army at these terrible places. Among them was the famous American reporter of the magazine *Life*, *Margaret Bourke-White*, who, deeply incensed by the horrifying scenes she was witnessing, photographed them as naturally as possible (Fig. 86). At this time realistic reportage of violence appeared in photography. This developed as a result of photographers' understandable desire to use this realistic style as a means to arouse and warn humanity. It would have been impossible to describe adequately in words the reality of those unbelievable scenes without appearing to exaggerate.

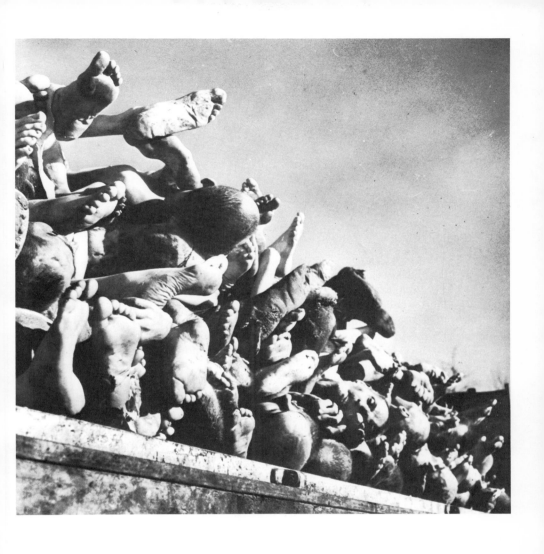

86 *Margaret Bourke-White*. Victims of the Buchenwald Concentration Camp. 1945 (*Time-Life* Archives, Picture Agency)

After the First World War, the autochrome plates of the French firm Lumière first made production of colour photographs possible. Other brands soon came on the scene, using a similar *grain réseau* principle: for example, the Agfa colour plate (later 'Agfacolor'). The low light-sensitivity—a colour plate requires approximately 60 times the exposure needed by normal monochrome negative material—and further technical problems delayed the development of colour photography and its acceptance by the general public. Of the few consumers who regularly used colour in the twenties, the American monthly *National Geographic Magazine* should be mentioned. It was already demonstrating how colour could increase the effectiveness of a travel report from distant lands.

The conditions for a real growth in colour photography were not ready until the second half of the 1930s, when the two great photographic enterprises, Eastman Kodak and Agfa, produced their new multi-layer colour films with chromogenic development to produce colour transparencies (Kodachrome and New Agfacolor). By then the modern photographic industry was in a position to bring quite large quantities of this material on to the market. There were successful advertising campaigns for the new colour films. Thus thousands of photographers soon had the chance to try out the possibilities of colour photography. Admiration for these colour photographs was almost unbounded, resulting indeed in a certain 'colour intoxication'. Photographers searched diligently for subjects incorporating all the colours of the rainbow, so that they could prove to themselves that every shade could be reproduced naturally.

Serious photographers, however, soon realized that 'coloured' did not necessarily mean 'colourful'. From an artistic point of view, the most praiseworthy of the early results were those pictures which approached the borders of black-and-white photography with their pastel shades. This meant that virtually grey tones merging into blue and green appeared most frequently, whereas brightly coloured elements emerged only in small areas. Also fairly successful were those pictures in which one colour predominated. Analagous to tone gradation in a monochrome photograph was the scale of variously saturated tones and of their primary colour, with differences in brightness adding to the total effect. It is noteworthy that the practical use of colour photography was illustrated in the first books giving advice on working with the new colour films.[77][78]

Similarly, as the new medium of the autochrome plates had enabled some photographers to develop interesting images, so also subtractive colour films soon attracted the attention of those who wanted to use colour for their creative work. Thus for example, Gisèle Freund started a series of colour portraits of famous people in 1938. At the same time approximately Paul Wolff was working on a colour series showing the workers in the various industries in Rüsselsheim. To make the vivid images he wanted, he needed to use 60 Nitraphot bulbs, each of 50 watt, which presented quite a technical problem.

Some important colour photographs, which were more than simply documents, were taken by those engaged in researching the technique. In this respect D. A. Spencer could be mentioned, for example, whose book *Colour Photography in Practice* was for a long time the standard work on the subject in English speaking countries.

The colour photographs obtained on the new subtractive films were soon also used for advertising purposes. However, the Second World War changed this situation somewhat, since the greatest interest was then concentrated on images dealing with the actual events in the war. Colour photography spread gradually to the work of war reporters, too. The last moments of the war on board *SS Missouri* in the Bay of Tokyo were captured in colour by David Douglas Duncan.

The simplicity of working on subtractive materials led a few photographers to specialize in colour photography to such an extent, that they prepared books which were fully illustrated in colour. Thus, for example, at the end of the 1930s and the beginning of the 1940s several publications appeared describing various countries pictorially, like *Countries and Nations on the Danube* by Erich Retzlaff, or the two books *Alps in Colours* and *Spain—A Colour Picture Work* by Kurt Peter Karfeld.

III The Development of Modern Photography since 1945

During the early post-war years, there was a widespread and unprecedented demand for consumer goods, as the market had been completely exhausted during the war in the majority of European countries. These favourable conditions for light industry also aroused an interest in large-scale advertising. There were good opportunities for this in the illustrated magazines, which also encouraged more widespread use of photography. It was also significant that active photography expanded to an unprecedented degree. Thus there was a sound basis for a fruitful development of photographic magazines, which indeed offered the best forum for the publication of good photographs. Many of these magazines, such as *Modern Photography* and *Popular Photography* in America and *Sowetskoe Foto* in the USSR, were publishing as many as a few hundred thousand copies per month. Perhaps it is even more significant that specialist photographic magazines, which were concerned exclusively with artistic matters and not with advice for amateur photographers, could be published, such as the Swiss magazine *Camera*, which is now edited by Allan Porter, the British *Creative Camera* edited by Colin Osman, and the Czech quarterly *Fotografie*, founded by Vaclav Jiru and continued by Daniela Mrazkova.

Following the example of the New York Museum of Modern Art, which had a photographic department before the Second World War, other art museums and picture galleries started photographic collections. Despite the theory that the photographic process is not complete until a printed reproduction has been made, the number of admirers of photographic originals grew to such a degree that it became possible for private photographic galleries to be opened in many countries, and the photographs were sold to collectors. As a consequence of this ever-growing interest in artistic photography, more and more collections by famous photographers were appearing on the book market. There were also more and more one-man photographic exhibitions, which were then discussed in the cultural sections of leading newspapers and magazines.

In Britain the Photographers' Gallery in London opened on 14 January 1971. This non-profit-making organization, directed by Sue Davies, helped considerably in presenting modern photographs to the British people. Of equal importance was the creation of the position of Photography Officer in the Arts Council of Great Britain in 1973. The first to be appointed was Barry Lane.

In the period after the Second World War, photography seemed to have achieved its independence as an autonomous field of art; and this was also clearly expressed in its acceptance by society.

As usual, before analyzing the conditions for the development of artistic photography, we must also examine the state of the technology, although very few limitations remained after the Second World War. In the early post-war years, camera

models which had dominated the market towards the end of the 1930s were improved still further. The main interest centred on the single-lens reflex (SLR) camera. The Dresden photographic industry was the forerunner in this field. The introduction of the mirror reflex viewfinder made these cameras as quick to operate as those with separate viewfinders, having the additional advantage of parallax-free viewing. Outside Europe, the Japanese also started intensive work on the construction of SLR cameras. The leaders in this field were the Asahi Optical Company, who were able to introduce their Asahiflex by 1951.[79] After this prototype, the Japanese camera industry was so successful in independent development of the SLR camera that most of the technical innovations came from there. The most important of these innovations was the measurement of exposure through the lens, the TTL (through-the-lens) system: in 1964 the Asahi Pentax Spotmatic came on to the market, and in 1972 the Pentax ES— the first SLR camera with fully automatic exposure. These innovations simplified work with precision-built cameras, making them speedy to operate. Convenient to handle, these cameras were used not only by journalists and other live photographers but also by fashion photographers who aimed at dynamic composition.

The importance of the miniature SLR camera also grew, thanks to the development of new accessories. Nowadays most models have interchangeable lenses, from the 'fish-eye' kind with an angular field of over 180°, to lenses of the extreme telephoto type. In addition, various accessories can be inserted for close-ups, and these have all contributed to the universal adaptability of the SLR camera. These possibilities have encouraged many photographers to use them artistically and to experiment with them.

However, some miniature camera en-

thusiasts still remained faithful to cameras with viewfinder and coupled rangefinder. The famous Leitz works in Wetzlar contributed to some extent towards the further development of these models, and with the introduction of inside measurement on the Leica M5, testified to the lasting value of this conception. A few Japanese firms also made their contribution by improving their cameras with a perfected system of automatic exposure setting (e.g. the Petri Computer).

The principle of the SLR camera was also successful in medium-format cameras. The principal successors of the pre-war Primarflex and Reflex Korelle were the Swedish Hasselblad, the Japanese Zenza

Bronica and the German Rolleiflex SL 66. Their rapid operation and extraordinary versatility encouraged studios to use these cameras; the improvement in quality of film also played some part in this, and nowadays results from medium-format, roll-film cameras can be just as good as those earlier achieved exclusively by large-format cameras using plates and sheet films. For some photographers the weight of these cameras seemed to be too great; but slides from roll-film cameras proved to be more suitable for blocks for colour reproduction. For this reason the newly designed Mamiya M 645, which appeared in 1975, was a significant step forward; it used film of the 4.5 × 6 cm format, and its weight was approximately that of an SLR camera taking miniature film. The Mamiya M 645 found immediate favour among photographers, and this stimulated the manufacturers to produce accessories including motor drive and a large choice of interchangeable lenses. This camera is regarded by photojournalists as extremely useful.

Large-format cameras, however, are still used for colour film, since big slides are found to be superior for making blocks. A good deal of original work has been carried out with new types of large-format cameras, such as the Fujica G 690 BL, the Linhof Press and the Mamiya 23 Professional.

After the Second World War, flash units became an important part of photographic equipment. These units, which facilitated technically reliable work under very unfavourable lighting conditions, were continually being improved. In addition to small models which could be attached to the camera, large pieces of equipment were also developed for professional studios, so that constructed scenes could be photographed with the same precision as in film studios.

Instant photography opened up a new era. From 1947, when Dr Edwin H. Land introduced to a meeting of the Optical Society of America a camera for taking 'one-minute pictures', this process underwent continual improvement, to the extent that by 1959 a finished photograph could be produced 15 seconds after it had been taken under the lighting conditions of a normal interior room.[80] In 1974, the evolution of this system in the monochrome field reached its peak with a material which presented simultaneously a positive and a copyable negative, 30 seconds after exposure. In 1963, Polacolor was introduced: a material for the production of instant pictures in colour. These materials were also continually being improved, and in 1975 Polacolor 2 was introduced, incorporating metallized colour material and an unprecedented freedom from fading. In addition, a new system was introduced in 1972 with the Polaroid SX 70, which delivered an instant colour picture within five minutes by means of a newly designed mirror reflex folding camera. Instant photography, which lifted the barrier between the imagination and the finished product, was immediately seized on by practising artists of other disciplines, who began to incorporate photography in their work—especially those in the 'New Objectivity' and Pop Art fields.

2 From the Post-War 'Human Interest' in Live Photography to the 'Family of Man' Exhibition

During the early post-war years people throughout the world were enjoying peacetime. This new feeling of relief was frequently expressed in pleasure at meeting others, and in a readiness to help those less fortunate. National frontiers, which during the war had been almost impregnable, were gradually opened. The younger generation in particular became interested in the way of life, culture and level of knowledge of other nations, as they had not been able to travel during the chaos of the war. This trend was reflected also in photography, and was used extensively for creative expression under the heading of 'Human Interest'. The popularity of 'Human Interest' as a theme prepared the way for the publication of photographs of this type in the big illustrated papers and weekly magazines, which were experiencing a kind of 'golden age' because of the visual potential of the photogravure process. Owing to the large number of weekly magazines, it was possible for unconventional reports on familiar themes to be published, as well as topical news items. This provided a challenge for photojournalists, as the balance of word and picture was at that time weighted in favour of illustrations: otherwise many readers would not have been able to digest the contents before the appearance of the following week's issue.

By this time many people had come to the conclusion, still valid today, that photographs of special events—for instance a royal wedding—were much more appealing for inclusion in a magazine than themes from everyday life. For these themes, photographers required more time; and this meant an increase in photographic staff for the various illustrated magazines. The number of photographers employed on the well-known weekly magazine *Life* was more than 30; many European illustrated journals, for instance *Stern*, had teams of about 15 to 20 photographic reporters. In addition, the editors used the services of freelance photographers more and more, in particular those specializing in live photographs. This was an important factor in the development of this photographic genre. In order to improve their contacts with the various magazines, and to enhance the coordination of their workloads according to their personal interests, a few famous freelance photographers, through the initiative of *Henri Carter-Bresson*, *Robert Capa* and *David Seymour*, joined together to form the 'Magnum' society in 1947. 'Magnum', of course, signifies in English a large bottle with a capacity of two quarts of spirit. The 'spirit' in this case was intellectual rather than alcoholic, for this group of photographers from different nations wanted to indicate with their choice of name their diverse intellectual strength.[81] Apart from the photographers already mentioned, the Swiss *Werner Bischof* was also a particularly well-known member of 'Magnum'. He took pictures all over the world, and these photographs showed his profound love of simple people (Fig. 87).

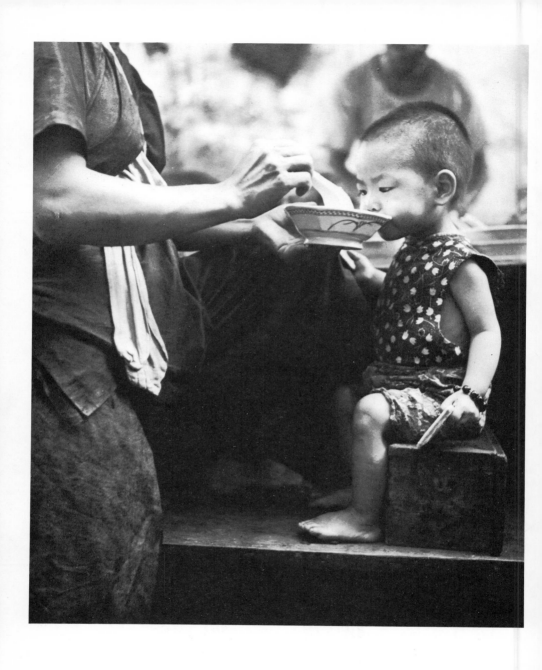

87 *Werner Bischof*. Hong Kong. 1962

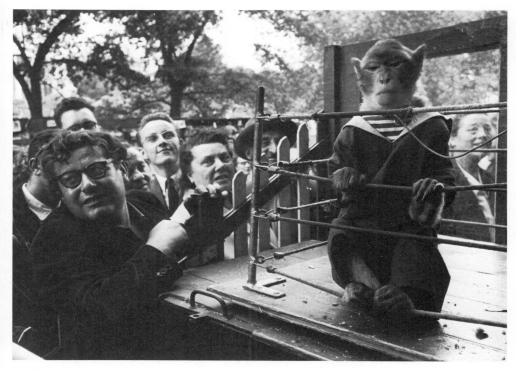

88 *Robert Doisneau*. Les Animaux Superieurs ('white apes' on show in a Paris street). 1954

In the ever-increasing circle of photographers who devoted themselves primarily to live photography, there was a certain tendency to specialize in one particular theme, since in this way the individual could make a greater impression. Thus *Robert Doisneau* was inspired by situations of a humorous nature (Fig. 88). *Gordon Parks*, despite his diverse activities as a member of the photographic staff of *Life*, was especially attracted by social subjects, particularly those concerning the lives of his black compatriots in the USA (Fig. 89). The British reporter *Bert Hardy* always seemed to be on the spot when events of world significance were taking place (Fig. 90); he demonstrated this with conspicuous success as one of the most courageous photojournalists on the London *Picture Post*.

By the end of the first decade after the war the number of live photographs had grown enormously. This fact called for a résumé of the results achieved so far. Edward J. Steichen was the person most qualified to handle this complicated task. As Director of the Photographic Collection at the Museum of Modern Art in New York, he undertook this daunting project, assembling a great collection of subjects from live photography in the 'Family of Man' Exhibition. Within this theme all the important manifestations of human life could be included, such as the birth of a child, childhood, youth, love between man and woman, matrimony and old age. By means of contributions from different countries, Steichen tried to show that in spite of varying national customs and religious practices, people throughout the

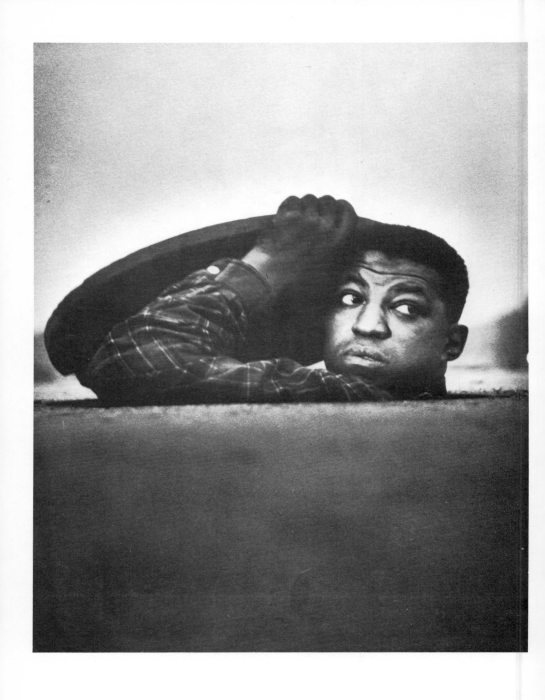

89 *Gordon Parks*. 'I'm going underground'. 1952 (*Time-Life* Archives, Picture Agency)

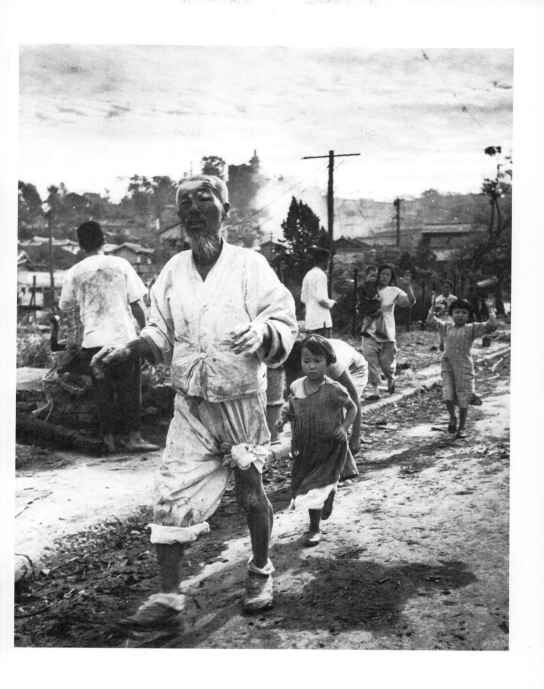

90 *Bert Hardy*. Old man in Inchon, Korea. 1950

world were really very similar. They should, therefore, easily be able to understand one another, if they would only look for what they had in common rather than for their differences. Thus Steichen did not merely want to establish this exhibition on the fame and importance of the photographers; he also aimed in his selection to combine the effects of the individual photographs in such a way that they all contributed to a general unified impression. Without a doubt his concept of the exhibition was a very creative one, since he was undertaking the task of presenting a directly appealing epic of mankind solely through the medium of photography. Soon after the opening of the 'Family of Man' Exhibition on 24 January 1955, even the most optimistic forecasts were surpassed, and the exhibition broke all visitor records in the Museum of Modern Art. The exhibition was subsequently shown in another 44 cities in America, as well as abroad. A total of nine million visitors saw the 'Family of Man' exhibition.

The value of Steichen's exhibition to the history of photography cannot be rated too highly. His selection of photographs and his presentation of them represented a major creative achievement in itself, and it set in motion an 'art of exhibition' in the field of photography. This new form of presentation not only constituted a success from an artistic point of view, but also fulfilled a need in society. The 'Family of Man' was able to attract the attention of a large section of the public—including many people who would otherwise be unlikely to set foot in an art museum or picture gallery. The result was a very important diffusion of visual art. Steichen's project meant, for photographers themselves, a categorization of the possibilities which could be exploited in live photography. Many photographers were so strongly influenced that they determined in future to participate in photographic exhibitions. Not only did the exhibition excite professional photographers, but it fascinated thousands of amateurs, who as a result developed a deeper insight into and a better understanding of problems of life and of human relations. As a result of its human attitude, the 'Family of Man' Exhibition extended the borders of photography into the field of social comment and analysis.

Surrealism is marked not only by a large number of creative manifestations, as has already been pointed out, but also by a remarkable vitality, for its influence is still felt today. In Surrealist art, which has been in existence for more than fifty years now, many changes have taken place, but all of these have respected the basic principle of creative Surrealist activity, namely the exploitation of the subconscious and the accidental.

Immediately after the war, photographers were able to discover and photograph many 'Objets Trouvés', which had been caused by unusual circumstances. At this time, when a great deal of rubble still lay on the streets from the last air-raids, *Vilem Reichmann* created a series of photographs entitled 'Wounded Town', containing surprisingly paradoxical compositions (Fig. 91). Surrealism in the first post-war years made great use of the creative accentuation of very detailed surface structures. This photographic procedure had originated principally in the 'New Objectivity' movement of the second half of the twenties. Since then, these discoveries had been converted into a generally usable photographic technique, with the result that they could also be used for Surrealist purposes. The main principle was that of the 'Objet Trouvé' discovered on surface structures.

Brassai surprised people in the first half of the 1950s with his series of photographs of drawings which beggars had scratched on to walls next to front doors to pass messages on to their colleagues. He depicted these

primitive ideograms as larger than life, and this gave them a completely different, strongly poetic effect (Fig. 92). Just as the Surrealist photographers in earlier years had been inspired by the naïve pictures and posters of the fairground booths, these primitive drawings, which had escaped people's attention for so long because of their inconspicuousness, now revealed the poetry to be found in everyday life. Sometimes marks on surface structures appeared

91 *Vilem Reichmann.* From the series *Wounded Town.* 1945

as a result of chance occurrences, such as the weather, and helped to alter the calligraphy. The sensitive photographic eye was able to find compositions in such cracks and fissures, which were then interpreted metaphorically by the photographer's imagination. A good photographic representation had such an effect on the object (of which only a portion was usually photographed) that its true identity was barely recognizable to the viewer, who therefore had to surrender himself completely to the imagination of the photographer. The Surrealistic subject was given a new, purely poetic value, as the photograph by *Jean-Pierre Sudre* (Fig. 93) clearly shows.

Many objects that were Surrealist in effect were by-products of human activities. Several photographers, for instance, discovered quite unreal visions in scraps of wood, and *Martin Martinček* devoted a whole book to the theme of chopped wood

92 *Brassai*. From the series *Graffiti*. 1957

93 *Jean-Pierre Sudre*. Abstract landscape. 1972

(Fig. 94)[82]. He created a similar series of pictures entitled, 'The effect of light playing on the surface of water'.

Modern industry with its new technologies was producing an ever-increasing amount of waste of unfamiliar kinds. Thus leftover pieces of plastic from the factories could be turned into fantasy figures, in a similar way to those created at one time by the remains from the traditional lead-smelting process; and many photographers discovered 'Objets Trouvés' which metaphorically reflected the existence of the industrial consumer society. *Alois Nožička* demonstrated in his photographs how such waste could become a rich source of inspiration for a photographer influenced by Surrealism (Fig. 95).

A further use of Surrealism in photography was expressed in artificially contrived compositions, which were to serve as models for photographs of dreamlike visions. At the same time, the claim made by Dali in the twenties was recognized— that as the representation of paranoic vision, a Surrealist painting should be as accurate as a colour photograph. According to the Surrealist chronicler Waldberg, paranoia signified to Dali an associative delirium, interpretative in character, with a systematic structure.[83] From Dali's mental attitude towards paranoia there emerged a method of irrational judgement, which was created by the critical recording of the dreamlike and illogical visions and image associations stemming from the subconscious.

The statement that a painter should try to reproduce his ideas with the qualities of a colour photograph also applies to photography itself. Thus Dali often worked with photographers, and one result of this cooperation was the self-portrait of Dali with seven naked girls forming a skull in the background; this photograph was taken by *Philippe Halsman* (Fig. 96).

Sometimes the artificial composition

94 *Martin Martinček*. Dancing Mexican girl from the series 'Unexplored World'. 1962–63

95 *Alois Nožička*. From the series 'Complementary Testimony'. 1961

96 *Philippe Halsman*. Dali with a skull made up of seven nude models. 1951

97 *Angus McBean.* Christmas card for 1951.

called for the construction of fairly com-plicated props in the studio. *Angus McBean,* who had been working on Surrealist-inspired photographs since the late thirties, created one of his most famous portraits in such a way, namely that of Audrey Hepburn, taken in 1951.[84] This was actu-ally an advertisement for the firm Lacto-Calamine Ltd, who wanted a 'dreamlike' picture. For this McBean constructed a scene with replicas of two marble pillars from the Roman forum. In the middle of this magical scene was Audrey Hepburn, with only her head visible, since her body remained hidden behind the scenery. This was so successful that as a result of the photograph, Audrey Hepburn, hitherto only a little-known dancer, was given a part in a film which established her in her acting career. At Christmas, McBean used to incorporate his montages in greeting cards

for his friends. In his 1951 Christmas card, he combined the images of living people with fine porcelain dolls (Fig. 97).

These examples demonstrate how im-portant contrasting objects can be to the photographer, in order—either deliber-ately or by chance—to develop an associa-tion of ideas during the photographic process. This idea has fascinated *Herbert List* since the thirties. The original idea for an artistic arrangement resulted from direct contact with reality, i.e. an 'Objet Trouvé'. Quite by chance, photographers suddenly realized how they could complete this sort of composition by means of an additional item. This combination was used, for example, by *Emila Medkova* in her visionary portrait (Fig. 98). A silhouette of a human profile which she recognized in a scrap of paper was completed by the addition of an artificial eye.

98 *Emila Medkova*. Negro. 1950

99 *Lorenzo Merlo*. Window No. 3.

Dali's work was not the only model for this inspired combination of 'Objets Trouvés' and visonary concepts: other Surrealist painters also offered fruitful suggestions. Thus the experiments of *Lorenzo Merlo* were a result of his admiration for Giorgio de Chirico and Paul Delvaux (Fig. 99). These associations had roots also in Merlo's background, for he was born in Turin, Giorgio de Chirico's native town, and he lived in Amsterdam at the time when Paul Delvaux was working in Belgium, the neighbouring country.

In the more recent Surrealist trends, photomontage again played an important role, and was substantially improved in comparison to pre-war methods. The technique of combining sections of photographs was so refined by graphic alterations and retouching that it was possible to produce compositions that looked homogeneous. This style was specially favoured by those who were at the same time photographers and graphic artists, such as *Reinhard Schubert* (Fig. 100). The artificial granularity of the photomontages facilitated the smooth combination of individual picture components, and also contributed to the conception of the whole dreamlike scene emerging from an ethereal mist, as is exemplified in the picture by *Paul De Nooijer* (Fig. 101).

Generally, however, the simple technique of cutting out and pasting up was replaced by superimposing several negatives during the enlarging process. Photocollage had become transformed into a rapid procedure, whereby the photographer could realize those dreamlike visions he had pictured in his imagination. The mounting of sections of different negatives using a positive process took somewhat longer. Many photographers preferred this method, as it enabled them to set free their visions and to control the selection and placing of new picture components. Thus at the beginning of the process the photographer did not usually

100 *Reinhard Schubert*. Untitled. Circa 1965

101 *Paul de Nooijer*. Point of view. 1974

102 *Jerry N. Uelsmann*. Restricted man. 1961

103 *Jan Splichal*. Photomontage on the theme 'Gothic Cathedral'. 1971

have an exact idea of the end product; this took shape while the work was actually in progress, with the imagination guiding the Surrealist compositions out of the subconscious. Perhaps the uncertainty of how a superimposed section might look after processing played some part. The result was a great improvement on photocollage, in which the photographer simply manipulated finished photographic elements.

Photographers were now in the position of being able to use all the photomontage possibilities. Because of exact structure representation, inanimate objects and living things could now be placed side by side

104 *Van Deren Coke.* Death and dying. 1974

in a dreamlike way. For example, *Jerry N. Uelsmann* combined a rough wall with a human face (Fig. 102).

105 *Jerry N. Uelsmann.* Navigation without numbers. 1971

More recently, in photomontage an approach has been made to experimental darkroom techniques. The alienation of reality achieved in this way underlines the Surrealist effect. Thus the tonal transformation of individual picture elements can produce a moonlight effect of a slightly ghostly nature, as is shown in the photomontage by *Jan Šplíchal* (Fig. 103). By pseudo-solarization, a sort of halo may be added to outlines, and this is particularly interesting in visionary pictures like that of *Van Deren Coke* (Fig. 104). Very pleasing results could be achieved by a rhythmic combination of the picture components in normal and reversed tonal values, a method which was employed in the somewhat complicated photomontage by Jerry Uels-

105 *Jerry N. Uelsmann.* Navigation without numbers. 1971

106 *Allan A. Dutton*. Montage with car.

107 *Allan A. Dutton*. Photomontage.

108 *Kikuji Kawada*. Monster.

mann, 'Navigation without Numbers' (Fig. 105).

Nudes or naked torsos had played an important part in the early Surrealist influences on montage. This tendency increased after the Second World War—encouraged by sexual liberation and by sex-appeal advertisements. In contrast with Karel Teige, who was one of the first to combine parts of the female body with inorganic and organic elements from nature and from cities, *Allan A. Dutton* directed his attention to modern pictorial elements. Thus he created a montage of a woodland scene with a nude and a vintage car (Fig. 106). In another photograph the same photographer placed a number of highly erotic nudes in a room bounded by exterior walls, which creates a very unreal effect (Fig. 107).

Hirtherto we have examined Surrealist trends only in Europe and America. However, similar tendencies may be found in

109 *Eikoh Hosoe*. Portrait of the author Yukio Mishima from the book *Ordeal by Roses*. 1962

other cultural areas, the most noteworthy of which is Japan, as there Surrealism was combined with the traditional taste for horror. Good examples of these trends may be found in the 'Objets Trouvés' in the work of *Kikuji Kawada* (Fig. 108).

According to tradition, flower worship was at the centre of native Japanese culture. *Eikoh Hosoe* compiled a volume of photographs on this theme entitled 'Ordeal by Roses', from which his portrait of the writer Yukio Mishima is taken (Fig. 109). Japanese photography involved this feeling for the hidden poetry in the insignificant, and many expressions of this kind were even borrowed by fashion and commercial photography because of their great attractiveness.

Although abstract painting had its roots in the first decade of the twentieth century, it was not until after the Second World War that its ideas were extended to other spheres of art. The general admiration for abstract composition had increased to such a degree that many photographers also wanted to follow these trends. In fact, abstraction was not really new to photography, for Coburn had carried out the first experiments of this nature with his 'Vortographs', and abstract forms also resulted from photograms. However, photographers now wished to create

110　*Minor White*. Sun, rock and surf; Devil's Slide, San Francisco. 1948

111 *Mario Giacomelli*. Landscape at Genovali. 1960

abstract forms by photographs taken with a camera. But photography was lacking one essential requirement for abstract expression, namely the liberation of the medium from its concrete bonds and its image-reproducing function.[85] The camera lens can only create an image, on the light-sensitive layer, of subjects which do exist, if only for an instant. The primary representation of reality may not be destroyed even by unconventional darkroom methods, but can only be transformed in unusual arrangements. Although the photographer could create unreal-looking compositions whose contents were difficult to decipher, this did not mean that his work was freed from its dependence on the real world. It was in fact a matter of applying the 'Objet Trouvé' principle again—no longer as dreamlike visions or metaphors as in Surrealism, but in the composition of forms discovered by the photographer.

At least at the beginning of his work, the abstract painter had a more or less exact idea of the abstract composition he wanted to create on the canvas. In contrast to this, the photographer had no preconceived idea of a form, but his skilled eye helped him to see how a chance arrangement could be abstractly effective, and he was clearly able to build up the composition by purely technical means.

Just as there were several styles of abstraction in abstract painting—such as geometric, calligraphic, impressionist and expressionist, as well as the automatic abstraction of 'Action Painting'—the photographs also showed a variety of characteristics. In this respect, the individually creative style of the photographer only partly influenced the product, for a great deal depended on the nature of the subject, which acted as a carrier of the abstract form.

Landscape themes often produced abstract results. *Minor White* was very skilful in using lighting to emphasize

112 *Lennart Olson*. Tjörbron bridge.

composition. The specifically chosen lighting conjured up images on the surface of the Pacific Ocean which were important for the photograph (Fig. 110). *Mario Giacomelli* emphasized the formal landscape structure of the fields, which contrasted with each other in the black-and-white tonal values because of the colours of the different plants (Fig. 111).

Modern buildings were also used as models for artificially emphasized pictures. *Lennart Olson,* for instance, created a series of bridge photographs, in which he graphically structured each composition by means of artificially enhanced contrast (Fig. 112), with the result that his pictures were very much akin to geometric abstractions.

The graphic effect which could be

113　*Keld Helmer-Petersen*. Rhythm of construction. Circa 1960

114　*Ján Šmok*. Nude. 1966

achieved from outlines of steel construc-
tions were used very successfully by the
Dane, *Keld Helmer-Petersen* (Fig. 113). From
the point of view of abstraction, the subject
did not in this case lose its original identity
to such a degree as Olson's bridge pictures
had done; nevertheless the overall im-
pression of the photograph is provided by
the play of lines and not by the actual
content.

By careful lighting and other technical
devices, a nude model could also be used as
a subject for various compositions, resulting
in either a recognizable outline of the sub-
ject—as in the photograph by *Ján Šmok*
(Fig. 114)—or a complete effacement of
form.

Just as the Surrealists discovered differ-
ent metaphors in surface structure, photo-
graphers also paid great attention to the
outer surfaces of various objects in their
search for abstract compositions. This style
was frequently adopted in the fifties by
Hans Hammarskiöld (Fig. 115). He usually
photographed his subjects at a short
distance, so that he achieved a photo-
graphically perfect result, with a correct
choice of lighting and contrast. Interest
in surface details also made it possible to
produce photographic analogies of calli-
graphic abstracts. *Aaron Siskind* in particu-
lar created masterly photographs of this
type (Fig. 116).

Microphotography is a borderline case

115　*Hans Hammarskiöld*. Peeled-off varnish. 1951

116　*Aaron Siskind*. From the series 'Homage to Franz Klein'. 1972

117 *Peter Keetman*. Luminogram. 1952

of detailed abstract composition. This form of applied photography often shows great aesthetic charm, although its actual content is often comprehensible only to specialists. We must here assume that for the majority of observers there is no direct connection with reality, and this gives rise to an abstract impression. Many microphotographs were taken in colour. *Manfred Kage* ventured so far into this field with his aesthetic experiments that some of his compositions were used as patterns for fabric samples. Painters such as Serge Poliakoff were so enchanted by the regularity of coloured surfaces in many microphotographs that they were inspired to use similar compositions in their own paintings.

A special type of abstract composition

118 *Peter Kocjancic*. Photomontage with Luminogram.

119 *Herbert W. Franke*. Electronic graphics (Oscillogram). Circa 1955

120 *Jaroslav Rajzik*. Geometrical light abstraction. Circa 1970.

was produced simply by the play of light. In this respect, luminograms are particularly worthy of notice. To produce these pictures, the photographer secured a small source of light to a cord and allowed it to hang over the camera. When he opened the shutter in the darkened room, the rays of light from the hanging lamp traced delightful patterns. This process was used in the picture by *Peter Keetman* (Fig. 117).

Peter Kocjančič went one step further by using a luminogram as part of a montage, combining it with an almost abstract silhouette (Fig. 118)[86].

Herbert W. Franke chose an oscilloscope as a source of patterns for his luminograms, taking his photographs from its back-projection screen—a method which he also

121 *Heinz Hajek Halke*. Drops of turpentine on a wet, swollen negative layer, blackened over a burning candle.

122 *Pierre Cordier*. Chimigram 28/5/61 (Detail). 1961

tried to establish theoretically (Fig. 119)[86].

Jaroslav Rajzík used light quite differently as a means of composition, by making light rays shine through various prisms, glass objects and even opaque plates. His severe compositions were thus really pictures of the diffraction patterns of light rays (Fig. 120).

Paul Konrad Hoenich[87] constructed an apparatus resembling a cine projector: the sun's rays were thrown from reflectors on to large projection areas, and coloured glasses were also placed in the path of the rays. If a photograph was taken of this constantly changing 'sun picture', an abstract composition again occurred, resulting from the play of light.

These attempts to achieve abstract forms in photography also led to experiments with treated negatives. The great experimenter *Heinz Hajek-Halke* allowed drops of turpentine to fall on a wet, swollen negative layer, and made it smoky over a burning candle. On enlarging such negatives, he produced fantastic-looking, completely abstract pictures (Fig. 121).

Pierre Cordier's 'Chimigrams' were also produced in part by manual operations. His technique was based on a process in which he put an exposed positive paper into developer. During development he protected some parts from the effect of the bath by covering them with his hands or by other objects[88], and was thus able to control by light the occurrence of bright figures on a dark background (Fig. 122). In the reverse procedure, the same thing took place first in the fixing bath; here, after development, the covered surfaces appeared dark against a light background. Pierre Cordier's experiments were somewhat reminiscent of Moholy-Nagy's photograms, which were produced on printing paper and therefore could also be continuously controlled. Cordier used the 'chimigram' technique with colour photographic materials too, and this substantially increased composition possibilities.

144

In the sixties new modifications in abstraction emerged in painting. Of these, 'Minimal Art' was of particular importance to photography; this occurred as a reaction against the cult of emotion and individual expression in Abstract Expressionism.[89] In their desire to present logically clear relationships and to eliminate every illusion or metaphor, the 'Minimal Artists' developed a means of expression reduced to tersely basic structures in form.[90] Their artistic endeavours were directed towards the visualization of fundamental experiences which determine our perception and our consciousness of space. 'Minimal Art' brought something to the visual arts which until then had been dealt with theoretically only by semantics or philosophy.[91]

'Minimal Art' was expressed in photography by a few American photographers, particularly *Dan Graham*. It was characteristic of his work that typical symbols of the present day, such as stereotyped American houses, were made into abstract forms without any superfluous accessories since they were in rows. This is parallel to the principle of series formation in 'Minimal Art.'

Basically, however, it should be pointed out that photography, because of its very nature, was not capable of fulfilling the conditions for abstract representation. As a result of its medial characteristics, there is a necessary connection between photography and reality. This disturbed many theoreticians, such as Karl Pawek, who accordingly rejected this medium as an art, although they recognized photography as a vital instrument of information.[92]

Directly after the Second World War, when different styles of photographic representation began to emerge, there was a tendency to attribute all the different results to a possible common denominator. *Otto Steinert* made an important contribution in this respect with his attempt to consider the criterion of personal experience as a basic requirement and a starting point for the modern trends in creative photography. This approach may at first seem very generalized, for both an abstract composition and a dynamic live photograph can be attributed to this principle. The importance of Steinert's theory, however, lay in his emphasis on the personal interpretation of reality through the subjective presentation of the image, which presupposed emotional experience to be the source. For this purpose Steinert coined the expression 'Subjective Photography', and under this heading he presented three international photographic exhibitions in Germany—in 1951 and 1954 in Saarbrücken, and in 1954 in Cologne. These exhibitions acquainted post-war Germany with pre-1945 avant-garde trends in photography, and made a beneficial contribution to the cultural renovation of a genre interrupted in Germany in 1933 when the Nazis seized power.

The significance of the 'Subjective Photography' exhibition was underlined by the publication of two volumes of photographs, bearing this title, which illustrated in their selection of pictures the new creative principle.

In a short introduction, Steinert ex-plained his theoretical views on the nature of the photographic process.[93] He believed that the whole procedure was divided into five main stages:

1 Choice of subject and its isolation from nature.
2 Vision in photographic perspective.
3 Vision in the photo optical image.
4 Conversion into photographic tonal values (and photographic colour values).
5 Release from lapse of time through photographic exposure.

In this summary Steinert aptly described the conceptual process of modern photography. It was of particular importance that he saw choice of subject as the first stage in the composition process, for a photographer's own specific way of expression is naturally reflected in his preference for certain subjects. Steinert was also correct in saying that the choice of subject, stylistically speaking, reflected its period. At the same time, he stressed that it was not the subject which caused the picture to be effective; it was the photographer's mastery of composition that transformed the subject into a picture. In this respect the principle of 'Subjective Photography' differs from many pre-war trends, which were based purely on the photographer's enthusiasm for the phenomena of reality and its portrayal without personal interpretation.

According to Steinert, the isolation of the subject from nature consists both of a certain dematerialization and of a release from the three-dimensionality of actual

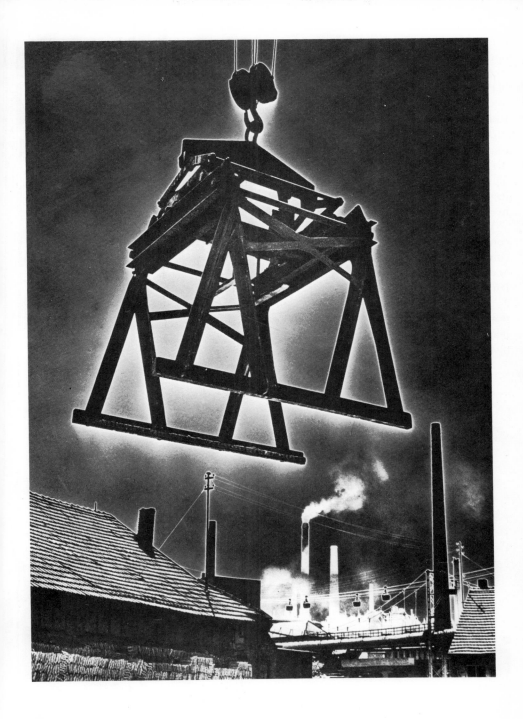

123 *Otto Steinert*. Industry impression (positive solarisation).

existence. This transformation occurs by optical means through the photographic 'reconstruction' of a subject on the surface of the photographic paper, so that the term 'reconstruction' not only refers to the technical process, but also includes the specific effect the picture has because of the photographer's personal horizon of experience, the result being an interpretation of reality. The special emphasis on subjective experience is important in this connection.

Vision in photographic perspective and composition, which does not necessarily coincide with a person's visual memory, on account of the use of interchangeable lenses with different viewing fields, permits a personal interpretation of the composition of a photograph, and this may be heightened by the use of technical equipment. In addition, the further condition,

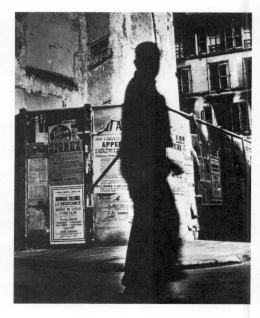

124 *Otto Steinert*. 'Appeal'. 1951

125 *Guido Mangold*. In the hospital.

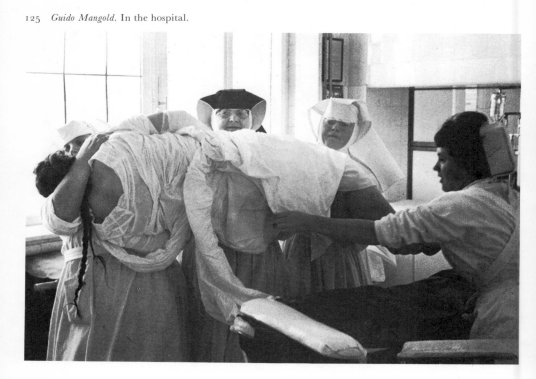

namely the vision of the subject in the photo-optical image, depends on the photographer's imaginative power to record accurately a portion of reality in its essential and basic elements. Hence it is necessary to search for those subject arrangements which are free from intrusive accessories. Individual interpretation is shown in the fulfilment of this condition, as the same subject would certainly be depicted differently by different photographers.

The transformation of the real world of colour into a photograph with photographic tonal values on the black-and-white scale was thought by Steinert to be an important method of abstraction, which could be used as an additional means of composition and therefore to emphasize the subjective interpretation. Finally, according to Steinert's theory, the release of the photographic subject from the course of nature is also an important part of photographic activity. Here Steinert expressed what former generations of photographers only suspected: namely that isolated moments make the subject unique in character.

From this brief summary of Steinert's basic theories it will be clear that the photographer, in addition to his essential command of photographic composition, required the courage to portray his individual experience in order to be creative. Steinert never underestimated the importance of technical expertise either, for he was aware of the fact that only the person who was able to transform his creative imagination into a technical form was capable of transforming his personal experience into a photograph. Steinert worked on all his enlargements himself to produce the end product, so as to be able to make last minute creative changes (Fig. 123). In his photographic work he also used various exposure techniques according to requirements, such as the blur of motion, the combination of a shadow with very detailed

126 *Josef Sudek*. From the series 'Glass Labyrinths'. 1965–70.

images, the representation of surface structure and so on (Fig. 124).

The basic rules of 'Subjective Photography' were generally practicable; they could be achieved by good live shots (Fig. 125) as well as by Surrealist or abstract photographs. This universality is reminiscent of the Bauhaus experiments, since they also investigated all the creative possibilities in this medium.

The principle of 'Subjective Photography' propagated by Steinert had been used previously, though in most cases intuitively, for otherwise Steinert would not have been able to arrange the above-mentioned exhibitions, which were a touchstone for the whole movement. A few photographers whom Steinert did not place in this category also used the principle; for instance, the famous Czechoslovakian mas-

ter of poetic still life, Josef Sudek (Fig. 126). This supplementary consideration is not intended to detract in any way from Steinert's own contribution, for his greatest merit lies in the fact that he described this photographic trend in detail and analyzed it theoretically. Steinert also used his discovery of the principle of 'Subjective Photography' in his teaching. His ability to assess every genuine effort towards personal achievement enabled him to respect the individual characteristics and temperament of each one of his pupils. Steinert's reputation as one of the most important photographic instructors in Europe extended far beyond the borders of Germany – a fact best illustrated by his large number of foreign pupils.

The concept of the 'New Objectivity', developed before the Second World War, was so innovatory for photography that younger photographers were adopting this style after it had passed its peak. A positive 'comeback' in realism can be observed in various forms in the painting of the sixties; and this development also influenced photography. However, photographers were aware that they could no longer get away with a literal portrayal. Hence they sought subjects for their pictures only in those objects to which they could give a magical dimension in their portrayal. They called this concept 'Magical Realism', a term which had already been used almost synonymously with the concept of 'New Objectivity' in painting[94], and which had been readopted by Heinz Neidel in his introduction to *Robert Häusser's* exhibition.[95]

This style also bore some similarity to Surrealism; but the products of 'Magical Realism' differed from those of Surrealism in that the subjects deliberately portrayed

127 *René Gerardy*. Landscape with Second World War air-raid shelters.

128 *Robert Häusser*. From the series 'House Slaughter'. 1963

129 *Kishin Shinoyama*. From the 'House of the Tattooed'. (Polaroid Collection, Cambridge, Massachussetts).

did not lose their original identity in photographs. As a connection between magical poetry and accurate representation, 'Subjective Photography' was certainly also important, and this was in accord with the realistic trend, since the personal experience which generally had to precede the taking of the picture was also obligatory in 'Magical Realism'.

The characteristics of 'Magical Realism' were expressed in many different ways in photography. In the field of landscape photography, the work of *Rene Gerardy* should be mentioned (Fig. 127), in which disused air-raid shelters from the Second World War created a macabre, magical impression, enhanced by the overcast sky. In the sphere of live photography, Robert Hausser's series 'Domestic Slaughtering' fulfils the stylistic criteria of 'Magical Real-

130 *Zvonimir Brkan*. 'Beside Himself'. Circa 1967

131 *Denis Brihat*. Pear. 1972

132 *Boaz Boris Karmel*. 'Portrait Phantastique'.

133 *Pal-Nils Nilsson*. Scissors. 1963

134 *Walter Danz*. Blossom of the passion flower. 1965

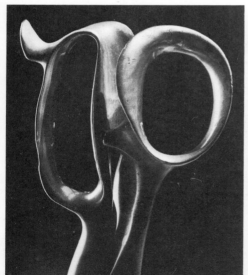

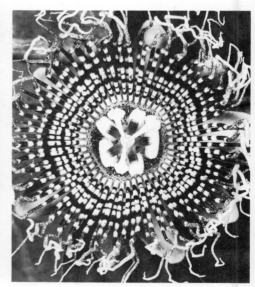

ism' (Fig. 128). The same applies to *Kishin Shinoyama's* photograph of the tattooed Japanese couple (Fig. 129).

Apart from accuracy of representation, a certain similarity to the 'New Objectivity' also lay in the fact that a single object was often chosen as a theme. All attention was then directed photographically to the chosen subject. A diving suit which was photographed from below, hanging on a drying rack, seems almost uncanny in the picture by *Zvonimir Brkan* (Fig. 130). In contrast to an object—in this case the diving suit—which had no special peculiarities in itself, *Denis Brihat* selected a fairly extraordinary pear as his subject; in this he found certain similarities to the human body, and thus a magical interpretation (Fig. 131). Very often in 'Magical Realism' the photographers concentrated on certain details of the subjects. *Boaz Boris Karmel*

shaped his pair of trousers in such a way that they almost resemble a portrait (Fig. 132). *Pål-Nils Nilsson* photographed a detail from a pair of scissors so skilfully under special lighting that the result almost approaches a modern sculpture (Fig. 133). Thanks to close-up technique, *Walter Danz* was able to take an unusually detailed photograph of the blossom of a passion flower (Fig. 134), so that this rare glimpse into the bloom's anatomy was an almost magical interpretation.

Another form of 'Magical Realism' is shown in the picture by *Diane Arbus*, who has concentrated on the abnormal, pathetic and lonely beings of America's subculture after the sixties. *Heinrich Riebesehl* worked along the same lines, and became famous for his series of photographs entitled 'People in a Lift'. His pictures show persons as being magically isolated and alienated

135 *Raymond Moore.* Wales. 1977

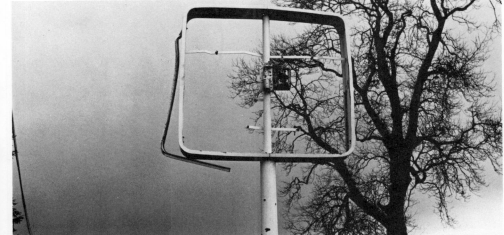

from their environment.

Raymond Moore found his themes in the everyday environment of his time, and his photographs showed some of the typical qualities of 'Magical Realism'. Thus his picture of the highway indicated the atmosphere of the reverse side of human civilization, as seen by the melancholy vision of the sensitive photographer (Fig. 135). The enigmatic shape of the broken traffic sign in the foreground was the 'Magic Realism' element.

It can basically be said that it is in their love of detail that photographers working in the style of 'Magical Realism' often border on Surrealism, in which the concrete identification of objects as such is not the central theme of the photograph.

After the Second World War, the general change in social structures brought about the widespread democratization of fashion; the 'up-to-date look' was no longer confined to the higher echelons of society. The new opportunities to follow the fashion, offered to large sectors of the population, created ideal conditions for a growth in fashion journals. Most of the photographers whose work appeared in these magazines followed the glamour concept. The great demand meant that new photographic solutions had to be found. A starting-point in the early post-war years was the classic concept, whereby the photographers emphasized fine facial features and the beauty of the body: this was mastered in particular by *Irving Penn*, who worked mainly for magazines published by Condé Nast (Fig. 136).

As living standards improved, several new fashion magazines appeared simultaneously in a number of countries. By using imaginative pictorial material, the individual editors competed with one another to make their publications as attractive as possible. This created very favourable conditions for a number of gifted photographers, who were able to devote a large part of their work to this theme. Among the most well-known were *Richard Avedon, David Bailey* (Fig. 137), *Stephen D. Colhoun, Frank Horvat, Horst P. Horst* (pupil of the fashion photographer of the thirties *Hoyningen-Huene*, already mentioned), *Karol Kallay, Taras Kuščynskyj, Charlotte March, John Wiley Rawlings, Regina Relang* (Fig. 138), *Franco Rubartelli* and *Oliviero Toscani*.

A woman's beauty, emphasized by the glamour concept, was used by photographers in addition for various publicity purposes. However, for this the photographer's creative imagination was just as essential as an attractive model.

In order to take increasingly original pictures for the fashion magazines, for advertising agencies and later for the home decor journals, fashion and publicity, photographers had to make greater use of original settings. This type of photograph was conceived more and more in a dynamic way; this was expressed by *L. Fritz Gruber* in another context: 'It was more appropriate that photography should record the single, irretrievable moment than that it should try to create something permanent and final that did not exist. A face glimpsed in passing, and a figure so blurred that it seems to be disintegrating, seem closer to real life; we are limited to the shorthand of longing for beauty.'[96]

In order that the highest technical quality should be guaranteed, which was especially difficult in colour photography, equipment in the photographic studio almost reached the level of that in the smaller film studio. Later, transportable lighting systems were also developed which could be taken to the selected location. Such pieces of equipment were naturally very expensive, and could therefore be afforded only by those photographers who, because of their success, were able to work

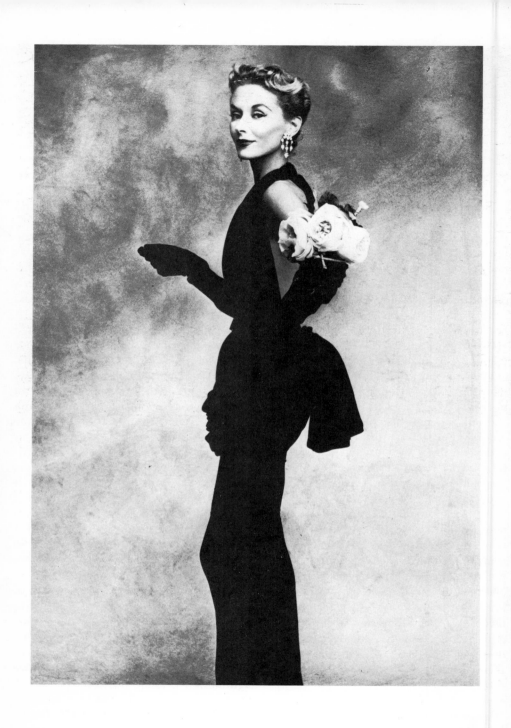

136 *Irving Penn*. Lady in a black dress. 1950 (Copyright Les Editions Condé Nast)

137 *David Bailey*. Fashion photograph for *Vogue*. 1974 (Copyright Conde Nast Publications Ltd.)

exclusively for clients who could pay high fees. This reciprocal relationship naturally demanded that photographers should become increasingly more specialized.

Despite the advantages of modern apparatus, some well-known photographers liked occasionally to take their fashion photographs outside the studio, in a natural environment. This could be said, for instance, of *Norman Parkinson*, who presented his models as real, living persons (Fig. 139). He achieved a sympathetic freshness in his pictures.

Parkinson frequently contributed to the British magazine *Vogue*, which in the period after 1945 became one of the most important fashion journals in Europe. A factor contributing to its high quality was its careful choice of photographers, including *Clive Arrowsmith*, *Terence Donovan*, *Hans Feurer*, *Barry Lategan* and *Helmut Newton* (Fig. 140). The art directors of *Vogue* certainly took on a considerable responsibility, as the quality of the photographs was as important as the fashion information contained in them.

While these developments, affecting only a relatively small circle of photographers, were taking place, the new profession of photographic model came into being. The models not only possessed the desired figure and photogenic appearance, but were also well trained in posing in the manner required by the photographer. In the course

138 *Regina Relang.* 'Cape story in torero style'. 1976

of time, the specialized directed work in the studio developed to such an extent that the famous photographer *Philippe Halsman* subdivided it into two different and opposite processes.[97] The first process was 'taking photographs': the assessment of reality and speedy appreciation of the subject emerging from it. On the other hand, 'making photographs' was based on the photographer's considered concept, according to which the scene could be prepared. The second method could naturally be used for exterior photographs, but the most favourable conditions for its

139 *Norman Parkinson*. Fashion photograph. (Copyright British *Vogue*, Condé Nast Publications Ltd.)

execution were in the photographic studio.

The popularity of fashion photographs of beautiful women was generally so great that unknown photographic models also had a good chance of being portrayed in glamour pictures. Some photographers, such as *Rolf Winquist*, did not want to repeat results already achieved, and searched for new angles on this type of photograph. He produced very interesting results, with glamour informally combined with simplicity (Fig. 141). The glamour style was also very important in connection with nude photography. In the fifties, the

140 *Helmut Newton*. Fashion photograph. (Copyright British *Vogue*, Condé Nast Publications Ltd.)

141 *Rolf Winquist*. Portrait of a girl.

142 *József Nemeth*. Nude with lily of the valley. 1956

146　*Robert Häusser*. Nescafé. 1956

gaudiness and primitiveness of the packaging aesthetically acceptable.

Pop Art romanticized the entire urbane product world which could be optically perceived—and not just the advertising industry with its packaging, posters and hoardings. Comic strips were especially important in this connection, as they visually entertained vast sectors of the population of America and Western Europe. David Antin's analysis,[100] which showed great confidence in the nature of Pop Art, demonstrated that interesting effects could be achieved by greatly magnifying a comic subject. Equally typical of the Pop Art format was the repetition principle in the form of a multiple picture: Pop Artists such as *Andy Warhol* often used the same photograph over and over again—

in his case a film star or mass media information. Multiple images pictured in a line intensified the fetish effect of the portrait to such a degree that the banality of the reproduction caused a levelling of the star cult in the composition of the painting.

The photograph was not only an important aid to Pop Art: many creative photographs should even be regarded as forerunners of Pop Art. *Herbert Loebel*[101] and *Andreas Feininger*[102], in their photographs of American main streets, which they took from a long distance with extreme telephoto lenses, condensed various billboards and street signs into new compositions which, as it were, ushered in the arrival of Pop Art. The style of *Robert Häusser* in 1951 was also Neo-Dadaist; the disfigurement of towns by stereotyped posters was illustrated by

147 *Floris M. Neusüss*. Wig display. 1973

148 *Les Krims*. Mickey Mouse nude. 1968

149 *R. F. Heineken*. Four costumes. 1968

150 *Reinhard Schubert*. Hausbier.

his photograph of a series of identical advertisements following on, one after another (Fig. 146). In works of this kind, an artistic spirit of the age was unconsciously reflected which was to develop further a few years later.

In the above-mentioned works of Loebel, Feininger and Häusser, there was a suggestion of a further development of the 'Objet Trouvé' principle. The world turned out to be full of compositions which had occurred by chance, and these could be interpreted as a parody on the flow of consumer goods. Photographers had merely to redirect their attention to the shop windows. However, in contrast to the Surrealists, who expressed dreamlike visions with these objects, the photographers inspired by Pop Art recorded more grotesque compositions which occurred by chance as a result of garish packaging. The best opportunities of finding such subjects were offered by heavily industrialized countries with their numer-

167

151 *Betty Hahn*. Street with rainbow (Gumprint on canvas with embroidery). 1971

152 *Floris M. Neusüss*. Three nudograms. 1972

153 *Ralph Gibson*. 'Déjà Vu'. 1973 (Wilde Gallery, Cologne)

ous streets of shops and boutiques. In America photographers such as *Lee Friedlander* accordingly set out exploring, while in Europe *Floris M. Neusüss* (Fig. 147) and actor photographer *Heinz Schubert* were among those who were similarly inspired by themes offered by the shop window.

Les Krims transferred the Pop Art principle of parody to nude photography; for him the photographing of a pin-up girl had been for some time a stereotype of an erotic fetish. Thus he placed a naked girl—wearing a Mickey Mouse head—posing fairly naturally against a wall, on which the children's comic-strip figure was repeated many times (Fig. 148). The subject choice and the use of the principle of repetition were logically in keeping with Pop Art.

Photomontage was also used for Pop Art purposes. *R. F. Heineken* constructed four female figures from pictures of various fetish-like objects, such as car accessories, and then topped each one with a portrait (Fig. 149). Many photomontages combined photographic technique with various graphic processes, as in the collage series 'Cosmetic Studies' by *Richard Hamilton*. Photographers like *Reinhard Schubert* (Fig. 150), who were both photographers and graphic artists, were best qualified to compose such works. *Betty Hahn* was also doubtless influenced by Pop Art. This American photographer enlarged her pictures on photographic screens and then finished her work with embroidery. In the composition 'Street with Rainbow' (Fig. 151), for example, the rainbow, the lines on the road and the roof are embroidered with coloured threads.

Ralph Gibson's photographic works are made up of a synthesis of Pop Art and Surrealist elements, and each photograph appeared as an individual work. Pieces of reality are combined into surprising situations, and this makes the photographic subjects mysterious despite their banality (Fig. 152).

The 'nudogram' photography of Floris N. Neusüss bears some resemblance to Yves Klein's Neo-Dadaist erotic action photographs, in which naked girls, painted blue, pressed the colour of their bodies on to the screen according to his instructions. They were actually photograms, which Neusüss created by placing his model in front of a roll of photographic paper, in a room faintly illuminated by a darkroom lamp. He then shone the light of a powerful torch on to the sensitive layer in the background, thus deliberately throwing the shadows cast by the model in different directions (Fig. 153). In this way Neusüss created a series of nudograms which were notable for their bizarre shapes.

The growth of Pop Art had an even more important consequence for photography: the interpretation of reality was once again regarded as an art form, and this in turn led to the artistic appreciation of a good photograph, and to the more widespread recognition of photography as an artistic medium.[103]

Op Art is actually a special variant of abstract geometric painting, and is based on special patterned compositions, synthesized by the observer's eye which, because of the inertia of the retina, gives the impression of rhythmic movement in the colour or structure. This trend had its roots in the Bauhaus, but it was not established experimentally until after the Second World War by Victor Vasarely, Jesus Raphael Soto and Bridget Riley. In 1964 it became known as Op Art, after a journalist with *Time* magazine used the term.[104]

When this artistic movement became widely known, similar tendencies began to appear in photography. There were three completely different methods of achieving this effect, according to the intellectual attitude and the technique applied. The first Op Art method was again by means of the 'Objet Trouvé', but this seldom proved successful. *Herbert Rittlinger* achieved one of the few satisfactory results when he discovered an object with an Op Art structure on an old roof.[105] The favourite method of achieving an Op Art style was by means of a sandwich montage which made use of a screen. With great inventive genius, *Zdenek Virt*, who as a graphic artist could himself produce various patterns, used this method in a series of nude photographs (Fig. 154). He produced so many that they filled an entire book. For those photographers who were not capable of graphically producing a pattern themselves, some manufacturers supplied negatives or transparencies of different screens. Apart from the above-mentioned sandwich montage (in which two negatives were laid one upon the other and developed together), the half-tone images could also be projected directly on to the body of a model or on to other subjects.

During the last few years, technical experiments have produced new results in Op Art photography. For instance, *Gottfried Jäger* worked on a variant of the

154 *Zdenek Virt.* Op Art nude. Circa 1965

principle of a multi-optical system which had in fact been discovered in 1854 by Disdéri for making successive portraits from different angles; for this Jäger used a multiple pinhole camera. Instead of producing individual photographs, Jäger used the multiple pinhole camera—specially designed by himself—for the simultaneous photographing of the pattern made by spots of light. The composition produced as a result of superimposing separate images of this luminous object was very similar to the artistic works of the Op Artists (Fig. 155). Its technical arrangement is rather similar, because the principle of the pinhole camera, actually the original 'camera obscura', is used. In this way it is fairly simple to produce plates with different arrangements of pinholes. Numerous variants of these photographs can be produced by changing the number, shape and size of the pinholes, the subject distance, the angular field and the exposure time, as well

155 *Gottfried Jäger*. Diaphragm structure 3.8.14.1.6.4. 1967

as by the choice of photographic material.[107] In colour photographs, the filter colour of the pinholes also plays a decisive role.

At about the same time as the rehabilitation of concrete reality as an art subject in 'New Realism' and in Pop Art, similar tendencies were appearing in the action art of the 'Happening'. This concept was used for the first time by Allan Kaprow in 1959 for an artistic event in the Reuben Gallery, New York. The 'Happening' was a collage improvised by the artist out of events which had no continuous theme, the intention being less to convey an idea than to intensify visual and tactile appeal by creative actions in which artist and spectators participated together. The once-only character of the 'Happening', and also its time limits, meant that the only lasting evidence of this event for people not taking part was in photographs or films. Thus, because of its capacity for documentation, photography took on an important role, and was hence also highly valued by most producers of 'Happenings'. This development continued steadily through the sixties, and photography rose to an important position in pictorial art.

In 'Land Art' and in so-called 'Conceptual Art', photography gained functions as supportive as in 'Body Art', in 'Process Demonstration' and in 'Trace Keeping'; to some extent, the realization of these artistic activities took place exclusively through photography. So 'Land Art' actions such as Robert Smithson's earthworks in a lake, and Mike Heizer's desert graves, exist today mainly only because of their photographic documentation, since they are subject to natural alteration by the weather.

To illustrate the function of photography within 'Conceptual Art,' Joseph Kosuth's 'One and Three Chairs' may serve as an example. The work consists of a single chair, with a photographic reproduction of the same chair alongside it and a lexical definition of the word 'chair' photographed and enlarged from Webster's Dictionary. The juxtaposition of reality, depicted reality and its description exemplifies the theoretical systematization and exactitude typical of 'Conceptual Art;' this also poses a problem for art itself, since the viewing principle as the essential function of art is being questioned.[109] Instead of a pictorial view, and in addition to sketches and written outlines, 'Conceptual Art' thus provides the observer with photographs to convey ideas and to offer thoughts and schemes. In this, certain parallels to Ducamp's 'Ready-Mades' become evident, as the creative action transfers itself into thought concepts.

With complicated arrangements of photomontage, photography permits a very precise communication of a design, impossible to achieve in a comparable way with just a textual description. The Dutchman *Jan Dibbets* systematized the passage of time by visual information in this way, and created in graphic photosequences a remarkably simple process, reducing to a scheme the concept of time and its passing. *Hans Haacke* uses photography as part of

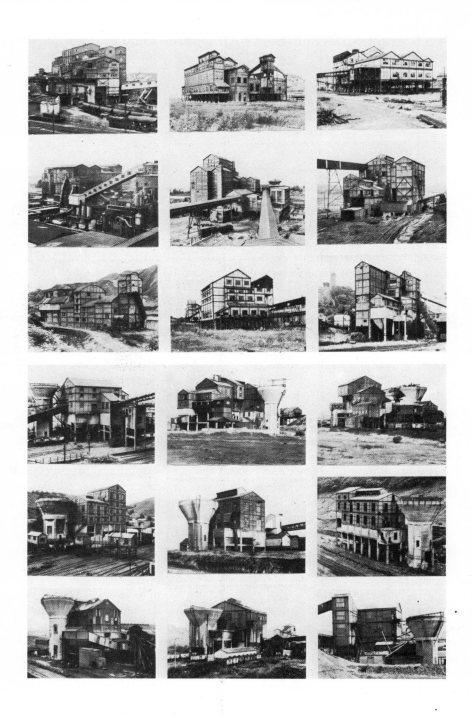

156 *Bernd and Hilla Becher*. Processing plants. 1966–75

157 *Klaus Rinke.* Bend in Rhine near Düsseldorf (montage of 18 different shots, each displaced 15 m). 1975

his systems of 'Real Time', in which he visualizes sociological complexes of 'Real Time' in their casual relationships, as well as biological growth processes and physical changes.

Bernd and *Hilla Becher*, who have transferred completely to photography in their artistic work, used a series of photographs to systematically reproduce certain types of building, such as timber-framed houses and water-towers of the 19th and 20th centuries (Fig. 156).

In the realm of 'Body Art' too, photography, together with film and video, has manifold functions assigned to it. While *Bruce Nauman* and *Vito Acconci* used photography as an instrument for recording their

manipulative activity with their body surfaces, *Arnulf Rainer* utilized photography of his face or body as base to be painted over or similarly altered. Forerunners of 'Body Art' were the erotic 'Happenings' of Yves Klein, and also the body actions of such Viennese artists as Hermann Nitsch and Rudolf Schwarzkogler. In the process demonstrations of *Klaus Rinke*, photography became a means of defining the relationship between space and time,[110] which the artist systematized in his so-called 'Primary Demonstrations', together with strictly organized photographic sequences: 'These recorded gestures and positions resulting from movements of body, head, arm, elbow, hand and

175

158a *Penny Moore*. The window and the mirror. 1976

158b (Student's work from Royal College of Art, London).

finger, are qualified exactly and literally; one scarcely notices that they also exert a distinct aesthetic charm in their ornamental interaction, but this results from their distinct function and a natural initial experience.'[111] (Fig. 157.)

Penny Moore produced a modest sequence consisting of only two images, attempting to demonstrate the space in the vicinity of a window (Fig. 158). In addition to the window itself, another object of major significance was a mirror, whose function was to be recognized only on one picture; this was quite deliberate. Both photographs forming this sequence were carefully composed with regard to lighting, which helped to make clear the nature of the space on both sides of the window.

In *Christian Boltanski's* 'Trace Keeping', photography becomes a subjective medium for a kind of story-telling, in which single photographs are assembled in a biographical picture sequence without named identification of the person recorded (Fig. 159). The important thing is rather to keep the individual traces which a person leaves behind him in his life, and prevent anonymity. Some artists use Polaroid Instant cameras to produce for themselves the photographs necessary for their realizations; others prefer to have the prints made by a photographic acquaintance according to their instructions. However, the link between avant-garde art and photography does not reveal itself merely in the medial use of the photograph as a carrier of information in the work of art; many avant-garde photographs were influenced by the stylistic characteristics of avant-garde art. Trends of this kind are expressed chiefly in

159 *Christian Boltanski*. From the photo album of the D. Family. 1971

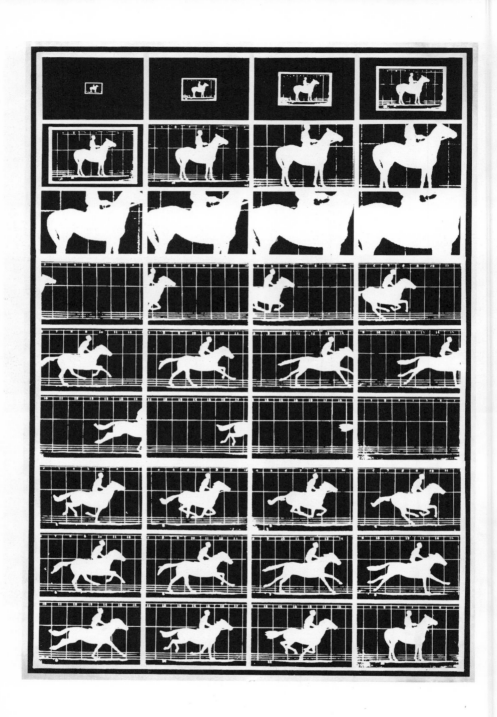

160 *Pierre Cordier*. Hommage à Muybridge. 1972 (Culture Section SICOF '73, Milan)

161 *Floris M. Neusüss*. Photo-Syntax (Photo-Sequence).

sequences formulated in a variety of ways. The principle of a photographic sequence was already known in the last century, and was used particularly by *Eadweard Muybridge* to investigate single phases of movement. This process has been enjoying renewed popularity in recent years, as for example in 'Hommage à Muybridge' by *Pierre Cordier* (Fig. 160).

Like process artist Klaus Rinke, the photographer *Duane Michals* also used his own person as his starting point when he wrote in the foreword to *Chance Meeting*: 'I don't walk through the streets with my camera in search of life. I'm not a reporter.

I'm not an observer. I am life. It is me. The pictures that I see in my thoughts are for me more valuable and real than any event which I may chance upon in the street. I am my own boundary. Every occurrence in my consciousness is material for my photographs.' In accordance with this self-understanding, Duane Michals has since 1969 been composing charming sequences of simple actions, whose individual stages fixed in each photograph have been thought out in detail (Fig. 162).

Bernard Plossu too created numerous variations of simple events which he recorded precisely in sequences. He intended

162 *Duane Michals.* Paradise regained (Photo-Sequence). 1968

163 *Ray K. Metzker.* Nude sequence (Photo-Sequence)

fluenced in his sequences by Pop Art, when for instance he recorded one and the same figure in various sizes (Fig. 161). *Ray K. Metzker* for his part concentrates on very graphically structured sequences, for which he uses a nude model (Fig. 163).

Ger Dekkers assembles photographic sequences of Dutch landscapes, in which only the spaces between camera positions change from picture to picture, with the horizon linking all the photographs remaining the same. Thus the natural landscape in the photosequence resembles an artificially constructed landscape (Fig. 164).

The principle of the 'Objet Trouvé', the various modifications of which could be traced in the evolution of photography since the time of Eugène Atget[116], found a qualitatively new application in the newest influences coming from the fine arts. *Mark Edwards* and *Chris Steele-Perkins* once noticed that at the ends of miniature films, which had been carelessly exposed after the insertion of fresh material into the camera, images were sometimes visible, the prints of which could be quite interesting. They accordingly searched through about 5,000 film ends, and chose 40 or so for an exhibition which they symbolically called 'Serendipity'. The creative action was not in the exposing of the film ends, but in noticing what 'Objets Trouvés' could be discovered in this way (Fig. 165). The complex collection of photographic prints enlarged from the film ends qualified as work done in the spirit of 'Conceptual Art'[117]. They acted in keeping with this by signing each print with both their names, since naturally they did not wish to distinguish whose were the prints and whose were the film ends.

by this to test the limits of the sequence, and assembled his experiences with the photography of banal situations in the book *Surbanalism*[113]. *Floris M. Neusüss* was in-

164　*Ger Dekkers*. Planned landscapes: 25 horizons
　　(Extracts from 25 sequences, each consisting of seven colour photos). 1974–77

165　*Mark Edwards and Chris Steele-Perkins*. From the series 'Serendipity'.

In this book it has been suggested several times that lack of technical equipment can limit a photographer's work. The growing popularity of photography owed much to the development of special camera accessories, which until a few years ago were manufactured more or less singly, solely for scientific purposes. Today it is no longer unusual to see a fish-eye lens with an angular field of more than 180°, or even an extreme telephoto lens with a focal length of more than 1000mm. The mass production of such equipment was encouraged by the many amateurs who treated themselves to this kind of apparatus mainly because of their enthusiasm for technical refinements. Professional photographers, for their part, were soon using these small 'technical miracles' for creative experiments.

The fish-eye lens made it possible to come surprisingly close to the subject, with the result that this extraordinarily short

166 *Thomas Cugini*. Taxi driver. Circa 1968

167 *Bohumil Novotný*. Ski-Icarus. Circa 1970

distance created quite new, greatly exaggerated perspectives. The resulting distortion could produce magical effects, as is illustrated in the photograph by *Thomas Cugini* (Fig. 166). The Czechoslovakian reporter *Bohumil Novotny*, proved by the example shown here (Fig. 167) that the fish-eye lens can also be responsible for dynamic shots. On the other hand, the extreme telephoto lens permits a photograph to be taken at a great distance from the subject, producing a flattened perspective in the limited field of sharp focus. *Andreas Feininger* used these artistic effects particularly well in his pictures of New York.

Many photographers are of the opinion that very attractive results can be produced not only by the new cameras but also by a few of the older models, now almost forgotten. *Josef Sudek* acquired an old Kodak Panorama camera, dating from the turn of the century. The non-typical format, produced by a horizontal panning of the camera across the subject during exposure, offered quite fresh possibilities (Fig. 168). Soon after Sudek's work, there occurred a renaissance of panorama cameras, new models of which are now manufactured for miniature film by both Japanese and Russian firms.

In the fifties, the American photographer *Weegee* designed a sort of kaleidoscope for his camera—the 'Weegeescope'—and was able to produce with this instrument a composition of various multiple reflections. It may have been his photographs which encouraged some accessory manufacturers to produce multiplying attachments. Today there are even accessories which can repeat the subject from three to six times. An example of this is to be seen in the picture by *Vaclav Jiru* (Fig. 169).

Many experiments have been made with

168 *Josef Sudek*. Panorama picture.

169 *Vaclav Jiru:* Duplicated tower. Circa 1973

170 *Karol Kallay*. Fashion picture with reflection.

171 *Gjon Mili*. Juggler.

hand, *Wojciech Plewiński* composed an epic montage from a photograph of a daydreaming youth and one of an aesthetically very beautiful nude (Fig. 186).

In photographic montages, however, nude pictures could also be used purely for purposes of form. *Jan Šplíchal* employed two negatives to portray different arm positions of his model, and emphasized the whole arrangement by using a screen during enlargement (Fig. 187). *Zdenek Virt* produced a sandwich montage from a nude photograph of a couple and a photograph of an oil slick on water, and this modified the somewhat erotic effect of the nudes (Fig. 188).

Karin Szekessy's group nude study of four girls gives an impression of feminine softness and relaxation in its restful aesthetic purity (Fig. 189). Basically it can be said that nude photography reflects the changing tastes of the time. Whereas at one time the well-proportioned glamour girl was in demand, today girls with boyish figures are required because of the trend towards unisex and jeans; and this effect can be emphasized by skilful posing, as is shown in the picture by *Josef Hnik* (Fig. 190).

In the section of glamour photography, some stylistic trends in portrait photography were also mentioned. These, however, concentrated less on the individuality of the subject than on a stylized pose, in which one took pleasure and which gave pleasure to others. Many serious photographers were opposed to this interpretation, and sought a creative counter-approach in psychological portraiture. With these aims in mind, the contemporary ideal of beauty was quite unimportant, since the photographic task was the representation of the psychic background of the physiognomy. For this kind of portrait, it was essential for the photographer to know a great deal about his subject, for only an understanding of what gave the face its characteristics could result in a psychological portrait study. Because of the great differences in people's personalities, a new solution had to be found for this task in almost every case. The most famous examples of successful portraits resulted from the photographer either knowing his subject well or making a profound study of his subject's intellect and personality. The photographer's positive attitude towards his model's occupation was equally important; and besides being a good psychologist and an excellent judge of human nature, he also had to possess considerable inventive talent in order to successfully translate his ideas into the metaphorical language of photography. These high requirements in portrait photography could well be the reason why relatively few photographers

devoted themselves systematically to this work.

Gisèle Freund's photographs are good examples; she portrayed the genius inherent in the people she photographed, among whom were politicians and philosophers such as Charles de Gaulle, André Malraux (Fig. 191), Walter Benjamin and Jean-Paul Sartre, and also famous artistic personalities, including writers like Samuel

191 *Gisèle Freund.* André Malraux. Circa 1940

192 *Philippe Halsman*. Portrait of Albert Einstein. 1948

193 *Richard Avedon*. Jacob Israel Avedon. 1973

Beckett and Eugene Ionesco, and painters like Richard Lindner.

It became evident that the part played by the eye is a very important element in psychological portraiture, as it reveals something of the inner nature of a person. This presupposes, however, the photographer's ability to establish a relationship between himself and the subject, so that the latter feels at ease and acts naturally. In this respect *Philippe Halsman* has achieved very remarkable results, as illustrated in his striking portrait of Albert Einstein, depending entirely on 'eye language' (Fig. 192). This unforgettable picture reveals the intellect of a genius who had to witness his scientific discoveries being misused by society.

Quite a different psychological effect emerges from the portrait by the well-known photographer *Richard Avedon* of his sick father (Fig. 193). Here we see an old,

194 *Richard Avedon.* The actor Oscar Levant. 1972

broken man, whose eyes reflect his entire life story. In this dispassionate study, Avedon achieves a very intense portrayal of the personality of his father, whom he loved and whose innermost feelings he knew. In his psychological portraits, Richard Avedon devoted a great deal of attention to his subject's facial expression, as can be seen in his photograph of the actor/pianist Oscar Levant (Fig. 194).

The majority of those photographers who concerned themselves with psychological portraits specialized like Gisèle Freund in prominent personalities, as they were able to find out details of their characters in advance, and thus could even work out an idea for an interpretative study. This applied, for instance, in the case of the portrait by *Chargesheimer* 'of the famous circus clown Grock (Fig. 195), and also to photographs by *Yousuf Karsh,* who portrayed an extraordinary number of famous

195 *Chargesheimer*. Grock, Dr. Adrian Wettach (1880–1959), the famous circus clown.

196 *Yousuf Karsh*. Portrait of Marshall McLuhan.
(Polaroid Collection, Cambridge, Massachus-
setts).

197 *Liselotte Strelow*. Count Wolff-Metternich in
front of his castle (Vinselbeck in Westphalia).
1957

people throughout the world. His portrait of the famous modern mass-media theoretician, Marshall McLuhan, shows that Karsh wished to bring out the social significance of this scholar (Fig. 196).

A considerable part of Bill Brandt's important work took the form of psychological portraits. As a result of his esteem for truth in photography, Brandt preferred to take his portraits in the home environments of those involved. For instance, his wonderful photograph of Graham Greene was taken in the writer's own flat in St James's Street. Another important feature of Bill Brandt's portraits was that in each case he bore in mind what he felt was characteristic of his chosen subject. Thus when photographing Edith and Osbert Sitwell, he depicted practically their whole figures; whereas in the case of Jean Arp he showed only one of the artist's eyes—a

correct use in portraiture of the principle of *pars pro toto*. Bill Brandt did not even hesitate to use a certain kind of journalistic portrait (see Chapter 16) if the person's character called for a slightly more dynamic portrayal.

In general, portraits of artists were a suitable field for the application of the psychological approach. Jorge Lewinski was attracted particularly by painters and sculptors, since he realized that the results of their creative activity could be photographed as well. Hence he produced interesting photographs in which the artists were shown confronted by their works.

A highly individualistic style in psychological portraiture was chosen by *Diane Arbus*. She took her photographs in as simple a manner as possible—often with a flash unit—and did not try to conceal the fact. For her, the subject was more import-

207

198 *Gracia Garcia Rodero*. Portrait of a girl.

ant than advanced photographic technique, which might overwhelm the person being photographed.

As psychological portrait photography developed, there was an increasing tendency to photograph the subject in a typical environment. This gave rise to a large number of possibilities of stylization, which each photographer used in the way best suited to him. *Liselotte Strelow's* portrait of Count Metternich (Fig. 197) with the silhouette of his castle in the background demonstrates her great skill.

The use of a characteristic background brings us to a further basic concept in modern photography, namely symbolic portraiture. In contrast to the psychological portrait, the complete effect here does not depend on facial expression; instead, particular symbols play a vital role in the message. Often the face itself takes up only a small amount of space in the photograph, in order to make room for the symbolic elements.

Psychological portrait photography is also emphasized very effectively by the addition of symbols. Thus the romantic predilection for melancholy is evident in the portrait of a woman by the young Spanish photographer *Gracia Garcia Rodero* (Fig. 198), who enhances the special effect of this sombre atmosphere by the deliberately dark lighting of meadow and sky, and by the strange building in the background. Many 'symbolic' photographs are based on a complicated scene in which the person almost disappears. An example of this is the almost Surrealist study of Francis Bacon, taken by *Antonio Galvez* (Fig. 199).

In his portrait of René Magritte, the

199 *Antonio Galvez*. Study of Francis Bacon.

200 *Duane Michals*. René Magritte. 1965

American photographer Duane Michals has combined an easel with the sitting form of the artist—probably by means of double exposure—and thus indicates on the one hand the painter's artistic activity and on the other the enigmatic magic of his style (Fig. 200). Naturally montage can also be used in such a way that symbols may be incorporated in a portrait, as is shown in the study by Antonio Galvez of Luis Buñuel (Fig. 201). *Jerry Uelsmann* created a double portrait montage of his two photographer friends 'Aaron and Nathan' by using the negative of one photograph and the positive of another (Fig. 202); in this way he symbolized their close affinity to photography.

Just as in the period between the two World Wars the unforgettable portraits taken by August Sander were incorporated in a pictorial volume, the new contributions based on the psychological approach found their place in a few important books. Probably one of the first was *Faces of Destiny* by Yousuf Karsh, published in New York and London in 1946. Although the book was a conspicuous success and was relatively soon sold out, Karsh did not give his consent for a reprint, since he felt that the printed photographs represented only a fifty per cent facsimile of the originals. However, the wide interest in his work encouraged him to start preparations for another volume. He wanted to add some 'significant faces', and thus in 1949 he went abroad to photograph some outstanding personalities. Thus the book project became the driving force for the creation of some very important portraits. However, it was not until ten years later that suitable conditions materialized for publication of this second work, when his famous *Portraits of*

Greatness reached the public. Karsh selected for this purpose 96 photographs which he regarded as depicting not only outstanding personalities, but also subjects with distinct human qualities. The book was welcomed by its readers as both an outline of some of Karsh's creative work and an evaluation of the significance of the persons portrayed. In his autobiography Karsh recalled that on one occasion he was offered, with every appearance of sincerity, five thousand dollars if he would include a certain portrait among those in *Portraits of Greatness*.[118] This incident may serve as an illustration of the importance of the book.

Now that the attraction of portraits of significant people had been discovered, this was further confirmed not long afterwards by the book called *Fame*, compiled by L. Fritz Gruber[119], director of the cultural section of the Photokina exhibition in Cologne. Although in this case a selection was made from contributions by various authors, past and present, the publication of the book indicated a wide interest in photographs in which the depicted face said something about the person's nature.

Interest in photographic publications grew constantly, and a number of typical books included portraits of famous people. In the seventies, among volumes consisting of photographs by a sole author, we should mention Halsman's *Sight and Insight*[120], which revealed a great wealth of inventive ideas. Halsman made a feature of his famous portraits created in the studio, where he was able to devise complicated arrangements (see page 120) and at the same time achieve results of the highest technical quality.

On the other hand, Arnold Newman, another great portraitist, who also lived in America, stated[121] that for his important photographs he used the studio as little as possible, as he felt it to be something like a sterile world. When preparing his book *One Mind's Eye*[122], he preferred to choose

201 *Antonio Galvez*. Study of Luis Buñuel.

natural environments for his psychological portraits of well-known personalities. In an interview with Danziger and Conrad[121], Newman said that he was especially interested in people who do things, and that the hardest working people he knew were creative people like artists, musicians and writers.

These books by Karsh, Halsman and Newman had in common the fact that they comprised master-portraits of celebrities, and in each case the author had been compelled to give due consideration to the individuality of the personalities involved. However, August Sander's earlier concept (see page 49) whereby portraits were used as anonymous representatives of various professions and social classes, experienced also a certain renaissance in modern book production during the seventies. Great

public interest was displayed in the issue in 1971 of a new and unusually large selection of Sander's best portraits under the title *Menschen ohne Maske*[123], followed soon afterwards by the English version entitled *August Sander—Photographer Extraordinary*[124].

Other publications also appeared which to some extent built on the same tradition. Especially noteworthy was the book presenting the theme through the work of Diane Arbus[125]. As in the case of Sander, her psychological and perhaps also sociological approach was expressed principally in her selective choice of portraits. Her main interest was in the more unusual characters in human society: thus her book included realistic pictures of giants, dwarfs, nudists etc.

Diane Arbus was originally a fashion photographer, but she changed her style, and instead of glamour photography she began to take pictures of people as realistically as possible.

The necessity to balance the idealization of the human face and figure with a strictly realistic approach to the portrait could also be observed in some books by authors who did not completely abandon their collaboration with fashion journals and publicity agents. Thus for instance Irving Penn (see page 152) showed in his publication *Worlds in a Small Room*[126] some representatives of well-known professions, as well as other interesting types of people from various countries. Penn, like Sander, let his carefully selected subjects pose full-face. But Penn did not use the natural environment, since he preferred simple and quiet backgrounds for all his studies. When travelling in countries in which he was not able to hire a studio with daylight entering from above, he used an especially designed tent without a roof.

Avedon's 1976 book *Portraits*[127] had an approach similar to the concepts of Sander and Penn with regard to front-view posing of subjects. Avedon used a studio as a rule

202 *Jerry N. Uelsmann.* Aaron and Nathan. 1969

for his portraits, and in nearly all cases had a light background, in order to avoid diverting the viewer's attention from the face. The resultant uniformity was compensated for by very lively expressions, quite individual to each person. Unlike Sander and Penn, Avedon did not choose unknown people as his subjects, but chiefly well-known artists, writers, lawyers and actors. On the whole, it can be said that the publication *Portraits* is unique, since underlying it were the principles applying both to portraiture of unknown people and to photographing celebrities.

In general, we can say that in most of these books of photographs the psychological portraits were representative of the photographers' complex view of their subjects. Thus in following evolutionary trends in modern photography, these publications are of prime significance.

The spectrum of live photography which had been established by the 'Family of Man' exhibition had long-lasting effects, and did not lose its appeal, particularly since social changes provided a new series of themes, so that photoreporters could not complain about a lack of subjects.

In the stylistic development of live photography, a consolidation of methods already used was noticeable. The capture on photograph of a telling moment was brought closer to perfection by a series of gifted photographers, such as *Eduard Boubat* (Fig. 203), *René Burri, Bryn Campbell, Jean-Philippe Charbonnier, Ernst Haas, Thurston Hopkins, Chris Killip, Stefan Moses, Ed van der Elsken, Miloñ Novotný, Hilmar Pabel, Eberhard Seeliger* and others. In the forties some women also achieved fame as top reporters, for instance *Gisele Freund, Galina Sanko, Margaret Bourke-White*. The feminine share in photojournalism increased continuously, and after the 'Family of Man' exhibition, *Carla Cerati, Inge Morath, Evelyn Richter, Grace Robertson* (Fig. 204), *Alena Sourkova, Elaine Tomlin* were among notable women photojournalists who were highly respected by their male colleagues. Naturally there were some differences in the approach to live photography; generally women preferred photographing women and children and in most cases used more conventional techniques than men, who were more inclined to adopt newer trends.

As well as in Europe and America, an interest in live photography developed in Asia as shown by the constantly growing number of significant contributions from that part of the world. This may be seen in the work of *Hiroshi Hamaya* (Fig. 205). While women reporters showed greater understanding of traditional female life, the Asian and African photojournalists paid greater attention to themes involving national customs, which they of course understood better than an outsider.

Extraordinary occurrences naturally attracted the attention of reporters most of all, and they photographed such themes more and more dynamically. An example of this was *Robert Lebeck's* picture of Leopoldville (Fig. 206). The harsh, unsparing reportage, already mentioned in connection with Margaret Bourke-White's pictures from a liberated concentration camp and Bert Hardy's photographs from Korea, was repeated by several others who worked under similarly dramatic conditions. *Donald McCullin* took many photographs of that kind successively in Cyprus, Africa and South-East Asia. *Ian Berry* took memorable pictures of the Sharpeville massacre in South Africa. The best photographs taken by *Larry Burrows* and *Philip Jones Griffiths* were associated with the war in Vietnam. The young freelance photographer *Mark Edwards* showed great comprehension of the tragedies accompanying the changes in Bangladesh (Fig. 207).

A thorough examination of live photography since 1955 will show that some important innovations have occurred. Many were closely connected with general improvements in communication brought

about by cinematography, which is all the more understandable since some photographers (notably *Rune Hassner*, *William Klein* and *Paul Strand*) also shot reportage films. Of the better-known film trends, 'Neo-Realism' exerted a special influence on photography in Italy, although about ten years elapsed between the first cinematographic works in this genre and its appearance in photography. Surprisingly, the best examples were photographs depicting the rural lifestyle; the photographers were able to reflect the Italian mentality more typically in country regions than in the towns. Thus they succeded in effectively portraying the typical Italian mixture of sheer high spirits, profound religious feeling and melancholia; the 'Neo-Realists' achieved this by using dark tonal values.

Towards the end of the fifties, *Mario Giacomelli* was a key figure among those taking a first decisive step towards 'Neo-Realism'. His dark, sombre pictures, often portrayed enigmatic scenes from an old people's home (Fig. 208) or black-clad villagers. Most of the other photographers following the trend of 'Neo-Realism' also directed the viewer's attention to the sombre aspects of life.

The love-hate relationship between photography and the negative side of life was also expressed in other Romance countries such as Spain, exemplified by the above-mentioned portrait by Gracia Garcia Rodero and by the picture of a genre scene by *Juan Dolcet* (Fig. 209).

The underground film also exerted certain influences on live photography; thus *Jim Clarke* created a whole series of pictures portraying young drug addicts

203 *Eduard Boubat.* First Snow. 1957

204 *Grace Robertson*. Mother's Day pub outing.

205 *Hiroshi Hamaya*. Children on the way to New Year's party. 1956

206 *Robert Lebeck*. The King's sabre. Leopoldville. 1960

207 *Mark Edwards*. From Bangladesh.

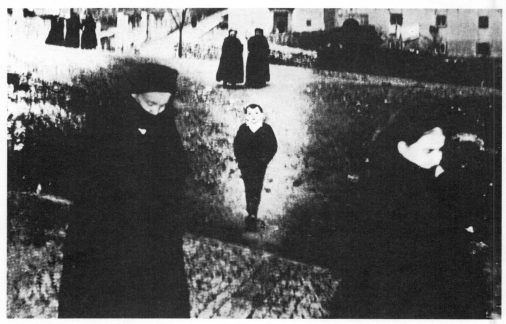

208 *Mario Giacomelli*. Scanno. 1961

210 *Gianni Berengo-Gardin*. The New Witch.

209 *Juan Dolcet*. The singer Mari Trini.

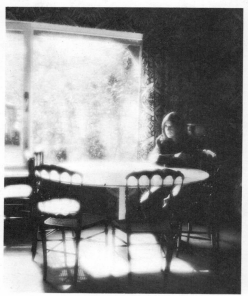

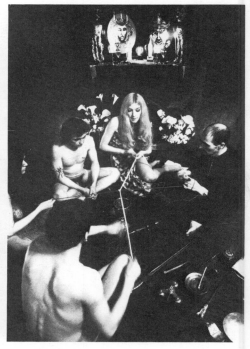

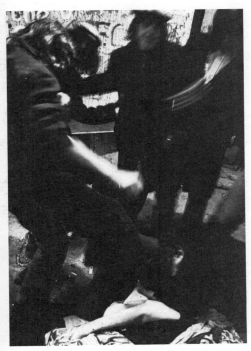

very realistically. Other photographers took pictures of parties which were more like orgies, and also private sex shows. An example of this is *Gianni Berengo-Gardin's* photograph 'The New Witch' (Fig. 210). Similar in style to the underground film were some shots of the street life of teenagers, and *David Dyas* secretly photographed some of these brawls (Fig. 211).

An innovation beyond the concepts which formed the 'Family of Man' exhibition was apparent in attempts by some photographers to capture the very heart of life with their cameras. The photographer took his pictures at a very close range. William Klein was one of the protagonists of this style, and inspired many others. His method was to choose moments when nothing exceptional was taking place, in order to catch unknown people in natural attitudes (Fig. 212). Sometimes

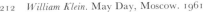

211 *David Dyas*. Teenagers in a scuffle.

212 *William Klein*. May Day, Moscow. 1961

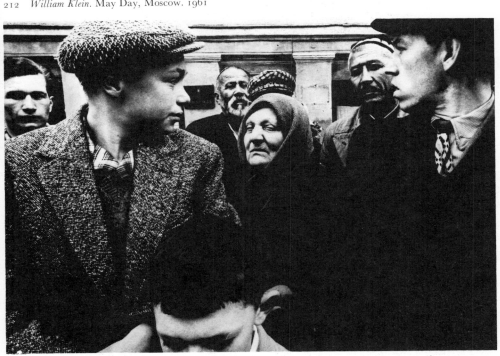

213 *William Klein*. Christmas shoppers in front of Macy's. New York. 1963

Klein used his Leica as near as possible to his subject, to dramatize the scene in which he was emotionally involved; he often tried to visualize in this way his personal impressions of a city (Fig. 213). Protagonists of live photography also worked in other creative photographic spheres in order to perfect the formal components of their works. Thus many reporters even used graphic representations if they considered that this enabled them to express their ideas more satisfactorily or above all more simply. This is impressively illustrated in the picture of a figure-skating couple by the well-known photoreporter *Hanns Hubmann* (Fig. 214). The graphic portrayal of the two people on ice corresponds to their graceful movements, which form the true content of the picture.

The Polish reporter *Stanislaw Jakubowski* based his photograph of a steelworker on a principle similar to the luminogram, and the movement of a glowing metal rod almost transformed him into an abstract figure (Fig. 215).

The poetic effects of Surrealism, of 'Magical Realism' and of 'Subjective Photography' also influenced press photography, as is shown in the picture by the freelance photographer *Hans Hammarskiold*, in which the concept is both poetic and journalistic (Fig. 216). These trends are revealed even more clearly in the photograph of an industrial landscape by *Vladimir Zitny*, a reporter associated with the biggest Czechoslovakian newspapers (Fig. 217).

The constantly growing significance of scientific research logically brought about an increasing interest among press photo-

graphers in this theme. It was their responsibility to popularize new discoveries in the straightforward visual language of photography. The photography by *Vladimir Lammer* of the cupola of a modern observatory shows how this may be achieved through unusual composition (Fig. 218). Many photographers who worked on this type of reportage had to use scientific accessories for their special photographic methods. Thus *Lennart Nilsson* produced results which conveyed the content of his picture and at the same time had great aesthetic appeal (Fig. 219).

Live photography also grappled with modern social problems. The attempt to achieve racial equality in the USA was treated as a central theme by many photographers—not only by a few whites with a strong sense of justice, such as *Leonard Freed*, but also by photographers from among the mass of coloured people involved. In addition to *Gordon Parks* (Fig. 220), who became world-famous through the magazine *Life*, many coloured graduates from the northern universities in the USA became prominent skilled photographers. They realized that good straightforward photographs could substantially assist in the struggle for a better future for the black people. In order to unite their forces more effectively, they founded a society which published the yearbook entitled *Black Photographers' Annual*.[128] A good example from this publication is the photograph by *Beuford Smith* from the series on Martin Luther King (Fig. 221).

The eloquence of live photography in

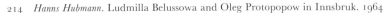

214 *Hanns Hubmann*. Ludmilla Belussowa and Oleg Protopopow in Innsbruk. 1964

215 *Stanislaw Jakubowski*. In the Steelworks (Archives of 'The Democratic Journalist, Prague)

the struggle for their rights was used by black photographers not only in the USA but also in South Africa. One of the most noteworthy of these African photographers was *Peter Magubane*, who compiled a book consisting of photographs he took during his twenty years as a photojournalist; the significance of this was confirmed by Ambassador Andrew Young, who wrote the foreword for it.[129]

Karl Pawek attempted to show the further development of live photography after 1955 in four 'World Exhibitions of Photography', assembling a collection of works by famous German reporters such as *Thomas Hopker* (Fig. 222) and by other photographers from many different countries. With this, Pawek traced a typical image of the world of today, which meant

216 *Hans Hammarskiöld*. In front of the Royal Castle in Stockholm. 1969

218 *Vladimir Lammer.* At the observatory in Ondre-
jov, Prague.

217 *Vladimir Žitny.* Tree and Industry.

naturally that very brutal pictures had to be shown in the exhibition. This horrified some visitors, as most people had hitherto been accustomed to photography being used to beautify reality.

Pawek's ideas about photography were closely oriented to journalism. He saw the main use of the photograph—if not the only one—on the pages of the weeklies and the newspapers. He was fond of declaring that the creative process is complete only with final reproduction in print, so that the original shape and layout could be altered by a graphic expert[130]. Naturally in this way the photographer's vision was not always maintained, and this point was used by Pawek in arguing against all efforts to regard creative photographs as works of art in themselves (see also page 142). This emphasis on reproduction in print diminished esteem for the qualities of the original positive.

In the German Democratic Republic a big exhibition of live photography was prepared by Karl-Eduard von Schnitzler and Rita Maahs, on the occasion of the 50th anniversary of the October Revolution. Its title, 'Vom Glück des Menschen' ('About the Happiness of Mankind') indicated the optimistic standpoint governing the choice of images. In the book bearing the same name[131], which was published by the organizers of the exhibition a year later, one of the principal ideas mentioned was that 'the happiness of mankind is based on his capability to live, to think, to love, to work, to create, to do good deeds, and to be prepared to struggle for all of these activities.' In contrast with Pawek's collections, it did not include any pictures of a brutal character, since the chief aim was to express a sincere belief in a happier future for all mankind.

The widespread use of live photographs in well-printed magazines was suddenly threatened by the successive closure of several important weeklies, mainly in English-speaking countries. It was a rela-

223

219 *Lennart Nilsson*. Foetus, 11 weeks, 5 cm.

220 *Gordon Parkes*. Harlem. 1963 (*Time-Life* Archives, Picture Agency)

tively lengthy process, influenced both by the replacement of printed news pictures by television and by the decision of most publicity agents to place their advertisements on television rather than in the weekly magazines. Profits from advertisements could no longer compensate in some countries for the increase in costs of paper, printing and postage. G. M. Grosvenor[132] has stated that for 150 of the biggest journals in America, the income from advertising was 854 million dollars in 1960, and 996 million dollars ten years later. This increase of 15% in a decade was not sufficient to cover the rising expenses incurred by many of these journals.

The closure of the important weeklies in

222 *Thomas Höpker*. Rhodesia.

the English-speaking countries was not, however, a speedy process. The famous British magazine *Picture Post* closed in 1957, whereas the American *Life* continued until December 1972, preceded by the closure of the fortnightly *Look* in October 1971. *Life* was renewed as a monthly journal in 1978; its new format reflects the changes in the use of photographs. Instead of reporting on current events the new version of *Life* uses picture-stories of more general interest. This calls for a more inventive approach, both photographically and editorially. There is also a predominance of colour rather than black-and-white. In all, then, these changes took fifteen years. There was thus a relatively long transition period, during which photographers oriented to live photography could gradually discover alternative outlets for their work.

Printed reproduction of live photographs in these magazines had had certain very important advantages. The principal one was their permanent availability: readers could easily retain them, whereas television transmissions can be retained only by the use of expensive video tape recorders. For this reason alone, there are surely millions of people who would like to have their magazines back.

In the German Federal Republic, there was a very long tradition of devotion to illustrated weeklies (see page 85), and this has enabled them to survive up to the present date despite problems connected with competition from television. In some other European countries, the editors of a few weekly magazines tried introducing material of a lasting character in order to maintain popularity. For instance, the Italian journal *Epoca*, whose circulation of 650,000 copies weekly in the second half of the sixties had dropped ten years later to 250,000, successfully enriched its content with a cultural supplement, mainly in colour, which is often detached for permanent retention by its readers.[133]

The reason why the greatest problems for the weeklies were in the English-speaking countries was probably the extraordinarily large-scale production, so that the editors had to be more sensitive to circulation than those in a similar situation in West Germany.

In contrast to this, weekly magazines remained very successful in the Socialist countries, since problems related to advertising revenue do not exist. All their publications are quite independent of advertising insertions for financial support. For example, the Czechoslovakian weekly *Kvety*, which has a circulation of over 250,000 copies (quite a large number relative to the 15 million inhabitants), includes only 5 pages, or even fewer, devoted to publicity, while 59 pages are of editorial matter. For this reason, prospects for all the illustrated journals in these countries are very good, so that the evolution of live photography is not likely to be adversely influenced despite the changes which have occured elsewhere.

15 Portrayal of the Human Environment as an Indirect Social Comment

As has already been mentioned, social conditions constituted an important theme for photography throughout the twentieth century. Although this kind of theme also dated back to the very beginnings of photography and had been regarded from many different viewpoints, suddenly the portrayal of people's environment took on a new significance. Originally the environment had been used as a theme because, being static, it was easily photographed; but gradually it became regarded as a tool for indirect social comment.[134] Sometimes such pictures could provide a direct social description of the situation of the community throughout a country. The American exhibition 'Social Landscape', organized by *Nathaniel Lyons* in the course of his work at George Eastman House in Rochester, was highly significant in this respect.

In modern photographs of the environment, both interiors and exteriors are to be found. The photograph of a solitary house situated near a road, taken by *Josef Prosek* (Fig. 223), clearly indicates the connection between the spaces reserved for living and for the transportation of goods to serve the people. This idea was emphasized by the large lorry in the lower part of the picture. The increasing consumption of industrial products has become a characteristic of modern society, and has influenced the environment in many ways. The adequacy of modern manufacturing methods can be seen in many family houses which were simply designed to facilitate construction.

Raymond Moore (Fig. 224) recognized that this kind of building could give indirect information about a certain class in present-day society. A comparison between the photographs of Prosek and those of Moore reveals that the latter went closer to the subject in order to clarify certain important features. Photographers of interiors are generally more detailed than those of exteriors. Thus *Italo Zannier* took an extensive series of photographs of rural dwellings in Friuli (Fig. 225), which, with the part suggesting the whole, were intended to stimulate the imagination of the spectator. In this way, without the directness of 'Neo-Realism', results could be obtained on the theme of human poverty akin to those achieved by realistic pictures.

The same 'pars pro toto' principle was also very well applied in the work of *Risto Laine*, who concentrated on a small part of an interior, showing only the table laid for a normal family meal (Fig. 226). The way the table was laid gave some indication of a certain lifestyle, and hence hinted at certain social qualities. In all these instances the choice of subject was of such importance that the effectiveness of the picture depended on the most direct approach to reality.

In Germany during the sixties, *Chargesheimer* developed a poetic style of social landscape photography, which can be seen in his book *Cologne 5.30*. In the foreword, Chargesheimer wrote: 'Cologne, 5.30 am. A town without people. Why do no people appear in this book? Their presence and their individuality would veil the purpose

223 *Josef Prošek*. House near a road.

224 *Raymond Moore*. Scene at Felixstowe Ferry.

225 *Italo Zannier*. Interior in Friuli. Circa 1965

of the pictures. Junctions, roads and squares, used and peopled day after day by thousands of pedestrians and vehicles, are here reduced to a skeleton. The camera is thus held in the grip of a constant focal length and a constant tripod height. Not for reasons of form. It is a search for the greatest possible objectivity. The naked picture of a city—environment and home of its inhabitants—is to become transparent, almost an X-ray picture for diagnosis.' (Fig. 227.)

Environmental photographs were important in that they gave creative information on where and how our contemporaries lived, and also on where they worked. Pictures of suburbs full of factories contributed significantly to modern socio-critical photography. *Thurston Hopkins*, who dedicated a large part of his career in photojournalism to pictures of this kind, showed in his photograph of 'The Potteries' (Fig. 228) the sombre atmosphere of an industrial district. Hopkins' approach to the depicting of the environment was evidently more subjective than in the case of the photographers previously discussed; he did not set out to portray the factory in detail, preferring to use a device such as the silhouette, which heightened the dramatic effect.

Problems arising from the relationship between our modern consumer society and the environment were treated theoretically by *Gyorgy Kepes*, who wrote concerning this question in general: 'Until the recent past,

226 *Risto Laine*. Table set for family meal.

227 *Chargesheimer*. From the series 'Cologne 5.30'. 1970

228 *Thurston Hopkins*. The Potteries, England. 1954

man had to concentrate his major efforts on safeguarding himself from hostile forces of the natural world—wild beasts, cold, sickness and hunger. At this juncture in history, the real wild beasts are created by man; we confront ourselves as the enemy. Nearly two centuries of industrial civilization have defaced and poisoned our environment. Shaped by the blighted spirit of cornered man, our cities are our collective self-portraits, images of our own hollowness and chaos. And if not properly guided, our immensely potent technology may carry within itself curses of even more awesome proportions. Scientific technology, with its barely understood, uncontrolled dynamics could do more than poison our earth: it is capable of wreaking havoc on man's genetic future.'

Logically, the problems discussed by Kepes must influence the choice of subjects for creative photography more than for any other branch of art, since one of the duties of

229 *Giorgio Lotti*. Foam on canal in centre of Venice. 1970

230 *Pentti Paschinsky*. A dumping-place, gulls in the sky and a lorry dumping garbage.

231 *Robert Häusser*. Edge of town. 1972

232 *Robert Doisneau*. 'The Hyacinths of Lorraine'. 1974

photography is to report creatively about the contemporary world and its actual problems.

Recently one of the major themes of contemporary photography has been environmental pollution, and photographers have tended to choose striking examples for an objective presentation of the theme. The Italian photojournalist *Giorgio Lotti* devoted special attention to this subject, and from his abundant supply of photographs is shown here a picture of a canal in Venice, with the contrast between the romantic gondola and the dirty foam on the surface of the water (Fig. 229).

Naturally one aim of photography was to show not only such exceptional instances as Venice, but also the treatment of refuse in modern towns all over the world. The photojournalistic approach, relying on the eloquence of epic situations, was very appropriate for depicting this kind of subject, as may be seen in pictures by the Finnish photographer *Pentti Paschinsky* (Fig. 230).

Some freelance photographers, however, used different methods, basing their pictures mainly on complicated, well-reasoned compositions. *Robert Häusser's* subject is made apparent by the contrast between the black shadows of the new building and the white plastic in the foreground. The harsh forms are so strikingly combined that by overemphasising the individual picture elements a feeling of imminent danger emerges (Fig. 231).

Photomontage was also utilized, as this can make dangers particularly clear. *Robert*

Doisneau, who is chiefly known as an exponent of live photography, created the famous picture 'The Hyacinths of Lorraine', in which the crippled hands of workers, superimposed on a picture of a great industrial undertaking, lament the lack of humanity in today's society (Fig. 232). It could be said that in this work Doisneau combined the classic conception of social photography with more recent trends, the main theme of which is the problem of the environment, a theme which in earlier days was unimportant in comparison with direct social need.

Live photography began to influence the portrait in the 1920s with the evolution of the use of photography in journalism (see Fig. 61). Practically all press photographers occasionally took such pictures, but the real expansion of this trend became evident just after the Second World War, when the big illustrated weeklies were still thriving. Gradually the borderline between the psychological approach (see Chapter 13) and the journalistic portrait became more clearly marked. However, there was a common aim: to show more than the mere face of a person. Thus perhaps the borderline was still somewhat diffused.

With the psychological approach, the photograph was generally taken only after careful preparation, either in the studio or in a well-chosen environment; the photographer had a more or less clear idea in his

233 *Felix H. Man.* Winston Churchill. 1954 (Collection of Schurmann and Kicken Gallery, Aachen)

234 *Petr Tausk*. Bill Brandt. 1976

235　*Thurston Hopkins.* Cellist, Amaryllis Fleming. 1953

mind as to how to arrange his subject. On the other hand, the journalistic portrait was usually more of an improvization, since the photographer could not prepare the composition so easily. He had to react promptly when taking his portraits, just as reporters in general do. Quite often he did not personally know the people involved before setting out to photograph them, with the result that he was frequently compelled to assess their inherent personalities in a relatively short time. As to translating his immediate impressions into the visual language of photography, the photographer had to look for an advantageous moment when facial expressions and hand gestures came to his aid. In the terms of Halsman's classification (see page 154), the psychological approach is concerned with 'making photographs', while the journalistic portrait is a result of 'taking photographs'.

As they increased in number, journalistic portraits crystallized into several dis-

236 *Wolfgang Barth.* Builder in Berlin. (Courtesy of *The Democratic Journalist*, Prague)

237 *Gabriele and Helmut Nothhelfer.* Corpus Christi, Berlin. 1974 (Collection of Wilde Gallery, Cologne)

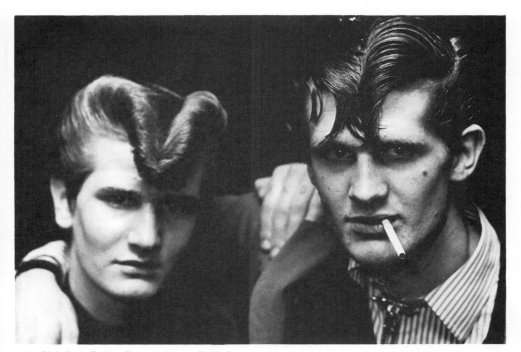

238 *Chris Steele-Perkins*. From the series *Teddy Boys*.

239 *Thurston Hopkins*. An inhabitant of the Liverpool slums. 1954

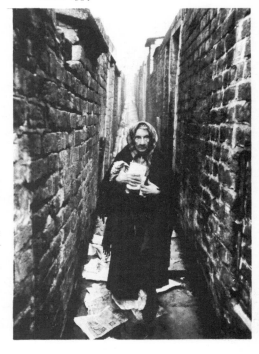

tinct categories. The great master of this type of picture, *Felix H. Man*—whose innovative contribution was perhaps best evaluated by Sir Tom Hopkinson[137]—concentrated his interest for the most part on facial expression (Fig. 233). For his photographs he favoured a Leica, which allowed for prompt and speedy action at appropriate moments. Apart from his live photographs, journalistic portraits always constituted a large proportion of his work; in fact, in his case there never was a sharp demarcation between the two genres, since many of his pictures were on the borderline. The exhibition mounted by Felix H. Man in 1976 in the National Portrait Gallery presented a rich harvest to Londoners, which included journalistic portraits of well-known writers and artists—for example T. S. Eliot, Henry Moore and Graham Sutherland—as well as famous politicians, of which the photograph of Sir

241

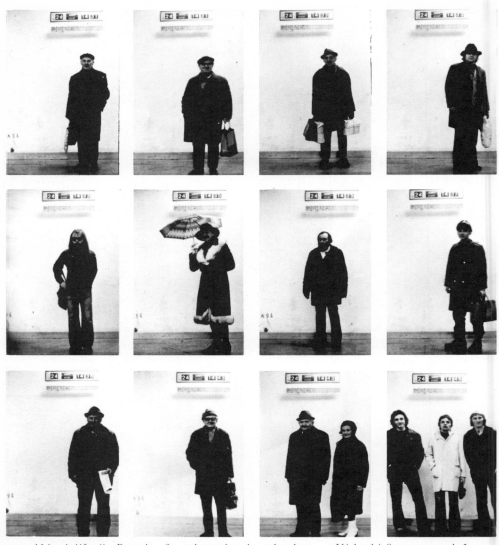

240 *Mehmed Akšamija*. Portraits of people passing through subway at Václavský Square on 24th January between 14.31 and 14.46. 1976 (Work of a student at the Department of Photography, Film and Television Faculty, Prague)

Winston Churchill was especially significant: this was later used for a poster.

Another category was based not only on facial expression but also on hand gestures, which often increased the power of the image. The portrait of Bill Brandt (Fig. 234) was taken by a photographer who had just seen him for the first time, and was highly impressed by his skill and courage.

The photograph was taken without any preparation in Bill Brandt's flat, while he was sitting at a table near a bay window. The liveliness in his facial expression and in his hand gesture compensated for the photographer's inability to control the natural lighting.

Significant hand gestures, in some cases deliberately shown as blurred owing to

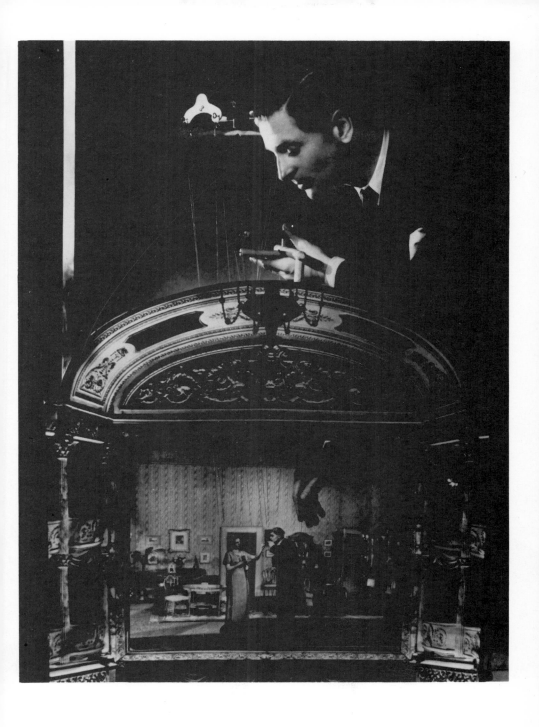

241 *Angus McBean*. Portrait of the theatre impresario Hugh 'Binkie' Beaumont. Circa 1947

242 *Arthur Elgort*. Fashion portrait. (Copyright of British *Vogue*, Condé Nast Publications Ltd.)

movement, on occasion may be used to direct the viewer's attention to some point of importance. This can be said to apply in the case of the photograph of the cellist Amaryllis Fleming, which was taken by *Thurston Hopkins* when she was playing the Elgar Cello Concerto in London's Albert Hall during a Promenade Concert (Fig. 235). A most eloquent moment was chosen for the photograph, just as the cellist closed her eyes in dedicated concentration. Although reflections in the eyes have long been considered a vital factor in journalistic portraiture, in this example a moment of absorption with the music was captured, which helped to provide an insight into the subject's personality.

Thus the principal emphasis was in Fig. 233 on facial expression, in Fig. 234 simultaneously on face and hand, and in Fig. 235 on hands in motion, while in each case the dark background was of no interest to the spectator. However, the correct delineation of an appropriate milieu became a significant factor in the transmission of information by a journalistic portrait. The liveliness in a face could be associated with symbols which could easily be deciphered. *Wolfgang Barth*, not content with depicting a builder (Fig. 236) as representing his trade, skilfully defined the locality of the building site as being in East Berlin by including the silhouette of the television tower.

Sometimes an actual event could serve as a background to a journalistic portrait, provided that it did not distract attention unduly. The main subject could then be separated clearly from the background by means of focusing, lighting, exaggeration of his size and so on. *Gabriele* and *Helmut Nothhelfer* made use of many variations of this principle. In Fig. 237, the main subject could be considered to be the man in the foreground, who undoubtedly represents the Roman Catholic aspect of Berlin, with the other men taking part in the religious festival completing the information. It is possible to find a similar approach in the works of some well-known Soviet photographers, such as *Max Alpert, Yakov Khalip, Galina Sanko* and *Alexander Ustinov*.

The journalistic portrait served very well for sociological communication, as long as an appropriate representative was selected for portrayal. In contrast with Sander's original effort to characterize the whole of human society by means of carefully prepared portraits, the journalistic approach used dynamic elements to enrich the information provided. *Chris Steele-Perkins* succeeded in taking some unprepared yet highly eloquent portrait photographs when working on the series 'Teddy-Boys' (Fig. 238). To complete the sociological information, it was naturally also important to depict the typical environment where the subject lived. This principle was applied by Thurston Hopkins in his journalistic portrait of an old woman in the Liverpool slums (Fig. 239).

Further enrichment of the journalistic portrait came through some experiences emanating from avant-garde experiments in photography. Thus the concept of sequences was used to extend the scope of information provided by the image. The Yugoslav photographer *Mehmed Aksamija* endeavoured to characterize people passing a point in the city at a certain time (Fig. 240). The location he chose had a neutral wall suitable as a background for a portrait, and he included in his picture a digital watch with a date indicator, so that precise information was provided as to the occasion of taking the photograph.

In fact, the broadening of the epic character of the portrait genre through experimentation had long traditions. For example *Angus McBean* frequently used techniques of montage and rephotographing to make portraits full of dynamic and narrative elements, as is exemplified in the photograph of theatre impresario Hugh

'Binkie' Beaumont (Fig. 241), which was taken in 1947 and published in *Sketch* magazine.

The principle of the journalistic portrait also influenced photographs published in fashion journals. The models were asked by the photographers to pose in everyday situations. *Arthur Elgort* created a portrait of a simple country setting (Fig. 242), which provided an interesting composition. Similar arrangements were devised by *Taras Kuscynskyj* and *Karol Kallay*, who generally favoured making portraits for fashion journals in daylight conditions. *Hans Feurer*, who often contributed to the British magazine *Vogue*, posed young girls in deserted corners of a city. *Barry Lategan* took the unusual step for fashion-journal portraiture of posing a model among working-class people, and the results were striking.

The rising popularity of journalistic portraits justified their use in pictorial books, of which two examples are worth consideration.

In 1970 *Bruce Davidson's East 100th Street* was published, consisting mainly of photographs of people living in this particular part of New York. This book was really innovative, as it revealed how much it is possible to say about human problems by depicting representative people in their environment in a journalistic way. Though some of the pictures approached the more static psychological style, the most lively examples were based on the journalistic portrait, for which Davidson was well prepared by his collaboration with the 'Magnum' group[138].

A recurrent alternation between the psychological and the journalistic approach to portraiture was typical of the work of *Arnold Newman*. After issuing the publication based on static psychological portraits[122], he prepared a new book *Faces USA*, which demonstrated his marvellous ability to take natural portraits of people at work and at leisure[139]. The individuals, depicted in dynamic situations, combined to give a complex view of life within one country.

17 The Family Portrait as a Contribution to Modern Social Photography

The family portrait has a very long tradition, for even during the last century, middle-class society adopted many upper-class customs, including a reverence for ancestors. Following the trends of the time, photographic studios tried to emulate painted portraits of famous families in their group photographs. In the course of time such a valuable collection of documentary photographs accumulated that it is worth giving the matter a sociological evaluation.

The modern family portrait, essentially depicting what is typical, is an important element of social photography. As the smallest social unit, the family could represent in a photograph a *pars pro toto* section of an entire social class. This advantage was discovered by August Sander when he was making systematic researches into characteristic features of society in the Weimar Republic. His approach was followed by other photo-

243 *Ed Barber*. From the series *One-Parent Family*. 1976

247

244 *George Rodger*. African tribal family from Southern Sudan.

245 *George Rodger*. Pakistani family on Indus river.

graphers who were concentrating on the family unit. The British photographer *Ed Barber*, for instance, created a whole series of photographs dealing with 'The One-Parent Family', showing living conditions when only one person was available to look after the children (Fig. 243). He took the individual photographs in flats occupied by selected people. Thus he was able to enrich the photographic studies with significant and eloquent symbols.

Photographs of families became important not only for showing the effect of modern trends on different social classes but also as an illustration of customs and social structure in different countries.

George Rodger, during his lengthy travels in Africa and Asia, took many interesting portraits of family groups which revealed features typical of each geographical region (Fig. 244 and 245). A good selection of photographs of this type appeared once in the *Ladies' Home Journal*.

The family portrait of today can, of course, be presented very dynamically, to the extent that such pictures can sometimes almost be regarded as a special form of live photography. It is an advantage that people in their usual environment behave more naturally in front of a camera than they do in a studio. Often a photographer's relatives act as subjects for modern family

249

portraits, with the result that everyone is relaxed, thus making the work easier. This point is well illustrated in the photograph by *Roger Mayne* (Fig. 246).

In addition to family portraits, which are regarded as characterizing one particular social stratum at a time, and therefore reduce the individual to a mere representative of one social class, there are also group photographs of famous people, each of whom is well-known as an individual. For a long time such personalities would allow only strictly 'official' family portraits to be released, as they held the belief that their individuality would emerge more clearly in that type of photograph. How-

ever, with the democratization of society, public relations demanded that in order to capture the sympathy of the public, it was far better to issue photographs showing that even important politicians were human beings. In order to photograph prominent people in such a way, the photographer had to be a psychologist as well as an expert in his special field. In this respect *Philippe Halsman*, whom we have already mentioned in connection with Surrealism, was an excellent portrait photographer, and his photograph of the five Eisenhower brothers indicates the extent of his photographic ability (Fig. 247).

In family photography, the glamour

246 *Roger Mayne*. Family group, Rose Cottage garden. 1970

247 *Philippe Halsman.* Five brothers Eisenhower. 1948

248 *Sir Cecil Beaton.* The Wyndham sisters. 1950 (Courtesy of Sotheby's, London)

approach was sometimes used if the upper classes were involved. The use of the style itself characterized certain social ambitions. These portraits were usually taken by specialists in fashion photography. *Sir Cecil Beaton*, whose key significance in modern glamour photography was discussed in Chapter 7, became known as the photographer of high society. Among his portraits are family groups, such as the picture 'The Wyndham Sisters' (Fig. 248), which was originally taken for the British magazine *Vogue*.

The many different symbols found in modern portraits give information about the families. This is illustrated by the photograph of the family of Juraj Herz, the film director and actor, which shows the artistic atmosphere of the household (Fig. 249).

249 *Petr Tausk*. The family of the film actor and director, Juraj Herz. 1975

In conformity with the trends of Pop Art, some painters used advertising posters as a basis for their pictures, which was in accordance with the spirit of an art genre which was fundamentally a satire on the flood of consumer goods. Thus one pictorial medium became the subject for another. Probably a similar evolution was responsible for a photographic image being used as a motif for a painting. However, if a photograph was to represent a typical contemporary mass consumer product, then it should not ideally be a creative image produced by an accomplished photographer; more suitable subjects were to be found among snapshots intended for family record only. Needless to say, such pictures exist by the million.

Painters carefully studied the nature of the snapshot in order to understand it well enough to use it as a motif. The knowledge attained by this process eventually formed the basis not only for experiments in the use of a photograph as a centrepiece in a painting, but also for application of the very primitive composition which was typical of snapshots. Some artists accordingly treated canvasses in this way, so that they finally resembled everyday amateur snapshots in most respects. When these paintings were very large, the effect could be almost magical. Common errors in photographic composition, as described in every handbook for beginners, were thus used deliberately for creative effect.

Since practically all of the general public were well acquainted with conventional snapshots, they were therefore prepared for this type of 'photographic realism' in a painting. If this new artistic trend in painting was a part of the culture of contemporary society, it was quite logical that some effect on photography coud be expected; in a similar way, photography influenced the foundation of Impressionism in painting, which in its turn affected trends in photography during the 1890s (see page 15). Thus history in a sense was repeating itself.

Obviously the photographic medium achieved accuracy of image, a property which could not be influenced by painting. The influence of painting was more concerned with the primitive composition of forms and of light and shade. Practically the entire evolution of creative photography was based on the assumption that the photograph was far more than a fortuitous look at reality, since it was completed by a search on the part of the human intellect for the best composition at the best moment. The vital aspect of the photographer's art was always considered to be his talent for creation of atmosphere by an appropriate use of light, in addition to an attractive arrangement of the individual picture elements. In the evolution of all branches of art could be observed intermittent reactions against traditional approaches. In modern photography, the influences of 'photographic realism' as affected by painting—perceived by individual photographers either with a clear comprehension of its nature or sometimes only subcon-

250 *Heinrich Riebesehl*. Photograph. 1975

251 *Paul Hill*. Hand in back of car, Brassington. 1976

sciously—successfully initiated a revolu-
tion, which was manifested in an even more
literal portrayal of reality, without any
effort to use the classical rules of com-
position.

Heinrich Riebesehl, originally a pupil of
Professor Steinert, quite often broke with
tradition by placing his main image ele-
ments in those picture areas which had
hitherto been considered ineffective (Fig.
250). His approach showed at the same
time a certain affinity for 'magical realism'
(see page 151), but with an even closer
approach to reality. That this was the work
of a master was indicated by the fact that
collectors very frequently purchased his
pictures.

255

252 *Paul Hill*. Light on railway seats, Birmingham. 1973

It has already been suggested that *Diane Arbus* chose the simplest possible ways of portrayal, in order to avoid distracting the viewer's attention from the message written on the faces of the people in her photographs (see page 189). Probably a very similar reason influenced *Paul Hill* when making his images of reality as straightforward as possible; in Fig. 251, the wooden post behind the car undoubtedly clashed with traditional concepts of composition, and thus introduced an artistic impression of crude reality. Another characteristic of 'photographic realism' was the selection of very simple motifs. Paul Hill acted in accordance with this spirit when he depicted the seats in the railway carriage (Fig. 252). In contrast to the approach of the 'New Objectivity' in the 1920s and 1930s, he did not try to show in detail the texture of the surfaces so that the spectator could appreciate the nature of the seats: he preferred to show the play of light and shade caused by the sunbeams shining through the carriage window. In a sense, this photograph is reminiscent of other photographers' efforts to incorporate complex information about the environment in their photographs of people (see Chapter 15).

Terry Morden, a pupil of Paul Hill at the Trent Polytechnic, showed his inclination for a straightforward portrayal of reality by directing the viewer's attention only to the main part of the motif, and neglecting its relationship with other pictorial elements. In Fig. 253 our main attention is centred on the lorry, and the accidental appearance of the smaller car in the foreground, with its inscription at the rear, helps again to provide a feeling of direct contact with reality.

256

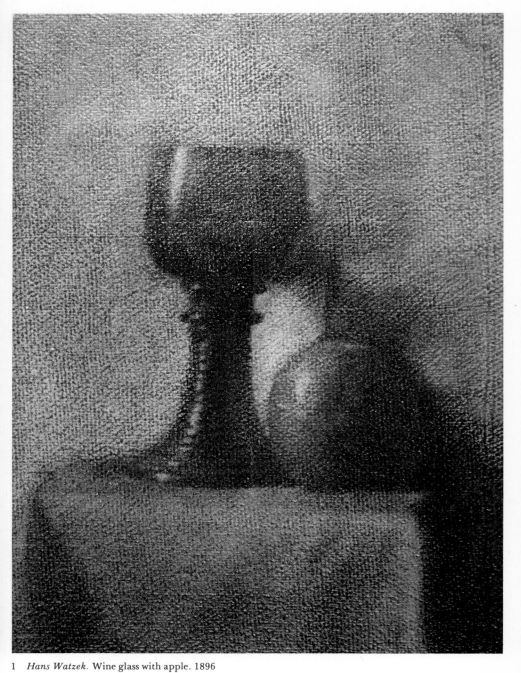

1 *Hans Watzek.* Wine glass with apple. 1896

2 *Heinz Hajek-Halke.* Untitled. 1960-61

3 *Peter Cornelius.* Paris. 1960-61

4 *Erwin Fieger.* Horseguards. 1960
(From *Magic of Colour,* Photokina)

5 *Walter Boje.* Indians in Canada. Circa 1960

6 *Wim Nordhoek*. Child's grave. Robert Mort. 1975

7 *Keld Helmer-Peterson*. Walls and roofs. Circa 1947
(From *122 Colour Photographs*)

8 *R F Heinecken*. 'Pin Up'. Film and collage. 1969

9 *Petr Tausk*. Enigmas and miracles of
Portobello Road, London. 1976

10 Astronaut Owen Garriot outside spaceship.
(Courtesy of Hasselblad, Göteborg)

11 *Jorge Lewinski.* Andrew Logan. 1976
(From *Faces USA*)

12 *Andy Earl.* Ascot series. 1978

13 *Neal Slavin.* Group portrait.
 (Collection of Schümann and Kicken Gallery, Aachen)

14 *Josef Sudek*. Still life. 1976
 (Print made by Jiří Ksandr from the original negative taken by Sudek)

253 *Terry Morden*. 'BP Oil'. 1976 (Work of student at Trent Polytechnic, Nottingham)

254 *Wilhelm Schürmann*. Arbour.

255　*James E. Hadfield*. Gable. 1976 (Work of student at Royal College of Art, London)

256　*John Gray*. 'Open'. 1976 (Work of student at Royal College of Art, London)

In availing themselves of the influences of 'photographic realism', certain individual photographers used earlier evolution and previous knowledge as a basis for modification. *Wilhelm Schürmann* in all probability found his own way because in his home town of Aachen on show in the Municipal Gallery was the famous Ludwig Collection, which contains the best examples of 'photographic realism' in painting on the European continent. Further, Schürmann, as one of the two proprietors of the Schürmann and Kicken Gallery, became a connoisseur of the photographs created in the spirit of the 'New Objectivity' in the 1920s and 1930s, and these feature heavily in the selection shown in this gallery. It could be said that Schürmann's work (Fig. 254) may be seen as a bridge between modern 'photographic realism' and classical 'New Objectivity'. Similarly, some pictures created by *James E. Hadfield* showed the influence of 'Minimal Art' and its admiration of abstract forms (Fig. 255). It is difficult to say whether these influences

257 *John Gray*. 'Rocket'. 1976 (Work of student at Royal College of Art, London)

258 *Jiří Ksandr*. White car. Circa 1975 (Work of student at the Department of Photography, Film and Television Faculty, Prague)

were used by Hadfield deliberately or from a subconscious store of visual impressions when he chose themes using very simple subjects which presented very clearly defined outlines.

At the beginning of this chapter, the connections between Pop Art and 'photographic realism' were discussed in general. It is quite logical that this should be observed in the work of some photographers. *John Gray* certainly approached the 'Objet Trouvé' in the manner of Pop Art when he took the photograph of a simple shop door (Fig. 256); whereas his other picture (Fig. 257) was an example of a purer application of 'photographic realism'.

Some photographers combined a choice of a simple theme with technical imperfection, which they regarded as a sign of reality. Thus *Jiri Ksandr* quite deliberately made use of minor defects in the smooth running of the shutter of a panorama camera (Fig. 258).

With regard to the roots of 'photographic realism', the creative use of the snapshot

was always of considerable significance, and this introduced some further dynamic features into photography. Thus *Emmet Gowin* took a series of photographs featuring members of his family moving around (Fig. 259)—commonly featured also by many amateurs. When discussing the nature of the snapshot, Gowin stated that the photograph belonged more to the world of things and facts than to the photographer[141].

One of the most important photographers who worked on the influences of 'photographic realism' together with the principle of the snapshot was *Lee Friedlander*. Even in his earliest work he showed a clear understanding of Pop Art in his depicting of certain 'Objets Trouvés', and his second generation of pictures was based on the most direct possible contact with reality. Friedlander did not generally apply the snapshot principle so far as to photograph a subject while it was in motion; his approach was to photograph a subject, if it suddenly took his interest, without making any effort to search for the best arrangement in accordance with traditional composition. The chosen part of reality was depicted in its simple form, and this often created an almost magical impression.

The snapshot technique, representing the photographer's immediate reaction to reality in his vicinity, was typical of much of the work of *Eva Kubinska*. In her photographs, houses, large posters and cars in streets took on a more attractive aspect than in real life, and this was particularly noticeable when she photographed abroad (Fig. 260).

Evidence of the rapid growth of this trend, based on very direct contact with reality, could be seen in some exhibitions. Among photographers included in the collection entitled 'Singular Realities', was the work of *Lewis .Ambler, Beverly Bryon, Eric Carpenter, Paul Hill, Guy Ryecart, Gail Tandy* and *Peter Turner* who were representative of the new direction. In the introduction to the catalogue of this exhibition, Gerry Badger justifiably wrote[142]: 'Most of the photographers contained here may be said to work as documents in a strict and necessarily narrow sense. Their primary intention, however, is to transcend the objectivity of the documentary genre, even the open subjectivity of straightforward formalism, and approach the poetic. Such a pursuit of the non-literal—created through the medium of an extremely perceptive divination of internal experience within the camera's confrontation with the world, rather than by seeking expressive refuge in a pseudo-painterly imposition of traditional graphic mores—is a relatively new or hitherto misunderstood area of interest for photographers working in this country, and has been evident particularly in the 1970s.'

The new attitude towards reality did not confine itself to Euro-American culture, but also influenced the evolution of photography in other continents. Some specially noteworthy results were achieved by Japanese photographers, such as *Tetsuya Ichimura, Ikko, Bishin Jumonji, Shigeru Tamura* and *Hiromi Tsuchida*.

In summarizing the circumstances surrounding the application of 'photographic realism', it is necessary to point out the unusually large number of contributions from pupils and recent graduates of certain photographic schools, which is shown to some extent in the choice of illustrations for this chapter. This phenomenon indicates that the direct approach to reality and the revolutionary ideas and techniques of the younger generation are taking over the traditional ideas of photographic composition. Thus history has a strong influence on the present and the probable future. For this reason it is difficult to provide this chapter with a definite close: we await further developments.

The wide public interest in live photo-graphy was not permanently damaged by the closure (mostly in the English-speaking countries) of the big weeklies. Of course new opportunities for the use of this sort of photograph had to be found gradually. When the prosperity of the weekly maga-zines was at its peak, live photography invaded the book world. For example, *Henri Cartier-Bresson* published in 1952 in Paris his *Images à la Sauvette*, and simul-taneously the English-language version was published in New York under the title *The*

Decisive Moment. Since then, more and more books have been based on live photography.

In the 'sixties and 'seventies, the quality of books about live photography became so high and specialized that they crystallized into a few distinctive groups. One of these categories covered permanent results of minor influences of the 'Objet Trouvé' principle (see page 83). *Gianni Berengo-Gardin* discovered an atmosphere approach-ing a dreamlike vision in Venice during the late autumn and winter, when tourists were absent. The photographs he took at that

261 *Tony Ray-Jones*. Glyndebourne. 1967 (Courtesy of John Hillelson Agency Ltd., London)

262 *Homer Sykes*. John Knill ceremony, St Ives, Cornwall. 1971 (From the book *Once A Year* published by Gordon Fraser, London)

263 *Sláva Štochl.* Stag.

included were both real and surreal, in order to express where he had been psychologically, emotionally and physiccally. In a sense a few of the pictures in this publication showed similar influences to those of painting on 'photographic realism'. The nature of some themes, for instance circuses with clowns, acrobats and trained animals, always suggested a poetic nostalgia far distant from actual modern life. The live photographs of subjects from such environments often tended somewhat towards Surrealism, and this was shown also by *Jill Freedman* in her book[148]. In this respect the question might well arise, whether the dreamlike atmosphere was based on reality, which the photographer could not ignore and had endeavoured to present a true picture of, or whether his Surrealist inclinations had led him to a synthesis between live photography and a reflection of a fantastic vision of reality.

In the work of the British photographer *Tony Ray-Jones*, a systematic search for Surrealist features in mundane reality could generally be detected. His book *A Day Off*[149], which appeared posthumously, implied something of this orientation in the cover picture (Fig. 261). The great richness of very different themes, involving the seaside, summer carnivals, dancers and social events, suggest that the driving force came from Ray-Jone's intellectual background. To some extent it is possible to sense in his work a quite original continuation from some of the photographs taken by Bill Brandt in the 'thirties and 'forties, from which it differed mainly in its more dynamic approach. From this there evolved the work of some photographers who built on the Ray-Jones approach. In the book *Once a Year—Some Traditional British Customs* by *Homer Sykes*[150], again many photographs (Fig. 262) represented a combination of live image with dreamlike poetry.

time formed the most significant part of his book *Venise des Saisons*[143]. Similarly, the Dutchman *Ed van der Elsken* chose for his publication *Sweet Life*[144], photographs of a slightly fantastic character, involving village festivals and popular amusements.

Robert Frank is an example of a photographer living in America who showed a desire for high-quality imagery in live photography used in books. His early book *Les Américans*[145] had a warm reception soon after its appearance. Probably his best-known publication was *The Lines of My Hand*[146], and in this the trend towards emphasis on dreamlike features was developed still further; the final form of this book appeared at the start of the 'seventies. *Charles Harbutt* stated, in reference to his book *Travelog*[147], that the photographs he

Quite another trend in the use of live

264　*Otto Steinert*. Children's Carnival. 1971

photography in book production was concerned with human conflict. Admittedly this approach was not brand new, since for example the older books produced by Margaret Bourke-White[151], Weegee[152], and to some extent even Jacob Riis[153] could be regarded as forerunners. Incidentally, all three publications were reprinted quite recently, and this indicates a fresh interest in them. The growing popularity of this type of book encouraged the development of modifications in the chosen theme. Thus problems associated with the lives of coloured people formed the basis of the book *Black in White America* by *Leonard Freed*[154]. Similarly many live photographs were to be found in *The Destruction Business* by *Donald McCullin*, who dedicated much attention to war events in Cyprus, Africa

and South-East Asia[155]. His human concern took the form of a blunt presentation of disaster, the eloquence of which served as a warning to mankind. This approach can also be observed in the work of *Philip Jones Griffiths*, whose book *Vietnam Inc* criticized that war by means of very strong images photographed at dramatic moments[156]. The Italian photographer *Gian Butturini*[157] was even more politically oriented in the compilation of his publications *Cuba 26 July*, *Chile Venceremos* and *Ireland after Londonderry*.

In the illustrated magazines, live photographs dedicated to one particular town began to appear. At one time these would be principally composed of studies of beautiful architecture and famous views of the city. It took a long time to convince both

265

265 *Andre Gelpke*. Swimmer, New York. 1972

publishers and potential customers that a town is not a dead complex of buildings, but primarily a living organism, pictures of which should be characterized by dynamic images of traffic and of life in the streets, squares and parks. Of the rich supply of this type of contemporary publication, some of the best are *William Klein's* monographs on *Rome* (1960), *Moscow* (1964) and *Tokyo* (1964). There was a similar tendency in the type of book aimed at providing an account of the people in one country—for instance *The English* by *Ian Berry*, or *Africa* by *Emil Schulthess*.

The live concept introduced a new degree of vividness to those publications whose aim was to illustrate the poetry of nature. *Slava Stochl* (whose photograph appeared among the 'Star Photographers' in *Photography Yearbook 1963* edited by Norman Hall) produced several books including photographs of deer (Fig. 263),

birds and even fishes. The sensitive eye of a photographer tracker was able to discover new qualities of poetry in nature.

When considering the evolution of books using live photographs, it is necessary to point out that the first of these books were compiled from photographs originally taken for periodicals; after a large number of these photographs had been accumulated, a selection would be published in book form. After an interest had been aroused in this kind of publication, more and more volumes were formed from photographs taken specifically for them. A skeleton would first be produced, from which the photographer would try to extract suitable motifs. This new trend was just becoming evident at the time of the closure of the big illustrated weeklies, which, logically, led to the growth in significance of books composed of live photographs.

The steady increase in the number of these books helped by improvements in printing quality, led to a growth of respect for live photography as an artistic form of expression. This also encouraged the collection of original prints of live photographs as independent works of art. For this purpose the most suitable photographs were those which were likely to be of lasting significance. Without a doubt this situation influenced the work of some prominent photographers during the seventies. Interest in collection encouraged well-known galleries to hold regular sales of live photographs. Thus Marlborough Fine Art Ltd. of London became the representative of Robert Frank and Bill Brandt, including Brandt's live photographs from the 'thirties; and the Schürmann and Kicken Gallery in Aachen in the Federal German Republic included among regularly featured photographers *Andre Gelpke*, *Tim N. Gidal* and *Umbo*.

The collecting of live photographs restored respect for the original positive. There is really a remarkable difference between the work of photographers concerned only with press photography and that of those aiming at the production of photographs as autonomous works of art.

Henri Cartier-Bresson, who took most of his photographs for publication in various types of periodical, did not make his own prints from the negatives, but preferred to use professional laboratories, in whose work he had sufficient confidence. He gave his views in these words:[159] 'Life seems to me to be too short to sacrifice a part of it to work in the darkroom, which would be to the detriment of pure photographic activity. However, in order to be able to get the prints I want, it is necessary to be in close contact with the laboratory.'

On the other hand, Tony Ray-Jones, one of the new generation dedicating themselves to live photography, was a typical perfectionist in the making of the original positive prints. Geoffrey Crawley described[160] how eager Ray-Jones was to accumulate profound knowledge of all the details of technique required to achieve the highest quality results.

Professor Otto Steinert generally devoted great care to the printing of original positives, and this approach was of course valid for his work in live photography (Fig. 264). He liked to try all kinds of dynamic expression, and at the same time he investigated this branch of photographic activity to select appropriate moments for autonomous motifs. Steinert's followers inherited his esteem for the original positive, and of these, *André Gelpke* achieved especially significant results in live photography (Fig. 265).

Most teachers of photography followed the tendency to make their own positive prints. Of those who were at the same time interested in live photography, *Chris Steele-Perkins* should be mentioned. He became a part-time lecturer in the Faculty of Communication at the Polytechnic of Central London mainly because he wanted to be free to make photographs without having to work to the dictates of editorial offices. Thus he could work for as long as he felt necessary on a series which attracted him (Fig. 266). Another well-known teacher, *Paul Hill*, never forgot his period of photojournalistic activity when lecturing at the Trent Polytechnic in Nottingham. He worked according to his own ideas, to the extent that he produced pictures with all the appearance of live photography in a partly artificial way (Fig. 267). He awakened an interest in dynamic pictures among some of his followers, of whom *Andy Earl* was soon producing noteworthy results (Fig. 268).

The increasing interest of collectors in live photography resulted in a considerable increase in prices of original prints, so that many admirers of this kind of picture were unable to afford them. For this reason the

266 *Chris Steele-Perkins*. From the series 'Teddy-Boys'.

267 *Paul Hill*. British general election, Wolverhampton. 1970

268 *Andy Earl*. Discussion at the car. (Work of student at Trent Polytechnic, Nottingham)

269 *Kevin Keegan.* Cyclist on street-lettering. (From *Real Britain Postcards* published by Co-optic, London 1974)

publication of postcard reproductions helped to spread enjoyment to a wider audience. There is no doubt that an important contribution towards this was the activity of the group called 'Co-optic', which published an attractive series of 'Real Britain Postcards' (Fig. 269).

The new uses for live photographs also influenced the whole intellectual background. Pawek's concept of regarding print reproduction as the end of the creative process (see Chapter 14) could not be valid any more in these circumstances, and was replaced by the general theory of the aesthetics of situations, which had its roots in Hegel's work. Now this was developed and reworked, having regard for the latest trends in the evolution of some branches of art. Quite logically, in such treatises photography found an important place.

Dusan Sindelar stated in his innovative book on the aesthetics of situations[161]: 'It is the nature of photography to have the ability to depict the world both at very short and long time intervals. Thanks to this property, photography is able to provide quite a new look at reality, and even to discover new realities. Through this process, the image influences the people's contact with live reality, especially in the qualities of the situations. Thus creative photography becomes a remarkable art of situations, with regard to the actual activity as well as in the sense of the eventual results, which are the photographs. Photography is one of the typical phenomena of the present time; it satisfies the needs of the broad masses of the people, who like to be in permanent, immediate and always new touch with reality.'

Pawek's exhibitions (see page 216) were based on the journalistic use of live photography. Pawek himself liked to say about the first exhibition, called 'What Is the Man?', that it was in a sense a large copy of a magazine[162]. The evolution of further uses for live photographs set the scene for some quite different types of exhibition. During the transition period between traditional applications in journals and new forms of books, there was considerable significance in two collections called 'The Concerned Photographer'. They were prepared by Cornell Capa (in collaboration with Michael Edelson), who wanted to show various approaches to the problems of human life as well as to personal conflict. For this reason both exhibitions were designed as a number of complete series, each series being the work of a single photographer, and not using Pawek's scheme of 'picture-chapters' according to themes. The first collection was devoted mainly to classic concepts of 'human interest', and contained sets of pictures from the works of *Lewis W. Hine, Werner Bischof, Robert Capa, David Seymour, Dan Weiner* and *Leonard*

Freed. With the exception of Freed, all the contributors had died before the mounting of the exhibition. 'The Concerned Photographer II' was prepared in a similar manner, and contained contributions from *Marc Riboud, Roman Vishniac, Bruce Davidson, Gordon Parks, Ernst Haas, Hiroshi Hamaya, Donald McCullin* and *Eugene W. Smith.* Thanks to this concept, the spectator was better able to understand the intellectual background of the various contributors, who could effectively express their opinions through their own 'language', manifested in a personal photographic statement.

Cornell Capa's ideas inspired some continuation of his original projects in other countries. In 1973 an exhibition 'The Concerned Photographer—Gruppo Italiano' presented personal views on Italian problems as seen by photographers from that country; the photographers were chosen by Lanfranco Colombo, the Director of the cultural section of Salone Internazionale Foto, Cine, Ottica (SICOF). The layout was by *Cesare Colombo*, who four years later mounted another very important exhibition of a similar kind, 'L'Occhio di Milano' ('The Eye of Milan'), covering the social history of that city from 1945 to 1977 in photographs taken by 48 prominent Italian photographers. Cesare Colombo was both an exhibition planner and an active photographer. He actually started his exhibition activities by preparing a collection from his own photographs on the theme 'Le Altre Donne' ('Other Women'): in this case he wanted to show the work of unknown wives and mothers, who in reality always provided the basis of life to men (Fig. 270).

270 *Cesare Colombo.* Supermarket.

The significance of planned exhibitions grew as they increased in number. In the seventies in London the Half-Moon Photographic Workshop began to organize loan exhibitions, prepared mainly as one-man shows from the works of certain photographers who endeavoured to discuss some human problems by means of their created images. Thus art was being used to convey information.

The accent on the personal contribution of the individual photographer probably stemmed from the new respect for the live photograph as an autonomous work of art. However, the concept based on presenting complex guided thoughts about human society, as devised in the 'Family of Man' by Steichen, were no less applicable in the new conditions. Among various exhibitions after 1975, one worth mentioning is 'The Quality of Life', produced and directed by Jurgen Schadeberg. Its first presentation in the foyer of the National Theatre in London in autumn 1976 was an indication of the value placed on the project by the British cultural authorities. If it is compared with the approaches of Steichen and Pawek, it will surely be found to be closer to the former. The organizers of 'The Quality of Life' did not endeavour to include all kinds of live photography, as perhaps Pawek did, but deliberately omitted those kinds in which the author did not show a certain amount of love for other people. This orientation was facilitated by the selection of only ten photographers — *Adrian Ford, Judy Goldhill, Martin Gowar, Bruce Hart, Jessie Ann Matthew, Charles Marriott, Keith Sandman, Christopher Schwarz, William Wise* and *Herbie Yoshinori Yamaguchi*—whose work was included in the exhibition. In a way it was a compromise between personal series from a few photographers (as in 'The Concerned Photographer') and a division of the exhibition into 'picture chapters'.

Live photographs formed quite an important part of the exhibition 'Concerning Photography', which set itself the task of educating visitors on how to look at creative images. The fact that this show was held in the 'Photographers' Gallery' in London was an indication of the high level of the project. The live photographs, which very many people came to see, undoubtedly helped to prepare the ground for the development of visual culture. All the photographs exhibited were original prints, and this added to the emotional response as people saw them.

During the early post-war years, colour photography was at its peak in the USA, as its development there had not been hindered as much as it had been in Europe. Moreover, the big illustrated magazines, with their numerous eye-catching advertisements, offered many opportunities for the use of colour photographs. This was especially true in the case of some fashion magazines, where the use of colour meant not only more exact information but also a more attractive format.

These favourable conditions for the use of colour photography in journalism enabled the photographer to try out the new medium on a wide range of subjects. In addition to the work they carried out for clients, their photographic curiosity and love of experiment encouraged photographers to develop in this field and try out all the possibilities. *Irving Penn*, for example, worked in this way, taking many photographs out of personal motivation. He made use in particular of the blur of motion, which can be seen, for instance, in his photograph of a bullfight, where he obtained effective shades of colour together with blurred contours.

A representative selection of colour photographs taken by photographers working for Condé Nast, the American publisher of fashion journals, was used in the book *The Art and Technique of Colour Photography*, which was compiled by Alexander Liberman[163]. Achievements in the progress of colour photography during and just after the Second World War were summarized in a thought-provoking outline, and this became a source-book valued by many photographers who were turning their attention to this region of creative activity.

In Europe, one of the first significant post-war publications was produced in Denmark—the outstanding book *122 Colour Photographs*, by *Keld Helmer-Petersen*, who showed in his pictures a deep understanding of fine colour composition[164]. He selected his subjects from the everyday environment, in which he was able to discover abstract forms (Colour Plate 7). Soon after the appearance of this book, the 28 November 1949 issue of the weekly magazine *Life* carried a feature about Helmer-Petersen's colour photographs under the title 'Camera Abstractions'. The evaluation in that article of his contribution to colour photography rightly suggested that a large proportion of these photographs were based on various modifications of colour composition, and that a systematic search for new forms was evident.

Keld Helmer-Petersen used colour slides, as did most of the American photographers working with colour. On the other hand, the post-war evolution of colour photography in Europe was characterized to a large extent by the technique of working from colour negative to colour positive, as it was found that in this way there were better opportunities to influence the process creatively. This new technique, developed during the war by Agfa, was now generally available, and was adopted by other film manufacturers

as well, such as Ferrania, Gevaert and Tellko, who also put colour negative films and colour papers on the market. This development also affected creative work: the advantage of colour enlargement on paper was that the colour reproduction could be influenced during copying, and the actual colour of the subject need not necessarily be retained.

One further criterion in the evolution of colour photography in Europe was the state of the polygraphic industry. Just as copying was already important to monochrome photography, this proved to be even more important for the general use of colour photography. Colour enlargements were still not sensitive enough to light, whereas the printed colour reproduction gave no problems in this respect, and printers in Germany, Italy, the Netherlands and Switzerland were able to reproduce colour photographs down to the finest detail, more successfully than in the USA.

In 1960, *Walter Boje* assembled a collection of colour photographs for the Photokina exhibition in Cologne, a selection of which later appeared in book form under the title *The Magic of Colour Photography*. This project was of great importance, since it epitomized the position of colour photography up to 1980. Walter Boje himself participated in this exhibition with his collection of ballet photographs, in which he used the blur of motion skilfully and effectively. The various contributors displayed almost all the technical possibilities of the time, such as the utlization of controlled colour saturation, the combination of colour with shade, deliberate tonal displacement, and the use of lenses of long focal length (having a very limited depth of field).

Since the 'sixties, most photographers have become aware of the differences between creative colour work and black-and-white photography. According to personal preference, individual photographers choose the methods which correspond to their own ideas, with the result that the end-product is nowadays very varied.

In addition to the classic concept of a sparing use of bright colours (Colour Plates 3, 4 and 5), several influences in common with black-and-white photography can be traced from the most important contemporary artistic schools of thought. For instance, Surrealist influences were creeping into publicity photographs more and more, because dreamlike portrayals attracted the viewer's attention. For similar reasons, photographers endeavoured to make use of the latest techniques. A photograph taken with a fish-eye lens, for example, could combine the attractiveness of colour reproduction with the impact of unusual width.

As compared with the monochrome image, the colour photograph offered a higher degree of information. For this reason colour was used very often not only for fashion and advertising purposes, but also for some themes in which colour could raise the narrative quality of the picture. Provided that such pictures were taken by an expert photographer, outstanding results could be produced irrespective of the necessity to adjust the photographs to the needs of social practice. Reporters were frequently able to show that their picture stories in colour exploited all the power of the medium in the eloquent communication of their thoughts. In this connection we should mention in particular *Larry Burrows*, whose colour photographs from Vietnam depicted the crude reality of the events much more impressively than black-and-white images would have done.

In order that the maximum information would be obtained, colour film was used by crews of spacecraft. Although these people were not professional photographers, quite a number of the photographs they took represented more than mere documents (Colour Plate 10), since emotional

excitement gave them the power to include in their pictures something of what they felt.

Colour was often used in portraiture, since customers liked to have the maximum of information in photographs of friends and relatives. In addition to this routine work, some of the great photographic masters also took advantage of colour in the creation of unconventional portraits. Thus the British photographer *Jorge Lewinski*, who endeavoured to discover behind the external features the innate qualities of a person, took quite a number of outstanding colour portraits. He chose for this purpose mainly people about whom he could express information of an 'epic' nature; an example was the portrait of Andrew Logan (Colour Plate 11). Similarly, the great master of American portrait photography, *Arnold Newman*, included in his new book *Faces USA*[139] a few fine colour portraits of extraordinary vivacity.

Portraits were also to be seen in the important exhibition 'European Colour Photography', which was held in the 'Photographers' Gallery' in London in 1978. Especially noteworthy were those by *Andy Earl*, whose work showed a sincere spontaneity (Colour Plate 12).

Neal Slavin demonstrated in his charming book *When Two or More Are Gathered Together*[166] what significance the colour factor may have for a group portrait. In his photographs Slavin tried to convey his impressions about those members of the community who favoured joining various clubs, associations, business societies and so on. The individual photographs allowed him to define various aspects of these human tendencies: in the case of people working on frankfurter stands in Sabrett (Colour Plate 13) there was a certain stereotyped uniformity, whereas in other pictures he tried to accentuate the individuality of single members of a group, in order to indicate a probable reason for them joining the others. The addition of colour gave the series a fairytale feeling.

In general, colour opened the door for the discovery of new kinds of visual poetry in the actual world by providing sensitive views of the landscape and nature. Within this genre, *Ernst Haas, Emil Schulthess, Dennis Stock* and many others produced highly impressive pictures, from which they could produce very visually poetic books. Some photographers tried to find unusually simple themes for pictures of that kind, as did *Wim Nordhoek* in the photograph of the child's grave (Colour Plate 6).

As in the case of the evolution of monochrome photography, the colour image too was influenced by various trends in modern art. In the great period of abstract painting, many photographers tried to find arrangements in the real world resembling simple compositions produced on canvas. In this category should be included some photographs taken by Keld Helmer-Petersen. In a quest for greater artistic freedom, *Heinz Hajek-Halke* manually prepared negatives which he enlarged in colour (Colour Plate 2). Interesting compositions were also produced by microphotography, since the actual subject remained concealed from the layman and his interpretation of the picture was purely subjective. During the sixties, *Manfred Kage* created technical micro-photographs of textile patterns, which could also be regarded as pleasing abstract compositions.

Pop Art, which altered the trend of abstract fine art, became no less important in colour photography. These influences were used in quite a number of ways, from modifications of the principle of the 'Objet Trouvé' to the montage of appropriate elements. *R. F. Heineken* used the colour medium in making Pop Art collages (Colour Plate 8), which he had found satisfactory in monochrome (see Fig. 149).

Colour montage and double exposure

have found more and more use in colour photography, as they can be employed in posters and in advertising. Finally it should be mentioned that unconventional darkroom techniques in negative/positive processing can also produce interesting improvements in colour. These experiments are likewise very useful in advertising. The growth in popularity of colour photography has already led many firms to produced more sensitized material for colour photographs than for black-and-white.

Surrealism remained as an active influence on new modifications in painting in the 1960s and 1970s. The same could be observed in photography too, in which colour made surprising effects possible with artificial arrangements prepared in the studio. *Sam Haskins* constructed fantastic objects which he combined with posing models. His colour photographs of nudes, made in that way, were especially interesting, and were often published as posters. Colour again aroused a feeling of a magic bridge between reality and Surreality.

The principle of the 'Objet Trouvé', as influenced by Surrealism, could also be applied very aptly in the region of the colour image; for in this case the closer contact with reality rendered the fortuitous meeting of incongruous objects more curious. As in the case of black-and-white photography, a great treasure house of themes was offered by secondhand shops (Colour Plate 9), fairs, waxworks and so on.

The trends in 'photographic realism', as affected by painting, had great significance for the evolution of colour photography. Quite naturally, the straightforward approach to reality was still more accentuated by colour. The results of this could be seen especially in the works of photographers of the younger and middle generations.

The varied work of numerous photographers has justified the place of colour photography in the visual culture of the second half of the twentieth century; some photographers well-known for their work in monochrome, such as Edward Weston, devoted at least part of their efforts to colour. Indeed, one of the most faithful protagonists of the black-and-white photograph, *Josef Sudek*, took some colour pictures just before his death[167]; but he never saw the positives of these, as they were printed posthumously (Colour Plate 14).

In this history of the development of modern photography, less space has been devoted to colour photography than to black-and-white, and hence the development of styles in this area has only been touched on rather than thoroughly analyzed. However, creative colour photography has become so rich in history that a separate study would seem to be justified.

Photography was once responsible for liberating painting from the task of capturing the immediate reality. Today, television has increasingly taken over the work of pictorial reporting of current affairs, which was earlier one of the most important duties of photography in the illustrated magazines. It appears that television nowadays is doing the same for photography as the latter did at one time for painting, with the result that photography is now able to devote itself more profoundly and responsibly to the artistic representation of reality. It is by no means the case that photography has killed off painting—as Paul Delaroche feared would happen—and similarly television does not endanger creative photography, apart from one or two traditional applications of photographic activity which have not been reorientated.

Photographers in the period up to 1918 accumulated most of their fundamental knowledge either as apprentices in studios or in a self-taught fashion, as was the case with amateurs generally; only a few well-known photographers—for instance František Drtikol—completed courses at photographic schools. Between the two World Wars, such photographic schools, mostly on an advanced level, were founded in many countries. Also some important courses were organized, with outstanding experts as teachers, as in the case of the Photo League in the USA. Many well-known photographers received their formal training in this way.

After the Second World War the situation altered radically, with opportunities for receiving photographic education at college and university level expanding throughout the world. At the same time, educational institutions of this kind became important centres of modern photography, since quite a number of these teachers were also photographers of distinction. Some who completed these full-time courses have now become teachers in turn, so that a second generation of college and university teachers of photography has emerged. Gradually studies in photography have become as highly regarded as those in any other art discipline. Part of this education is devoted to the history of photography; students thus learn to respect work done in the past, and can also admire original prints. This should help to complete the emancipation of photography as an autonomous discipline of art, and should clear the way for an independent development of the medium.

The British scientist Samuel Lilley once wrote[168]: 'History is the science of the future.' Although these words were uttered by a historian of science, they are also valid in the humanities. One of the aims of this book is to assist young photographers in finding a way to develop and extend into the future the ideas and trends which have evolved in the past. The students of today will be the practitioners of creative photography of tomorrow. For that reason, this book includes some photographs taken by gifted students and others who have just

271 *Jiří Poláček*. Street by the brewery. 1978 (Work of student at the Department of Photography, Film and Television Faculty, Prague)

completed courses in British and Czechoslovak photographic schools, as an anticipation of the future.

In Czechoslovakia the work of Josef Sudek is widely admired, and many young photographers are trying to follow his tradition. Naturally the most valuable contributions are of an independent nature, as exemplified by *Jiri Polacek* (Fig. 271), whose work shows clear connections with Sudek, but whose use of mundane reality would never have appealed to Sudek, who always loved the romantic scene. For a healthy evolution, it is necessary to absorb the basic spirit of creative photography, and also to add to this originality and invention.

Appendix

by *Karin Thomas*
enlarged for the British edition by *Petr Tausk*

Further Reading

Arcari, A., Menotti, M., Celentano F.: *Guida al fotoreportage*, Milan 1960.

Barthel, Tobias M.: *Photo Graphism international*, Munich 1965.

Baucken, Rudolf: *Geliebte Sekunde*, Munich 1958.

Basner, Georg, Lohse Bernd, Reuter Niels: *Photographie heute*, Frankfurt am Main 1958.

Beaton, Cecil and Buckland, Gail: *The Magic Image*, London 1975.

Beiler, Berthold: *Parteilichkeit im Foto*, Halle 1959.

Beiler, Berthold: *Die Gewalt des Augenblicks*, Leipzig 1967.

Beiler, Berthold: *Denken über Fotografie*, Leipzig 1977.

Beiler, Berthold and Föppel, Heinz: *Erlebnis, Bild, Persönlichkeit*, Leipzig 1973.

Benjamin, Walter: *Kleine Geschichte der Photographie* (1931), Frankfurt am Main 1976.

Benjamin, Walter: *Das Kunstwerk im Zeitalter seiner technischen Reproduzierbarkeit* (1936), Frankfurt am Main 1969.

Billeter, Erika and Schmoll gen. Eisenwerth, J. A.: *Malerei und Photographie im Dialog von 1840 bis heute*, Bern 1977.

Boje, Walter: *Magie der Farbenphotographie*, Düsseldorf 1961.

Braive, M. F.: *Das Zeitalter der Photographie*, Munich 1965.

Brevern, Marillies von: *Künstlerische Photographie von Hill bis Moholy-Nagy*, Berlin 1971.

Burkhardt, Hellmuth: *Aktfotografie*, Halle and der Saale 1958.

Charbonnier, Jean-Philippe: *Un photographe vous parle*, Paris 1961.

Coe, Brian: *Colour Photography, the First Hundred Years 1840–1940*, London 1978.

Coe, Brian and Gates, Paul: *The Snapshot Photograph, the Rise of Popular Photography 1888–1939*, London 1977.

Chini, Renzo: *Il linguaggio fotografico*, Turin 1968.

Coke, Van Deren: *The Painter and the Photograph*, Albuquerque 1972.

Coke, Van Deren et al: *One Hundred Years of Photographic History*, Albuquerque 1975.

Coleman, A. D.: *The Grotesque in Photography*, New York 1977.

Czartoryszka, Urszula: *Przygody plastyczne fotografii (History of Creative Photography)*, Warsaw 1965.

Danziger, James and Conrad, Barnaby III: *Interviews with Master Photographers*, London 1977.

Honnef, Klaus and Weiss, Evelyn: *Documenta 6, Vol. 2: Fotografie*, Kassel 1977.

Doherty, Robert J.: *Sozial-dokumentarische Photographi in den USA*, Luzern 1974. English Translation: *Social Documentary Photography in the USA*, Garden City 1976.

Doty, Robert: *Photography as a Fine Art*, Rochester 1960.

Doty, Robert and White, Minor: *Photography in America*, London 1974.

Elisofon, Elliot: *Color Photography*, New York 1961.

Everard, John: *Photographs for the Papers*, London 1923.

Feininger, Andreas: *The Creative Photographer*, Englewood Cliffs 1955.

Franke, Herbert, W.: *Kunst und Konstruktion*, Munich 1957.

Franke, Herbert and Jäger, Gottfried: *Apparative Kunst*, Cologne 1973.

Gabor, Mark: *A Modest History Pin-Up*, London 1974.

Gassan, Arnold: *A Chronology of Photography*, Ohio 1972.

Gernsheim, Helmut: *Creative Photography*, London 1962.

Gernsheim, Helmut and Gernsheim, Alison: *The History of Photography*, London 1955.

Gernsheim, Helmut and Gernsheim, Alison: *A Concise History of Photography*, London 1965.

Gidal, Tim, N.: *Deutschland—Beginn des modernen Photojournalismus*, Lucerne 1972. English Translation: *Modern Photo Journalism, Origin and Evolution 1910–1933*, New York 1973.

Gilardi, Ando: *Storio sociale della fotografia*, Milan 1976.

Gräff, Werner: *Es kommt der Neue Fotograf?* Berlin 1929.

Green, Jonathan: *Camera Work—A Critical Anthology*, Millerton 1973.

Green, Jonathan: *The Snapshot*, Millerton 1974.

Gregorová, Anna: *Fotografická tvorba (Creative Photography)*, Martin 1972.

Gruber, L. Fritz: *Fame*, London 1960.

Gruber, L. Fritz: *Grosse Photographen unseres Jahrhunderts*, Düsseldorf 1964.

Gruber, L. Fritz: *Antlitz der Schönheit*, Cologne 1965.

Günter, Roland: *Fotografie als Waffe*, Hamburg 1977.

Günther, Hanns: Technische Schönheit, Zürich 1929.

Halsman, Philippe: *Halsman on the Creation of Photographic Ideas*, New York 1961.

Hedgecoe, John: *The Book of Photography*, London 1976.

Herzfelde, Wieland: *John Heartfield*, Dresden 1962.

Hlaváč, Ľudovit: *Fotografický detail ako metóda tvorby (Photographic Detail as a Method of Creative Work)*, Martin 1964.

Hlaváč, Ľudovit: *Sociálna fotografia na Slovensku (Socio-Critical Photography on Slovakia)*, Bratislava 1974.

Hoenich, Paul Konrad: *Sonnenmalerei*, Cologne 1974.

Holme, Charles et al.: *Art in Photography* (The Studio), London 1905.

Holter, Patra: *Photography Without a Camera*, London 1972.

Howell, Georgina: *Vogue—Six Decades of Fashion*, London 1975.

Hurley, F. Jack: *Portrait of a Decade—Roy Stryker and the Development of Documentary Photography in the Thirties*, Baton Rouge 1972.

Hütt, Wolfgang: *Landschaftsfotografie*, Halle a.d. Saale 1963.

Jäger, Gottfreid and Holzhäuser, Karl Martin: *Generative Fotografie*, Ravensburg 1975.

Janis, Eugenia Parry et al.: *Photography within the Humanities*, Danbury 1977.

Jay, Bill: *Views on Nudes*, London 1971.

Jenny, Hans: *Cymatics*, Basel 1967.

Jirů, Václav: *Současná sovětská fotografie (Contemporary Soviet Photography)*, Prague 1972.

Jirů, Václav: *Pobaltská sovětská fotografie (Photography in Baltic Soviet Republics)*, Prague 1974.

Juhl, Ernst et al.: *Camera-Kunst*, Berlin 1903.

Kahmen, Volker: *Fotografie als Kunst*, Tübingen 1973. English Translation: *Photography as Art*, London 1974.

Kemp, Wolfgang: *Foto-Essays zur Geschichte und Theorie der Fotografie*, Munich 1978.

Kempe, Fritz: *Fetisch des Jahrhunderts*, Düsseldorf 1964.

Kempe, Fritz: *Vor der Camera*, Hamburg 1976.

Kempe, Fritz: *Photographie zwischen Daguerreotypie und Kunstphotographie*, Hamburg 1977.

Kluge, Hans A.: *Foto in Farben*, Zwickau 1938.

Kraszna-Krausz, A. et al.: *Photography as a*

Career, London 1944.

Kraszna-Krausz, A. et al.: *The Focal Encyclopedia of Photography*, London 1956.

Lacey, Peter: *The History of the Nude in Photography*, London 1964.

Lécuyer, Raymond: *Histoire de la Photographie*, Paris 1945.

Lewinski, Jorge: *Photography—A Dictionary of Photographers, Terms and Techniques*, London 1977.

Lewinski, Jorge and Clark, Bob: *Colour in Focus*, Kings Langley, Hertfordshire 1976.

Liberman, Alexander: *The Art and Technique of Color Photography*, New York 1951.

Linhart, Lubomír: *Sociální fotografie (Socio-Critical Photography)*, Prague 1934.

Lyons, Nathan: *Photographers on Photography*, Englewood Cliffs 1966.

Mehnert, Hilmar: *Die Farbe in Film und Fernsehen*, Leipzig 1974.

Moholy-Nagy, Laszlo: Malerei, Fotografie, Film, Munich 1925 and Mainz reprinted 1967. English Translation: *Painting, Photography, Film*, London 1969.

Moholy-Nagy, Sibyl: *Moholy-Nagy—Experiment in Totality*, Cambridge Massachussetts 1950.

Moreck, Curt: *Sittengeschichte des Kinos*, Dresden 1926.

Morosov, Sergey: *Ruskaya khudozshestvennaya fotografia (Russian Creative Photography)*, Moscow 1955.

Morosov, Sergey: *Sovetskaya khudozshestvennaya fotografia (Soviet Creative Photography)*, Moscow 1958.

Morosov, Sergey: *Iskusstvo videt (The Art of Seeing)*, Moscow 1963.

Mrázková, Daniela and Remeš, Vladimír: *Fotografovali válku*, Prague 1975. English Translation: *Russian War*, New York 1977 and London 1978.

Mumford, Lewis: *Art and Technics*, New York 1952.

Neumann, Thomas: *Sozialgeschichte der Photographie*, Neuwied 1966.

New British Image, London 1977.

Newhall, Beaumont: *The History of Photography from 1839 to the Present Day*, New York 1964.

Newhall, Beaumont: *Airborne Camera*, London 1969.

Newhall, Beaumont and Newhall, Nancy: *Masters of Photography*, New York 1958.

Padouk, Rudolf: *Umělecká fotografie a její tvorba (The Art of Photography and Its Nature)*, Olomouc 1930.

Pawek, Karl: *Totale Photographie*, Olten 1960.

Pawek, Karl: *Das optische Zeitalter*, Olten 1963.

Pawek, Karl: *Das Bild aus der Maschine*, Olten 1968.

Petrák, Jaroslav: *Žeň světla a stínu (The Harvest of the Light and Shadow)*, Prague 1910.

Petzold, Paul: *Light on People*, London 1971.

Petzold, Paul: *Effects and Experiments in Photography*, London 1973.

Pollack, Peter: *The Picture History of Photography from the Earliest Beginnings to the Present Day*, New York 1958.

The Real Thing—An Anthology of British Photographs 1840–1950, London 1976.

Roh, Franz: *Foto-Auge*, Stuttgart 1929, Tübingen (reprinted) 1973.

Rosten, Leo et al.: *The Look Book*, New York 1975.

Rothstein, Arthur: *Photojournalism*, New York 1965.

Rothstein, Arthur: *The Depression Years*, New York 1978.

Rotzler, Willi: *Photographie als künstlerisches Experiment*, Lucerne 1974. English Translation: *Photography as Artistic Experiment*, Garden City 1976.

Scharf, Aaron: *Creative Photography*, London 1965.

Scharf, Aaron: *Art and Photography*, London 1968.

Scherman, David E. et al.: *The Best of Life*, New York 1973.

Schimmer, Fritz: *Rangerhöhung der Fotografie*, Halle a.d. Saale 1958.

Schreiber, Hermann: *Die Welt in einem Augenblick*, Tübingen 1969.

Schuneman, R. Smith: *Photographic Communication*, London 1972.

Skopec, Rudolf. *Photographie im Wandel der Zeiten*, Prague 1964.

Šmok, Ján: *Akt vo fotografii (Nude in the Photography)*, Martin 1969.

Šmok, Ján: *Za tajomstvami fotografie (The Secrets of Photography)*, Martin 1975.

Šmok, Ján, Pecák, Josef and Tausk, Petr: *Barevná fotografie (Colour Photography)*, Prague 1975.

Sontag, Susan: *On Photography*, New York 1977.

Springorum, Friedrich: *Der Gegenstand der Photographie*, Munich 1930.

Steinert, Otto: *Subjektive Fotografie*, Bonn 1952.

Steinert, Otto: *Subjektive Fotografie 2*, Munich 1966.

Steinert, Otto and Fabri, Albrecht: *Selbstportraits*, Gütersloh 1961.

Stelzer, Otto: *Kunst und Photographie*, Munich 1966.

Stenger, Erich: *Die Photographie in Kultur und Technik*, Leipzig 1938.

Strelow, Liselotte: *Das manipulierte Menschenbildnis*, Düsseldorf 1961.

Stryker, Roy Emerson and Wood, Nancy: *In this Proud Land—America 1935–1943 as seen in the FSA Photographs*, Greenwich Connecticut 1973.

Sydeberg, Hans Jürgen: *Fotografie der 30er Jahre*, Munich 1977.

Szarkowski, John: *Looking at Photographs*, New York 1973.

Szarkowski, John: *From the Picture Press*, New York 1973.

Szarkowski, John: *Mirrors and Windows— American Photography Since 1960*, New York 1978.

Szarkowski, John and Yamagishi, Shoji: *New Japanese Photography*, New York 1974.

Tausk, Petr: *Současná světová fotografie (Contemporary Photography in the World)*, Prague 1970.

Tausk, Petr: *Základy tvorivej farebnej fotografie (The Roots of Creative Colour Photography)*, Martin 1973.

Tausk, Petr: *Fotografie ve společenské praxi (Photography in the Social Praxis)*, Prague 1973.

Tausk, Petr: *An Introduction to Press-Photography*, Prague 1976.

Tausk, Petr: *Okamžitá fotografia, súčasnosť— možnosti—perspektivy (Instant Photography, Present—Opportunities—Perspectives)*, Martin 1977.

Tausk, Petr: *Čiernobielá tvorivá fotografia (Black and White Creative Photography)*, Martin (in print).

Tausk Petr and Hofstätter, Hans: *100 temi di fotografia*, Milan 1977.

Tausk, Petr et al.: *Oborová encyklopedie SNTL—praktická fotografie (SNTL Encyclopedia—Practical Photography)*, Prague 1972.

Taylor, John and Lane, Barry: *Pictorial Photography in Britain 1900–1920*, London 1978.

Thornton, Gene: *Masters of the Camera*, New York 1976.

Time-Life Library of Photography:
The Art of Photography, New York 1971.
The Camera, New York 1970.
Caring for Photographs, New York 1972.
Colour, New York 1970.
Documentary Photography, New York 1972.
Great Photographers, New York 1971.
The Great Themes, New York 1970.
Light and Film; New York 1970.
Photographing Children, New York 1971.
Photographing Nature, New York 1971.
Photojournalism, New York 1971.
The Print, New York 1970.
The Studio, New York 1971.

Turroni, Giuseppe: *Nuova fotografia italiana*, Milan 1959.

Turroni, Giuseppe: *Guida all estetica della fotografia a colori*, Milan 1963.

Wescher, Herta: *Die Geschichte der Collage*, Cologne 1974.

White, Minor: *Being Without Clothes*, Millerton 1970.

Wise, Kelly et al.: *The Photographers Choice*, Danbury 1975.

Wulffen, Erich et al.: *Die Erotik in der Photografie*, Vienna 1931.

Young American Photography, New York 1974.

Young British Photographers, London 1974.

Zannier, Italo: *Breve storia della fotografia*, Milan 1974.

Acknowledgements

[1]Walter Boje: *Die Ausdrucksmöglichkeiten und Stilrichtungen der Modernen Farbphotographie (Expressive Possibilities and Stylistic Trends of Modern Colour Photography)*, in: Collected Edition of *Interkamera 69*, Prague 1969, pp 353–374.
[2]Ilya Ehrenburg: *Menschen, Jahre, Leben (People, Years, Life)*, Moscow 1961.
[3]Wolfgang Baier: *Quellendarstellungen zur Geschichte der Fotografie (Basic Attitudes in the History of Photography)*, Halle 1964, pp 297f.
[4]The Kodak Museum Catalogue, Harrow 1947.
[5]Wolfgang Baier, op cit, pp 276f.
[6]Edgar Yoxal Jones: *Father of Art Photography O. G. Rejlander*, London 1973.
[7]Henry Peach Robinson: *Pictorial Effect in Photography*, London 1869.
[8]Hans Hildebrandt: *Die Kunst des 19 und 20 Jahrhunderts (The Art of the 19th and 20th Centuries)*, Wilpark—Potsdam 1924, p 125.
[9]Robert Doty: *Photography as a Fine Art*, Rochester 1960.
[10]Jaromir Petrak: *Podstata a Raz tzv Umelecke Fotografie (The Nature and Aim of So-Called Art Photography)*, in *Fotograficky Obzor*, Year 20, 1912, pp 2–5, 31–36.
[11]Fritz Kempe: *Die Kunstphotographie in Deutschland (Art Photography in Germany)*, in: Exhibition Catalogue *Kunstphotographie um 1900 (Art Photography around 1900)*, Essen 1964, pp 7–18.
[12]Herman Speer: *Die Wiener Schule (The Viennese School)*, in: Exhibition Catalogue *Kunstphotographie um 1900 (Art Photography around 1900)*, Essen 1964, p 19ff.

[13]Anna Farova: *Fotograf Frantisek Dritikol (Photographer Frantisek Drtikol)*, in: Exhibition Catalogue Kunstwerbemuseum, Prague 1972, p 16.
[14]L. Fritz Gruber: *Die Kunstphotographie in Amerika (Art Photography in America)*, in: Exhibition Catalogue *Kunstphotographie um 1900 (Art Photography around 1900)*, Essen 1964, pp 25–31.
[15]James Thrall Soby: *Modern Art and the Recent Past*, Norman 1957, pp 158–163.
[16]Quotation from Beaumont Newhall: *The History of Photography*, New York 1964, p 111.
[17]Otto Stelzer: *Kunst und Photographie (Art and Photography)*, Munich 1966, p 99.
[18]Rudolf Baucken: *Geliebte Sekunde (Precious Seconds)*, Munich 1958, p 84.
[19]*50 Jahre Leica (50 Years of the Leica)*, Wetzlar 1974, p 3.
[20]Anton Giulio Bragaglia: *Fotodinamismo Futurista*, Turin 1970.
[21]Hans Richter: *Dada—Kunst und Antikunst (Dada—Art and Anti-Art)*, Cologne 1964, pp 38f.
[22]Willy Rotzler: *Photographie als Künstlerisches Experiment (Photography as Artistic Experiment)*, Lucerne 1974, p 23.
[23]Hans Richter, op cit, p 92.
[24]Hans Richter, op cit, p 100.
[25]Hans Walzek: *Wiener Photographische Blätter (Viennese Photographic Pages)* 1897, Volume IV, p 33.
[26]*50 Jahre Leica (50 Years of the Leica)*, Wetzlar 1974.
[27]Walter Heering: *Das Rolleiflex-Buch (The Rolleiflex Book)*, Seebruck am Chiemsee 1958, p 276.

[28]Wolfgang Baier, op cit, p 276ff.

[29]B. S. Myers: *Die Malerei des Expressionismus (Expressionist Painting)*, Cologne 1957, p 222.

[30]Albert Renger-Patzsch: *Fotografie und Kunst (Photography and Art)*, in: *Photographische Korrespondenz (Photographic Correspondence)*, Year 63, 1927, No 3, pp 80–83.

[3]Quotation from W. Schöppe: *Meister der Kamera Erzählen (Masters of the Camera Speak)*, Halle o J, p 52.

[32]Fritz Kempe: *Albert Renger-Patzsch—Der Fotograf der Dinge (The Photographer of Things)*, Essen 1967.

[33]Hans Günther: Einleitung zu *Technische Schönheit* (Introduction to *Technical Beauty*), Zurich 1929.

[34]Berthold Viertel: *Glaube an den Menschen (Faith in Mankind)*, in: Helmar Lerski, *Der Mensch—Mein Bruder (Mankind—My Brother)*, Dresden 1958.

[35]Ladislav Sutnar and Jaromir Funke: *Fotografie Vidi Povrch (Photography Sees the Surface)*, Prague 1935.

[36]Petr Tausk: *Podil Chemiku na Formovani Zakladu Tvurci Fotografie v Ceskoslovensku (The Part Played by the Chemist in the Fundamental Development of Creative Photography in Czechoslovakia)*, address to Assembly of Chemists, Brünn 1974.

[37]*Fragen der Meisterschaft in der Sowjetischen Filmkunst (Questions of Skill in Soviet Film Art)*, Berlin 1953, p 65.

[38]Quotation from Beaumont Newhall, op cit.

[39]Paul Strand: *Photography*, Camera Work, Nos 49–50, reprinted in: *Camera Work, a Critical Anthology*, Millerton 1973, pp 326f.

[40]Paul Menz: *Art Deco*, Cologne 1974.

[41]Karin Thomas: *DuMont's Kleines Sachwörterbuch zur Kunst des 20 Jahrhunderts (DuMont's Concide Encyclopedia of the Art of the 20th Century)*, Cologne 1973, p 157.

[42]Max Ernst: *Beyond Painting*, New York 1948, p 21.

[43]Marcel Jean: *Geschichte des Surrealismus (History of Surrealism)*, Cologne 1961.

[44]Michael F. Braive: *Das Zeitalter der Photographie (The Photographic Era)*, Munich 1965, pp 247f.

[45]Marcel Jean, op cit, p 176.

[46]Bernd Lohse: *Live-Photographie—eine Neumodische Erfindung? (Live Photography—a Modern Discovery?)*, in: *Interkamera 69*, Prague 1969, pp 329–338.

[47]Alfred Eisenstaedt: *The Eyes of Eisenstaedt*, London 1969, p 15.

[48]Leonid Wolkow-Lannit: *Boris Ignatowitsch*, Moscow 1973, p 9.

[49]James Thrall Soby, op cit, p 167.

[50]Anna Farova: *Henri Cartier-Bresson*, Prague 1958, p 11.

[51]Lubomir Linhart, *Localni Fotografie (Social Photography)*, Prague 1934, p 59.

[52]*Life Photography—Das Photo als Dokument (The Photography as Document)*, Amsterdam 1974, pp 88f.

[53]Robert J. Doherty: *Sozialdokumentarische Photographie in den USA (Social-Documentary Photography in the USA)*, Lucerne 1974, p 10.

[54]Paul Wolff: *Meine Erfahrungen mit der Leica (My Experiences with the Leica)*, Frankfurt am Main 1934.

[55]Tim N. Gidal: *Deutschland—Beginn des Modernenen Photojournalismus (Germany—The Start of Modern Photo-Journalism)*, Lucerne and Frankfurt am Main 1972, p 15.

[56]Willi Baumeister: *Das Unbekannte in der Kunst (The Unknown in Art)*, Cologne 1960, p 141.

[57]Otto Croy: *Photomontagen und Kombinationsaufnahmen (Photomontages and Combined Photographs)*, in: *Deutsches Kamera-Almanach (German Camera Almanac)*, Volume 22, 1932, pp 47–62.

[58]Hans Richter, op cit, p 119.

[59]Willy Rotzler, op cit. p 24.

[60]Alfred Durus: *John Heartfield und die Satirische Photomontage (John Heartfield and the Satrical Photomontage)*, in: *John*

Heartfield: *Photomontagen zur Zeitgeschichte I (Photomontages of Era I)*, Zurich 1945, pp 17–28.

[61]Willy Rotzler, op cit, p 24.

[62]Laszlo Moholy-Nagy: *Photographie ist Lichtgestaltung (Photography is Modelling with Light)*, in: *Photographische Korrespndenz (Photographic Correspondence)*, Year 64, 1925, pp 133–138.

[63]Herta Wescher: *Die Collage (The Collage)*, Cologne 1968, p 149.

[64]Man Ray: *Self-Portrait*, Boston 1963, pp 128f.

[65]Laszlo Moholy-Nagy, op cit.

[66]Laszlo Moholy-Nagy: *Die Photographie in der Reklame (Photography in Advertising)*, in: *Photographische Korrespondenz (Photographic Correspondence)*, Year 63, 1927, pp 257–260.

[67]Paul Barz: *Schwarz/Weiss, Spiel und Gestaltung im Reich der Fotografie (Black-and-White, Play and Moulding in the Photographic Field)*, Düsseldorf 1962.

[68]Ladislav Noel: *Robime Fotogram (We Make a Photogram)*, Martin 1972.

[69]Wolfgang Baier: op cit, pp 172f.

[70]L. Fritz Gruber: *Man Ray Portraits*, Gütersloh 1963, pp 9f.

[71]Jaroslav Fabinger: *Novy Zpusob Provadeni Reklamnich Fotografii (New Photographic Techniques for Publicity Purposes)*, in: *Fotograficky Obzor*, Year 44, 1936, pp 124f.

[72]Laszlo Moholy-Nagy: *Malerei, Fotografie, Film (Painting, Photography, Film)*; original edition Munich 1925; reprinted Mainz 1967, p 37.

[73]Laszlo Moholy-Nagy, op cit.

[74]Paul Renner: *Mechanisierte Grafik (Mechanized Graphics)*, Berlin 1930, pp 124f.

[75]Franz Roh: *Foto-Auge (Photo-Eye)*, Stuttgart 1929.

[76]Werner Gräff: *Es Kommt der Neu Fotograf (The New Photographer Is Coming)*, Berlin 1929.

[77]Hans A. Kluge: *Foto in Farben (Photograph in Colour)*, Zwickau.

[78]Eduard von Pagenhardt: *Agfacolor, das Farbige Lichtbild (Agfacolor, the Colour Photograph)*, Munich 1938.

[79]Herbert Keppler: *The Asahi Pentax Way*, London 1973, p 12.

[80]*Die Entwicklung der Polaroid-Sofortbild-Photographie (The Development of Polaroid Instant Photography)*, in: *Camera*, Year 53, 1974, No 10, pp 11–53.

[81]Anna Farova: *Robert Capa*, Prague 1973, p 15.

[82]Martin Martincek: *Nezbadany Svet (Unexplored World)*, Bratislava 1964.

[83]Patrick Waldberg: *Der Surrealismus (Surrealism)*, Cologne 1965, p 68.

[84]L. Fritz Gruber: *Antlitz des Ruhmes (Face of Renown)*, Cologne 1960, p 70.

[85]Petr Tausk: *Mutual Influences between Photography and Painting*, in: *The British Journal of Photography Annual 1973*, London, pp 148–161.

[86]Herbert W. Franke: *Kunst und Konstruktion (Art and Construction)*, Munich 1957.

[87]Paul Konrad Hoenich: *Sonnenmalerei (Sun-Painting)*, Cologne 1974.

[88]Quotation from Hervert W. Franke und Gottfried Jäger: *Apparative Kunst (Art with Apparatus)*, Cologne 1973, pp 186ff.

[89]Karin Thomas, op cit, pp 144–146.

[90]Op cit.

[91]Gregory Battcock: *Minimal Art, a Critical Anthology*, London 1968, pp 175–179.

[92]Karl Pawek: *Totale Photographie (Total Photography)*, Olten 1960.

[93]Otto Steinert: *Uber die Gestaltungsmöglichkeiten der Fotografie (On the Creative Possibilities of Photography)*, in: *Subjektive Fotografie 2 (Subjective Photography 2)*, Munich 1955.

[94]Paul Ferdinand Schmidt: *Geschichte der Modernen Malerei (History of Modern Painting)*, Stuttgart 1952, pp 224ff.

[95]Heinz Neidel: *Robert Häusser—Magischer Realismus (Magical Realism)*, in: *Ausstellungskatalog des Instituts für Moderne Kunst (Exhibition Catalogue of the Institute for Modern Art)*, Nürnberg 1972.

[96]L. Fritz Gruber: Vorwort zu *Antlitz der*

Schönheit (Foreword to *Face of Beauty*), Cologne 1965.

[97] Philippe Halsman: *Halsman on the Creation of Photographic Ideas*, New York 1961, p 13.

[98] Rolf Gunter Dienst: *Pop-Art*, Wisebaden 1965, pp 16f.

[99] Rolf Gunter Dienst: op cit, p 13.

[100] David Antin: *'Pop'—Ein Paar Klärende Bemerkungen ('Pop'—A Few Explanatory Remarks)*, in: *Das Kunstwerk (The Work of Art)*, Year 12, 1966, Nos 10–12, pp 8 and 11.

[101] William C. Seitz: *The Art of Assemblage*, New York 1961, p 72.

[102] Andreas Feininger: *Die Welt Neu Gesehen (The World Seen Anew)*, Düsseldorf 1963, p 50.

[103] Cesare Brandi: *Le Due Vie (The Two Ways)*, Bari 1966, p 146.

[104] Cyril Barrett: *Op-Art*, Cologne 1974, p 10.

[105] Herbert Rittlinger: *Weitgereister Herr mit Linse (Far-Travelled Man with a Lens)*, Wiesbaden 1967, pp 152f.

[106] Zdenek Virt: *Op Art Akte (Op-Art Nudes)*, Hanau 1970.

[107] Quotation from Herbert W. Franke and Gottfried Jäger, op cit, pp 181–185.

[108] Karin Thomas: op cit, p 104.

[109] Karin Thomas: *Bis Heute: Stilgeschichte der Bildenden Kunst im 20 Jahrhundert (Till Now: History of the Style of Pictorial Art in the 20th Century)*, Cologne 1975, p 333.

[110] Op cit, p 338.

[111] Götz Adriani: *Klaus Rinke*, Cologne 1972, p 9.

[112] Duane Michals: *Chance Meeting*, Cologne 1973.

[113] Bernard Plossu: *Surbanalisme*, Paris 1973.

[114] Bill Brandt: *Persepectives of Nude*, London 1961.

[115] Sam Haskins: *Cowboy Kate and Other Stories*, London 1965.

[116] Petr Tausk: *The 'Objet Trouvé' in Photography—Its Significance and the Evolution of Its Use from Eugene Atget until the Present Day* in: 'Creative Camera', February 1977, No 152 pp 56–57.

[117] Petr Tausk: *Serendipity: 'Revue Fotografie 77'*, Vol. 21, 1977, No 3 pp 77–78.

[118] Yousef Karsh: *In Search of Greatness*, New York 1962, pp 181–184.

[119] L. Fritz Gruber: *Fame*, London 1960.

[120] Philippe Halsman: *Halsman Sight and Insight*, Garden City 1972.

[121] James Danziger and Barnaby Conrad III: *Interviews with Master Photographers*, London 1977, pp 115–116.

[122] Arnold Newman: *One Mind's Eye*, London 1974.

[123] August Sander: *Menschen ohne Maske*, Lucerne 1971.

[124] *August Sander—Photographer Extraordinary*, London 1975.

[125] *Diane Arbus—'Aperture' Monograph* Millerton 1972.

[126] Irving Penn: *Worlds in a Small Room*, London 1974.

[127] Richard Avedon: *Portraits*, New York 1976.

[128] *The Black Photographers' Annual*, New York 1973.

[129] *Maguban's South Africa*. Foreword by Ambassador Andrew Young, New York 1978.

[130] Karl Pawek: *Totale Photographie*, Olten 1960, p 168.

[131] Rita Maahs and Karl-Eduard von Schnitzler: *Vom Glück des Menschen*, Leipzig 1968.

[132] Gilbert M. Grosvenor: *A Look at Magazines in the 70's*, in R. Smith Schuneman: *Photographic Communication*, London 1972, pp 248–256.

[133] Mario De Biasi: *Personal Communication*.

[134] Dana Tausková: *Fotografie životního prostředí včera a dnes. (Photography of the Environment in the Past and To-Day)* Lecture held at the 'Fotoforum' in Ružomberok, Czechoslovakia, October 1978.

[135] Nathan Lyons: *Contemporary Photographers toward a Social Landscape*, Rochester 1966.

136Gyorgy Kepes et al.: *Arts of the Environment*, New York 1972, pp 3–4.

137Tom Hopkinson: *Felix H. Man*, in *British Journal of Photography*, 22nd October 1976.

138Bruce Davidson: *East 100th Street*, Cambridge, Massachusetts 1970.

139Arnold Newman: *Faces USA*, Garden City 1978.

140*La Famiglia Italiana in 100 Anni di Fotografia*, Milan 1968.

141Emmet Gowin, in: *The Snapshot*, Millerton 1974, p 8.

142Gerry Badger: *Singular Realities*, Newcastle upon Tyne 1977.

143Gianni Berengo-Gardin: *Venise des Saisons*, Lausanne 1965.

144Ed van der Elsken: *Sweet Life*, New York 1966.

145Robert Frank: *Les Américains*, Paris 1958.

146Robert Frank: *The Lines of My Hand*, Los Angeles 1972.

147Charles Harbutt: *Travelog*, Cambridge, Massachusetts 1973.

148Jill Freedman: *Circus Days*, New York 1975.

149Tony Ray-Jones: *A Day Off*, London 1974.

150Homer Sykes: *Once a Year—Some Traditional British Customs*, London 1977.

151Erskine Caldwell and Margaret Bourke-White: *Say, Is This the USA*, New York 1941, reprinted New York 1977.

152Weegee: *Naked City*, New York 1945, reprinted New York 1975.

153Jacob Riis: *How the Other Half Lives*, New York 1890, and 1901, reprinted New York 1971.

154Leonard Freed: *Black in White America*, New York 1968.

155Donald McCullin: *The Destruction Business*, London 1971.

156Philip Jones Griffiths: *Vietnam Inc.*, New York 1971.

157Gian Butterini: *Cuba 26*, Luglio, Milan 1971. *Cile venceremos*, Milan undated. *Dall' Irlandia dopo Londonderry*, Milan undated.

158Sláva Štochl: *Lovcovo jitro (Hunter's Morning)*, Prague 1973.

159Anna Fárová: *Henri Cartier-Bresson*, Prague 1958, p 19.

160Geoffrey Crawley: *Personal Communication*.

161Dušan Šindelář: *Esteika situací*, Prague 1976, p 89.

162Karl Pawek: *Personal Communication*.

163Alexander Liberman: *The Art and Technique of Color Photography*, New York 1951.

164Keld Helmer-Petersen: *122 Colour Photographs*, Copenhagen 1948.

165Walter Boje: *Magie der Farbenphotographie*, Düsseldorf 1961.

166Neal Slavin: *When Two or More Are Gathered Together*, New York 1974.

167Jiří Ksandr: *Personal Communication*.

168Samuel Lilley: *Men, Machines and History*, London 1965.

Ansel Adams

born 1902

American photographer who was originally a pianist, but at 28 exchanged the concert platform for a camera. His photographs are stylistically precise in composition of foreground and background, with horizontal and diagonal alignment. Using special tints, he carried out his own half-tone printing. He published several textbooks of photography and lectured at the California Institute for Fine Arts. Like Edward Weston, he was a member of the *f*64 Group.

This Is the American Earth San Francisco 1960. Co-author *Nancy Newhall*.

Death Valley and the Creek Called Furnace Los Angeles 1962. Co-author *Edwin Corle*.

The Tetons and the Yellowstone Redwood City 1970. Co-author *Nancy Newhall*.

Death Valley Redwood City 1970. Co-author *Nancy Newhall*.

Artificial-light Photography Dobbs Ferry 1971.

The Print Dobbs Ferry 1971.

Natural-light Photography Dobbs Ferry 1971.

The Negative—Exposure and Development Dobbs Ferry 1972.

Camera and Lens—the Creative Approach Dobbs Ferry 1974.

Singular Images New York 1974. Co-author *Liliane DeLocke*.

A Yosemite Album Redwood City 1974.

Images 1923–1974 Boston 1975. Foreword by *Wallace Stegner*.

Photographs of the South-West Boston 1976.

The Portfolios Boston 1977. Introduction by *John Szarkowski*.

Polaroid Land Photography Hastings-on-Hudson 1978.

Max Alpert

born 1899 Odessa

Russian photographer, who, after taking a course in photography, served in the Red Army from 1917 to 1924, and in 1924 became photoreporter for the *Workers' Newspaper*. From 1929 to 1931 he was photoreporter for *Pravda* and a member of ROPF (Russian Society of Proletarian Photographers). In 1931 *A Day in the Life of the Fillipow Family* was produced. During the Second World War, he was a photoreporter for *Tass*. Since 1959, he had been a reporter for Sovinformbyro, and latterly for the agency Novosti.

Sowjetische Fotographie 1928–32. Munich 1975 (Series Hanser 194). *Rosalinde Sartori/Henning Rogge*.

Max Alpert Moscow 1974. *R. Karmen*.

Russian War New York 1977, London 1978. *D. Mrazkova/V. Renies*.

James Craig Annan

born 1894 Glasgow

died 1946

British photographer, who composed his portrait photographs of well-known British personalities in the style of Impressionist paintings. From 1890, he made pigment prints from old negatives of David Octavius Hill.

Diane Arbus

born 1923 New York

died 1971 New York (suicide)
American photographer, who initially specialized in fashion, and studied under Lisette Model from 1959. In the sixties her photography concentrated on city subculture, and she took very sympathetic group photographs of the down-and-out, the ugly and the subnormal. In 1967 she participated in the exhibition 'New Documents' at the Museum of Modern Art, New York. In 1970–71 she lectured at the Rhode Island School of Design.
Diane Arbus Millerton, New York 1972. *M. Israel.*
Catalogue Stedelijk van Abbe-Museum, Eindhoven 1975.

Eugène Atget
born 1856 Libourne
died 1927 Paris
Frenchman who had several occupations (sailor, actor, painter) before turning to photography. His subjects influenced painters such as Utrillo, Derain, Vlaminck and Kisling. He became particularly famous for his photographic documentation of Paris, and for his equally profuse architectural scenes. He had an insight into the hidden poetry of things, and his creative worth was not discovered by the Surrealists until a short time before his death.
Photographs de Paris Leipzig and Paris 1930. Introduction by *Camille Recht.*
Eugène Atget. Prague 1963. *Berenice Abbott.*
The World of Eugène Atget New York 1965. *Berenice Abbott.*
Lichtbilder Munich 1975. Introduction by *G. Forberg* and *Camille Recht.*
Eugène Atget, Magicien du Vieux Paris en Son Epoque Paris 1976. *Jean Leroy.*
Das Alte Paris Cologne 1978. Introduction and text by *C. B. Rüger, R. E. Martinez, G. Freund* and *K. Honnef.*

Richard Avedon
born 1923
Freelance photographer living in USA. Specialist in fashion, advertising and portrait photography. He enriched studio photography with a dynamic representation of movement. He contributed to *Harper's Bazaar* and later to *Vogue.*
Observations London 1959. Co-author *Truman Capote.*
Nothing Personal Harmondsworth 1964. Co-author *James Baldwin.*
Portraits New York 1976. *Harold Rosenberg.*
Photographs 1947–77 New York 1978. *Harold Brodkey.*

David Bailey
born 1938
British photographer taking an interest in fashion, portrait and journalism. He was assistant to John French for 11 months in 1959. From 1960 contributed to *Vogue.* He published photographs in *The Sunday Times, The Daily Telegraph, Elle* etc. In his books he often included his realistic portraits as well as creative reportage.
Box of Pin-Ups London 1965.
Beady Minces London 1973.
Another Image: Papua New Guinea London 1975.

Dmitry Baltermans
born 1912
Received degree in mathematics from University of Moscow, but followed this profession for only one year. Since then he preferred to act as photoreporter for the newspaper *Izvestija.* During the Second World War he became one of the best-known war reporters. In peacetime he became chief reporter of the weekly *Ogonok.* Apart from the USSR, he had personal exhibitions in London 1964, New York 1965, Rome 1969, Prague 1970, Nicosia 1971, West Berlin 1972, Budapest 1973, Tampere 1974, Brussels 1974, Antwerp 1974 and Sarajevo 1976.
Russian War New York 1977, London 1978. *D. Mrazkova/V. Remes.*

Selected Photographs Moscow 1977.
Introduction by *Vasilij Peskov*.

Rudolph Balogh
born 1879
died 1944
Hungarian photoreporter. Started taking photographs at age of 14. Opened studio in Budapest in 1912. During First World War worked as photoreporter in the Army. After the war he contributed to the evening newspaper *Az Est*. He especially favoured themes of country life, landscapes and the open plains (Puszta).
Munkassaga Budapest 1969. *Ernö Vajda*.

Herbert Bayer
born 1900 Haag, Austria
After military service in First World War, became an apprentice in Schmidthammer's architecture and decorative arts studio in Linz. Subsequently he studied under Kandinsky at the Bauhaus in Weimar; he became a teacher in typography and layout at the Bauhaus in Dessar, 1925–28. There he took an interest in photography and especially in photomontage. He moved to America in 1938, and has lived there since then.
The Way beyond Art—the Work of Herbert Bayer New York 1947. *Alexander Dorner*.
Das Werk des Künstlers in Europa and USA Ravensberg 1967.
Herbert Bayer Un Concepto Total Mexico 1975. *Prampolini/Ida Rodriguez*.

Cecil Beaton
born 1904 London
British photographer, illustrator, stage and costume designer, author and compiler of numerous books, such as *Cecil Beaton's Scrapbook*, *The Face of the World*. He has photographed nearly all the famous personalities in the political and cultural circles of Britain, France and America, with his very personal interpretation. From 1928 he was star photographer for *Vogue*, and from 1937 he was official court photographer to the British Royal Family. He was knighted in 1972.
The Book of Beauty 1930.
Cecil Beaton's Scrapbook 1937.
Portrait of New York 1938.
My Royal Past 1939.
Face to Face with China 1945. Co-author *Harold Rattenburry*.
The Glass of Fashion 1954.
The Face of the World 1957.
Quail in Aspic 1962.
Images 1963. Introduction by *Christopher Isherwood*.
Royal Portraits 1963.
The Best of Beaton 1968. *Truman Capote*.
Beaton Portraits 1968.
Cecil Beaton—Stage and Film Designs London and New York 1975. *Charles Spencer*.

Bernd and Hilla Becher
born 1931 Seigen (Bernd)
born 1934 Potsdam (Hilla)
German photographers, who undertook the task of photographically documenting industrial plants of the 19th and 20th centuries (water-towers, mine-shafts, scaffolding). Numerous exhibitions both within Germany and abroad, e.g. Sao Paulo Biennial 1977.
Anonyme Skulpturen Düsseldorf 1970.
Die Architektur der Förder—und Wassrtürme Munich 1971.
Vergleiche Technischer Konstruktionen, Katalog Aachen 1971.
Katalog London 1974.
Bernd & Hilla Becher: Zeche Zollern 2 Munich 1975. *H. G. Conrad/E. Neumann*.
Bernd & Hilla Becher, Fotografien 1957–75 Cologne/Bonn 1975. *Klaus Honnef*.
Fachwerkhäuser des Siegener Industriegebiets Munich 1976.
Industriebauten Munich (undated).

Hans Bellmer
born 1902
Bellmer began to make dolls with a Surrealist appearance in Berlin in 1932; he photographed these subjects and accentuated the Surrealist qualities in the pictures. He became well-known in France through his photographs, which were reproduced in *Minotaure* in 1935. He moved from Germany to France in 1938.
Photography as Art London 1974. *Volker Kahmen.*

Gianni Berengo-Gardin
born 1930
Italian freelance photographer. He started to take photographs as an amateur while living in Venice. He moved to Milan, and opened a studio there for advertising photography in 1964. He was also attracted to live photography; he produced picture stories for various journals, and also several books. He was one of the exhibitors in 'The Concerned Photographer—Gruppo Italiano'.
Venise des Saisons Lausanne 1965.
 Introduction by *Giuliano Manzutto.*
L'Occhio Come Mestiere Milan 1970.
 Introduction by *Cesare Columbo.*

Werner Bischof
born 1916 Zurich
died 1954 South America (accident in the Andes while travelling through Peru and Chile)
Swiss photographer who studied at Zurich Institute for Arts and Crafts. From 1942 he worked on the magazine *Du*. From 1945 he was a war correspondent, reporting from France, Germany and the Netherlands, and also sending reports from Italy and Greece. In 1948 he reported from the Olympic Games for the magazine *Life*. In 1949 he became a member of the 'Magnum' group. For *Life* he reported from Japan, Korea, Hong Kong and Indochina in the early fifties.

Du Special Numbers: 5, 1946; 6, 1949; 7, 1953.
Fotos von Werner Bischof 1959. *Gasser.*
Querschnitt, Meisterfotos Zurich 1961.
Werner Bischof 1966. *Anna Fárová.*
Werner Bischof 1973. *Flüeler.*
Werner Bischof 1916–54 New York 1974. Editor *R. Burri.*
Grosse Photographen unserer Zeit: Werner Bischof Lucerne 1975. Co-authors *Flüeler/Niklaus.*

John Blakemore
born 1936 Coventry
John Blackmore was encouraged to photograph by seeing Steichen's 'Family of Man' exhibition. He first photographed as an amateur while serving in the RAF. He then worked as a professional freelance photographer. Since 1970 he has been a lecturer in photography at Derby College of Art and Technology. He now favours the photography of nature, with a contemplative attitude in his choice of motifs.
British Image 3 London 1977.
 Introduction by *Gerry Badger.*

Karl Blossfeldt
born 1865 Schielo/Harz
died 1932 Berlin
After a course in modelling at an art workshop, Blassfeldt studied at the Berlin Institute of Arts and Crafts and at the Leipzig Academy. Inspired by his travels in Italy, Greece and North Africa, he began to collect and prepare plants, and to take photographs of them, which he used from 1898 as models in his work as lecturer in the modelling department of the Berlin Educational Institute of the Museum of Arts and Crafts. In 1900 he took his first series of photographs of plants, and in 1928 the book *Urformen der Kunst* was published, followed in 1932 by *Wundergarten der Natur*.
Urformen der Kunst 1928.
Wundergarten der Natur 1932.
Wunder in der Natur 1942. *Dannenberg.*

Portfolio Karl Blossfeldt 1975. *Kahmen/
Wilde.*
Katalog Karl Blossfeldt, Fotografien 1900–32
Cologne 1976. *Klaus Honnef.*

Irena Blühova

born 1904
Irena Blühova studied at the Bauhaus in
Berlin under Peterhans. After returning to
Czechoslovakia she took an interest in
socio-critical photography, and became a
member of the 'Sociofoto' group in Bratis-
lava. During the Nazi occupation she
worked for the Resistance. After the Second
World War she became the director of a
publishing house.
SocialnaFotografia ne Slovensku Bratislava
1974. *L. Hlavac.*

Walter Boje

born 1905
German photographer and journalist, spec-
ializing in colour photography. In 1961 he
published the innovatory book *Magie der
Farbenfotografie (Magic of Colour Photo-
graphy).* Lives in Leichlingen, near Cologne.
Magie der Farbenfotografie. Düsseldorf 1961.

Walter Bosshard

born 1892 Samslagern (near Zurich)
Swiss photographer, who first studied the
science of teaching and art history. In the
early twenties he travelled to Sumatra,
Siam, India and the Far East, and in 1927
he went on a two-year expedition to Tibet.
He became associated with the interpreta-
tion of photographic travel documents.
In 1930 he went on a further expedition to
India and China for the *Müncher Illustrierte
Presse* and met the Chinese political leaders
Chiang Kai-Shek and Mao Tse-Tung, and
this established his reputation as an expert
on China. In 1932 he participated in the
Artic flight of the Zeppelin airship. From
1939 he travelled to the Balkan States and
the Near East for the *Neue Zürcher Zeitung,*
and he was present at the founding of the

UN in 1945. His photographic activity
came to an end after an accident in Korea
in 1953.
Durch Tibet und Turkestan 1942.
Indien Kämpft.
Grünes Grasland Mongolei.
*Deutschland—Beginn des Modernen
Photojournalismus* Lucerne/Frankfurt
1972. *Tim N. Gidal.*

Eduard Boubat

born 1923 Paris
Boubat studied originally at the École
Estienne, and specialized in photogravure.
After the Second World War he worked in
a xylographic studio, and began to photo-
graph during weekends. His main interest
was in the lives of people. Since 1953 he
worked for the journal *Réalités.*
Ode Maritime Tokyo 1957.
*Moderni Francouzska Fotografie (Modern
French Photography)* Prague 1966. *J. A.
Keim.*
Eduard Boubat Lucerne 1972. *George
Bernard.*
Women Henley-on-Thames 1972.
Anges Paris 1974.
L'Art du Mithila Paris 1976. Co-author
Yves Vequand.

Margaret Bourke-White

born 1904 New York
died 1971 Connecticut
American photographer who studied at
various universities. She was a leading
photoreporter, and worked for *Life* from
1935. In 1942 she became a war reporter.
Her pictures of the liberated Buchenwald
concentration camp are famous, as are her
pictures on India and Gandhi's non-
violent resistance. In 1952 she went to
Korea. She had to give up her work in
1956 because of ill-health.
The Story of Steel 1928.
Eyes on Russia 1931.
USSR Photographs 1934.
You Have Seen Their Faces 1939. *Caldwell.*

Say, Is This the USA? 1941.
Shooting the Russian War 1942.
Half-Way to Freedom 1949.
Portrait of Myself 1963.
The Photographs of Margaret Bourke-White
 1972. *Sean Callahan.*
Margaret Bourke-White Catalogue Ithaca
 1972.

Anton Giulio Bragaglia
born 1890 Frosinone
died 1960 Rome
Italian author, theatre producer and film
director. He published a manifesto on the
future of photography entitled *Fotodina-
mismo Futurista.*
Manifesto, Fotodinamisto Futurista Rome
 1912, reprinted Turin 1970.
Malerei und Photographie im Dialog
 Kunsthaus Zurjch 1977.

Bill Brandt
born 1904
British freelance photographer. Brandt was
assistant to Man Ray from 1929 to 1931,
and found the artistic atmosphere of Paris
very exciting. When back in England
during the thirties, he took an interest in
live photography; he took important photo-
graphs of miners in their environment as
well as in London's East End. He also en-
hanced the journalistic approach to the
portrait. Thanks to his contacts with the
French avant-garde during his stay in
Paris, Brandt was able to discover Surrealist
features in everyday reality, and he often
connected this with live photography and
journalistic portraiture. At the beginning
of the forties, he photographed people
sheltering in the Tube during air-raids, as
well as destruction after bombing. At about
the same time he photographed the stone
circles at Avebury and Stonehenge, show-
ing the fifties feeling for the magical features
of these phenomena. During the fifties
Brandt photographed nudes using new
perspective approaches. In addition to
taking photographs, he also constructed
compositions of real objects. He acted as a
visiting lecturer at the Royal College of Art
in London.
The English at Home London 1936.
A Night in London London 1938.
Camera in London London 1948.
Literary Britain London 1951.
Perspectives of Nudes London 1961.
Shadow of Light London 1966 and 1967.

Brassai
born 1899 Kronstadt/Siebenbürgen
Brassai (whose real name was Gyula
Halasz) studied in Budapest and Berlin,
and established himself as a painter and
journalist in Paris in 1923. Since then he
has occupied himself with photography.
His publication of *Paris by Night* (1933)
made him world-famous. His night photo-
graphs of the underworld and demi-
monde of Paris, with their eccentric char-
acters and establishments, are now re-
garded as milestones in the portrayal of
reality by photography. From 1932 to 1938
he took his 'graffiti' photographs, pictures
of trivial signs scratched on walls in
disreputable streets, which Brassai regarded
as a hybrid art and portrayed them in all
their poetic, ritual strength. Brassai was a
close friend of Picasso, Braque, Breton,
Eluard, Henry Miller and Salvador Dali.
Volupté de Paris 1935.
Trente Dessins Paris 1946. With a poem by
 Jacques Prévert.
Camera in Paris London 1949.
Histoire de Mari Paris 1949 Introduction by
 Henry Miller.
Seville en Fête Paris 1954.
Graffiti : Zwei Gespräche mit Picasso
 Stuttgart/Berlin/Zurich 1960.
Picasso & Co. London 1967.
Brassai New York 1976. Co-author
 Lawrence Durrell.
Das Geheime Paris—Bilder der 30er Jahre
 Frankfurt 1976.

Denis Brihat

born 1928 Paris

French photographer showing deep understanding of poetic features of reality. In 1950 he started to take photographs for *Monuments Historiques*. In 1955 and 1956 he was travelling in India. He received the 'Prix Nièpce' in 1957. He always had a high regard for the photographic original, and for this reason mounted numerous exhibitions of his work.

Un Citron (album containing 18 prints)
 Bonnieux 1964.
Moderni Francouzska Fotografie Prague 1966.
 J. A. Keim.
Photographies Denis Brihat Paris 1972.
 Jean-Pierre Sudre.

Wynn Bullock

born 1902 Chicago
died 1975

American freelance photographer. Bullock originally prepared himself for a career as a concert pianist. In 1928 he became interested in photography, but still studied music. During the forties he tried to make a living as a commercial and portrait photographer. He made experiments with unconventional laboratory techniques. After meeting Edward Weston in 1948, he ceased his experimentation and began to find his way to 'straight photography'. In 1955 some of his photographs were accepted as a contribution to the 'Family of Man' exhibition. As a freelance photographer in the fifties and sixties, Bullock achieved significant results in landscape and nature work. In some cases his compositions approached abstraction.

The Widening Stream 1965. Text by
 Richard Mack.
Wynn Bullock 1971. *Barbara Bullock.*
Wynn Bullock Photography, a Way of Life.
 Dobbs Ferry 1973. *Barbara Bullock-
 Wilson.*
The Photograph as Symbol 1976.
Wynn Bullock London 1976. *David Fuess.*

Larry Burrows

born 1926
died 1971

British photojournalist, particularly known through his war reports from Vietnam, where he finally lost his life.

Henry Callahan

born 1912

American photographer and teacher of photography. From 1946 Callahan was an instructor at the Institute of Design in Chicago, and in 1961 he became head of the Photographic Department at the Rhode Island School of Design. His own work was closely associated with avant-garde art; the composition in many of his best-known photographs resembles abstract painting.

Henry Callahan New York 1967. *Paul
 Sherman.*
Henry Callahan Millerton 1976. *John
 Szarkowski.*

Bryn Campbell

born 1933

British photographer working with the press. After years of work for *The Observer*, he started as a freelance photographer, through 'Magnum' in 1972. Campbell is a Trustee of the 'Photographers' Gallery' in London.

British Image 1 London 1975.

Cornell Capa

born 1918 Budapest

Brother of Robert Capa, and, like him, combining a feeling for actuality with a deep humane sympathy. In 1936 he financed his medical studies in Paris by processing the photographs his brother had taken during the Spanish Civil War. In 1937 he went to the USA and became a photographer for the magazine *Life*. After his brother's death in Indochina in 1954,

Cornell took over his work at Magnum Photos and also worked as a photojournalist for many international illustrated magazines.

Robert Capa

born 1913 Budapest
died 1954 Indochina
Robert Capa (whose real name was Anfrei Friedman) studied in Berlin, where he worked as a photographic assistant until he fled from the Nazis. In 1933 he went to Paris. He became a war correspondent in the Spanish Civil War in 1936, and in China after the Japanese invasion in 1938. During the Second World War he worked for the magazine *Life* in the theatres of war in Europe, and in 1948 he reported on the war in Palestine. In 1947 he helped found Magnum Photos in New York.
Death in the Making 1937.
The Battle of Waterloo Road 1943. *Forbes-Robertson.*
Slightly out of Focus 1947.
The Russian Journal 1948. *Steinbeck.*
Report on Israel 1950. *Shaw.*
Images of War 1964.
Robert Capa Prague 1913. *Anna Farova.*
Robert Capa 1913–54 New York 1974. *Cornell Capa/B. Karia.*

Henri Cartier-Bresson

born 1908 Chanteloup
French production assistant of the film director J. Renoir, 1937–38. Cartier-Bresson was a founder-member, with R. Capa and D. Seymour, of the society 'Magnum Photos'. He exhibited at the Museum of Modern Art in New York in 1946, in London in 1955, and in Paris and New York in 1967. On his world tours he took excellent photographs which captured the life and nature of the people, together with the atmosphere of their environment.
The Photographs of Henri Cartier-Bresson 1947. *Kirstein.*
Images à la Sauvette 1952.

Les Européens 1955.
D'Une Chine à l'Autre 1955.
Moscou 1955.
Henri Cartier-Bresson. Prague 1958. *Anna Farova.*
Danses à Bali 1960.
Photographies 1963.
Vive la France Paris 1970. Co-author *F. Nourissier.*
The Face of Asia 1972. *Shaplan.*
All About Russia.
Images of Man 2/4 New York 1975.

Jean-Philippe Charbonnier

born 1921 Paris
French photographer interested mainly in live photography. In 1944 he started to work for the newspaper *Libération*. In 1950 he became a member of the staff of the well-known monthly journal *Realités*, and this gave him opportunities to report from almost all over the world. He worked with *Realités* until 1974. Since 1976 he has taught photography at L'Ecole Superieure d'Arts Graphiques in Paris. He took part in workshops at the College of Art and Technology in Derby in 1976, 1977 and 1978.
Les Chemins de la Vie 1957. Introduction by *Philippe Soupalt.*
Un Photographe Vouse Parle Paris 1961.
107 Photographiesen Noir et Blanc, 1945–71 Le Havre 1972.
Six Albums sur le Maroc 1968–73.

Chargesheimer

born 1924 Cologne
died 1972 Cologne
From 1955 he worked as a freelance photographer. He had a special liking for portraiture. He became known for his self-willed, unusually bold interpretation of portrait composition, and also for his volumes of photographs of Cologne and the Ruhr.
Cologne Intime Cologne 1957.
Unter Krahnenbäumen Cologne 1958.
Im Ruhrgebiet Cologne 1958.

Romanik am Rhein Cologne 1959.
Zwischenbilanz Cologne 1961.
Köln 5 Uhr 30 Cologne 1970.

Paul Citroen
born 1896
German painter, graphic artist and photographer, who joined the Dadaists in Berlin in 1919 and became known for his excellent city photomontages and photocollages. His works were based on the theme of the city, and reached their peak in his 'Metropolis Variation' of 1923. Citroen worked in close cooperation with the Dutch photographer Erwin Blumenfeld, from whom he took over the collage process for photographs and postcards.
Die Geschichte der Collage Cologne 1974.
 Hertha Wescher.
Paul Citroen Bielefeld 1978. Introduction
 by *Michael Pauseback.*

Alvin Langdon Coburn
born 1882 Boston
died 1966
American photographer who lived and worked in England. He became famous for his 'Vortographs', which had an abstract effect, and were produced with the aid of three mirrors placed to form a triangle.
Alvin Langdon Coburn—Photographer London
 1966 An autobiography, with
 introduction by *Alison* and *Helmut
 Gernsheim.*

Van Deren Coke
born 1921 Lexington
American photographer, teacher and historian of photography. Van Deren Coke began to take photographs in 1936. He attended summer classes at the Clarence White School of Photography in 1941. He received an MFA in art history and sculpture at Indiana University in 1958. Appointed Associate Professor at Arizona State University to teach photography and art history in 1961. Appointed Head of the Department of Art at University of New Mexico and immediately promoted to rank of Professor in 1963. He became Director of the International Museum of Photography in Rochester in 1971. In 1972 he returned to the University of New Mexico as Director of the Art Museum and Professor of Art.

*The Painter and the Photograph—from
 Delacroix to Warhol* Albuquerque 1972
Photographs 1956–73 Albuquerque 1973
 Introduction by *Henry Homes Smith* and
 Gerald Nordland.

Cesare Colombo
born 1935 Milan
Italian freelance photographer. Colombo started to study economics, but soon realized that his ambition was to be a professional photographer. From 1957 to 1963 he directed the Public Relations department of Agfa in Milan. Since 1963 he has been a freelance photographer and part-time teacher of photography at the school of the 'Societa Umanitaria'. Edited the journal *Foto-Film* between 1965 and 1968. He exhibited at 'The Concerned Photographer—Gruppo Italiano' in 1973.
Le Prealpi Varesine Rome 1964. Co-author
 Piero Chiara.
Architetto Giancarlo de Carlo Milan 1964.
 Co-authors *Vittorio Sereni/Carlo Boa* and
 Egidio Mascioli.
Francesco Negri Fotografo a Casale Milan
 1969.

Thomas Joshua Cooper
born 1947
American photographer and teacher of photography living in Britain. Received degree of MA in photography at University of New Mexico in 1972. His nature photographs have an atmosphere approaching very near to 'Magical Realism'. He is Senior Lecturer in photography and the history of photography at Trent Polytechnic in Nottingham.

Pierre Cordier

born 1933 Brussels

Belgian photographer who initially studied politics and administration at Brussels University. In 1956 he created his first 'Chimigram', and he then completed a practical course at Otto Steinert's school in Saarbrücken. Since 1965 he has been lecturing at the 'Ecole Nationale Superieure d'Architecture et d'Arts Visuels' in Brussels. He is a member of the 'Deutsche Gesellschaft für Fotographie'.

Catalogue: Foto Galerie 'Die Brücke' Vienna 1973.

Peter Cornelius

born 1913 Kiel
died 1970 Kiel

German photojournalist who became known for his unconventional colour photography.

Magie der Farbenphotographie Düsseldorf 1961. *Walter Boje.*

Gerry Cranham

born 1929 Farnborough

British photojournalist showing a special interest in photographing sport. Cranham was originally an athlete, and thus he has a personal understanding of his chosen theme.

Imogen Cunningham

born 1883
died 1976

American photographer. After receiving a qualification in chemistry at the University of Washington, she took up a post at the Curtis Studio in Seattle. She opened her own studio in Seattle in 1910. Apart from her commercial activity, she created some outstanding work, in which was to be seen the evolution of the romantic, impressionistic approach to the 'New Objectivity'. She was a member of Group *f*64.

Photographs Seattle 1970. Introduction by *Margery Mann.*

Bruce Davidson

born 1933 Oak Park, Illinois

American photographer. Studied photography at Rochester Institute of Technology, and then philosophy and graphic arts at Yale University. Became a member of 'Magnum'.

Contemporary Photographers toward a Social Landscape New York 1966. *Nathan Lyons.*

East 100th Street Cambridge, Massachusetts 1970.

George Davison

born 1856
died 1930

British amateur photographer of great significance. First defended Emerson's Naturalistic Photography, and later propagated an impressionistic approach towards creation of images resembling paintings. Davison played an important role in the forming of Kodak Ltd in Britain; he was Managing Director from 1901 to 1907.

Ger Dekkers

born 1929 Borne (Netherlands)

Dutch graphic artist who studied at Academy of Arts in Enschede from 1950 to 1954. Since 1972 he has been assembling photosequences of Dutch landscapes in which the foreground of each picture alters but the horizon remains the same. The sequences have a common element as a result of the horizon being placed horizontally in the middle of each square picture. The camera position is moved laterally each time, and always by the same distance. This makes a natural landscape seem artificial.

Catalogue Ger Dekkers Galerie M, Bochum 1976.

Catalogue Ger Dekkers Kröller-Müller Museum, Otterlo 1977.

Robert Demachy

born 1859
died 1938

French amateur painter and photographer, who wrote theoretical works on photography. His photographs show the influences of painting and Impressionism.
Robert Demachy—Photographs and Essays London 1974. Co-author *Bill Jay*.

Jean Dieuzaide
born 1921 Grenade-sur-Garonne
French photographer, known for his poetic approach towards reality. In 1955 he received the Prix Nièpce, and in 1961 the Prix Nadar.
Mon Aventure avec le Brai Toulouse 1974.
Introduction by Jean Claude Lemagny.

Robert Doisneau
born 1912 Gentilly
French photographer, interested in reportage. Doisneau studied lithography at the École Éstienne in Paris. After the Second World War he became a freelance photographer, contributing to many well-known journals. He showed a lively understanding of the visual comic situation in his photographs.
Le Paris de Robert Doisneau Paris 1974.
Text by *Max-Paul Fouchet*.
Robert Doisneau Nantes 1975. Introduction by *Robert Giraud*.

Terence Donovan
born 1936
British fashion photographer. Donovan worked as an assistant to John French in 1956. He soon found his own way, and began contributing to *Vogue* and *Elle*. He became one of the best-known creators of top fashion photographs. He also contributed to television.

Frantisek Drtikol
born 1883 Pribam (Czechoslovakia)
died 1961 Prague
Czechoslovak photographer who studied in Munich. His allegorical compositions were influenced by modernism and symbolism.

Frantisek Drtikol Katalog
Kunstgewerbemuseum Prague 1972.
Anna Farova.

Brian Duffy
born 1933
British fashion photographer. Duffy began his career as an assistant to John French. He later contributed to *Vogue* and some other fashion journals.

David Douglas Duncan
born 1916 Kansas City
American photographer who, after studying archaeology, became interested in deep-sea diving and hence underwater photography. In 1938 he went on expeditions to Chile and Peru as correspondent, photographer and art historian. In 1945 and 1946 he worked as a photojournalist in Korea, Indochina and Palestine. From 1956 to 1959 he collected an extensive photographic report in colour on Moscow. In 1957 he spent a few months with Picasso, which resulted in the publication of '*The Private World of Pablo Picasso*'.
This Is War 1951.
The Private World of Pablo Picasso 1958.
The Kremlin 1960.
Portfolio Lausanne 1972.
Prismatics Düsseldorf 1973.
Goodbye Picasso New York 1974.
The Silent Studio London 1976.

Harold E. Edgerton
born 1903 Fremont, Nebraska
American scientist, who was able to use his own inventions for creative experiments in photography. Edgerton was Professor of Electrical Engineering at the Massachusetts Institute of Technology. He developed the stroboscope flash unit, with which he was able to take unusual photographs of successive phases in the movement of objects.

Josef Ehm
Czechoslovak freelance photographer and

teacher of photography. He learnt photography as an apprentice in a portrait studio. In 1934 he was appointed teacher in the State School of Graphic Art in Prague. In the thirties he was influenced by the 'New Objectivity' and by Surrealism, and these trends formed a synthesis leading to his discovery of poetry in reality. As a freelance photographer he then took a great deal of interest in pictures of historic monuments and architecture. He prepared numerous books showing the beauty of Prague and of Czechoslovak castles.
Josef Ehm Prague 1961. *Jiri Masin.*

Alfred Eisenstaedt
born 1898 Dierschau
After first working purely as an amateur photographer, Eisenstaedt became a professional reporter in 1927, when his works were published in *Weltspiegel*. His first major commission was to photograph Thomas Mann being presented with the Nobel Prize in 1927. After six years of successful photojournalism for big European and American papers, he went to the USA in 1936 and worked for the magazine *Life*. Many of his photographs of statesmen, stars of screen and stage, famous authors, scientists and musicians featured on the cover of this publication, but he also photographed American activities during the Second World War. His 3500 negatives of the Abyssinian campaign are world-famous. He has received many awards.
The Eye of Eisenstaedt London 1969.
Witness to Nature London 1971.
Deutschland—Beginn des Modernen Photojournalismus Lucerne/Frankfurt 1972. *Tim N. Gidal.*
Panoptikum Lucerne/Frankfurt 1973.
Martha's Vineyard New York 1975. *H. B. Hough.*
Alfred Eisenstaedt's Album London 1976.

Hugo Erfurth
born 1874 Halle
died 1948 Gaienhofen, Lake Constance
German photographer, who, after studying art at the Dresden Academy of Arts, practised an artistic/impressionistic style of photography around the turn of the century. In the twenties he was one of the leading figures in psychological portraiture. His studio in Dresden became a meeting place for artists.
Meister der Kamera Erzählen Halle 1937. *Wilhelm Schöppe.*
Bildnisse Gütersloh 1961. *Otto Steinert.*
Museum Folkwang: Bildnisse Hugo Erfurth Essen 1961.
Hugo Erfurth der Altmeister der Deutschen Porträtfotografie In 'Modern Fototechnik', June 1971. *Martin Hansch.*
Hugo Erfurth der Fotograf der Goldenen 20er Jahr Munich 1977. *Bernd Lohse.*

Elliot Erwitt
born 1928 Paris
American photographer interested in live photography. Erwitt grew up in Hollywood, and in 1948 moved to New York, where he took portraits of authors for book jackets. In New York he met Edward Steichen, Roy Stryker and Robert Capa, and they influenced his development. In 1953 he joined 'Magnum', of which he later became president. Assignments for various journals and advertising agencies enabled him to travel all over the world.
Photographs and Antiphotographs London 1972.
The Private Experience London 1974. Text by *Sean Callahan.*
Son of Bitch London 1974.
Recent Developments New York 1978. Introduction by *Wilfrid Sheed.*

Frederick H. Evans
born 1852 London
died 1943

An experienced bookseller, Evans became famous in the 1890's for his photographs of English cathedrals and French chateaux. He printed all his photographs on platinotype paper. After the First World War, when this type of paper was no longer available, he gave up photography.
Frederick H. Evans New York 1973.
 Beaumont Newhall.

Walker Evans

born 1903 St Louis
died 1975 New Haven
American photographer. He initially studied philology at various colleges in America, and in 1926 studied at the Sorbonne in Paris. In 1928 he decided to take up photography, and in the thirties devoted himself to the architecture of the southern states of America and also to Black African art. Later he took photographs of cotton-pickers and farmers of the southern states for the Farm Security Administration. From 1945 he was editor of the magazine *Fortune* until he became a lecturer at Yale university in 1965.
The Crime of Cuba 1933.
African Negro Art 1935. *Sweeny.*
American Photographs 1938. *Kirstein.*
Let Us Now Praise Famous Men 1941. *Agee.*
The Mangrove Coast 1942. *Bickel.*
Many Are Called—Subway Portraits 1966. *Agee.*
Message from the Interior 1966. *Szarkowski.*
Walker Evans. New York 1971. *Szarkowski.*
Photographs for the Farm Security Administration, 1935–38 New York 1973.
American Photographs New York 1975.
Walker Evans at 'Fortune', 1945–65 Boston 1977. *Leslie K. Baier.*
First and Last New York 1978.

Andreas Feininger

born 1906
American photographer and writer of books on photography. Feininger was born in Germany, where his father, the well-known painter Lyonel Feininger, was teaching at the Bauhaus. He started to study the design of furniture at the Bauhaus. After a short period during which he took photographs of architecture, he moved to America in 1939. After being associated with photographic agencies he began to work for the weekly magazine *Life*. Feininger was a very gifted photographer with a clear sense of the correct use of technique; this was to be seen especially in his photographs taken with lenses of extreme focal lengths. He wrote several books on photography, which became very popular and were translated into several languages.
The Face of New York New York 1954.
Changing America New York 1955.
The Complete Photographer London 1965.
The Complete Colour Photographer London 1969.
Andreas Feininger Dobbs Ferry 1973. Co-author *Ralph Hattersley.*
The Perfect Photographer London 1976.

Erwin Fieger

born 1928 Töplei (Czechoslovakia)
German photographer of Czechoslovak origin, who followed various professions after the Second World War until he was able to attend the Stuttgart Academy of Arts. In 1960 he took part in the 'Magic of Colour' exhibition. He became known for his commercial and photographic activity for Lufthansa, for his photographic reports of world tours, and for his sport photoreportage.
Farbiges London 1962.
Grand Prix 1963.
13 Photo Essays.
Japan—Sunrise Island 1971.
Sapporo 1972.
München 1972.
Mexico 1973.

Robert Frank

born 1924
Swiss photographer, specializing in por-

trayal of everyday life and the despair of people in their anonymous environments—more or less representing the opposite point of view to that of Cartier-Bresson after the Second World War. Frank worked as a fashion photographer for *Harper's Bazaar*. His book *The American* (1969) was composed of photographs taken during a visit to America in 1955.

The American 1969.
Robert Frank London 1976. Introduction by *Rudolph Wurlitzer*.

Herbert W. Franke

born 1927 Vienna
Austrian scientist and journalist who studied physics, chemistry, psychology and philosophy at the University of Vienna. After working on scientific research for industry, he became a freelance technical writer in 1956, and experimented in radiography and light-graphics.

Apparative Kunst—Vom Kaleidoscope zum Computer Cologne 1973. Co-author *Gottfried Jäger*.

Leonard Freed

born 1929
American photographer interested in a humanitarian approach to current problems of mankind. Represented in the exhibition 'The Concerned Photographer'.

Black in White America New York 1968.
Leonard Freed's Germany London 1971.

John French

born 1907
died 1966
British fashion photographer of key significance. French was originally an engraver and block-maker, and this experience assisted him in coming to a clear opinion as to the essential properties of a photograph for good reproduction on the printed page. His advanced technical knowledge prepared the way for his revolutionizing of fashion photography. He be-

came important not only through his own work, but also as a teacher of some of the younger British fashion photographers who initially acted as his assistants.

Gisele Freund

born 1912 Berlin
German photographer who studied sociology and aesthetics in Frankfurt, where she met Walter Benjamin in 1932. In 1933 she fled from Germany to Paris, where in 1936 at the Sorbonne she wrote a dissertation on the history of photography. In 1936 she started work on her series of portraits of artists and writers, which were published in *Life*. From 1947 to 1954 she was a member of 'Magnum Photos', and has mounted many exhibitions since 1963. She now lives in Paris. She received the Cultural Prize of the 'Deutsche Gesellschaft für Photographie' in 1978.

Photographie und Bürgerliche Gesellschaft Munich 1968.
The World in My Camera New York 1974.
Photographie und Gesellschaft Munich 1976.
Katalog GF: Landesmuseum Bonn 1977.
Mémoirs de l'Oeil Paris 1977.

Semen Osipowitsch Friedland

born 1905 Kiev
Russian photographer who worked as photoreporter, editor and head of the 'Department of Work for the Masses' at Unionfoto. He was a contributor to the magazine *Building the USSR*. From 1933 he undertook photoreporting for *Pravda*. In 1935 he became head of the Moscow Association of Photoreporters.

Sowjetische Fotografie 1928–32 (Series Hanser 194) Munich 1975. *Rosalinde Sartorti/Henning Rogge*.

Lee Friedlander

born 1934 Aberdeen (Washington)
American photographer who became famous for his pictures of towns and streets. Lives in New York.

Work from the Same House 1969.
Self-Portrait 1970.
The American Monument 1975.
Kunstforum-Sonderband (Art Forum special issue) 'Die Fotografie' Mainz 1976.
Portfolios: *15 Photographs; Photographs of Flowers; The American Monument. Photographs* New York 1978.

Hamish Fulton

born 1946 London

English painter, who turned to photography in 1969. During walks he photographed lonely and inaccessible landscapes, symbolizing in them an experience of space in time and nature. Most of his photographs are published together with text.

Catalogue: Hamish Fulton—Sixteen Selected Walks Kunstmuseum Basel 1975.

Jaromir Funke

born 1986 Skutec (Czechoslovakia)
died 1945 Prague

Czechoslovak photographer and teacher of photography. Funke was one of the most important members of the Czechoslovak photographic avant-garde during the 1920s and 1930s: next to Sudek, who was his friend, he could be classed as the second most important photographer of his country. He combined in his work the highest degree of precision, in line with the 'New Objectivity', with his admiration for the elusive poetry of the everyday world, for which he had an understanding, thanks to the influence of Surrealism. He also paid great attention to lighting effects in the pure composition of his photographs. As Professor of Photography in the State School of Graphic Art in Prague, he taught many pupils who later became well-known photographers.

Fotografie Vidi Povrch (Photography Sees the Surface) Prague 1935. Co-author *Ladislav Sutnar*.
Jaromir Funke Prague 1960. *Lubomir Linhart*.
Jaromir Funke Prague 1970. *Ludvik Soucek*.

Arnold Genthe

born 1890 Berlin
died 1942 New York

German photographer, who studied philology at the Universities of Berlin and Jena, and mastered several languages. In 1895 he emigrated to San Francisco, where he started out as an amateur photographer and eventually opened a portrait studio. His photographs were chiefly of San Francisco's Chinatown. In 1911 he went to New York and took portraits of many prominent people. On his extensive travels he photographed landscapes and towns.

Rebellion in Photography (Date unknown).
Old Chinatown 1913. *Irwin*
The Book of the Dance (Date unknown).
Impressions of Old New Orleans (Date unknown).
As I Remember 1939.

Helmut Gernsheim

born 1913 Munich

Gernsheim studied the history of art in Germany at first, but after 1933, on account of the political situation, he decided to attend the State School of Photography. In 1937 he moved to Britain, and began to work in London as a freelance colour photographer. His photographic work also included black-and-white studies created in the spirit of the 'New Objectivity'. After the Second World War he became more interested in the history of photography, and started to write books on this subject, together with monographs about some outstanding photographers, partly in collaboration with his wife Alison Gernsheim.

In 1959 he received the Cultural Prize of the 'Deutsche Gesellschaft für Photographie'. He now lives in Britain and in Switzerland. He wrote about twenty books, of which the following are specially noteworthy.
New Photo Vision London 1942.
The History of Photography London 1955. Co-author *Alison Gernsheim.*
Creative Photography London 1962.
A Concise History of Photography London 1965. Co-author *Alison Gernsheim.*

Mario Giacomelli

born 1925
Italian photographer, living in the small town of Senigallia on the Adriatic Sea. He started as an apprentice in a printing house, since he was unable to continue his studies after the death of his father. When he had just reached adulthood he began to take photographs. With his sense of a sombre atmosphere he soon became highly regarded in Italy. He won the contest for 'Best Italian Photographer' for 1956–57. For Italian television he produced a series of photographs to accompany the poem 'A Silvia' by Giacomo Leopardi. He mounted many one-man exhibitions throughout the world.

Ralph Gibson

born 1939 Los Angeles
American photographer who studied at San Francisco Art Institute. His photographs are individual works, illustrating his ideas with a combination of magical/realist forcefulness and cool impartiality.
The Somnambulist 1970.
Déjà Vu 1973.
Days at Sea 1974.

Georg Gidal

born 1908
died 1931 (accident)
German photographer, who initially studied biology and medicine. With his brother Tim he worked on numerous daily papers and magazines as a photoreporter.

Tim N. Gidal

born 1909 Munich
German photographer, who studied history, the history of art, and political economy. In 1929 he published his first photographic report, entitled *The Day of a Coal-Miner*, in the *Münchner Illustrierte Presse.* In the thirties he worked for many periodicals. From 1938 to 1940, with Felix H. Man, he was regarded as one of the leading reporters for *Picture Post*, under Stefan Lorant; during the war he was a chief reporter in the British Army. After the war he delivered lectures on photographic reporting, and between 1955 and 1970 published 23 books on photoreporting for the courses.
23 Bücher über 23 Länder 1955–70.
Everybody Lives in Communities—Eine Humanisierte Geographie für Elementarschulen (A Human Geography for Elementary Schools) 1972.
Modern Photojournalism—Origin and Evolution 1910–33 New York 1974.
In the Thirties Jerusalem 1975.
Deutschland—Beginn des Modernen Photojournalismus Lucerne/Frankfurt. 1972.

Emmet Gowin

born 1941 Danville (Virginia)
American photographer. He received a degree of MFA at Rhode Island School of Design, where he studied under Harry Callahan. Received a Guggenheim Fellowship, and a Fellowship from the Virginia Museum of Fine Arts. He lives in Pennsylvania and commutes to Princeton University, where he is a guest lecturer.
The Snapshot Millerton 1974. *Jonathan Green.*
Photographs New York 1976.

Philip Jones Griffiths

born 1936

British photojournalist, who started his professional career in 1961. He contributed particularly to *The Sunday Times Magazine*. He earned international fame through his photographs from Vietnam, where he spent three years as 'Magnum' photographer. He is visiting lecturer in the Department of Photography at the Royal College of Art in London.

Vietnam Inc New York 1971.

Ernst Haas

born 1921 Vienna

Freelance photographer of Austrian descent living in America. Originally started to study medicine, but soon turned to photography. He became a member of 'Magnum' in 1949. He is best known for his unusual colour photographs, in which he has used the interaction of varying colour shades to create poetic impressions.

The Creation New York 1971.
In America London 1975.
In Deutschland Düsseldorf 1976.

Robert Häusser

born 1924 Stuttgart

German freelance photographer. Studied photography under Professor Hege at Weimar. In 1952 he moved to Mannheim. In his creative approach there are discernible contacts with 'Magical Realism' and Pop Art. His work embraces many kinds of themes, with the driving force based on emotional activity. He mounted many one-man exhibitions, both in Germany and abroad, and received numerous awards for his photographic work. Since 1967 he has been living alternately in Mannheim and in Ibiza.

Robert Häusser Portfolio Das Deutsche Lichtbild, Stuttgart 1959. *Robert D'Hooghe*.

Robert Häusser Augsburg 1971. *Juliane Roh*.
Robert Häusser. Mannheim 1972. *Heinze Fuchs*.
Robert Hässer Photographische Bilder Bielefeld 1973. *J. W. Von Moltke*.
Mannheim Mannheim 1975.
Bilder von der BASF Ludwigshafen 1978.

Heinz Hajek-Halke

born 1898 Berlin

Internationally recognized German representative of experimental photography, who studied at the Fine Arts Academy in Berlin. At first he worked at copperplate printing, and he was a designer and press illustrator before turning to photography in 1924–25. He was friendly with the press photographer Willi Ruge. His first original commerical photographs were produced before the war. In 1933 he began scientific photography in the field of biology. He published his first book on experimental photography in the fifties, and mastered the possibilities of colour photography, which he used for graphic composition.

Experimentelle Fotografie Bonn 1955.
Lichtgraphik 1964.
Heinz Hajek-Halke Göttingen 1978.
Heinz Hajek-Halke—Fotografie, Foto-Grafik, Lichtgrafik Berlin 1978.

Philippe Halsman

born 1906 Riga

American photographer of Latvian descent, who first worked as an engineer in Paris, and then went as a photographer to New York in 1940. His portraits and reports, which he produced in large numbers for *Life*, distinguish themselves because of their witty, humorous qualities. In 1942 his first *Life* cover picture was published; since then he has produced 101 *Life* covers and literally hundreds of cover pictures for most leading publications. In 1945 he became President of the American Society of Magazine Photographers. He lives in New York.

Dali's Moustache (Date unknown).
Jump Book New York 1959.
Halsman on the Creation of Photographic Ideas New York 1961.
Halsman—Sight and Insight Garden City 1975.

Hiroshi Hamaya
born 1915
Japanese freelance photographer. He started to take photographs in 1931, and in 1937 became a freelance. After the Second World War, in 1949, he made a comeback to the journalistic world. In 1960 he became a contributing photographer to 'Magnum'. In the years 1963 to 1969 Hiroshi Hamaya visited West Germany, France, Switzerland, USA, Mexico and Canada, and finally made a trip round the world. He showed a fine awareness of the spirit of life in Japan, as well as a feeling for characteristic events in other countries.
Snow Land 1956.
Japan's Back Coast 1957.
Umrumch-Hsinchiang China 1957.
The Red China I Saw 1958.
Selected Works by Hiroshi Hamaya 1958.
Children in Japan 1959.
The Document of Grief and Anger 1960.
Det Gomda Japan 1960.
Landscapes of Japan 1964.
Photographs 1935–67 Oiso Kanagawa-Ken 1968.
American America 1971.
Nature of Japan 1975.

David Hamilton
born 1933
Freelance photographer of British descent living in France. Hamilton became well-known for his fine erotic pictures of young girls, generally taken with soft focus. He contributed to well-known journals such as *Twen, Réalités* and *Vogue*. Later he concentrated his efforts mainly on the

preparation of pictorial volumes.
Sisters New York 1977. Text by *Alain Robbe-Grillet*.
Souvenirs Kehl 1977. Co-author *Denise Couttés*.
Erinnerungen an Bilitis Kehl 1977.
Dreams of a Young Girl New York 1977. Text by *Alain Robbe-Grillet*.
David Hamilton's Private Collection Kehl 1977.
The Best of David Hamilton Kehl 1977.

Hans Hammarskiöld
born 1925 Stockholm
Swedish freelance photographer, member of Tio Fotografer group. Hammerskiöld started to take photographs in 1942, and then studied under Rolf Winquist in Studio Ugglia in 1947. Since 1949 he has been a freelance photographer. In 1952 he visited New York. In 1954 he came to live in London and worked for *Vogue;* in 1957 he returned to Sweden and in 1958 joined the Tio Fotographer group in Stockholm.
Värmland det Sköna Stockholm 1951.
Stockholmskärlek Stockholm 1952.
Obejktivt Sett Stockholm 1953.
Billa Och Jag Stockholm 1958.
Lillasyster Och Jag Stockholm 1959.
Hiljöavsnittet i Svensk Form Stockholm 1961.
Forna Dagars Sverige—1700 Talet Stockholm 1962.
Mit liv i konsten Stockholm 1967
Det levande slottet Stockholm 1978
Hans Hammarskiöld Helsingborg 1979. *Rune Jonsson*

Charles Harbutt
born 1935 New Jersey
American freelance photographer. Studied journalism at Marquette University in Milwaukee. Became associate editor for *Jubilee Magazine*. In 1963 he joined 'Magnum'. His art developed within the docu-

mentary tradition, and thus his photographs were at the same time real and Surreal.

Travelog Cambridge (Massachusetts) 1973.

Bert Hardy

born 1913

British photojournalist. He became known mainly through his association with the weekly magazine *Picture Post*, of which he was the top staff photographer.

Bert Hardy London 1975. *Tom Hopkinson.*

Edward Hartwig

born 1909 Moscow

Polish freelance photographer. Originally an apprentice in the studio of his father Ludwig Hartwig in Lublin, he came to Vienna in 1930 to undertake further study in photography. Until the start of the Second World War, he lived in Lublin, where he and his father worked together in their studio. After the war he moved to Warsaw, where he still lives. He became one of the founders of the Association of Polish Creative Photographers (ZPAF). His work includes a wealth of different themes, from live photography, psychological portraiture and advertising subjects to creative experimentation of a slightly Surrealist character.

Edward Hartwig Prague 1966. *Zbigniew
 Pekoslawski.*

Photo-Graphics Warsaw 1960.

Sam Haskins

born 1926 Johannesburg

Freelance photographer born in South Africa, now living in Britain. After training in a British photographic school from 1947 to 1950, Haskins opened a school of his own in Johannesburg. As a result of his new style in erotic photography, he became known throughout the world, and was able to publish his photographs in books. His personal favourite was a book of quite a different character, showing the spirit and traditions of South Africa. An enthusiastic reception was also given to Haskins' posters and calendars, which he prepared mainly for the Asahi Optical Company. In 1968 he moved to London, where he opened a studio for advertising photography.

Cowboy Kate and Other Stories London 1965.

Five Girls New York 1967.

November Girl London 1967.

African Image London 1967.

Haskin's Posters Zurich 1972.

Rune Hassner

born 1928 Östersund (Sweden)

Swedish freelance photojournalist. Member of Tio Fotografer group. He exhibited his photographs in Stockholm, Lund, Rochester and Brno.

Raoul Hausmann

born 1886 Vienna

died 1971 Limoges

German Dada painter and creator of 'text pictures', who became well-known for his ironically critical photomontages in the twenties. His technique of mounting typographic and photographic fragments of texts and pictures provided a pattern for the development of photomontage until the Pop Art movement.

Hurra, Hurra, Hurra!—Satiren Giessen
 1970.

Am Anfang War Dada Giessen 1972.

Je Ne Suis Pas un Photograph (date
 unknown).

Keld Helmer-Petersen

born 1920 Copenhagen

Danish photographer and teacher of photography. He studied photography under Harry Callahan at the Institute of Design in Chicago in 1950–51. From 1952 he was a professional photographer with a special interest in architecture and the decorative

arts. He also taught photography at the Academy of Arts in Copenhagen.

122 Colour Photographs Copenhagen 1949.
Fragments of a City Copenhagen 1960.

John Heartfield
born 1891 Berlin
died 1968 Berlin

Heartfield (whose real name was Helmut Herzfeld) was a painter, author, graphic artist and photographer in the Berlin Dada circle, where he created innovations in the field of photomontage, as Hausmann did; he used these as an instrument of political satire.

12 Fotomontagen aus den Jahren 1930–31.
Krieg im Frieden—Fotomontagen zur Zeit 1930–38 Munich 1973.
33 Fotomontagen Dresden 1974.
John Heartfield Dresden 1962, 1976. Co-authors *Herzfelde/Wieland.*

Hugo Henneberg
born 1863 Vienna
died 1918

Austrian photographer who became well-known for his coloured aquatints and oleographs. From the mid-1890s he worked with Watzek and Kühn on the development of this earliest form of colour photography.

Das Trifolium des Wiener Camera-Clubs: Hans Watzek/Hugo Henneberg/Heinrich Kühn, in *'Die Kunst in der Photographie'* Berlin 1898. *Alfred Buschbeck.*

Paul Hill
born 1941 Ludlow

British freelance photographer and teacher of photography. He was originally trained as a reporter, and worked for several newspapers. In 1965 he became a freelance photographer. He is a member of the Society of Industrial Artists, photography consultant of the West Midlands Arts Association and secretary of the Society for Photographic Education. He recently be-

came joint Course Tutor at the Creative Photography Course at the Trent Polytechnic in Nottingham, and he is proprietor of the Photographers' Place in Derbyshire. He mounted one-man exhibitions of his photographs in Wolverhampton in 1971, London in 1972, Birmingham in 1973 and Paris and Madrid in 1977.

Singular Realities Newcastle-upon-Tyne 1977. *Gerry Badger.*

Lewis Wickes Hine
born 1874 Oshkosh (Wisconsin)
died 1940 Hastings-on-Hudson (New York)

American photographer, who was originally a teacher before he devoted himself to photography, without having a definite appointment or specific commissions. His photographs taken in cotton factories in the southern states were both skilful in subject choice and socially concerned. In 1908, the magazine *Charity and the Commons* published his pictures of the New York slums, and *The Pittsburgh Survey* published his series on the lives of the miners. He took photographs of the exploitation of children for the American Federal Commission on Child Labor, and this contributed to the passing of a law protecting children from exploitation. During the First World War he was a war correspondent in Europe.

Negelected Neighbors in the National Capital 1909. *Weller.*
Street-Land, Its Little People and Big Problems 1915. *Davis.*
A Seasonal Industry 1917. *Van Kleeck.*
Rural Child Welfare 1922. *Clopper.*
Empire State: A History of New York 1931.
Men at Work 1932.
Lewis W. Hine and the American Social Conscience 1967. *Gutman.*
Lewis W. Hine. 1970. *Barrow.*
Lewis W. Hine New York 1974. *Gutman.*

Paul Konrad Hoenich
born 1907

Painter and graphic artist living in Israel.

He developed so-called 'sun-painting', which used projection and colour photography.
Sonnenmalerei Cologne 1974.

Thomas Höpker
born 1936 Munich
German photojournalist who studied art history and archaeology. He began to take photographs at the age of 14, and is today one of the most versatile of photojournalists. Most of his work is done for *Stern* magazine. In his photographic reportage he is mainly concerned with the anonymous suffering of the starving in India and in Black Africa.
Berliner Wände Munich 1976. Co-author
 G. Kunert.
Leben in der DDR.
Expeditionen in Künstliche Gärten.

Oskar and Theodor Hofmeister
born 1871 died 1937 (Oskar)
born 1868 died 1943 (Theodor)
German amateur photographers, who made important contributions to the development of photography with their teaching and their membership of the 'Gesellschaft zur Förderung der Amateurphotographie' (Society for Furtherance of Amateur Photography). In their so-called 'sketch-book' they portrayed several shots of each subject.

Burton Holmes
born 1870 Chicago
died 1958
Thanks to family wealth, Holmes was able to be independent, and thus he could organize expensive travels throughout the world. When the occasion arose he photographed typical scenes in many different countries. He used this picture material to illustrate public lectures about his impressions from abroad. As early as the nineties, he used $3\frac{1}{2} \times 4\frac{1}{2}$ in glass slides, which were exquisitively tinted in watercolours by a team of Japanese artists.

The Man Who Photographed the World— Burton Holmes Travelogues 1886–1938 New York 1977. *Irving Wallace/Genoa Caldwell.*

Thurston Hopkins
born 1913
British photojournalist. He was originally trained as a magazine illustrator at Brighton College of Art. From 1930 to 1939 he worked as a Fleet Street press photographer. In 1939–45 he was a member of the RAF Photographic Unit. After the Second World War he worked as a freelance photographer for various newspapers and journals. During the period 1949–57 he worked exclusively for *Picture Post*, and from 1958 to 1968 worked mainly for advertising agencies. In 1968 he began to teach photography, firstly part-time in Birmingham, and later full-time at the Guildford School of Photography. In 1975 Barry Lane prepared a retrospective exhibition of his work, which was sponsored by the Arts Council of Great Britain.
Thurston Hopkins London 1977. *Robert Muller.*

Horst P. Horst
born 1906 Germany
Portrait and fashion photographer working in New York, who studied architecture in Hamburg and in Paris with Le Corbusier. In 1932 Horst began working as a photographer for *Vogue* as Hoyningen-Huene's assistant. He became famous for his portrait photographs of well-known women, such as Gertrude Stein and Barbara Hutton.
Photographs of a Decade 1944.
Patterns from Nature 1946.
Vogue's Book of Houses, Gardens, People 1968.
Salute to the Thirties 1971.

Eikoh Hosoe
born 1933 Yamagata (Japan)
Japanese freelance photographer. In 1954 he graduated in photography at Tokyo

College, and thereafter he started a career as a freelance photographer. In his work, reality very often approaches Surrealism. Hosoe collected some of his photographs in pictorial publications.

Man and Woman 1961.

Killed by Roses 1963.

Kamaitachi 1969.

Embrace 1971.

Ordeal by Roses 1971.

New Japanese Photography New York 1974.
 John Szarkowski/Yamagishi Shoji.

Emil Otto Hoppé

born 1878 Munich
died 1972

British photographer born in Germany. In accordance with his father's wishes he began a career in banking. It was not until 1907 that he became a professional photographer in London. After about 18 years of predominantly portrait activity, he became interested in travelling, and in compiling illustrated books from photographs taken by him on these occasions; most of these publications appeared simultaneously in Britain, Germany and Switzerland. In his creative approach during the twenties and thirties, he inclined towards the 'New Objectivity'.

Taken from Life 1922. Co-author *John D. Beresford.*

The Book of Fair Women 1922. Co-author *R. King.*

In Gipsy Camp and Royal Palace 1924.

London Types Taken from the Life 1926.
 Co-author *William P. Ridge.*

Picturesque Great Britain 1927.

Das Romantische Amerika Berlin 1930.

The Fifth Continent 1931.

Round the World with the Camera 1934.

The Image of London 1935.

Camera on Victorian London 1936.

The London of George VI 1937.
 A Hundred Thousand Exposures— The Success of a Photographer London 1945.
 Introduction by *Cecil Beaton.*

George Hoyningen-Huene

born 1900 St Petersburg
died 1968 Los Angeles

American photographer of Russian origin who fled via Sweden to France during the October Revolution. After studying in the studio of the painter Andre Lhote, he was employed in 1925 as an illustrator and arranger of fashion photographs by *Vogue* in Paris. By 1928 he was principal photographer on the magazine, and was a close friend of Cecil Beaton. In 1935 he emigrated to New York, and worked for *Harper's Bazaar* in addition to *Vogue.* In 1946 he participated in film productions in Hollywood, and was portrait photographer for several film companies.

Meisterbildnisse 1932. *Frenzel.*

Hellas 1943.

Egypt 1943.

Mexican Heritage 1946.

Hans Hubmann

born 1910

German photojournalist, who began work as a photographer in the forties, and documented conditions in Germany after the Second World War.

Gesehen und Geschossen Munich 1969.
 Introduction by *Franz Hugo Mösslang.*

Kurt Hutton

born 1893 London
died 1960 Aldeburgh (England)

German photojournalist (real name Kurt Hübschmann), who worked for Dephot, the German photographic agency, from 1930. Previously he had worked as a studio and commercial photographer. As a photojournalist, he worked under Felix H. Man.

Creative Photography London 1962. *Helmut Gernsheim.*

Boris Ignatowitsch

born 1899 Ukraine

Russian journalist on the *Lurgansk Newspaper* and contributor to *Red Star* newspaper

from 1918 to 1919. In 1920 he was a delegate at the first Rosta conference, where he worked with Majakowski. Concerned with the theory and history of photography. In the thirties Ignatowitsch produced reports on post-revolutionary art and work in the USSR.

Boris Ignatowitsch Moscow 1973. *Leonid Wolkow-Lannit.*

Izis

born 1911 Mariampol (Lithuania)

Izis (real name Israélis Bidermanas) was apprenticed to a local photographer at the age of 13. He moved to Paris in 1930 and worked in a portrait studio. During the Second World War he joined the French Resistance, and after some deliberation he took portrait photographs of French partisans. In 1946 he exhibited 200 photographs of Paris and 100 portraits. He began contributing to the magazine *Lilliput*. As he was not able to earn enough as a freelance photographer, he opened a portrait studio. He became a photographer with *Paris Match* in 1949. His live photographs showed a full understanding of 'Magical Realism'.

Paris de Rêve Paris 1950.

Paris Enchanted London 1952.

Grand Bal de Printemps Paris 1951. Text by *Jacques Polieri.*

Charme de Londres Paris 1952. Text by *J. Prévert.*

Gala-Day London London 1952.

Paradis Terrestre Paris 1954. Text by *Colette.*

Le Cirque d'Izis Paris 1965. Introduction by *J. Prévert.*

Moderni Francouzska Fotografie (Modern French Photography) Prague 1966. *J. A. Keim.*

Gottfried Jäger

born 1937 Burg (near Magdeburg)

German photographer and designer, who studied at the State Technical School of Photography in Cologne. From 1964 onwards he made investigations into varied photographic techniques, and conducted experiments with the multiple-diaphragm camera. In addition to his journalistic activity for the technical press, he also published works on the problems of professional training in photography, and the aesthetics of photography. In 1968 he introduced the expression 'Generative Photography'.

Apparative Kunst—Vom Kaleidoskop zum Computer Cologne 1973. Co-author *Herbert W. Franke.*

Generative Fotografie Ravensburg 1975. Co-author *Karl Martin Holzhäuser.*

Vaclav Jiru

born 1910

Czechoslovak photographer and editor of photographic journals. He was interested in photography from his teens, but started in journalism as a writer. His first photographs were published in various journals as early as 1927. He joined the Resistance movement in the Second World War, and was arrested by the Gestapo in February 1940. He remained in a Nazi concentration camp until the end of the war. In 1957 Jiru founded the quarterly *Revue Fotografie*, and remained as editor until his retirement. As a freelance photographer, he is known particularly through his pictures of Prague, which he incorporated in several books and one-man exhibitions. At present he is Chairman of the Union of Czechoslovak photographers.

Zrcadlo Zivota (Mirror of Life) Prague 1949.

Praha Mesto Fotogenicke (Prague the Photogenic City) Prague 1968.

Vaclav Jiru Prague 1971. *Vaclav Zykmund.*

Soucasna Sovetska Fotografie (Contemporary Soviet Photography) Prague 1972.

Pobaltska Sovetska Fotografie (Photography in the Baltic Soviet Republics) Prague 1974.

Frances Benjamin Johnston
born 1864
died 1952
American photographer, interested primarily in taking photographs of a documentary character. She had the capacity to depict decisive details through a picture—to make statements about the real world. She was one of the pioneers of women in photography: she encouraged other women to become professional photographers, and arranged exhibitions of their work.

A Talent for Detail—The Photographs of Miss Frances Benjamin Johnston 1889–1910. New York 1974. *Pete Daniel/ Raymond Smock.*

Women of Photography San Francisco 1975. *Margery Mann/Anne Noggle.*

Gertrude Kasebier
born 1852 Des Moines (Iowa)
died 1934 New York
American photographer, a member of Photo-Secession, who became famous for her portrait and landscape pictures in the style of the old master painters.
Malerei und Photographie im Dialog Kunsthaus Zurich 1977.

Manfred P. Kage
born 1935 Delitzsch (near Leipzig)
German chemical engineer, who studied painting and the natural sciences on his own, and took up scientific photography as a profession in 1959. He worked in the areas of micro- and macro-photography, interference optics and X-rays.
Apparative Kunst—Vom Kaleidoskop zum Computer Cologne 1973. *H. W. Franke/ G. Jäger.*

Karol Kallay
born 1926 Cadca (Czechoslovakia)
Versatile Czechoslovak freelance photographer. Kallay received a degree in economics at the Technical University of Bratislava. In 1953 he was accepted as a member of the Union of Slovak Fine Art-

ists, and this made it possible for him to work as a freelance photographer. He took fashion photographs for *Saison, Jardin des Modes, Sibylle,* and also for some Czechoslovak fashion journals. In addition to fashion, he always devoted a good deal of attention to live photography. He started a successful collaboration with both the German and American editions of the magazine *Geo.* Most of his work now involves colour photography.

Italy Today Prague and London 1962.
Karol Kallay Prague 1963. *Lubor Kara.*
New York—Die Explodierende Metropole Berlin 1966.
Mexico City Berlin 1969.
Pieseň o Moskvě (Song of Moscow) Bratislava 1972.
Piesen o Slovensku (Song of Slovakia) Bratislava 1973.
Piesen o Slovenskom Narodnom Povstanie (Song of the Slovak National Revolution) Bratislava 1975.

Dora Kallmus *(D'Ora)*
born 1880 Vienna
French society photographer who became famous for her many portrait photographs of famous artists, actors and actresses.

Art Kane
born 1925 New York
American freelance photographer with special interest in colour. He took a degree at the Cooper Union School of Art. In 1952 he became art director of *Seventeen* magazine. In 1959, in order to have more time for creativity, he began to work as a freelance photographer. He has won 13 gold medals at the New York Art Directors' Club.
The Persuasive Image London 1975. Text by John Poppy.

Yousef Karsh
born 1908 Armenia
Canadian photographer, well-known for his portraits of famous political and cultural

personalities, whom he portrayed with brilliant technical skill, always in their own environment or in a typical pose.

Faces of Destiny New York 1956.
Portraits of Greatness New York 1959.
In Search of Greatness New York 1962.

Kikuji Kawada

born 1933 Ibaraki (Japan)

Japanese freelance photographer. Kawada graduated in economics at Rikkio University in 1956. At first he worked as a staff photographer for *Shincho-Sha;* then in 1959 he became a freelance. He always showed a comprehension of Surreal properties of reality, and a propensity for grotesque motifs.

Sacré Atavism Tokyo 1971.

Peter Keetman

born 1916

German commercial and industrial photographer, who made a name for himself through his scientific photography and his abstract colour photographs.

André Kertesz

born 1894 Budapest

Austrian photojournalist, who worked in Paris as a freelance reporter for *Frankfurter Illustrierte, Berliner Illustrierte, Strassburger Illustrierte* and *The Times*, from 1925 to 1928. In the thirties he contributed to all the big illustrated magazines, especially *Look, Vogue* and *Harper's Bazaar*. In addition he organized many exhibitions of modern photojournalism.

Enfants 1933. Text by *Jaboune*.
Paris Vue par André Kertesz 1934. Text by *Pierre MacOrlan*.
Nos Amis les Bêtes 1936. Text by *Jaboune*.
Les Cathedrales du Vin 1937. Text by *Pierre Hamp*.
Day of Paris 1945. Text by *George Davis*.
André Kertesz Photographer 1945. *J. Szarkowski*.

André Kertesz Photographies 1965. *Alice Gambier*.
André Kertesz 1960. *Anna Farova*.
Twelve at War (chapter: *André Kertesz Soldier and Candid Cameraman in World War I*) 1967. *Robert E. Hood*.
The Concerned Photographer 1968. Editor *Cornell Capa*.
On Reading 1971.
Katalog Stockholm 1971.
André Kertesz 60 Jahre Fotografie, 1912–72 Düsseldorf 1972. Editor *N. Ducrot*.
Deutschland—Beginn des Modernen Photojournalismus Lucerne/Frankfurt 1972. *Tim N. Gidal*.
J'Aime Paris New York 1974.
New York Discovered New York 1975.
On Reading New York 1975.
Washington Square New York 1975.
Millerton 1976.

William Klein

born 1926 New York

American photographer, who first worked as a painter in Fernand Leger's studio, until he undertook his first photographic experiments in 1954. He designed numerous covers for the magazine *Domus*, and was art director of *Vogue* for a few years. Then he became very interested in live photography, to which he contributed with his original, very straightforward approach, often achieved by means of wide-angle lenses. He compiled several illustrated books with photographs taken in various cities.

New York London 1956.
Rome London 1960.
Moscow New York 1964.
Tokyo New York 1964.

Les Krims

born 1943 Brooklyn (New York)

American art photographer, who became known for his ludicrous and grotesque Surrealist photographs, each of which has an underlying narrative. He studied at New

York City Public School, the Cooper Union and the Pratt Institute of Art. He has held numerous exhibitions in the USA and in Europe.

The Little People of America Buffalo 1972.
The Deerslayers Buffalo 1972.
The Incredible Case of the Stack O'Wheats Murders Buffalo 1972.
Making Chicken Soup Rochester 1972.
Fictcryptokrimsographs 1975.
Vienna 1976.
Kunstforum-Sonderband: Die Fotografie Mainz 1976.
The Grotesque in Photography New York 1977. *A. Coleman.*

Boris Kudoyarov

born 1903
died 1973
Soviet photographer, one of the founders of modern Soviet photojournalism. Kudoyarov began taking reportage photographs in Soviet Central Asia. During the Second World War he was in Leningrad right through the siege, acting as war reporter of *Komsomolskaya Pravda*, and created an unusually expressive picture series about that city at war.

Boris Kudoyarov Moscow 1975. *Lidiya Dyko.*
Russian War New York 1977, London 1978. *Daniela Mrazkova/Vladimir Remes.*

Heinrich Kühn

born 1866
died 1944
Austrian photographer of German origin, who originally studied natural sciences and medicine in Leipzig and Freiburg. He developed the technique of the coloured aquatint with Watzek and Henneberg, and became a representative of Impressionist art photography.

Technik der Lichtbildnerei Halle 1921.
Zur Photographischen Technik Halle 1926.
Das Trifolium des Wiener Camera-Clubs: Hans Watzek/Hugo Henneberg/Heinrich

Kühn in 'Die Kunst in der Photographie' Berlin 1898. *Alfred Buschbeck.*
Heinrich Kühn 1866–1944 Photographien; Katalog Innsbruck 1976. *H. Speer.*

Taras Kuscynskyj

born 1932 Prague
Czechoslovak fashion, portrait and landscape photographer of Ukrainian descent. As his name is difficult to pronounce, he often uses 'Taras' as a signature. In 1961 he received a degree in architecture from the Technical University in Prague. His portraits of girls became well-known. In 1966 he began to work as a freelance photographer. He always valued highly the original positive, and for this reason he showed his photographs in many one-man exhibitions in Czechoslovakia, the Netherlands, West Germany, Austria and Japan. Two television films have been made about his kind of creative work.

Ciernobiela Tvoriva Fotografia (Black-and-White Creative Photography) Martin (in print). *Petr Tausk.*

Dorothea Lang

born 1895 Hoboken (New Jersey)
died 1965 San Francisco
American photographer. After studying educational theory, she attended Arnold Genthe's photographic studio, and the photography school at New York's Columbia University. In 1919 she opened a portrait studio in San Francisco. From 1935 she concentrated on documentary photography; she was a member of the team of photographers documenting the conditions of the rural population for the Farm Security Administration. From 1954 she produced photographic reports for *Life* and other magazines, and travelled to Asia, South America and the Near East.

Jacques-Henri Lartigue

born 1894 Courbevoie
French photographer. As a child he was

encouraged by his father to take photo-graphs. His early photographs, which are distinguished by meticulous technique and good composition, depict mainly the world of flying-machines, motor cars and society. In 1919 he applied himself to painting, and in the thirties made friends with Van Dongen, Colette, Cocteau and Picasso. His photography of that time reveals a close connection with the film world.

The Photographs of Jacques-Henri Lartigue: Catalogue, Museum of Modern Art New York 1963. *John Starkowski.*

Les Photographies de Jacques-Henri Lartigue Lausanne 1966. *Jean Fondin.*

Diary of a Century New York 1970. *Richard Avedon.*

Portfolio Jacques-Henri Lartigue New York 1972. *Anaïs Nin.*

Jacques-Henry Lartigue and Women Paris 1973.

Jacques-Henri Lartigue and Cars Paris 1974.

Lartigue 8 × 80 Paris 1975.

Barry Lategan
born 1935
British fashion photographer. Lategan was born in South Africa, and moved to Britain in 1961. He contributes in particular to *Vogue.*

Clarence John Laughlin
born 1905 Lake Charles (Louisiana)
American freelance photographer. Laugh-lin began to take photographs in 1934, and worked from 1936 to 1940 as a Civil Service photographer. Then he worked for *Vogue* in New York in 1940–41. When he joined the Army he worked with the unit special-izing in the colour photography of secret maps and documents. From 1949 to 1969, he earned his living by photographing contemporary architecture. In 1969 he became an Associate of Research of the University of Louisville. In his freestyle work he created many pictures showing a fine sense of Surrealist poetry.

New Orleans and Its Living Past Boston 1941.

Ghosts along the Mississippi New York 1948 and 1962.

Clarence John Laughlin—The Personal Eye Millerton 1973. *Jonathan Williams/ Lafcadio Hearn.*

Helmar Lerski
born 1871
died 1956
Photographer who lived and worked in America from 1893, and in Berlin from 1915. He lived in Palestine from 1938 to 1948 and then went to Zurich, where he worked as an actor and film producer. In his photographic work he had a preference for portraiture, in which he emphasized the expressiveness of the face with skilful lighting effects.

Köpfe des Alltags Berlin 1931

Metamorphose

Der Mensch, Mein Bruder

Jorge Lewinski
born 1921 Poland
British freelance photographer and teacher of photography. Lewinski came to Britain during the Second World War, and after it completed his studies, receiving a BSc degree in economics. He became a pro-fessional photographer in 1965. He is now Senior Lecturer in photography and art history at the London College of Printing. He is well-known through his psychological portraits and colour photographs.

Byron's Greece London 1975. Co-author *Lady Elizabeth Longford.*

Colour in Focus London 1976. Co-author *Bob Clarke.*

Photography—A Dictionary of Photographers, Termsn and Techniques London 1977.

Camera at War 1979.

This Other Eden London 1979. Co-author *Margaret Drabble.*

Georgij Lipskerov

born 1896

Soviet photojournalist. He was originally a sportsman, and hence in the first period of his photographic career he favoured sporting themes. From 1941 to 1945 he was an important war correspondent.

Georgij Lipskerov Moscow 1976. *Igor Buryak.*

El Lissitzky

born 1890 Smolensk

died 1914 Moscow

Russian painter, designer, architect and art theorist, an important founder-member of the Russian avant-garde movement, who worked particularly on the composition possibilities of photomontage.

El Lissitzky—Maler, Architekt, Typograph, Fotograf Dresden 1967. Co-author S. Kuppers.

Künstlerphotographien im XX Jahrhundert Hannover 1977.

Herbert List

born 1903 Hamburg

German amateur photographer who turned his hobby into a profession in 1936. Since the thirties he has been working on the Surrealist conception of photography.

Herbert List Photographien 1930–70 Munich 1976. *Günther Metken.*

Joan Lyons

born 1937 New York

American photographer and teacher of photography. She received a BFA degree at Alfred University in 1957. She teaches at the Visual Studies Workshop in Rochester. Her own photographic work is of an experimental character; combined with traditional photography, she often uses xerography and drawing.

The Photographers' Choice Danbury 1975. *Kelly Wise et al.*

Nathan Lyons

born 1930

American photographer and teacher of photography. He studied at Alfred University. He has run private workshops on photography since 1958, and became a visiting lecturer at the University of Minnesota from 1963. Later he was appointed Curator of Photography and Associate Director of the George Eastman House in Rochester. Then he organized and taught photography at the Visual Studies Workshop in Rochester. His photographic images resemble abstract pictures.

Photography 63 Rochester 1963.

Photographers on Photography Englewood Cliffs 1966.

Contemporary Photographers toward a Social Landscape Rochester 1966.

The Persistence of Vision Rochester 1967.

Vision and Expression Rochester 1969.

Angus McBean

born 1904 Newbridge

British photographer, well-known for his original stage images and montages. In 1935 McBean opened a studio of his own in London. He contributed to *The Sketch* and *Lilliput*. His Surrealist portraits are particularly notable.

Fame London 1960. *Fritz L. Gruber.*

Creative Photography London 1962. *Helmut Gernsheim.*

The Magic Image London 1975. *Cecil Beaton/Gay Buckland.*

Donald McCullin

born 1935 London

British photojournalist, known chiefly through his war reportage. He reported from Cyprus in 1964, Congo in 1967, Vietnam in 1968, Cambodia in 1970, Biafra in 1970–71, Pakistan in 1971, and Indochina in 1972.

The Destruction Business London 1971.

Is Anyone Taking Any Notice? London 1971.
The Magic Image London 1975. *Cecil
Beaton/Gay Buckland.*

Felix H. Man

born 1893 Freiburg (Germany)
British photographer (real name Hans
Baumann) living in Rome. His photo-
graphic activity began in 1914 when he
recorded his wartime experiences with his
pocket camera. After the war he studied
art at the Munich School of Arts and
Crafts. Eventually he worked as a photo-
journalist, and many of his photographic
reports were published in the *Münchner
Illustrierte* after 1930. He became famous for
his interviews with important personalities
of the time, such as Mussolini, Stavinsky
and Liebermann. In 1934 he moved to
London, where he worked for *Weekly
Illustrated, Lilliput* and *Picture Post* until
1938. In 1948 his first reports in colour
appeared in *Picture Post*, and others ap-
peared later in *Life*. In the fifties he became
more and more interested in contemporary
art and in the history of lithography.
Eight European Artists 1953.
Über die Anfänge der Lithografie in England
1967.
Artist's Lithograph 1970.
Europäische Graphik seit 1963.
*Felix H. Man: The British Journal of
Photography Vol 124, No 6080* 1977. *Tom
Hopkinson.*
60 Jahre Fotografie Bielefeld 1978.

Werner Mantz

born 1901 Cologne
German photographer living in Maastricht.
He studied at the Bavarian State Institute
for Photography. In 1922 he opened a
portrait studio in Cologne. In the second
half of the twenties his main field of
activity was in architecture. In 1937–38
he created a photographic series on the
Limburg mines. In 1938 he moved to
Maastricht, where he devoted himself

increasingly to portrait and child photo-
graphy.
*Vom Dadamax zum Grüngürtel—Köln in den
20er Jahren. Katalog Kunstverein*
Cologne 1975.
Portfolio Werner Mantz Aachen 1977.
Schurmann/Kicken.
Werner Mantz Fotografien 1926–38 Bonn
1978. *Klaus Honnef.*

Charlotte March

born (date unknown) Hamburg
German photographer who attended the
Alsterdamm School of Art in Hamburg
until 1954 and then worked as a graphic
artist. She encountered photography by
chance, and it seemed a magical world to
her. Thus her works embody a highly
personal interpretation of things.

Mary Ellen Mark

born 1940 Philadelphia
American photojournalist. She received a
degree in painting at the University of
Pennsylvania, after which she continued
her studies in photography. In 1965 she
received a Fulbright scholarship, which she
used for travelling in Turkey. After her
return to America she contributed to *Look,
Paris Match* and *Esquire*.
The Photojournalist London 1974. Text by
Adrienne Marcus. Co-author *Annie
Leibowitz.*

Paul Martin

born 1864 Herbeuville (France)
died 1944
British photographer interested in live
photography. He originally lived with his
parents in France. After the defeat of the
Commune in 1872, the family moved to
London. He was an apprentice wood
engraver, and from 1884 photography was
his hobby. In 1899 he opened a photo-
graphic studio with H. G. Dorrett, but at
the same time was taking many live photo-
graphs outside the studio. His contribution

to the evolution of the creative use of the snapshot were very important.

Victorian Candid Camera Newton Abbot
 1973. *Bill Jay*.
Paul Martin—Victorian Photographer
 London 1978. *Roy Flukinger/Larry
 Schaaf/Standish Meacham*.

Martin Martincek
born 1913
Czechoslovak freelance photographer. He graduated as Doctor of Law at the Law Faculty in Bratislava. After many years as an amateur photographer, he decided at the end of the fifties to make freelance photography his profession. His work in photography has two aspects: themes from the Slovak countryside, concentrating especially on disappearing folklore, and series of metaphorical pictures based on a refined use of the principle of the 'Objet Trouvé'. For the unusual quality of his work, he was awarded the honorary title of 'Artist of Merit' by the Czechoslovak Government.

Nezbadany Svet (The Undiscovered World)
 Bratislava 1964. Text by *Laco
 Novomesky*.
Vam Patri Ucta (To You Honour Is Due)
 1967. Text by *Milan Rufus*.
Ludia v Horach (People in the Mountains)
 Bratislava 1969. Text by *Milan Rufus*.
Svetlana Vlnach (Lights in Waves) Bratislava
 1969. Text by *Andrej Plavka*.
Koliska (Cradle) Martin 1972. Text by
 Milan Rufus.
Vrchari (Highlanders) Martin 1975. Preface
 by *Alexander Matuska*.
Hora (The Mountain) Martin 1978. Text
 by *Milan Rufus*.
Martin Martincek Martin 1979. *Ludovit
 Hlavac*.

Roger Mayne
born 1929
English photographer. He turned to photography after studying chemistry at Oxford.

From clearly structured sections of nature he soon progressed to the portrayal of human situations. His photographic reports are characterized less by social criticism than by objective recording; but he does not conceal his sympathies for the subjects he is portraying—especially young people.

Ralph Eugene Meatyard
born 1925 Normal (Illinois)
died 1972 Lexington
American photographer. He worked originally as an optician. He began to study photography under Van Deren Coke. As a photographer he took a special interest in demonstrating the poetry of simple reality. He often tried to utilize various kinds of blurring of an image caused by the movement of either the subject or the camera.

Ralph Eugene Meatyard Millerton 1974.
 James Baker Hall/Guy Davenport.

Lorenzo Merlo
born 1935 Turin
Photographer of Italian descent living in the Netherlands. Merlo studied photography in New York and at the San Francisco Academy of Art. He is known especially through his photocollages. At present he lives in Amsterdam and works there as director of the Canon Photo Gallery.

Duane Michals
born 1932 McKeesport (Pennsylvania)
American photographer who developed a self-willed narrative concept of poetically arranged photographic sequences. Each sequence embodies a story communicated by the arrangement of the pictures.

Chance Meeting Cologne 1972.
Things Are Queer Cologne 1972.
The Photographic Illusion London 1975.
*Take One and See Mount Fujiyama, and
 Other Stories* Rochester 1976.
Real Dreams 1976.

Gjon Mili

born 1904

American photographer of Albanian descent. Mili came to the USA in 1923. He received a degree in electrical engineering at the Massachusetts Institute of Technology in 1927. His specialized scientific and technical knowledge later enabled him to make creative experiments in high-speed photography. He was a contributor to *Life*.

Photographies Paris 1971.

Leonard Misonne

born 1870 Gilly (Belgium)
died 1943

Belgian photographer, who specialized in misty romantic landscapes. He softened sharp contours by means of a filter device of his own. He also produced aquatints from several of his negatives.

Ein Fotograf aus Belgien 1870–1943—
 Romantische Landschaft Munich 1976.

Laszlo Moholy-Nagy

born 1895 Borsod (Hungary)
died 1946 Chicago

Hungarian painter, sculptor, graphic arttist, stage designer and photographer. He was Principal of the Bauhaus from 1923 to 1928. In the field of photography he accomplished a great deal of pioneering work in photomontage, which could be seen in his *Bauhaus Book (Bauhausbuch) No 8*. In the Chicago 'New Bauhaus', he continued the work started in Dessau.

Malerei, Fotografie, Film. Bauhausbuch No 8
 Munich 1925, reprinted Mainz 1967.
Moholy-Nagy London 1974. Editor
 R. Kostelanetz.

Sarah Moon

born 1940

British fashion photographer living in France. She worked as a fashion model, and then decided to try taking photographs herself. Her success with her photography

enabled her to contribute to various journals. One of her photographs was included in the representative portfolio *Twelve Instant Images on Polaroid Type* 105 *Positive/Negative Film*.

Raymond Moore

born 1920 Wallasey

British photographer and teacher of photography. He was a painter before he took up photography. He studied at Wallasey College of Art from 1937 to 1940, and later received an exhibition scholarship to the Royal College of Art, where he studied from 1947 to 1950. He is Lecturer in Creative Photography at Watford College of Art. As a photographer he shows an understanding of creative work in the spirit of 'Magical Realism'.

Photographs by Raymond Moore Cardiff 1968.
 Peter Jones/Eric de Maré.

Inge Morath

born (date unknown)

American photographer of Austrian descent. She joined 'Magnum', and published her photographs in such magazines as *Life*, *Paris Match* and *The Saturday Evening Post*. She married Arthur Miller in 1962, and he wrote the text for her book *In Russia*. The excellent photographic work of Inge Morath displays a clear comprehension of the poetry of everyday life.

Fiesta in Pamplona Paris 1954, New York
 1956. Text by *Dominique Aubier*.
Venice Observed Lausanne 1956. Text by
 Mary McCarthy.
From Persia to Iran New York 1961. Text
 by *Edouard Sablier*.
Bring Forth the Children New York 1960.
 Text by *Yul Brynner*.
Le Masque Paris 1967. Co-author *Saul
 Steinberg*.
In Russia New York 1969. Text by Arthur
 Miller.
Inge Morath Lucerne 1975. *Olga Carlisle*.

Barbara Morgan
born 1900 Buffalo (Kansas)
American photographer and painter
(maiden name Barbara Brooks Johnson).
She studied art at the University of
California in Los Angeles from 1919 to
1923. She married Williard D. Morgan in
1925. She moved to New York in 1930,
where she opened a painting studio. She
turned her attention to photography in
1935, and was photographically active
until 1955, when she supplemented her
photography with painting again.
*Martha Graham—Sixteen Dances in
 Photographs* New York 1941.
*Summer's Children—A Photographic Cycle of
 Life in Camp* New York 1951.
Aperture 11:1 Rochester 1964.
Barbara Morgan Hastings-on-Hudson 1972.
 Peter Bunnell.

Ugo Mulas
born 1928 Pozzolengo (Italy)
died 1973 Milan
Italian freelance photographer. He left the
Faculty of Law in favour of becoming a
photographer in 1954. He was well-known
for his portraits, and also for those photo-
graphs which owed something to his
contacts in avant-garde circles in the fine
arts.
Alik Cavaliere Milan/Turin 1967.
Con Marianne Moore Milan 1968.
New York—Arte e Persone Milan 1968.
Allegria di Ungaretti Milan 1969. Co-author
 Annalisa Cima.
Calder Milan 1971.
Fotografare l'Arte Milan 1973. Co-author
 Pietro Consagra.
Ugo Malas Parms 1973. *Arturo Carlo
 Quintavalle.*
*Photography as Art—Art as Photography 2.
 Catalogue* Kassel 1977.

Martin Munkasci
born 1896 Kolozsvar
died 1963 New York

Hungarian painter, who entered photo-
graphy by chance in 1923, and within a
short time was in great demand as a photo-
reporter in Hungary. From 1927 he worked
for the Ullstein publishing company in
Berlin, and travelled all over the world for
the *Berliner Illustrierte.* In the thirties he
emigrated to the USA, and took photo-
graphs for *Harper's Bazaar* and other big
magazines. He specialized in highly per-
sonal portraiture of famous artists, politi-
cians and society personalities.
Fool's Apprentice 1945.
Nudes 1951.
Spontaneity and Style London. Biographical
 text by *Colin Osman.*

Floris M. Neusüss
born 1937 Lennep
German photographer who studied photo-
graphy, graphic arts and painting in
Wuppertal, Munich and Berlin. In his
photographs he favoured double exposure
in order to achieve a magical effect. Since
1966 he has been a lecturer at Kessel
University.
Figuren und Masstäbe, 1961–76. Catalogue
 London 1976.
Kunstforum-Sonderband 'Die Fotografie'
 Mainz 1976.
*Photography as Art—Art as Photography.
 Catalogue* Kassel 1975.
*Fotografie an der Gesamthochschule Kassel.
 Catalogue* Kassel 1976.
*Photography as Art—Art as Photography 2.
 Catalogue* Kassel 1976.
Fotografie 1957–77 Kassel 1977.

Arnold Newman
born 1918
American portrait photographer. He has
skilfully mastered the portrayal of his
subjects' lives and occupations.
One Mind's Eye London 1974.
Faces USA Garden City 1978. Foreword
 by *Thomas Thompson.*

Helmut Newton

born 1920 Berlin

Fashion photographer now living in France. His chief contributions have been to British and French *Vogue*. Apart from his fashion photographs, he has devoted his attention to the creation of erotic pictures, some of which he has contributed to *Playboy* and others he has used for his own books.

White Women Munich 1976. Introduction
 by *Guy Peellaert*.

Sleepless Nights New York 1978.

Horace W. Nicholls

born 1867 Cambridge

died 1941

British photographer, a pioneer in the journalistic use of the image. Took photographs during the Boer War. During the First World War, he worked as an official photographer in the service of the Department of Information. Thereafter, from 1919 to 1932, he was a member of the staff of the Imperial War Museum.

Pal-Nils Nilsson

born 1929

Well-known Swedish photojournalist, who has participated in all the large photographic exhibitions of the world.

Natur 1956.

Lanskap 1956.

Wim Nordhoek

born (date unknown) Holland

Dutch photographer and graphic artist. In his colour photograph he shows the whole by depicting a part. He has an eye for a subject, and in his camera style a humane conception is revealed through his love of the unpretentious. He is a lecturer at the Royal Academy of Arts in s'Hertogenbosch. He has produced numerous calendars and book illustrations on travel themes.

Grundlehre der Farbfofgradie Düsseldorf
 1978.

Gabriele and Helmut Nothhelfer

born 1945 Berlin (Gabriele)

born Bonn (Helmut)

German photographers, who studied together at the Lette School in Berlin and the Folkwang School in Essen. Both favour documentary photography, such as people in typical attitudes at fairgrounds.

Kunstforum-Sonderband 'Die Fotografie'
 Mainz 1976.

Waclaw Nowak

born 1924 Krakow (Poland)

Polish photographer, well-known for his pictures of the nude. He received a degree from the Faculty of Architecture at Krakow Polytechnick in 1952. He has participated in many exhibitions, and his photographs have been published in photographic journals throughout the world.

Vision and Expression Rochester 1969.
 Nathan Lyons.

Views on Nudes London 1971. *Bill Jay*.

Lennart Olson

born 1925 Göteborg

Swedish freelance photographer. He became a professional photographer in 1942, and turned freelance in 1955. He is a member of Tio Fotografer. He is chiefly known for his photographs which resemble abstract paintings; some of his photographs of this type were used to decorate a bank in Stockholm in the sixties.

Litet Stockholmsalbum Stockholm 1962.

Hilmar Pabel

born 1910 Rawitsch

German photographer, who acquired his photographic knowledge at the Agfa Photographic School in Berlin. After studying German philology, philosophy and journalism, he became an independent photographer and war reporter for the *Neue Illustrierte Zeitung*. After the war, on behalf of the Rowohlt publishing house and the Bavarian Red Cross, he provided over 2000

child portraits to help in the reunion of families. He travelled to Formosa, Japan, Indonesia, China, the Far East and other flashpoints of political strife on behalf of the illustrated magazine *Quick*. From 1961 to 1970 he was a photographer on the staff of *Stern*, and thereafter a freelance photo-journalist.

Jahre Unseres Lebens 1954. *Steinborn.*
Antlitz des Ostens 1960.
Der neben Dir.

Norman Parkinson

born 1913
British fashion photographer of great re-nown. He worked mainly for the magazine *Vogue*. He enriched fashion photography with his fresh and vivid approach.
Sisters under the Skin New York 1978.

Gordon Parks

born 1912 Fort Scott (Kansas)
American photographer, originally active in various spheres. In 1942 he worked for the Farm Security Administration. From 1949 to 1970 he worked as a photo-journalist for *Life*. In addition to his photographic activities, he has written film scripts and was a film director.
Flash Photography New York 1947.
The Learning Tree 1963.
A Choice of Weapons 1966.
A Poet and His Camera 1969.
Whispers of Intimate Things New York 1971.
Born Black 1971.
In Love 1972.
The Concerned Photographer 2 1972. *Capa.*
Sozial-Dokumentarische Photographie in den USA 1974. *Doherty.* New York 1975.

Irving Penn

born 1917
Well-known American fashion and portrait photographer, painter and graphic artist. He worked for *Vogue* in 1943, and achieved world fame through his unconventional commercial pictures and his artistic colour photography.
Worlds in a Small Room, by Irving Penn as an Ambulant Studio Photographer New York 1974.
Irving Penn Turin 1975.
I Platini di Penn. Catalogue Turin 1975.
Irving Penn, Augenblicke Lucerne 1975.
Introduction by *Alexander Libermann.*

Nicola Perscheid

born 1864
died 1930
German photographer, who first worked in Görlitz and Leipzig, then from 1905 in Berlin. She is said to have produced the first colour bromoil prints, using a three-colour picture with three negatives. Her pictures are in the graphic style of art photography.

Walter Peterhans

born 1897
died 1960
German photographer who studied at the Leipzig Academy for Graphic Arts, con-centrating in particular on reproduction photography. In 1929 he became head of the photographic department at the Bau-haus, where he developed a type of photo-graphic 'material collage'. After the Bau-haus closed in 1933, he taught at the Reimann School in Berlin. In 1938 he received an appointment at the Illinois Institute of Technology in Chicago.

Wojciech Plewinski

born 1929
Polish magazine photographer. He first tried to make a career as a sculptor, and studied at the Faculty of Arts in Krakow University before deciding to take up architecture. Eventually he chose photo-graphy as his profession, and became staff photographer for the Polish magazine *Prezekroj (Cross-Section)*. Apart from his work for the magazine, he took a large

number of photographs as free works of art; this part of his activity was devoted mainly to nude photography.

Views on Nudes London 1971. *Bill Jay.*

Josef Prosek

born 1923 Mseno (Czechoslovakia)

Czechoslovak freelance photographer. In 1945–47, he studied in the photographic department of the State School of Graphic Art in Prague. He became editor of the photographic section of the weekly illustrated magazine *Kvety*, and worked in that capacity from 1951 to 1956. From 1956 he has been a freelance photographer. His mature work obviously developed from his original contacts with avant-garde art circles in his youth, especially with regard to the creative use of the 'Objet Trouvé'. He always strengthens the final effect of the 'Objet Trouvé' with his intelligent presentation. He is chairman of the Photographic Group in the Union of Czechoslovak Fine Artists.

Josef Prosek Prague 1962. *Jan Rezac.*
Ceskoslovensko Prague 1965.
Pariz v Parizi (Paris in Paris) Prague 1967.

Constant Puyo (known as Le Commandant Puyo)

born 1857 Dorlaix
died 1933 Paris

Officer, later a professional photographer. His photographs were in the style of Impressionist paintings.

John Wilsey Rawlings

born (date unknown)
died 1912

American fashion, theatrical and portrait photographer, also known for his specialist book *100 Studies of the Figure*. Worked chiefly for *Vogue*.

Man Ray

born 1890 Philadelphia
died 1976 Paris

American artist and photographer of Surrealism and Dadaism, of great significance in the development of art over the last few decades. In the sphere of photography, his Rayographs were pioneers of their technique and composition.

Man Ray—Self-Portrait Boston 1963.
Man Ray Portraits Gütersloh 1963.
Man Ray Rayograph Nadar 4 Turin 1970. *Giulio Carlo Argan.*
Man Ray Clin d'Oeil Turin 1971. *Giuliano Martano.*
Man Ray Munich 1973. *Janus.*
Man Ray Photographs 1920–34 New York 1975. Introduction by *A. D. Coleman.*
Man Ray l'Occio e Il Suo Doppio. Catalogue Rome 1975. *Maurizio Fagiolo dell'Arco.*
Man Ray Lucerne 1975. *Lara Vinca Masini.*
Man Ray London 1975. *Roland Penrose.*

Tony Ray-Jones

born 1941 Wells
died 1972 London

British freelance photographer. He studied at the London College of Printing from 1957 to 1961. Then he completed his education at Yale University from 1961 to 1962, with the aid of a scholarship, and studied further with Alexey Brodovitch and Richard Avedon. Finally he received an MFA degree from Yale University. From 1965 he was a freelance photographer, working for various journals and magazines. He spent the last two years of life preparing photographs for a book which was published posthumously. He died suddenly of leukaemia.

A Day Off—An English Journal London 1974. Introduction by *Ainslie Ellis.*

Vilem Reichmann

born 1908 Brno (Czechoslovakia)

Czechoslovak freelance graphic artist and photographer. He received a degree from the Faculty of Architecture in Brno. After finishing his studies, he taught for a few

years, and then became a clerk. From the end of the Second World War he worked as a freelance artist. In his photography he tended towards the application of Surrealist influences. The significance of his work was confirmed by the award of the distinction 'Artist of Merit.'.
Vilem Reichmann Prague 1961. *Vaclav Zykmund.*

Regina Relang
born 1906 Stuttgart
German photographer, who started work as a fashion designer, and then attended the art academies of Stuttgart and Berlin. From 1932 to 1939 she continued her studies in Paris. Then she joined with those photographers who founded the 'Magnum' group after the Second World War. Since 1949, she has been a fashion photographer specializing in Haute Couture, and is a fashion reporter for various magazines, including Vogue.

Albert Renger-Patzsch
born 1897 Würzburg
died 1966 Wamel (Germany)
German photographer, who was interested in photography since his childhood. After military service during the First World War, he studied chemistry in Dresden. In 1922 he was a photographic contributor to the series of books *The World of Plants.* After the publication of these photographs, his first book, *The Choir Pew of Cappenberg,* appeared in 1925. He became closely acquainted with such men of letters as Thomas Mann, Ricarda Huch, Hermann Hesse and Ernst Jünger. In 1928 he devoted himself to the landscape of the Ruhr region in Essen, and to industrial and architectural photography. In 1933 he became a lecturer at the Folkwang School in Essen. In 1944 his photographic archives were destroyed.
Das Chorgestühl von Cappenberg 1925.
Die Halligen 1927. *Johannsen.*

Die Welt Ist Schön 1928. *Heise.*
Technische Schönheit Zurich 1929.
Lübeck 1928. Dresden 1929. *Heise.*
Norddeutsche Backsteindome 1929. *Burmeister.*
Eisen und Stahl 1930. *Vögler.*
Hamburg 1930. *Schuhmacher.*
Sylt, Bild einer Insel, Landschaft als Dokument Munich 1936.
Deutsche Wasserburgen 1940. *Pinder.*
Paderborn 1949. *Schneider.*
Rund um den Möhnesee 1951. *Henze.*
Lob des Rheingaus 1953. *Curtius.*
Hohenstaufenburgen in Süditalien 1961. *Hahn.*
Bäume 1962. *Jünger.*
Im Wald 1965. *Haker.*
Gestein 1966. *Jünger.*
Albert Renger-Patzsch—Der Fotograf der Dinge Essen 1967. *Fritz Kempe.*
Katalog Fotografien 1925–66, Industrielandschaft—Industriearchitektur— Industrieprodukt Rheinisches Landesmuseum Bonn 1977.

Marc Riboud
born 1923 Lyon
French freelance photographer. He studied engineering at L'École Central de Lyon and was employed in a machine factory in Lyon until 1952. The next year he photographed the Theatre Festival in Lyon, and his pictures were published in the journal *Arts.* This encouraged him to take up the career of professional photographer. In 1953 he joined 'Magnum', and began to take live photographs all over the world.
Women of Japan London 1959.
The Three Banners of China London 1966.

Heinrich Riebesehl
born 1938 Lathen/Ems (Germany)
German photographer, who studied photography under Otto Steinert at the Folkwang School in Essen. From 1965 to 1968, he worked at the Institute for Scientific Photography, and was a photojournalist for the *Hannoversche Presse.* His series of

photographs 'People in the Lift' (1969) became well-known. He organized numerous exhibitions on photographic history.

Menschen im Fahrstuhl Hannover 1970.

Experiment Strassenkunst Hannover 1970.

Photographierte Erinnerung Hannoser 1975.

Heinrich Riebesehl—Situationen und Objekte Riesweiler 1978. *Jörg Kirchbaum.*

George Rodger

born 1908

British photojournalist. After attending St Bees College in England, and having practised in various professions in America, he became a professional photographer, working in Britain for the BBC from 1936 to 1939. Then from 1940 to 1947 he worked for the magazine *Life*. In 1947 he joined 'Magnum', and worked as a freelance photographer. He always liked to travel, and thus taking photographs in foreign countries always appealed to him. Apart from publishing photographs in journals, he compiled several illustrated books from his pictures.

Desert Journey.

Red Moon Rising 1943.

George Rodger London 1975. *Inge Bondi.*

Alexander Rodchenko

born 1891 St Petersburg

died 1956 Moscow

Modernist painter, graphic artist and photographer in the Russian avant-garde movement. In photography, he distinguished himself with his realistic technique with the camera at an oblique angle, and with his experiments in photocollage.

Pro Eto Moscow 1923. Reprinted Ann Arbor 1973.

Alexander Rodchenko Budapest 1975. *German Karginov.*

Alexander Rodchenko Moscow 1968. *L. Volkov-Kannit.*

Künstlerphotographien im XX Jahrhundert

Hanover 1977.

Alexander Rodchenko—Fotografien 1920–38 Cologne 1978. *Evelyn Weiss.*

Jaroslav Rössler

born 1902

Czechoslovak professional photographer. He was trained as an apprentice in the studio of Frantisek Drtikol, where he remained after receiving a licence for another eight years. With the exception of one year's interruption, he practised further in Paris from 1926 to 1935. After returning home to Prague, he set up his own small studio for portrait photography. His best work was done outside routine tasks. All his life he has remained an enthusiastic photographer, exploring all possibilities for creative expression. His work is extraordinarily wide-ranging, including composed portraits, photographs of objects in the spirit of the 'New Objectivity', early live photographs and reportage, poetic images influenced by Surrealism, photographic montage, and pictures created by means of unconventional darkroom techniques.

Surrealismus and Fotografie. Catalogue Essen 1966.

Jaroslav Rössler Exhibition Catalogue Brno 1975. Introduction by Anna Farova.

Jaroslav Rössler Revue Fotografie 79, No 2 1979. *Petr Tausk.*

The Roots of Modern Photography in Czechoslovakia. History of Photography (quarterly), 1979. *Petr Tausk.*

Gertrude Rösslerova

born 1894

died 1976

Czechoslovak professional photographer (maiden name Gertrude Fischerova). She was trained as an apprentice in the studio of Frantisek Drtikol. She married Jaroslav Rössler, and went with him to France. She made very impressive photographs of the dance—her picture 'Aggression' was pub-

lished in *Photograms of the Year—1925*—but her most important contribution to creative photography was her studies of the male nude.

Gertruda Rösslerova Revue Fotografie 79, No 2
 1979. *Petr Tausk.*
The Roots of Modern Photography in
 Czechoslovakia. History of Photography
 (quarterly), 1979. *Petr Tausk.*

Arthur Rothstein

born 1915
American photojournalist, who studied at Columbia University in New York. In the late thirties he worked for the Farm Security Administration. He began working for *Look* in 1940, and he was appointed head of the photographic department of that magazine in 1946. After the Second World War, he devised a 3-D process which he called 'Xography'. In 1969 he became consultant to the US conservation authority. In 1971 he became joint publisher of the Sunday periodical *Parade*.

Photojournalism 1956.
The Bitter Years 1962. *Steichen/Mayer.*
Creative Color 1963.
Look at Us 1967. *Saroyan.*
Color Photography Now 1970.
In This Proud Land 1973. *Stryker/Wood.*
Sozial-Dokumentarische Photographie in den
 USA 1974. *Doherty.*

Drahomir J. Ruzicka

born 1870 Trhova Kamenice
(Czechoslovakia)
died 1960 New York
American photographer of Czechoslovak origin. He moved with his parents to America in 1876. Later he studied medicine in Vienna, and practised medicine in New York from 1894 onward. He began to take photographs in 1904, and exhibited his photographs from 1912. He was a student in photography under Clarence H. White. His work followed the spirit of American 'straight photography'; and later, under the influence of the 'New Objectivity', it was a significant help in the evolution of modern photography in Czechoslovakia in the twenties, where he exhibited his pictures.

Drahomir J. Ruzicka Prague 1959. *Jiri*
 Jenicek.

Erich Salomon

born 1886 Berlin
died 1944 Auschwitz Concentration Camp
German photojournalist and lawyer. He was the first photoreporter to use the new Ermanox to the full; unnoticed, he took photographs in law courts and parliament buildings with a wealth of originality and journalistic flair. He photographed almost all the great statesmen of his time, and was always discovering new ways of capturing their pictures as inconspicuously as possible. He worked for the Ullstein publishing house, for the *New York Times* and for *The Daily Telegraph*. He was the first great technically brilliant photojournalist with a studied, timeless concept of documentation.

Berühmte Zeitgenossen in Unbewachten
 Augenblicken 1931.
The History of Photography New York 1938.
 Beaumont Newhall.
Words and Pictures New York 1952. *Wilson*
 Hicks.
The History of Photography London 1955.
 Helmut Gernsheim.
The Picture History of Photography New
 York 1958. *Peter Pollack.*
Porträt einer Epoche Frankfurt am Main
 1963.
Obevakade Ögonblick (Unguarded Moments).
 Katalog Stockholm 1974.
Portrait of an Age New York 1975.
Katalog Düsseldorf 1976.

August Sander

born 1876 Herdorf am Sieg (Germany)
died 1964 Cologne
German photographer, who had already taken his first photographs by 1892. After

working on a temporary basis at the mine in Herdorf, and completing his military service, he became a professional photographer. He spent a few years wandering through Germany, and eventually attended the Dresden Academy of Arts. In 1910 he moved to Cologne, where he participated in the Workers' Federation Exhibition in 1914. In the twenties he assembled a series of photographs on the theme 'People without a Mask' (1927) and published *Face of the Time* (1929). In 1933 his photographic plates were seized by the Nazis, and he devoted himself to landscape photography in the Westerwald. He was best known for his portraits of representatives of particular professions, which he assembled under the title *People of the 20th Century*.

Antlitz der Zeit 1934.

Künstlerporträts Map with 12 original photographs. Munich, undated.

Rheinlandschaften Map with 12 original photographs. Munich, undated.

Deutschenspiegel Gütersloh 1962.

Konfrontatie 2: August Sander—William Diepraam. Katalog Eindhoven 1974.

August Sander, Rheinlandschaften Munich 1975. *Wolfgang Kemp.*

Gemalte Fotografie—Rheinlandschaften (date unknown). *Joachim Hensinger von Waldegg*

Theo Champion, F. M. Jansen und August Sander. Katalog Bonn 1975–76.

Menschen ohne Maske. Photografien 1906–52 Munich 1976. Text by *Gunther Sander*.

August Sander London 1977. *John von Hartz*.

Galina Sanko

born 1904

Soviet photojournalist. She became a well-known photographer in the thirties. She photographed the passage of the ice-breaker Krasin to the island of Vrangel, as well as the construction of great new factories. During the Second World War she was a war reporter. After the war she joined the staff of the journal *Ogonok*.

Galina Sanko Moscow 1975. *Savva Morozov.*

Russian War London 1978. *Daniel Hrazkova/Vladimir Remes.*

Christian Schad

born 1894 Misebach (Germany)

German painter and graphic artist. He was one of the Zurich Dada group, and, like Man Ray, used direct photography without a camera as an artistic form with his 'Schadographs', or 'Photograms'.

Schadographien 1918–75 Katalog Wuppertal 1975.

Heinz Schubert

born 1925 Berlin

German actor and photographer, whose first photographic works were based on the model books of Brecht. He looks for subjects among the surprising, Surreal and grotesque arrangements of tailors' dummies and displays of goods in shop windows which he comes across in his travels.

Katalog Heinz Schubert Hamburger Kunstverein 1977.

Reinhard Schubert

born 1937 Holzhausen (Germany)

German photographer and graphic designer. After some artistic education he went to Brazil for two years, where he worked as retoucher in a big photographic studio. Back in Europe, Schubert completed his education in the Academy of Fine Arts in Stuttgart under Professor Eugene Funk and then took the position of graphic designer in an advertising agency in Frankfurt. Since 1972 he has worked as a freelance designer on the visualization of books. One-man exhibitions of his photographs were held in Brno (1972) and in Bratislavô (1973). In 1978 he was invited for a month as visiting lecturer to Mexico City.

Wilhelm Schürmann
born 1946
German photographer, who originally studied chemistry at University, and later became a freelance photographer, contributing to various daily papers. He is now a lecturer on photography at Aachen Technical College, and organizes numerous exhibitions on historical and contemporary photography.
Kunstforum-Sonderband 'Die Fotografie' Mainz 1976.
Wilhelm Schümann Riesweiler 1979.

David Seymour (known as Chim)
born 1911 Warsaw
died 1956 Suez Canal
Photojournalist of Polish origin, co-founder of 'Magnum Photos'. He became well-known for his admonitory pictures of forlorn, hungry, mutilated, orphaned children which he photographed in war-torn areas. He was killed in 1956 while reporting on the war in the Suez Canal region.
David Seymour—Chim New York 1974.

Ivan Shagin
born 1904
Soviet photojournalist. After working in several occupations, Shagin came to Moscow, where he met Roman Karmen, who wakened his interest in photography. He became chief reporter for the newspaper *Komsomolskaya Pravda* in 1932, and held this position until 1950. Then he placed his photographic work with various publishing houses. His activity as a war reporter in the first half of the forties was particularly important.
Russian War London 1978. *Daniela Mrazkova/Vladimir Remes.*

Ben Shahn
born 1898 Kaunas (Lithuania)
died 1969 New York
American painter, lithographer and amateur photographer, who used photographic models for his realistic, socially oriented painting. He was a close friend of Walker Evans, and was a member of the group of photographers working for the Farm Security Administration from 1935 to 1940.
The Bitter Years 1962. *Steichen/Mayer.*
In This Proud Land 1973. *Stryker/Wood.*
Ben Shahn—Photographer. An Album for the Thirties New York 1973. *Margaret R. Wiess.*
Sozial-Dokumentarische Photographie in den USA 1974. *Doherty.*
The Photographic Eye of Ben Shahn London 1976. *Davis Pratt.*

Arkadii Shaikhet
born 1898
died 1959
Soviet photojournalist. He was one of the founders in the twenties of Soviet photography oriented on the live photography. He had a sensitive approach to depicting events of everyday life, which he demonstrated particularly well in the early thirties with Max Alpert in the picture-story 'One Day of the Family Fillippov'. He was one of the most important of the Soviet war-reporters in the first half of the forties.
An Introduction to Press Photography Prague 1976. *Petr Tausk.*
Russian War London 1978. *Daniela Mrazkova/Vladimir Remes.*

Jeanloup Sieff
born 1933 Paris
French freelance photographer. He became well-known for his fashion photographs which used perspective distortion, as well as for some live photography. He contributed some of his pictures to *Vogue, Réalités* and other journals.

Aaron Siskind
born 1903
American photographer, who became well-known in the thirties for his socially critical

reports of living conditions in Harlem. In the forties he developed a photographic style tending towards the abstract, akin to that of Minor White. In his photographs individual objects recede in favour of a startling overall impression.

Aaron Siskind Horizon Press 1965.
Bucks County—Photographs of Early Architecture New York 1974. Text by *William Morgan*.
Places—Photographs, 1966–75 New York 1976.

Neal Slavin
born 1941 New York
American photographer with special interest in colour. He originally studied painting at the Cooper Union. In 1961 he received a scholarship to Lincoln College, Oxford University; and at this time he became interested in photography. In 1968 he was awarded a Fulbright Grant in photography, which he used for a journey to Portugal.

Portugal New York 1971. Afterword by *Mary McCarthy*.
When Two or More Are Gathered Together New York 1974.

W. Eugene Smith
born 1918 Wichita (Kansas)
American freelance photographer with a special interest in live photography. His first steps in photography were associated with his love for aeroplanes, which he photographed. In 1936 he began to study at the University of Notre Dame. In 1939 he joined the photographic staff of the magazine *Life*, and held this position until 1941, when he turned to freelance work. In 1944 he rejoined *Life* to become a war correspondent in the Pacific, and this time he remained until 1954, when he joined 'Magnum'. Three times he received a Guggenheim Fellowship. His photographs, filled with warm understanding of human problems and of his love for all people, became known world-wide.

W. Eugene Smith—His Photographs and Notes Millerton 1969. Afterword by *Lincoln Kirstein*.
Minamata New York 1975.
Photography within the Humanities Danbury 1977. *Janis/Eugenia Parry et al.*

Jan Smok
born 1921 Lucenec (Czechoslovakia)
Czechoslovak photographer and teacher of photography. Smok studied book-binding at the State School of Graphic Art in Prague, and thereafter Cinematography at the Faculty of Film and Television in Prague. On completing his educational course, he remained as a lecturer. In 1958 he was appointed Associate Professor of the Technique of Cinematography, and in 1960 he became Principal of the Department of Photography. In 1961 he experimentally introduced a full-time course in Creative Photography, and this became in 1967 a regular branch of study in Film and Television Photography. In 1974 he was appointed Professor of Film and Television Photography, and in 1975 he became Principal of the newly established Department of Creative Photography. In his own photographic work, he experimented chiefly with the creative use of various lighting effects, particularly in association with nude photography.

Akt vo Fotografii (Nude in Photography) Martin 1969.
Za Tajomstvami Fotografie (The Secrets of Photography) Martin 1975.

Jan Splichal
born 1929 Dolni Sloupice (Czechoslovakia)
Czechoslovak photographer. He originally studied at the Secondary Schools of Art in Jablonec and Nisou. He is mainly interested in montage, in which a combination of elements from two or more photographs is a sort of creative game for him,

giving him greater freedom in expressing his lyrical concepts.
Jan Splichal Prague 1971. *Petr Tausk.*

Chris Steele-Perkins
born 1947 Burma
British freelance photographer and teacher of photography. Born in Burma, he was moved one year later to England, where he has lived ever since. He received a degree in psychology at the University of Newcastle-upon-Tyne. During his studies, he became involved with photography while working on a student newspaper. After completing his studies, he became a freelance photographer. Later he began to teach photography as a part-time lecturer in the Faculty of Communication at the Central London Polytechnic.

Edward J. Steichen
born 1879 Luxembourg
died 1973 West Redding (Connecticut)
American photographer whose family emigrated to the USA in 1881. After taking courses in photographic lithography and poster design, he joined Alfred Stieglitz in New York in 1900. During a trip to Europe he met Rodin, and in 1902 he became a member of Photo-Secession. In 1905, with Stieglitz, he opened the '291 Gallery' in New York. During the First World War he took aerial photographs for the Army. In the twenties and thirties, he took fashion and commercial photographs for *Vogue* and *Vanity Fair*. From 1946 he was Director of Photography at the Museum of Modern Art, and organized numerous exhibitions. From 1952 to 1955 he prepared the famous exhibition 'The Family of Man'.
Camera Work No 2 1902.
Steichen, the Photographer New York 1929. *Sandberg.*
The First Picture Book 1930.

US Navy War Photographs 1946.
A Life in Photography (Autobiography). Garden City 1963.
Edward Steichen Millerton 1976.

Otto Steinert
born 1915
German photographer and teacher. Steinert became known for his systematization of photographic style and for his theory of 'Subjective Photography'. He became a Professor at the Folkwang School in Essen.
Subjektive Fotografie Bonn 1952.
Subjektive Fotografie 2 Munich 1955.
Otto Steinert—Der Initiator einer Fotografischen Bewegung Essen 1959. *J. A. Schmoll* (known as *Eisenwerth*).
Selbstportraits Gütersloh 1961. Co-author *Albrecht Fabri.*
Hugo Erfurth Bildnisse Gütersloh 1961.
Otto Steiner und Schüler Essen 1965. *Fritz Kempe/Hermann Schardt.*
Ereignisse in Stahl Düsseldorf 1965.
Otto Steinert a Zaci (Otto Steinert and Pupils) Brno 1967. *Petr Tausk.*
Otto Steinert und Schüler (Otto Steinert and Pupils) Essen 1967. *E. Plunien.*
Das Technische Bild- und Dokumentationsmittel Fotografie Essen 1973.
Otto Steinert—Initiator einer Fotografischen Bewegung. Katalog Essen 1976. *Fritz Kempe.*

Alfred Stieglitz
born 1864 Hoboken
died 1946 New York
American engineer, painter and photographer, who studied in Berlin. In 1902 he founded 'Photo-Secession' and the magazine *Camera Work*, after publishing various journals on photography. In 1905 he opened the '291' photographic gallery, which also exhibited avant-garde art; it achieved international renown. In 1928 some of his photographs were purchased by the Museum of Fine Arts in Boston. As a photographer, he was a strong advocate of

genuine photography, and he was particularly well-known for his winter pictures of New York and for the series of portraits of his wife, the artist Georgia O'Keefe.

America and Alfred Stieglitz New York 1934.

Alfred Stieglitz—Photographer Boston 1965. *Doris Bry.*

Alfred Stieglitz—an American Seer New York 1973. *Dorothy Norman.*

Alfred Stieglitz Millerton 1976. *Michael Hiley.*

Sir Benjamin Stone

born 1838 Birmingham
died 1974
British collector of photographs, then photographer. He made a very important contribution to British photography with his realistic portraits, his group pictures, and his early live photography. He had a clear awareness of the unique properties of a photograph, and he was able to utilize this in his own work.

Customs and Faces—Photographs by Sir Benjamin Stone London 1972. *Bill Jay.*

Sir Benjamin Stone, 1838–1914—Victorian People, Places and Things Surveyed by a Master Photographer. Catalogue London 1974. *Colin Ford(Madeleine Phelps.*

Paul Strand

born 1890 New York
died 1976 Paris
American photographer, who studied under Lewis Hine at the Ethical Culture High School in New York. His acquaintance with Stieglitz introduced Strand to 'Photo-Secession' and the '291' group. In 1915 he created his first subjective photographs, and in 1921 he made his first avant-garde film, 'Manhattan', with Charles Sheeler. In 1933 he became head of the photographic and film section at the Mexican Ministry of Education. In 1935 he met Eisenstein in Moscow. Thereafter he undertook numerous travels and published a number of books. In 1950 he emigrated to France, and

published photographic books on France, Italy, Egypt, Romania, Morocco and Ghana.

Paul Strand, A Retrospective Monograph (2 Volumes) New York 1971.

Camera Work, a Critical Anthology New York 1973. *Jonathan Green.*

The Magic Image Boston/Toronto 1975. *Beaton/Buckland.*

Ghana, an African Portrait Millerton 1976.

Paul Strand—Sixty Years of Photography Millerton 1976. *Calvin Tomkins.*

Mexican Portfolio New York 1967. (Reprint of 1940 edition).

Liselotte Strelow

born 1908 Pomerania
German photographer, who began her photographic training after a course in agriculture. In the thirties she worked for Kodak, until she was able to open her own studios in Berlin in 1938 and in Detmold after the war. Since 1950, she has been a freelance photojournalist, and has earned a name for herself with her portraits of famous personalities from the cultural and artistic life of West Germany during the fifties and sixties. She has issued publications on portraiture, and lives in Hamburg.

Das Manipulierte Menschenbildnis Düsseldorf 1961.

Porträts 1933–72. Katalog Bonn 1977.

Josef Sudek

born 1896 Kolin an der Elbe
died 1976 Prague
Czechoslovak photographer, who first took up photography in 1911. In 1919 he joined the Amateur Photographic Club in Prague, and he studied at the National Graphics School in Prague from 1922. In 1924, with Jaromir Funke, he founded the Czechoslovak Photographic Society. In 1928 he prepared a portfolio of twelve original photographs of the Cathedral of St Vitus in Prague, for which J. Durich wrote an introduction. He acquired a studio of his

own, situated in a wooden hut in a court-yard among tenement houses, where he carried out both portraiture and advertising photography. He devoted a large part of his creative work to free photographs of Prague, landscapes and nature. After 1940 he decided to use only the technique of contact printing. After the Second World War he acquired an old Panoramic Kodak camera, and began to create his famous pictures of unorthodox format with black frames. On the occasion of his 60th birth-day, the Readers' Club issued a large monograph about his work, containing 232 reproductions, and it had an edition of 30,000 copies. The emolument from this enabled him to devote himself solely to free creative work. He received from the Gov-ernment the honorary distinction 'Artist of Merit' in 1961, and the 'Order of Labour' in 1966. He was photographing practically up to the last days of his life; the sensitivity of his vision had in no way weakened, nor had his endeavour to include news photography in his range. He contributed to the representative portfolio *Twelve Instant Images on Polaroid Type 105 Positive/Negative Film*. A short time before his death he took some colour photographs, which were printed posthumously.

Nas Hrad (Our Castle) Prague 1945. Co-author *A. Wenig*.
Magic in Stone London 1947.
Lapidarium Narodniho Musea (Stone Collection of the National Museum) Text by *V. Denkstein, Z. Drobna, J. Kybalova*. Prague 1958.
Josef Sudek Fotografie Prague 1956. *Lubomir Linhart*.
Praha Panoramaticka (Panoramic Prague 1959. Introduction by *Jaroslav Seifert*.
Karluv Most Fe Fotografie (Charles's Bridge in Photography) Prague 1961. Text by *Jaroslav Seifert* and *Emanuel Poche*.
Josef Sudek Prague 1964. *Jan Rezac*.

Janacek—Hukvaldy Prague 1971. Text by J. Seda.
Catalogue of the Museum of Decorative Arts Prague 1976. Introduction by *Anna Farova*.
Catalogue of the Moravian Gallery. Brno 1976. Introduction by *Antonin Dufek*.
Catalogue of Edition Lichttropfen. Aachen 1976. Introduction by *Werner Lippert* and *Petr Tausk*.
Portfolio of 13 Photographs Prague 1976, 1978. Introduction by *Petr Tausk*.
Sudek New York 1978. Text by *Sonja Bullaty*.

Jean-Pierre Sudre
born 1921
French photographer, who studied at the École Nationale de Cinématographie in Paris during the early forties. His photo-graphs have been exhibited both in France and abroad since 1952.
Bruges, Au Berceau de la Peinture Flamande Paris 1963. Text by *Francois Cali*.
Diamantine Paris 1964.

Frank Meadow Sutcliffe
born 1853, Leeds
died 1941
British professional photographer, whose work was concerned with landscape and live photography in Whitby. The most significant part of his work was associated with 'natural photography' and 'straight photography'. By 1922 he had practically retired from photography; his most im-portant pictures had been created before 1910—mainly in the 19th century.
Frank Sutcliffe—Photographer of Whitby London 1974. *Michael Hiley*. Editor *James Fraser*.

Aladar Szekely
born 1870
died 1940
Hungarian portrait photographer (actual name Bleyer). He studied in Munich,

Berlin, Dresden and Hamburg. In 1906 he opened his portrait studio in Budapest. He became especially known for his portfolios of painters' and writers' portraits. After the death of the poet Endre Ady, he compiled a photographic album about his life, for which the introduction was written by the famous Hungarian writer Zsigmond Moricz.

Aladar Szekely Munkassaga Budapest 1968. *David Katlin.*

Karin Szekessey-Wunderlich

born 1939 Essen

German photographer who has become known for her extravagant nude and fashion photography. The painter Paul Wunderlich used her photographs of boyishly slim girls in lavish surroundings as models for his fantastic erotic paintings.

Paul Wunderlich und Karin Szekessy Correspondenzen Zurich 1977. *Fritz J. Raddatz.*

Karel Teige

born 1900
died 1951

Czechoslovak critic and journalist, who was inspired by Rodschenko in the twenties to produce his own photomontages of a poetic character.

Shomei Tomatsu

born 1930 Nagoya (Japan)

Japanese freelance photographer. He is known mainly through his contributions to *Hiroshima-Nagasaki Document 61*, which was published by the Japanese Conference for Banning the H-bomb in 1961.

New Japanese Photography New York 1974. *John Szarkowski/Shoji Yamagishi.*

Peter Turner

born 1947

British freelance photographer and co-editor of *Creative Camera*. He studied photography at the Guildford School of Art. As a photographer he showed a very straightforward approach to reality. He published many articles about photography in various journals.

P. H. Emerson, Photographer of Norfolk London 1974. Co-author *Richard Wood.*

Singular Realities Newcastle-upon-Tyne 1977. *Gerry Badger.*

Jerry Uelsmann

born 1934

American freelance photographer and teacher of photography. He received a BFA degree from the Rochester Institute of Technology, and MS and MFA degrees from Indiana University. He became a Graduate Research Professor of Art at the University of Florida. In his photographic work, he was concerned mainly with creating montage photographs in the spirit of Surrealism.

Jerry Uelsmann Millerton 1973. *Peter C. Bunnell.*

Silver Meditations—Jerry Uelsmann Dobbs Ferry. *Peter C. Bunnell.*

The Photographers' Choice Danbury 1975. *Kelly Wise et al.*

Umbo (real name Otto Umbehr)

born 1902

German photojournalist, who studied at the Bauhaus in Weimer from 1921 to 1923. In the twenties he was co-founder of the German Photo Agency, and he was one of the leading international photographic reporters. Since 1965 he has been lecturing at the Hanover School of Art.

Deutschland—Beginn des Modernen Photojournalismus Lucerne/Frankfurt 1972. *Tim N. Gidal.*

Alexander Ustinov

born 1909

Soviet photojournalist. He worked on the staff of *Pravda* as a photographer. He became particularly well-known for his war reporting.

*Alexander Ustinov—Izbrannye Fotografii
(Selected Photographs)* Moscow 1976.
Viktor Maevskiy.
Russian War London 1978. *Daniela
Mrazkova/Vladimir Remes.*

Ernö Vadas

born 1899
died 1962
Hungarian photographer, who achieved
great fame in the thirties. In 1927 he
exhibited his photographs for the first time,
and in 1929 he became a member of the
Hungarian National Association of Photo-
graphers. He received a Medal of the
Royal Photographic Society. He became
editor of the journal *Foto* and President of
the Hungarian Photographic Association
in 1954. The most important part of his
work consisted of the dynamic portrayal of
life.

Zdenek Virt

born 1923
Czechoslovakia freelance photographer,
graphic artist and teacher of photography.
He studied graphic art and book illustra-
tion at the College of Decorative Arts in
Prague. He has been since 1967 a visiting
lecturer on nude photography in the
Department of Photography at the Film
and Television Faculty in Prague. As a
photographer he became known for the very
high quality of many of his nude photo-
graphs, as well as for his photographic
montages used to illustrate novels.
Op Art Akte Hanau 1970.
Vision Hanau 1973.

Hans Watzek

born 1848
died 1903
Austrian photographer, who studied at the
Leipzig and Munich Academies of Art.
He took up photography in 1890, and
became a member of the Vienna Camera
Club in 1891. He developed the aquatint

colour process with Kühn and Henneberg,
and this brought him fame.
*Das Trifolium des Wiener Camera-Clubs:
Hans Watzek/Hugo Henneberg/Heinrich
Kühn* (In *Die Kunst in der Photographie*).
Berlin 1898. *Alfred Buschbeck.*

Wolfgang Weber

born 1902 Leipzig
German photojournalist, who studied eth-
nography and music. He began his work as
a journalist with a photodocumentary on
the cultural situation in Black Africa, while
studying phonetics. He then prepared
various reports in word and picture for the
Berliner Illustriert and the *Münchner Illustri-
erte Press*. During the war he made neutral
photographic reports of both sides. After
the war he was chief reporter for the *Neue
Illustrierte*, and reported from the world's
troublespots. Since 1955 he has specialized
in reports from the third world, and has
undertaken many travel documentaries for
television.
Hotel Affnbrotbaum.
Abenteuer einer Kamera.
Barcelona—Weltstadt im Werden.
Abenteuer Meines Lebens.
Auf Abwegen um die Welt.
*Deutschland—Beginn des Modernen
Photojournalimus* Lucerne/Frankfurt
1972. *Tim N. Gidal.*

Weegee (real name Arthur Fellig)

born 1899 Zloczew (Poland)
died 1969 New York
American photographer of Polish origin,
who started as a street photographer in New
York. He worked for the police from 1915
to 1935 as a photographic reporter of
accidents, crimes, etc. In 1945 he published
his first book *Naked City*. From 1947 he
worked for *Life*, *Vogue*, *Look* and *Harper's
Bazaar*. Since 1950 he took photocarica-
tures and portraits of well-known person-
alities. He had a close connection with the
Hollywood film scene from 1968.

Weegee's Creative Camera 1959. *Ald.*

Naked City New York 1975.

Weegee by Weegee—an Autobiography New York 1975.

Naked Hollywood New York 1975. Co-author *Mel Harris.*

Weegee's People New York 1976.

Weegee the Famous New York 1977. *Lou Stettner.*

Aperture History of Photography Millerton 1978.

Stephen Weiss

born 1945 Birmingham

British freelance photographer. He studied economics at Pomona College in California. In 1971 he became a freelance photographer, and in 1972 founded 'Co-optic', the photographers' co-operative, with the aim of facilitating the exhibiting and publishing of creative photographs.

Brett Weston

born 1911 Los Angeles

American freelance photographer, son of Edward Weston, with whom several times he shared a studio. He was a member of the group *f*64. As in the case of his father, he favoured large-format cameras, which allowed him to obtain great wealth of detail in his photographs, which approached the 'New Objectivity' in style.

Voyage of the Eye Millerton 1975.

Afterword by *Beaumont Newhall.*

Edward Weston

born 1887 California

died 1958 California

American photographer, who took his first photographs at the age of 16 with the family's postcard camera. In 1911 he opened a portrait studio in California, and specialized in child photography. He was creatively inspired by abstract art, and experimented with close-ups and abstractions. In 1923 he went to Mexico, where he acquired a small portrait studio. He re-

turned to America in 1927. He founded the *f*64 group with Ansel Adams, Williard van Dyke and others in 1932. In 1937 he was the first photographer to receive a scholarship from the Guggenheim Foundation.

The Art of Edward Weston New York 1940. Editor *Merle Armitage.*

California and the West New York 1940.

The Daybooks of Edward Weston 2 Volumes: Volume 1, Mexico; Volume 2, California Millerton 1973. *Nancy Newhall.*

Edward Weston—The Flame of Recognition: His Photographs Accompanied by Excerpts from the Daybooks and Letters Millerton 1975. *Nancy Newhall.*

Edward Weston, Fifty Years New York 1975. *Ben Maddow.*

Edward Weston, Leaves of Grass London 1976. *Walt Whitman.*

Nudes Millerton 1977.

Edward Weston—70 Photographs New York 1978. *Ben Maddow.*

Clarence H. White

born 1871 Ohio

died 1925 Mexico

American amateur photographer, co-founder of 'Photo Secession'. From 1907 he was a Professor at Columbia University, New York. For a time he conducted some summer schools on photography in Maine. From 1909 onwards he co-operated with Stieglitz. His photographic style is characterized by illustrations to novels.

Minor White

born 1908 Minneapolis

died 1976 Massachusetts

American freelance photographer and teacher of photography. He received a BS degree in botany, with a minor in English, at the University of Minnesota in 1933. He wrote poetry, but in 1937 turned his attention seriously to photography—he had been given his first camera at the age of

eight. In 1940 he was appointed teacher of photography at La Grande Art Center in eastern Oregon, and in 1941 he showed his first photographs in the national 'Image of Freedom' exhibition, at the Museum of Modern Art in New York. After the Second World War, he studied art history and aesthetics at Columbia University Extension Division. In 1952 he was a co-founder of the important quarterly *Aperture*. From 1953 to 1964 he organized many important exhibitions of photography. In 1965 he was appointed Visiting Professor at Massachusetts Institute of Technology, and purchased a house in Arlington, Massachusetts. In 1976 he re-recived an Honorary Doctorate of Fine Arts from San Francisco Art Institute. As a photographer, he showed a deep understanding of visual poetry. In his profound work could be seen images based on a metaphorical interpretation of reality, as well as photographs resembling abstract paintings, and some pictures continuing the traditions of the 'New Objectivity'.

Mirrors, Messages and Manifestations Millerton 1969.

Being without Clothes Millerton 1970. Editor *Minor White*.

Octave of Prayer Millerton 1972. Editor *Minor White*.

Rites and Passages Milerton 1978. Introduction by *James Baker Hall*.

Rolf Winquist

born 1910 Göteborg
died 1966
From 1935, Winquist was a nautical photographer on the world's oceans. He also took fashion and industrial photographs. He was emulated by the younger generation of Swedish photographers.

Italo Zannier

born 1932 Spilimbergo (Italy)
Italian freelance photographer and teacher of photography. He studied at the Academy of Fine Arts and Architecture in Venice. At present he is a freelance photographer, and also gives lectures on photography for the Senior Course in Industrial Design, and on the technique of communication, in the Faculty of Architecture in Venice.

Un Casa é una Casa Pordenone 1971. Co-author *Elio Bartolini*.

Breve Storia della Fotografia Milan 1974.

70 Anni di Fotografia in Italia Modena 1978.

Georgij Zelma

born 1906
Soviet photojournalist. From the second half of the twenties he has photographed the building of the USSR. He became staff photographer of *Izvestiya*, and in this post he worked as a reporter in the Second World War.

Russian War London 1978. *Daniela Mrazkova/Vladimir Remes*.

Georgij Zelma—Izbrannye Fotografii (Selected Photographs) Moscow 1978. Boris Vilenken.

John Zimmerman

born 1928 Los Angeles
American photojournalist, specializing in reportage of sporting events. He joined the staff of *Sports Illustrated* in 1956, and later became a freelance photographer in Los Angeles. He achieved fame with his experimental photographs using unconventional effects in depicting sport.

Photographing Sport London 1975. Text by *Sean Callahan and Gerald Astor*. Co-author *Mark Kauffman*.

Index